joan miró

EDITED BY

Marko Daniel and Matthew Gale

WITH CONTRIBUTIONS BY

Christopher Green, Kerryn Greenberg,
William Jeffett, María Luisa Lax, Robert S. Lubar,
Joan M. Minguet Batllori and Teresa Montaner

THE
LADDER
OF
ESCAPE

joan
miró

 Thames & Hudson

First published in 2011 by order of
the Tate Trustees by Tate Publishing,
a division of Tate Enterprises Ltd,
Millbank, London SW1P 4RG
www.tate.org.uk/publishing

on the occasion of the exhibition
Joan Miró: The Ladder of Escape

Tate Modern, London
14 April – 11 September 2011

Fundació Joan Miró, Barcelona
13 October 2011 – 25 March 2012

National Gallery of Art, Washington
6 May – 12 August 2012

First published in 2012 in hardcover in the
United States of America by Thames &
Hudson Inc., 500 Fifth Avenue, New York,
New York 10110

thamesandhudsonusa.com

ISBN 978-0-500-09367-2

Library of Congress Catalog Card Number
2011933180

Designed by LewisHallam
Printed in Italy by Conti Tipicolor, Florence

FRONT COVER *A Star Caresses the Breast of
a Negress* (*Painting Poem*) 1938 (detail of no.8)
BACK COVER Colita, Miró removing the mural
at *Miró Otro*, Barcelona, 1969 (see pp.176–9)
FRONTISPIECE Rogi André, *Miró* c.1934

Measurements of artworks are given in centime-
tres, height before width, followed by depth.

From around 1920 Miro habitually titles his work
by inscribing them on the reverse in French (or,
very rarely, in Catalan). This is used here for the
first mention of each work, with the English to
follow. Earlier paintings without inscriptions have
been given their conventional English titles.

FSC
www.fsc.org
MIX
Paper from
responsible sources
FSC® C016114

Contents

**The Hope of a
Condemned Man I** 1974
(detail of no.159)

Foreword

Across a long and productive career Joan Miró's work oscillated between passionate commitment and contemplative withdrawal, and it is this tension that lies at the heart of *Joan Miró: The Ladder of Escape*. Sometimes he could prove very direct. In 1936, at the start of the Spanish Civil War when he threw in his lot with the Republican government, he grimly acknowledged that Fascism was 'against everything that represents the pure value of the spirit'.[1] However, the oscillation may also be perceived in two exemplary late works that challenged conventions and helped inspire our project. Although he was world-famous, Miró rejected official overtures in Franco's Spain; consequently, he only became well known in his native Barcelona during the late 1960s and through his subsequent establishment of the Fundació Joan Miró, which opened in 1975. In these circumstances many were surprised by the violence with which he pilloried the dictatorship in collaborating on the satire *Mori el Merma* (loosely, 'Death to the Bogeyman') with the theatrical troupe La Claca in 1977. A contrasting note is struck with the great triptych *L'Espoir du condamné à mort* (*The Hope of a Condemned Man*) 1974, in which the painter's characteristic colour survives only in isolated explosions. Miró saw this triptych in relation to the regime's execution of the Catalan anarchist Salvador Puig Antich; it was, to an extent, an act of sympathy and subversion, presenting a profoundly human concern worthy of contemplation.

The belief that these examples were not isolated instances proved compelling. This exhibition, therefore, sets out to trace Miró's shifting responses to the politics of his time. *Joan Miró: The Ladder of Escape* was initiated during 2007–8 in conversations between Vicente Todolí, then Director of Tate Modern, and Rosa Maria Malet. During the period of development other exhibitions suggested that this might be a fertile line of enquiry, without strictly anticipating the approach.[2] Further reinforcement came from scholars – several of whom have contributed to this volume – who uncovered much of what Miró had deliberately left ambiguous. The resulting process of re-imagining Miró, undertaken by the curators Marko Daniel, Matthew Gale, Kerryn Greenberg and Teresa Montaner, has been extraordinarily invigorating and has generated an energetic collaboration between Tate Modern

and the Fundació Joan Miró. Twenty years after our own collaboration on an exhibition of Miró in the 1930s at the Whitechapel Art Gallery, it has been our pleasure to be involved again in a project very close to our own concerns.

It would not have been possible to put together an exhibition on such an ambitious scale without the support of individuals and institutions who are guardians of these great works. Their generosity and willingness to recognise the cogency of the project has been very encouraging. In addition to the thanks expressed in the Acknowledgements we add our own to all those who have offered advice, knowledge and support. We should make special mention of Emilio Fernandez Miró and Joan Punyet Miró, the artist's grandsons and formidable experts in their own right, who have been unfailingly enthusiastic in their encouragement through-out. Jacques Dupin, a friend of the artist whose numerous texts written over the last six decades combine acuity of insight and poetic vision, stands out among scholars. He has encouraged so many in their engagement with Miró's work and will continue to have an unparalleled influence on future generations.

In London the exhibition has benefited greatly from the tremendous support of the Institut Ramon Llull, to whom we would like to extend our sincere thanks. We are also grateful for the generous sponsorship from British Land, Finsbury and Goldman Sachs and additional sponsorship from the JCA Group. This continuing involvement in our activities is extraordinarily valuable.

We have also benefited from the advice of His Excellency Ambassador Casajuana and the generous support of the Office for Cultural and Scientific Affairs at the Embassy of Spain. We would also like to thank the Spanish Tourist Office for their valuable involvement with the exhibition. Finally we would like offer our warmest thanks to the Tate Patrons for their important commitment towards the exhibition. To all of these benefactors, sponsors and advisors, especially in times when economics threaten to curtail cultural activities, we should like to express our sincere gratitude.

The National Gallery of Art in Washington is deeply grateful to the Anna-Maria and Stephen Kellen Foundation for its extraordinary commitment to the Gallery's exhibitions program. We also would like to thank Buffy and William Cafritz for their kind support of the exhibition in Washington. Finally, we would like to express our gratitude for the generous support of the Institut Ramon Llull, an exhibition sponsor for London and Washington.

The catalogue, like the exhibition itself, draws widely on recent research. The editors have set out the premise that while Miró's political statements were rare, much of his art lies on the fulcrum between engagement and escape. Two key scholars of the artist and the period, Robert S. Lubar and Joan M. Minguet Batllori, have brought their vast knowledge to bear in providing overviews. Other specialist essays by Christopher Green, William Jeffett and María Luisa Lax join texts by the exhibition's curators to form the body of the catalogue.

In the end, the most powerful impact of Miró's work lies in what he poured into it, both overtly and implicitly. It repays the experience of looking: a testing of the visual, of what could be conveyed and what discerned. *Joan Miró: The Ladder of Escape* reveals that Miró struggled at different moments of his life with the balance between engagement and retreat. To borrow his own words for the title of this exhibition has served to acknowledge this pervasive ambiguity. As his friend Roland Penrose (who was responsible for the great Miró exhibition at the Tate Gallery in 1964) remarked, the ladder alluded to Miró's desire 'to rise beyond the limitations that bind us to earth ... to transcend the incomplete condition of daily life'.[3]

ROSA MARIA MALET, Director, Fundació Joan Miró
NICHOLAS SEROTA, Director, Tate
EARL A. POWELL III, Director, National Gallery of Art

1 Miró in Georges Duthuit, 'Où allez-vous, Miró?',
 Cahiers d'Art, no.8–10, 1936, [published 1937],
 in Rowell 1986.
2 Umland 2008; Llorens 2008.
3 Penrose 1970, p.193.

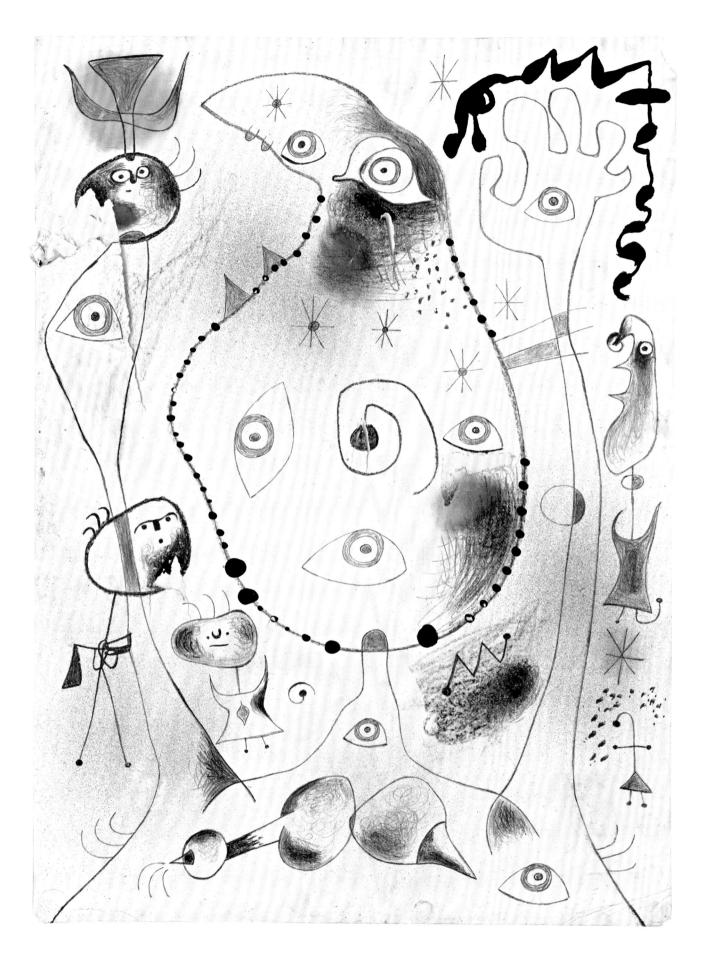

Barcelona Series (VII) 1944
(see no.108)

Acknowledgements

Joan Miró characterised himself as a pessimist. Many know his whimsical figures and celebratory colours, but *Joan Miró: The Ladder of Escape* reveals the seriousness that underpinned his work. His figures may appear mischievous, but they also reveal anxieties, as wonderment goes hand in hand with rupture. In our approach we have drawn upon recent scholarship and at the same time developed ideas during fertile exchanges between the collaborative partners at Tate Modern and the Fundació Joan Miró. With the encouragement of Rosa Maria Malet and Vicente Todolí, who first proposed the project, it has been an enormous pleasure to work as part of the curatorial team alongside Teresa Montaner, whose knowledge of Miró's work is especially profound, and our colleague Kerryn Greenberg. With the support of Sònia Villegas we have debated and investigated Miró's works with a sense of discovery that mimics the artist's own. It has also been a pleasure to discuss the project in detail with Harry Cooper at the National Gallery of Art, Washington DC, where the tour concludes.

Our reading of Miró's work has been welcomed in many quarters. The artist's grandsons Emilio Fernández Miró and Joan Punyet Miró have been generous in sharing their knowledge and making available their records at the Successió Miró in Palma; without this help the project would scarcely have been possible. We would also like to acknowledge Lola Fernández Jiménez and Ana Rullan Estarellas for their help in different capacities, and to thank Pilar Ortega and her colleagues at the Successió who have bolstered our research.

As well as the Fundació Joan Miró in Barcelona, the artist endowed the Fundació Pilar i Joan Miró in Palma; here, again, records and works were put at our disposal. We are grateful to the Director, Magdalena Aguiló Victory, curator María Luisa Lax and their colleagues for, among many things, an inspiring tour of Miró's studios, which still bear the traces of paintings included in this exhibition. Other support has come from the work of Miró scholars. Pre-eminent among these is Jacques Dupin, author of the most authoritative volume on Miró that was published nearly fifty years ago and that encouraged so many in their engagement with the work. He is, of course, also co-author with Ariane Lelong-Mainaud (whose help has been especially significant) of the multi-volume catalogue raisonné of paintings and that of drawings. Our approach has been necessarily shaped by their work and that of other Miró scholars over the years, including Maria Lluïsa Borràs, Victòria Combalia, Rosalind Krauss, Remi Labrusse, Carolyn Lanchner, Roland Penrose, Margit Rowell and Anne Umland.

No exhibition can be achieved without the support of those who have works in their collections. We are very grateful to the following for lending their precious paintings, drawings, sculptures and prints. Among private collectors and foundations: The Aylan Group; Patricia Phelps Cisneros and Gabriel Pérez-Barreiro of the Fundación Colección Patricia Phelps de Cisneros; Colección 'El Conventet', Barcelona; Richard and Mary L. Gray and the Gray Collection Trust; Alessandra Carnielli, Director, and Maya Joseph-Goteiner, The Pierre and Tana Matisse Foundation, New York; Emilio Fernández Miró and Joan Punyet Miró, Successió Miró,

Palma; Helly Nahmad and Dany Ardouin of the Helly Nahmad Gallery, London; Batsheva and Ronald Ostrow; Ceil Pulitzer; STUDIO PER, arquitectos; Billie Milan Weisman, Director, Frederick R. Weisman Foundation, Los Angeles. We have been particularly fortunate in benefiting from Helly Nahmad's enthusiasm for the project and consequently generous loans from the Nahmad Collection. We are also grateful to all those lenders who prefer to remain anonymous.

Among the public collections we would like to thank the following, and their colleagues too numerous to mention by name: Samuel Keller, Director, Fondation Beyeler, Basel; James Cuno, President and Eloise W. Martin Director, as well as Douglas Druick and Stephanie D'Alessandro, Art Institute of Chicago; David Franklin, Director and Deborah A. Gribbon, formerly Interim Director, and their colleagues Heather Lemonedes and William Robinson, Cleveland Museum of Art; Simon Groom, Director of Modern and Contemporary Art, and Patrick Elliott, Scottish National Gallery of Modern Art, Edinburgh; Hartwig Fischer, Director, Folkwang Museum, Essen; Eric M. Lee, Director and Malcolm Warner, Kimbell Art Museum, Fort Worth; Sean O'Harrow, Director, and Pamela White (former Interim Director), University of Iowa Museum of Art; Sophie Lévy, Director, Lille métropole musée d'art moderne, Villeneuve d'Ascq; Sylvie Ramond, Director, Musée des Beaux-Arts de Lyon; Manuel J. Borja-Villel, Director, and Rosario Peiró, Museo Nacional Centro de Arte Reina Sofía, Madrid; Guillermo Solana, Chief Curator, Museo Thyssen-Bornemisza, Madrid; Thomas P. Campbell, Director and Gary Tinterow, Engelhard Chairman, Department of Nineteenth-Century, Modern and Contemporary Art, Metropolitan Museum of Art, New York; Glenn Lowry, Director, Ann Temkin, Chief Curator of Paintings and Sculpture, and Cornelia H. Butler, The Robert Lehman Foundation Chief Curator of Drawings, The Museum of Modern Art, New York; Richard Armstrong, Director, and Susan Davidson, Solomon R. Guggenheim Museum, New York; Magdalena Aguiló Victory, Director, and María Luisa Lax, Fundació Pilar i Joan Miró, Palma de Mallorca; Alfred Pacquement, Director, and Brigitte Leal, Musée national d'art moderne, Centre Pompidou, Paris; Timothy Rub, Director and Chief Executive, Innis Howe Shoemaker and Michael R. Taylor, Philadelphia Museum of Art; Larry J. Feinberg, Director and Eik Kahng, Santa Barbara Museum of Art; Daniel Birnbaum, Director and Lars Nittve, former Director, Moderna Museet, Stockholm; Brian Kennedy, Director, Rod A. Bigelow (formely Interim Executive Director), Amy Gilman and Tom Loeffler, Toledo Museum of Art; Richard Koshalek, Director, Hirshhorn Museum and Sculpture Garden, Washington, DC; Earl A. Powell III, Director, Dodge Thompson and curator Harry Cooper, National Gallery of Art, Washington, DC.

In London this exhibition has been made possible by the provision of insurance through the UK Government Indemnity Scheme. On behalf of Tate we would like to thank the Department for Culture, Media and Sport and the Museums, Libraries and Archives Council for providing and arranging this indemnity. We are also most grateful to those who acted as intermediaries as well as all the authors of this catalogue and others who have enriched the project in other ways: Dawn Ades, Miguel Cabañas Bravo, Olivier Camu, Cristian Cirici, Melanie Clore, Mariona Companys, Agnes de

la Beaumelle, Julián de la Cierva, Christian Derouet, Clara Drummond, John Elderfield, Moriah Evans, Michael Finlay, Marcel Fleiss, Christopher Green, Carmen Godia, Anna Haas, Sandy Heller, Diana Howard, William Jeffett, Kazumasa Katsuta, Veronique de Lavenne, María Luisa Lax, Ariane Lelong-Mainaud, Daniel Lelong, Albert Loeb, Maria Los, Robert S. Lubar, Isabelle Maeght, Joan M. Minguet Batllori, Eric Mouchet, Didier Ottinger, Sandrine Pissarro, Roman Plutschow, Mathias Rastorfer, Margaride Sala, Manny Silverman, Esperanza Sobrino, Susan Talbott, Anne Umland, Emilio Marcos Vallaure, Paolo Vedovi, Leslie Waddington.

By far the largest number of works in the exhibition from any single source are from the Fundació Joan Miró in Barcelona. For London and Washington visitors this is an astonishing opportunity to grasp the richness and variety of the artist's work, especially from the highpoints of his career in the 1960s and 1970s. As well as the consistent and unwavering support of Rosa Maria Malet and Teresa Montaner, we would like to acknowledge all their colleagues who have made it possible to move these great works around the world. In Barcelona, where the exhibition will open at the centre of Miró studies, the impact will be quite different. New juxtapositions will emerge as the great works within the collection of the Fundació are placed alongside works from elsewhere, and connections made in the artist's studio at the time of their conception will be regenerated. We are thrilled that *Joan Miró: The Ladder of Escape* will conclude its tour at the National Gallery of Art in Washington, the home of *The Farm*. It has been a pleasure to work with Dodge Thompson and curator Harry Cooper. Their colleagues have been helpful at every stage.

Finally, at Tate the exhibition and catalogue have been given sustained impetus especially by Nicholas Serota, but initially by Vicente Todolí and more recently by his successor Chris Dercon, and Sheena Wagstaff. Kerryn Greenberg has been indefatigable, as well as being a thoughtful contributor on many fronts. Stephanie Bush has brought the exhibition together with characteristic seamlessness, and Rachel Kent, Stephen Mellor (until his retirement), Phil Monk, and Helen Sainsbury have all offered steady support and advice. Stuart Comer has masterminded the parallel film programme. At an early stage preliminary research was undertaken by Ariane Coulondre and Claudia Segura; Katy Norris worked on the chronology; and Ester Ramos and Claire Lebossé made a valuable contribution at a later stage. We would like to acknowledge Alice Chasey and Beth Thomas, the project editors on this volume, and all those at Tate Publishing who have made it possible, including James Attlee, Celia Clear, Bill Jones, Johanna Stephenson, Roger Thorp, Emma Woodiwiss, Laura Wright and Roz Young. Philip Lewis's catalogue design and his contribution to the exhibition are characteristically elegant. We would also like to thank all those in other parts of Tate for their enthusiasm, including colleagues in the Archive and Library, Art Handling, Communications, Conservation, Curatorial, Development, Front of House, Learning, Legal, Media, Press, Special Events and Registrars. Finally, we thank our families for their support and forebearance.

MARKO DANIEL
MATTHEW GALE

Self-Portrait
1937–8 – 23 February 1960
(see no.82)

For quotations see
p.28 n.1 and p.43 n.9.

In the present struggle I see, on the Fascist side,
spent forces; on the opposite side, the people, whose
boundless creative will gives Spain an impetus which
will astonish the world.

Joan Miró, 1937

I understand the artist to be someone who, amidst the
silence of others, uses his voice to say something, and
who has the obligation that this thing not be useless but
something that offers a service to man. For the fact of
being able to say something, when the majority of people
do not have the option of expressing themselves, obliges this
voice in some way to be prophetic. To be, in a certain sense,
the voice of its community … For when an artist speaks in
an environment in which freedom is difficult, he must turn
each of his works into a negation of the negations, in an
untying of all oppressions, all prejudices, and all the false
established values.

Joan Miró, 1979

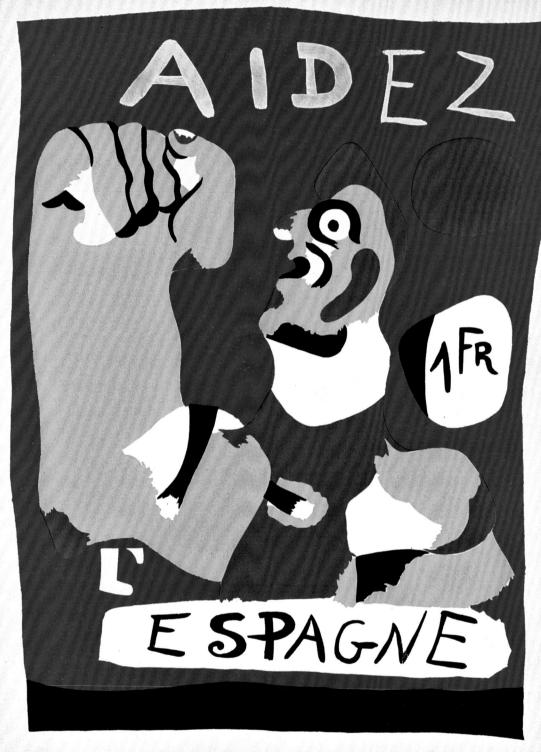

Dans la lutte actuelle, je vois du côté fasciste les forces périmées, de l'autre côté le peuple dont les immenses ressources créatrices donneront à l'Espagne un élan qui étonnera le monde. Miró.

Introduction:
Free and Violent Things

MARKO DANIEL AND MATTHEW GALE

In his most public declaration during the Spanish Civil War, Joan Miró inscribed *Aidez l'Espagne* (literally, *Help Spain*, no.1) with a dismissal of the 'spent forces' of Fascism, contrasting them with his belief in the 'boundless creative will' of the people who would 'give Spain an impetus which will astonish the world'.[1] Miró was rarely given to such forceful pronouncements. He did not, overtly at least, subscribe, sign up, support and march.[2] Instead, an ingrained sense of loyalty to his locality, a concentration on his creativity, and an interplay between personal association and Surrealist automatism all came together in works that still leave one breathless at their audacity. For many, this fluency was so instinctive as to appear childlike; indeed, in the inter-war years both the creativity and violence of his work were measured in relation to a developing understanding of child behaviour.[3] Most notorious was the ambivalence of André Breton, the Surrealist leader who, in 1941, despite Miró's long association with the movement, qualified his admiration for the artist's 'spontaneity of expression' by identifying 'a partially arrested development at the infantile stage'.[4] Perhaps this misunderstanding of the artist's achievement now sounds more severe than it did in the 1940s, when reliance on the telling gesture and expressive freedom was transmuting into what would become known as Abstract Expressionism and *informel*.

Even within the Surrealist and formalist views of Miró's output there is potential for further investigation, and scholarship over recent years has opened up the possibility of seeing the artist responding to the events and, more specifically, the politics of his time. Miró certainly witnessed some of the most turbulent years in Spanish and European history. He passed from a youthful awareness of Catalan concerns, through an optimistic internationalism to the catastrophe of the Spanish and World wars. The repressions experienced under the dictatorships of Miguel Primo de Rivera (1923–30) and Francisco Franco (1939–75) enforced strategies that gradually evolved into a pattern of negotiated evasion and resistance. By the late 1960s Miró's international reputation could no longer be ignored within Spain, even as he joined a younger generation of artists in opposing the regime.[5] He lived to celebrate the transition to democracy that followed Franco's death in 1975.

Miró's political response was sporadic. Even as he professed a revolutionary 'assassination of painting',[6] there were times, in the dream paintings of the late 1920s and the devotion to ceramics in the 1950s for instance, when he concentrated on the aesthetic and material qualities of his work. It is in this sense that the 'ladder of escape' recurs in his imagery: it signals his desire for withdrawal to his own artistic world, echoed in his retreat to the family farm at Mont-roig or, in later life, to his studio in Palma. However, the moments that concern us here were those when he marshalled worldly affairs in his work or, less happily, was no longer able to resist their pressures. In this sense, the 'ladder' of his imagery is unavoidably grounded in reality, and escape is borne of awareness. In focusing primarily upon three periods and the echoes around them in his immensely rich career – broadly the years 1918–25, 1934–41 and 1968–75 – we have sought to draw out the oscillation of Miró's sometimes uncomfortable confrontation with social and political concerns. Within this context, his empathy with his fellow beings emerges all the

2

House with Palm Tree 1918
Oil on canvas
65 × 73
Museo Nacional Centro de
Arte Reina Sofía, Madrid

FREE AND VIOLENT THINGS

more powerfully in works that convey anxiety and suffering as well as pride and defiance.

These qualities were evident in *Aidez l'Espagne*. Against its ultramarine sky, the yellow figure dressed in red grows out of the word 'Espagne'. The print's chromatic richness anticipated its reduction to the size of a postage stamp,[7] but it also speaks – in the colours of Catalonia – for an intensity of engagement. The figure's huge fist, raised to the height of the red sun, lends defiance to the plea: help will support strength, it declares. Even without the added inscription, there is little doubt that Miró's purpose for *Aidez l'Espagne* was propagandising. It recalls the exhortation 'Spain! Spain! Eternal land of French dreams' that had appeared in one of Louis Aragon's recent texts, and had included 'the Castilian poet … [and] the Catalan peasant' among those united in the cause.[8] By depicting a peasant Miró represented rootedness over incursion, democracy against militarism, liberty in the face of Fascism. Instead of the dominant modes of propaganda (Social Realism and photomontage), he fashioned an extension of his own pictorial language, demonstrating that contemporary art could serve a social purpose.[9]

This was not an isolated instance for Miró nor, of course, was he alone in adopting this position at this watershed moment of the Spanish Civil War of 1936–9. *Aidez l'Espagne* was made at the same time as, and shares its imagery with, Miró's vast (now lost) mural, *Le Faucheur* (*The Reaper*), painted in the Spanish Republican Pavilion at the Paris Exposition Internationale in the summer of 1937 (see pp.118–21).[10] It appeared alongside Julio González's *Montserrat*, Alberto Sánchez Pérez's *The Spanish People Have a Path that Leads to a Star*, Alexander Calder's *Mercury Fountain* and, famously, Pablo Picasso's *Guernica* (see nos.74–5). Miró's mural reflected the trepidation with which he viewed the 'terrible drama' of the Civil War from Paris (itself riven with social unrest).[11] In conversation with the critic Georges Duthuit, he summoned up a portentous vision of fascist suppression: 'More violently than ever before there will be a struggle against everything that represents the pure value of the spirit.'[12] It is the resistance shown by that 'pure spirit' that set the tone for *Aidez l'Espagne* and the volcanic upsurge of the peasant in *The Reaper*.[13]

In a contemporary article, for which the punning title 'Miroir d'Espagne' made explicit Miró's reflection on contemporary events, the exiled Spanish poet Juan Larrea explained the symbolism of *The Reaper*: 'Miró has put his martyred people at the centre of his canvas by placing in his painting a peasant armed with a sickle, a reaper taken by a curious artistic phenomenon from "els Segadors", the hymn of Catalan freedom.'[14] Defusing (though not denying) the association with the sickle of the Soviets, this identification of Miró's painting with a Catalan struggle was multivalent. It collided the Republican resistance to Francoism with the internal regional conflict, so that Catalonia equated to Spain in its resistance to fascism. Larrea extended the painter's pessimism: 'Spain is the first nation to reach the end of its history … with the furious unleashing of primary apocalyptic representations'.[15]

Surprisingly, it soon proved possible to play down the political vision of *The Reaper* and the long-matured painting that immediately preceded it, *Nature morte au vieux soulier* 1937 (*Still Life with Old Shoe*, see no.73). The latter, with its assembly of everyday objects submitted to nightmarish inner illumination, is a work of immense intensity: Miró made a sketch on a newspaper dated 22 January 1937 and began the painting two days later.[16] While it recalls Salvador Dalí's slightly earlier Civil War painting *Autumnal Cannibalism* 1936 (no.3),

even in its details of apple, bread and wounding cutlery it seems to reflect upon events to such an extent that Miró himself came, much later, to consider it his *Guernica*.[17] However, in 1941, though acknowledging the impact of Civil War on the painter, the American curator James Johnson Sweeney claimed that the still life was an 'unconscious token of his sympathy for the poverty and suffering' in Spain, while the mural was 'a return to the more fantastic decorative spirit which characterized his earlier work as a whole'.[18] This may have been a judicious protection of the artist who had just returned to an uncertain reception in Spain, and it was prefaced by a further diversionary qualification: 'While Miró never had any serious political interests or affiliations, he was undoubtedly hedged in on all sides by discussions of Marxian philosophy and of class injustice.'[19] Despite a circumspection that contrasts with the piercing anxiety of these paintings, this at least served as an acknowledgement that Miró's involvement with the Surrealists (certainly those who 'hedged') was qualified. Though he did not subscribe to all aspects of their ideology, at that moment especially bound up in the conflict between Trotskyism and Stalinism, Miró certainly shared Breton's denunciation of the Civil War and of 'the forces of regression and darkness responsible for its unleashing'.[20] In his interview with Georges Duthuit, he had indicated that 'one must resist all societies … if they aim to impose their demands on us'.[21] The paintings show his struggle to come to terms with those forces.

Catalan identity ran like a thread through Miró's work, though for most of its course it was interwoven with the liberation afforded by the cultural transgression and political radicalism of Surrealism. Painting was to be 'assassinated', and this position underscored by innovation; in 1928 he told an interviewer: 'when I've finished something … I've got to take off from there in the opposite direction.'[22] A year later, however, he was reluctant to comply with an enforced ideological position as Breton sought to bring Surrealism into line with Communism. In answer to a questionnaire on 'the ideal of group endeavour', Miró responded by acknowledging the ideal but stating: 'individuals whose personalities are strong … will never be able to give in to the military discipline that communal action necessarily demands.'[23] At this stage he chose, rather equivocally, neither to comply with Breton nor to abandon Surrealism for the 'dissident' configuration around Georges Bataille.[24] This ambivalence surely reflects his preoccupation with the most reductive of his works to date, dream paintings such as the monumental work known as *The Birth of the World* 1925 (no.5). Sebastià Gasch had remarked upon the asceticism of such works in 1928, and a year later Michel Leiris compared them to an ascetic's 'understanding of emptiness'.[25] Later still, Vicente Huidobro claimed for the artist 'the dematerialisation of matter in order to convert it into new material'.[26]

Alongside the ascetic, community and communal action were concerns at other stages. They lay, as we have seen, behind *Aidez l'Espagne* and *The Reaper* of 1937. These Promethean peasants were in a lineage of etiolated personages and savage figures (of 1935 and 1934 respectively, see pp.72–7) stretching back to the *Tête de paysan catalan* series of 1924–5 (*Head of a Catalan Peasant*, see nos.29–32, 34) and even earlier. Of course Miró's conception of such a personification differs from the direct engagement in group

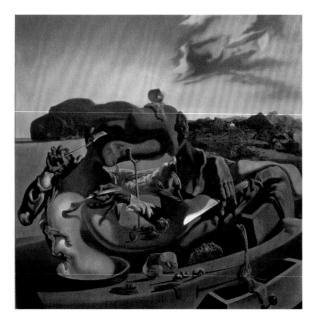

3
Salvador Dalí
Autumnal Cannibalism
1936
Oil on canvas
65.1 × 65.1
Tate. Purchased 1975

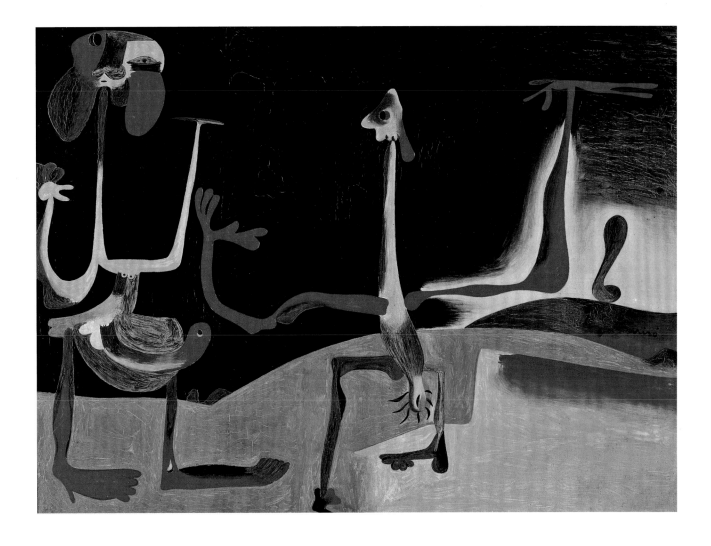

4
**Homme et femme devant
un tas d'excréments**
15–22 October 1935
*Man and Woman in Front
of a Pile of Excrement*
Oil on copper
23 × 32
Fundació Joan Miró,
Barcelona. Gift of
Pilar Juncosa de Miró

endeavour usually associated with political activism, so that his commitment to intervene and the intervention itself remained – as they would do throughout his career – detached.

In 1917 Miró had favoured the heroism of Futurism, and this briefly fired the radicalism of the Agrupació Courbet (Courbet Group) that he formed with colleagues including Enric Ricart and Josep Ràfols. He wrote in Marinettian vein to Ricart: 'Down with all sentimentalism … Let us be masculine. Let us transplant the primitive soul to the ultramodern New York'.[27] For all the stridency of this (rather un-Mironian) call to action, it came immediately on the artist's return from Mont-roig, his creative retreat in the Tarragona countryside. Since 1911 Mont-roig had been at the heart of his reconnection with the rural lifestyle of his grandparents' generation that, as a city child, he had only experienced fitfully.[28] This generated an image of timelessness – the 'primitive soul' – that he consistently identified with Catalonia and the emblematic figure of the peasant farmers who tended the land and who, as tenants, featured distantly in such paintings as *La Ferme* 1921–2 (*The Farm*, see no.17). In such precise,

'détailliste' works he recognised and celebrated the peasants' – and, by extension, his own – symbiotic relationship with the land, its eternal values, and its manifestations of robust eroticism.[29] These specifically Catalan qualities were easily recognised; looking back in 1934, the critic J.V. Foix identified 'local characteristics (of a geographical order)' in Miró's work: 'simplicity, clarity, objectivity, plasticity and, accepting the paradox, REALISM'.[30]

The rural was always in tension with the urban. As a young painter in Barcelona, Miró orientated himself towards the international avant-garde, so that his native city was soon displaced in his affection by Paris. As is often recalled, he wrote in 1919: 'I would a thousand times rather … fail *utterly, totally* in Paris than go on suffering in these filthy, stinking waters of Barcelona.'[31] Encouraged by the exhibitions held at the Galerie Dalmau at the time of the First World War (especially of exiles from Paris such as Marie Laurencin, Albert Gleizes, Robert and Sonia Delaunay and Francis Picabia), he focused his efforts on going to the French capital. Perhaps, more profoundly, the particular position of Catalan culture

allowed for this accommodation of apparently irreconcilable aspects. It was, after all, a strand in discourses of autonomy that made place and language not only contemporary concepts but also progressive. To be Catalan, it could be argued, was to be modern, European and outward-looking.[32]

The small farmers and tenants of Mont-roig were among the burgeoning classes. Locally inclined towards autonomy, some were politically motivated towards separatism and some, even, towards the communalism of anarchism that had swept through Spain during the second half of the nineteenth century.[33] At times Miró identified himself with the Catalan peasant: one early account of spending days 'among the vines and the trees and running about with a rifle' anticipates *Paysage catalan (Le Chasseur)* 1923–4 (*Catalan Landscape (The Hunter)*, see no.18).[34] In the related *Head of a Catalan Peasant* paintings, the peasant's red hat, the *barretina*, associated with liberty, is the one consistent detail across the sequence, just as it features in the folkloric postcards that the painter sent in these years.[35] Earlier still, the open-necked red shirts of the 1917 *Portrait of Vicens Nubiola* (see no.12) and his own 1919 *Self-Portrait* (see no.16) announced a more generic revolutionary allegiance to the manual worker.[36] Such radicalism may be associated with Miró's military service in the fervid autumn of 1917, when his regiment was called out to break up strikes. This exposed the political dynamic between the centralised Spanish state and the movement for Catalan autonomy.[37]

It may be that this shocking formative moment for Miró foreshadowed his subsequent anxieties as he recalled the conflict between fellow citizens. This would generate images conceived during the Civil War such as the startling *Femme hantée par le passage de l'oiseau libellule présage des mauvaises nouvelles* (*Woman Haunted by the Passage of a Bird-dragonfly Omen of Bad News*, no.7), completed in September 1938, at the time of the Munich negotiations between Chamberlain, Daladier and Hitler that led to the Nazi annexation of the Sudetenland. The fact that Miró could not restrain this atmosphere of foreboding in a painting made for his dealer's children now seems a measure of his anxiety. It is as if he felt compelled to warn even the young.

It is hardly surprising that Miró's paintings and statements made after his return to Franco's Spain were rather more circumspect. In private, his assessment of the situation was bleak. In 1945 he wrote to his Parisian dealer, Pierre Loeb: 'During these tragic years I have continued working every day, and this has helped me keep my balance – my work has kept me on my feet; otherwise I would have gone under; it would have been a catastrophe.'[38] With the return of peace in Europe he revived the international connections that his isolation within Spain had curtailed. As a signal of intent, he began in 1945–6 to plan a vast exhibition of 400 works to be shown in Paris.[39] This scheme came to nothing, but it was indicative of Miró's ambition to re-establish himself in the art world after the Second World War. Though he did exhibit in the Galeries Laetanes in Barcelona, the large-scale project was very deliberately aimed at Paris. This is reminiscent of his campaign around 1928 that marked a moment of radical departure in his work; both showed a characteristic strand of defiance.

The opportunities for such liberation were limited within Spain, but Miró's internationalism was a lifeline for him and, by extension, for those who saw him as an example – such as the artists emerging in the late 1940s, especially Joan Brossa, Modest Cuixart, Joan Ponç and Antoni Tàpies, who congregated around the semi-clandestine periodical *Dau al Set* from

**Painting [The Birth of
the World]** 1925
Oil and tempera on canvas
251 × 200
The Museum of Modern Art,
New York

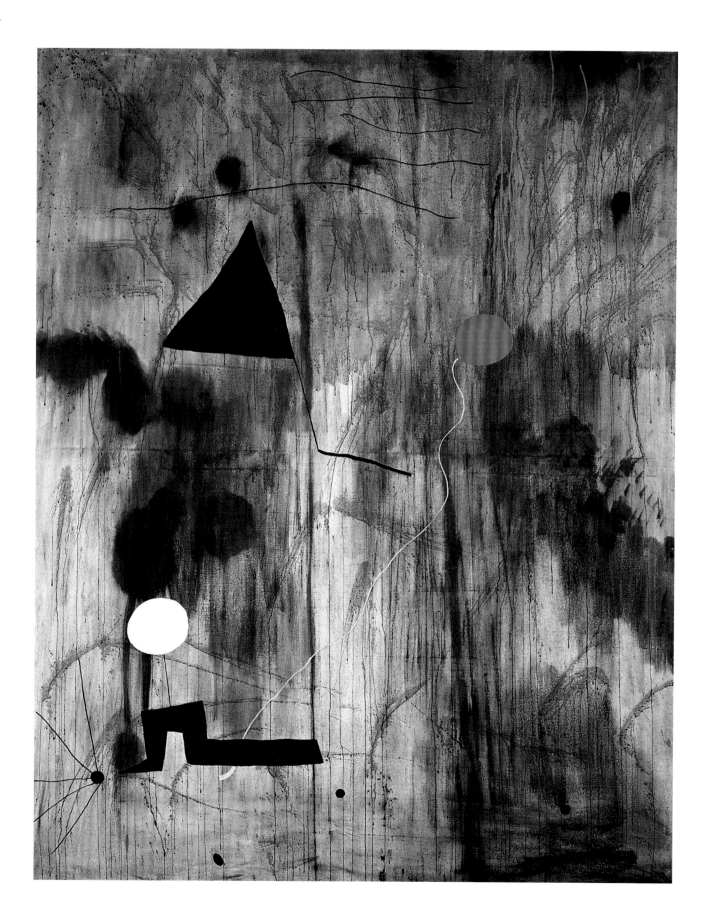

6
Barcelona Series (XIX)
1944
No.19 from a set of 50
black and white lithographs
70 × 52.4
Fundació Joan Miró,
Barcelona

7
**Femme hantée par
le passage de l'oiseau
libellule présage des
mauvaises nouvelles**
September 1938
*Woman Haunted by the
Passage of a Bird-dragonfly
Omen of Bad News*
Oil on canvas
80 × 315
Toledo Museum of Art

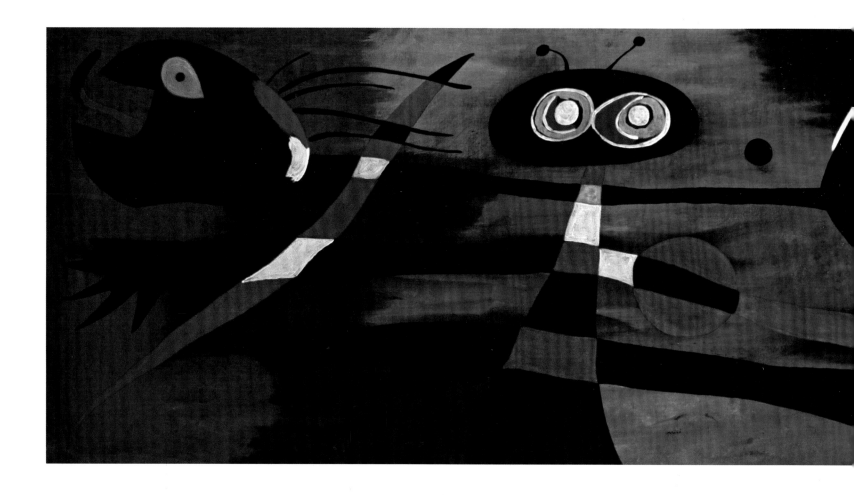

1948.[40] Though he was given to caution, Miró participated in their activities from a position of authority. In 1950 he was the subject of an interview entitled 'Miró Advises our Young Painters', in which he responded guardedly to the suggestion that it was only possible for young artists to succeed abroad: 'Maybe because it forces them to eliminate a superficial provincialism … You have to be universal, not boxed in by some narrow outlook'.[41] A year later he returned to the subject of a collective art in a radio interview with Georges Charbonnier, broadcast in Paris, arguing that it constituted a need to 'go further than the self – strip himself of his individuality, leave it behind, reject it – and plunge into anonymity'.[42] By reference to craft traditions – and this is the period of his concentration on ceramics in collaboration with Josep Llorens Artigas – Miró placed his assertion within a continuity that had obvious appeal to the values of the Franco regime, even if the notion of 'collectivity' harked back to the camaraderie of Communist ideals. Indeed, when pressed over the absence of 'followers', he spoke, somewhat regretfully, of how 'the whole organisation of society is based on individualism.'[43] Nevertheless, Tàpies would later recall Miró talking of 'striking a blow' in the pursuit of a social impact for art.[44]

Other echoes of earlier debates reverberated in the re-positioning of Miró in Paris. Gasch's and Leiris's observations of the artist's tendency towards emptiness were echoed by Christian Zervos, though this time as a matter for concern. In 1952 Zervos expressed the hope that Miró's inventiveness could be sustained, fearing that his work might 'have gained more in façade than in depth, more in embellishment than in solidity'.[45] Though it is not surprising that the painter was bitter about such comments made by a close ally, it is symptomatic that they did not deter him from an increased distillation in his work in the 1950s and 1960s.

This coincided with a gradual cultural thaw in Spain in this period, which culminated in the 'paradox that informalist abstraction would become an almost official art'.[46] Government support was seen, for instance, in the *Arte Otro* exhibition in 1957 and the participation of Tàpies, Eduardo Chillida and Antonio Saura at the Venice Biennale in 1958. Recognising the danger of co-option, Miró had actively avoided involvement in the official Spanish exhibitions; but this generation continued to be recognised abroad as producing an art of resistance. One critic wrote: 'It is not so much political painting; it is something more: the very expression

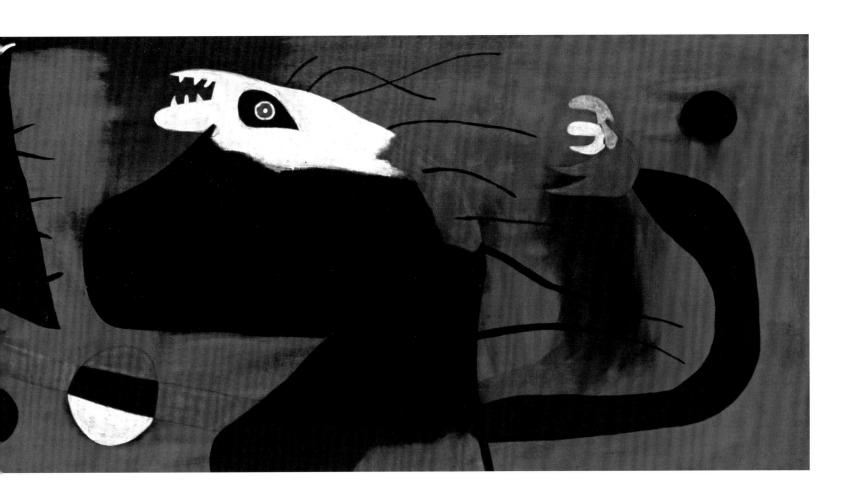

8
Une Étoile caresse
le sein d'une négresse
(peinture-poème)
April 1938
A Star Caresses the
Breast of a Negress
(*Painting Poem*)
Oil on canvas
129.5 × 194.3
Tate. Purchased 1983

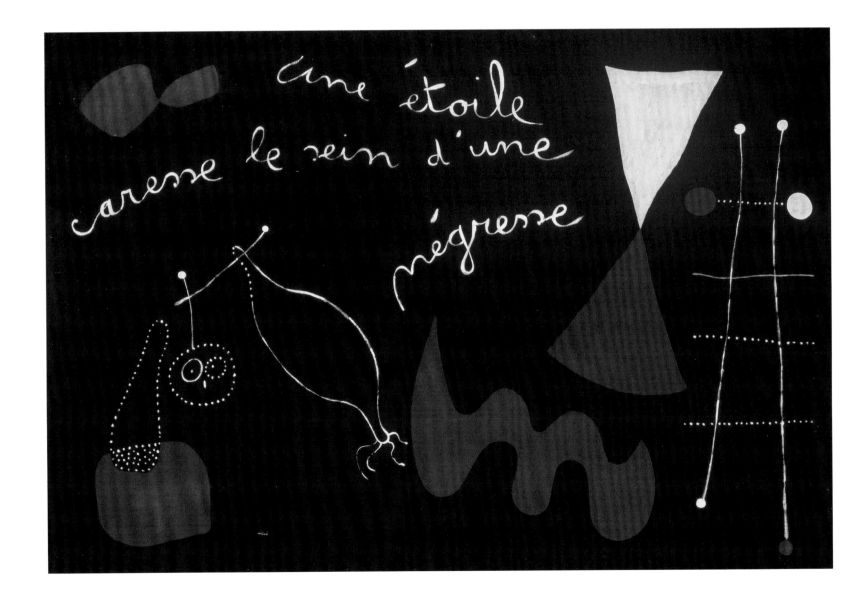

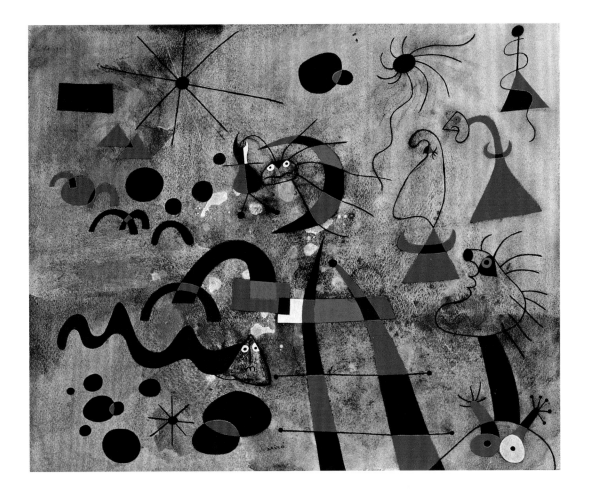

9
L'Échelle de l'évasion
31 January 1940
The Escape Ladder
Gouache, watercolour
and ink on paper
40 × 47.6
The Museum of Modern Art,
New York. Helen Acheson
Bequest, 1978

of creative forces for too long repressed in man.'[47] The cultural liberalisation of the regime coincided with the wider impact in Europe of Abstract Expressionism through *The New American Painting* exhibition that toured in 1959. Although some of his contemporaries were aware of Abstract Expressionism, Miró was better informed than many of them, having been in New York in 1947 (when he identified Arshile Gorky as the most interesting young American painter) and again in 1959. Returning the compliment of Jackson Pollock's avowed interest in his painting, Miró later called the American's work 'a direction I wanted to take but which up to then had remained at the stage of an unfulfilled desire'.[48] He later rose to the challenge presented in his great triptychs of 1961 and 1962 (see nos.150–52).[49]

Miró's identification with Catalonia became proverbial and he never renounced it. In discussion with Georges Charbonnier in 1951 he firmly identified himself as a Catalan but added: 'my nature is actually pessimistic. When I work, I want to escape this pessimism.'[50] Two decades later Juan Perucho linked Miró with 'the physical roots of the country' and drew attention to his sign of quiet resistance: the use of 'the luminous and absolute Catalan name of Joan'.[51] The challenge of such a

small gesture – reinforced by Miró's insistent use of French for his titles – culminated in his balancing his retrospective in Barcelona in 1968 with an alternative exhibition, *Miró Otro*, the following year.[52] Such positions were precarious in the face of official invitations. But they also laid Miró open to accusations of accommodating the regime, most notably those implied by Eduardo Arroyo's contemporaneous remakes of key Miró paintings containing embedded signs of Francoist repression.[53]

Miró's response lay in his work. Asked by Georges Raillard in November 1975 what he considered the most important thing he had done in opposition to Francoism, Miró responded: 'Free and violent things.' He qualified this as: 'The works themselves, through their violence and their sense of liberty. That has touched people, I feel that now very clearly.'[54] These qualities, together with his emphatic identification with Catalonia, may characterise the moments of Miró's most powerful engagement. If, in the most general terms, his early work of the years 1918–25 captures his Catalan identity, the violence of his work of the 1930s is as striking as the liberation of the late works. 'The word *freedom*', he declared in 1936, 'also has a meaning for me, and I will defend it at any cost.'[55]

Tête 1940 – 1 March 1974
Head
Oil and acrylic on canvas
65 × 50
Fundació Joan Miró,
Barcelona

1 *Cahiers d'Art*, nos.4–5, 1937, pp.156–7, text trans. by Peter Watson, in 'Joan Miró', *Horizon*, vol.4, no. 20, Aug. 1941, pp.132–3 (see p.15 in this volume).

2 Although see the texts by Joan Minguet and María Luisa Lax in this volume.

3 Rémi Labrusse discusses Miró's work in relation to the theories of the French sociologist Marcel Mauss, who was influential on those associated with the periodical *Documents* (Labrusse, 'Le Potlach', in Beaumelle 2004, pp.32–51); and Mauss and the thinking of the child psychologist G.H. Luquet are discussed by Christopher Green ('The Infant in the Adult: Joan Miró and the Infantile Imagination', in Jonathan Fineberg (ed.), *Discovering Child Art: Essays in Childhood, Primitivism and Modernism*, Princeton 1998, pp.210–34).

4 Breton, 'Artistic Genesis and Perspective of Surrealism', New York 1941, in André Breton *Surrealism and Painting*, trans. Simon Watson Taylor, London 1972, p.70. Margit Rowell discusses the duality in the poet's understanding of the artist, 'André Breton et Joan Miró', in Agnès Angliviel de la Beaumelle, Isabelle Monod-Fontaine and Claude Schweisguth (eds.), *André Breton: La beauté convulsive*, exh. cat., Centre Georges Pompidou, Paris 1991, p.182.

5 Antoni Tàpies (*Selected Essays*, trans. Antoni Kerrigan, Eindhoven 1986, p.26) remarked in 1968 that the 'official acceptance' of Picasso and Miró came 'from the moment it became impossible to hide the fact that they were considered, world-wide, as personalities of the highest order'.

6 The 'assassination of painting', a phrase Miró first used around 1927, is much discussed in literature on the artist, and considered comprehensively most recently in Umland 2008.

7 Conceived for sale in support of the Spanish Republic, hence '1 Fr[anc]', it did not come about due to the French Government's adoption of the non-intervention treaty (8 August 1936). The pochoir print was completed by March 1937: a photograph of it is discussed by Roland Penrose in a letter to Miró of 5 April 1937 (Fundació Pilar i Joan Miró, Palma; we should like to thank María

Luisa Lax for drawing our attention to this document). It was sold in the Spanish Republican Pavilion at the Paris Exposition Internationale. Oskar Kokoschka also made an *Aidez les enfants basques* poster (see Lionel Richard, *L'Art et la guerre: Les artistes confrontés à la Seconde Guerre mondiale*, Paris 1995, p.104).

8 Aragon, 'Ne rêvez pas qu'a l'Espagne', in *Europe*, no.167, 15 Nov. 1936, pp.352, 359.

9 Both forms of verisimilitude were used at both extremes of the political spectrum; photomontage was a key medium for Josep Renau, who masterminded the Spanish Republican Pavilion. See Marko Daniel, 'Spain: Culture at War', in *Art and Power: Europe under the Dictators 1930–45*, exh. cat., Hayward Gallery, London 1995, pp.63-8. The engagement of modernism in the fight against Fascism was the subject of Communist-sponsored public debates, chaired by Aragon, in Paris in May 1936; see Serge Fauchereau, *La Querelle du réalisme*, Paris 1987.

10 No records of the commission survive; the exhibition opened in May, but June is suggested as a likely date for Miró's access to the completed Pavilion (Robin Adele Greeley, *Surrealism and the Spanish Civil War*, New Haven and London 2006, p.198, n.2). Although painted *in situ* onto the celotex panels of the building's unitary structure (clearly visible in the photographs; see pp.118–21), Miró anticipated that it would tour with *Guernica* to benefit the Republic (see Miró (Paris) to Joan Prats, 3 Jan. 1938, in Minguet, Montaner and Santanach 2009, p.584). Instead, it is said to have been sent to Valencia and probably destroyed. A colour scheme, informed by the artist's memory, was reconstructed by Fernando Martín Martín (*El Pabellón español en la Exposición Universal de París en 1937*, Seville 1983). See also Catherine Freedberg, *The Spanish Pavilion at the Paris World's Fair*, New York 1986, and Josefina Alix Trueba (ed.), *Pabellón español: Exposición International de París, 1937*, exh. cat., Museo Nacional Centro de Arte Reina Sofía, Madrid 1987.

11 Miró (Paris) to Pierre Matisse, 12 Jan. 1937, in Rowell 1986, p.146.

12 Miró quoted in Georges Duthuit, 'Où allez-vous, Miró?', *Cahiers d'Art*, vol.11, no.8–10, 1936 [published 1937], in Rowell 1986, p.154.

13 William Jeffett, 'A "Constellation" of Images: Poetry and Painting, Joan Miró, 1929–41', in Malet and Jeffett 1989, p.32.

14 Juan Larrea, 'Miroir d'Espagne; A propos du "Faucheur" de Miró au Pavillon Espagnol de l'Exposition 1937', in *Cahiers d'Art*, vol.12, no.4–5, 1937, p.157.

15 Ibid., p.158.

16 The sketch is FJM 1615. See Teresa Montaner's text in this volume.

17 The comparison to *Guernica* is traced to 1973 and taken up by Miró thereafter (Robert S. Lubar, 'Still Life with Old Shoe', in Umland 2008, p.231, n.16). See also Lubar 2003.

18 Sweeney 1941, p.68. He avoids specifying the Spanish Civil War by writing of the suffering as 'so acute at this period in the world of his boyhood'.

19 Ibid. Sweeney had drawn this contrast in 1934 ('Joan Miró', *Cahiers d'Art*, vol.9, no.1–4, 1934, p.48), noting that Miró 'had cut himself off from a movement which had basically so much in common with his own ideals as Superrealism [sic] when he saw the political character it was taking that was eventually to be its undoing'

20 Breton, 'Visit with Leon Trotsky', 11 Nov. 1938, in *What is Surrealism? Selected Writings*, ed. Franklin Rosemont, London 1978, p.175.

21 Miró quoted in Georges Duthuit, 'Où allez-vous, Miró?', *Cahiers d'Art*, vol.11, nos.8–10, 1936 [published in 1937]; in Rowell 1986, p.150.

22 Miró quoted in Francesc Trabal, 'A Conversation with Joan Miró', *La publicitat*, 14 July 1928, in Rowell 1986, p.98.

23 The questionnaire was circulated on 12 February 1929 and Miró attended the meeting of 11 March where he was amongst the painters defending individuality (see chronology in Beaumelle, Monod-Fontaine and Schweisguth 1991, p.189). It is sometimes seen as a breaking point between Miró and Breton, but the poet (letter 18 April 1929, FJM, repr.,

ibid.) invited Miró to contribute drawings to the special 'Le Surréalisme en 1929' edition of *Variétés* (June 1929), where the response was also published (Rowell 1986, p.108).

24 As Umland (2008, pp.7–8, 88–91) has noted, Breton published less on (and of) Miró in 1929–30 than did Bataille and his associates at *Documents*, including Michel Leiris and Carl Einstein; for the relationship with Bataille see Rosalind Krauss 'Michel, Bataille et Moi', in *October*, no.68, Spring 1994, pp.3–20.

25 Sebastià Gasch, 'Joan Miró', in *L'Amic de les Arts*, no.26, 30 June 1928, cited in Félix Fanès, 'El debate surrealista en Canaluña: El "grupo antiartista" y *L'Amic de les Arts*', in *Huellas dalinianas*, exh. cat., Museo Nacional Centro de Arte Reina Sofía, Madrid 2004, p.244. Michel Leiris, 'Miró', in *Documents* 1929, republished in Leiris, *Brisées: Broken Branches*, trans. Lydia Davis, San Francisco 1989, pp.25–9. For consideration of Leiris's text see Christopher Green's text in this volume.

26 Vicente Huidobro, 'Joan Miró', in *Cahiers d'Art*, vol.9, no.1–4, 1934, p.40.

27 Miró (Barcelona) to Ricart, [1 Oct. 1917?], in Rowell 1986, pp.52–3; Minguet, Montaner and Santanach 2009, p.74.

28 See Llorens 2007, p.27. Victòria Combalia remarks on Miró's city upbringing colouring his approach to the country in 'Miró surrealista: Rebelde en Barcelona, callado en París', in *El Surrealismo y sus imagines*, Madrid 2002, p.108.

29 Robert S. Lubar has explored the role of Mont-roig, Miró and Catalan identity; see his text in the present volume; see also 'Miró's Mediterranean: Conceptions of a Cultural Identity', in *Joan Miró* 1993, pp.25–48.

30 J.V. Foix, 'Joan Miró', in *Cahiers d'Art*, vol.9, no.1–4, 1934, p.52 [published in Catalan].

31 Miró (Mont-roig) to E.C. Ricart, 14 Sept. 1919, in Rowell 1986, p.65.

32 See Robert S. Lubar's text in this volume.

33 Gerald Brenan's contemporary (and occasionally eye-witness) account of the causes of the Spanish Civil War touches upon the relative prosperity of the Catalan peasants, as well as the role of

the vine-tending *rabassaires* in the short-lived Catalan Republic of 1934 (Brenan, *The Spanish Labyrinth*, London [1943] 1960, pp.99, 282).

34 Miró (Mont-roig) to E.C. Ricart, 18 Oct. 1918, in Rowell 1986, p.58.

35 See Christopher Green's text in this volume. Among the postcards of peasants in *barretinas* sent by Miró are those to Picasso (Barcelona, 29 Dec. 1922), Bartomeu Ferrà (Barcelona, 31 Dec. 1923) and Sebastià Gasch (S. Hilari Sacalm, 29 July 1926); see Minguet, Montaner and Santanach 2009, pp.258, 271, 298.

36 Nubiola was a teacher of horticulture at the Escola Superior de Bells Oficis. Miró exhibited the painting in 1919 under the title *El jove de la garibaldina vermell* (*Young Man Wearing a Red Garibaldina*), see Lubar 2002, pp.407–8.

37 See Robert S. Lubar's text in this volume.

38 Miró (Mont-roig) to Pierre Loeb, 30 Aug. 1945, in Rowell 1986, p.197.

39 The conversation began with Christian Zervos, proprietor of *Cahiers d'Art* (Miró [Barcelona] to Zervos, 13 May 1945, in Rowell 1993, pp.90–1) and was outlined most clearly in the proposal to a M. Rebeyrol (see Miró [Barcelona] to Rebeyrol, 19 June 1945, ibid., pp.92–3). It was also launched with Pierre Loeb, Miró's Paris dealer, on 30 Aug. 1945 (Mont-roig, in Rowell 1986, pp.197–8) and 27 Jan. 1946 (Barcelona, in Rowell 1993, pp.85–7).

40 See the recent texts by Victòria Combalia ('Le voyage de l'art catalan') and Emmanuel Guigon ('Dau al Set (1948–1956)'), in *Barcelone 1947–2007*, exh. cat., Fondation Maeght, Saint-Paul de Vence 2007.

41 Rafael Santos Torroella, 'Miró aconseja a nuestros jóvenes pintores', *Correo Literario*, 15 March 1951, republished in Rafael Santos Torroella, *Entrevista a Miró, Dalí i Tàpies*, Barcelona 2004, pp.37–8.

42 Miró interview with Georges Charbonnier, radio broadcast, 19 Jan. 1951, in Rowell 1986, p.217.

43 Ibid., p.219.

44 Tàpies 1986, p.8.

45 Zervos, 'Notes à la recherche des jeunes', *Cahiers d'Art*, no.1, 1952, p.9,

cited in Christian Derouet, 'Miró à Zervos, une correspondance promotionelle', in *Cahiers d'Art: Musée Zervos à Vézèlay*, Paris 2006, p.117.

46 María Dolores Jiménez-Blanco, 'Significados del Informalismo Español', in *À Rebours: La rebelión informalista / The Informal Rebellion, 1939–1968*, exh. cat., Museo Nacional Centro de Arte Reina Sofía, Madrid 1999, p.72.

47 Lasse Söderberg, 'A Barcelone et à Madrid: Peinture et vérité', *Cahiers du Musée de Poche*, no.2, June 1959, p.64. For Miró's resistance to official overtures see María Luisa Lax's text in this volume.

48 Miró interview with Margit Rowell, 21 April 1970, in Rowell 1986, p.279. Pollock had acknowledged the importance of Picasso and Miró in an interview in *Art & Architecture*, vol.61, Feb. 1944, p.14, reprinted in Francis V. O'Connor and Eugene V. Thaw (eds.), *Jackson Pollock: A Catalogue Raisonné of Paintings, Drawings, and Other Works*, vol.4, New Haven 1978, p.232.

49 See Marko Daniel's text on the triptychs in this volume. The paradox of an official acceptance of *informel* in Spain was exacerbated by the parallel between painterly freedom and political liberty that surrounded American painting in the Cold War and set it against the conformity of Eastern Bloc Socialist Realism.

50 Rowell 1986, p.224.

51 Juan Perucho, *Joan Miró y Cataluña*, Barcelona [1968], p.8.

52 See William Jeffett's text in this volume.

53 Arroyo showed his work in *Miró rehecho o La desgracias de la coexistencia*, Galleria Il Fante di Spade, Rome 1967 and *Eduardo Arroyo: Miro refait ou les malheurs de la coexistence*, Galerie André Weill, Paris 1969. Miró dismissed Arroyo as naïve (Raillard 1977, pp.54–5).

54 Ibid., pp.188–9. The interviews were conducted in November 1975; Franco died on 20 November.

55 Miró quoted in Georges Duthuit, 'Où allez-vous, Miró?', *Cahiers d'Art*, vol.11, no.8–10, 1936 [published in 1937], in Rowell 1986, p.150.

Miro's Commitment

ROBERT S. LUBAR

On the occasion of Joan Miró's eightieth birthday in 1973, the artist Antoni Tàpies spoke of his colleague's legacy in Catalonia:

> It's about him constantly bearing witness on behalf of his country, about his love of the country and his belief that you need to be as deeply rooted as possible to do something great. Miró, personifying the highest spirit of Catalonia, was the first to achieve this. He, like no other, has given expression to the solar, anguished cry of our people, our loving and free exuberance, our rage, our blood … And thus, like our spirit, he has created something totally universal.[1]

Writing just two and a half years before the death of Francisco Franco, as the full weight of the military dictatorship in Spain was balanced on an increasingly precarious support, Tàpies spoke not of Miró's art or of his political sympathies, but of his lifelong engagement with his homeland – his defence of the Catalan nation, its people and traditions. Tacitly ignored by the Spanish regime until 1968[2] and largely unknown to all but a small circle of progressive artists, poets, architects and historians at home, Miró had assumed an almost mythic status as an outsider in his native land, while internationally he received prestigious awards and was universally celebrated for his contributions to modern European art.

The question of Miró's political engagement in his home country is a thorny issue that requires considerable elaboration, extending as it does far beyond the years of Franco's dictatorship. If Tàpies identified Miró with the cause of

Catalan nationalism under siege by the forces of reaction, Miró had acted in the interests of the Catalan people from the very outset of his artistic career. Born in 1893, he came of age at a time of resurgent Catalan nationalism following centuries of political oppression by the highly centralised Spanish state.

By the mid-nineteenth century a powerful middle class had emerged in Catalonia, enriched by textile manufacturing and trade with Spain's New World colonies. The new industrial bourgeoisie sought legitimisation and self-definition through culture, looking to native folk and popular traditions in poetry, art and music, and adopting Catalan over Spanish as the literary language of choice. As Catalan nationalism entered into a more active and expansive phase, encouraged by Spain's demoralising loss of its last remaining colonies after the Spanish-American War of 1898 and the political vacuum that ensued,[3] electoral victories at the regional and national levels meant that political Catalanism became a force to be reckoned with. In 1906 a newly formed coalition of Catalan parties known as Solidaritat Catalana was victorious in Barcelona's municipal elections, earning forty-one of the forty-four seats allotted to Catalonia in national elections the following year. Although this alliance was fragile and fraught with internal contradictions, it gave great impetus to the formation of a Catalan national consensus and the project of nation building. Under the leadership of the conservative, Catholic and monarchist Lliga Regionalista, which held firmly on to the reins of power in Catalonia from 1906 until 1923, a broad institutional infrastructure for the advancement of Catalan culture was established: the Institut d'Estudis Catalans

The Farm 1921–2
(detail of no.17)

(Institute of Catalan Studies) was formed, new technical schools were opened in Barcelona, and pedagogical reforms were adopted in the educational system. At the same time the Biblioteca de Catalunya (Library of Catalonia) was founded, and art historians looked to Catalonia's medieval past to establish the broad racial guidelines of a national artistic identity, a visual tradition that would have a profound impact on the young Miró. As historical research into the origins and formal characteristics of Catalan Romanesque art grew in the early decades of the twentieth century, architects and art historians, among them Josep Puig i Cadafalch and Joaquim Folch i Torres, joined forces to save decaying murals from Romanesque churches throughout the Pyrenees. Many were transported to Barcelona for installation in public collections, which Miró assiduously visited as a youth. The impact is immediately visible in his *Self-Portrait* of 1919 (no.16): its hieratic composition, extreme frontality and formal stylisation owe a clear debt to apsidal frescoes from Tahull and Ripoll.[4] In 1913 the philologist Pompeu Fabra established orthographic and grammatical norms for the Catalan language and in 1914 the Mancomunitat de Catalunya (Commonwealth of Catalonia) was constituted, structurally overseeing the four provinces that comprised the Catalan region within the Spanish state.

Throughout this period political Catalanism was a deeply opportunistic movement that did not in itself imply secession from the Spanish state. The Lliga sought to secure a high degree of regional autonomy for Catalonia through a politics of accommodation with the central government and to maintain at all costs the class position of the ruling elite within the monarchical system. However, internecine class conflict, runaway inflation during the First World War and a wave of political murders threatened to undermine the considerable gains that had been made in the first two decades of the century, leading the Captain General of Barcelona, Miguel Primo de Rivera, to stage a *coup d'état* and declare military rule across Spain in 1923. Following his death in 1930 and the proclamation of the Second Spanish Republic in April 1931, Catalonia's political fortunes were once again favourably altered. The deferred dream of an independent Catalan state

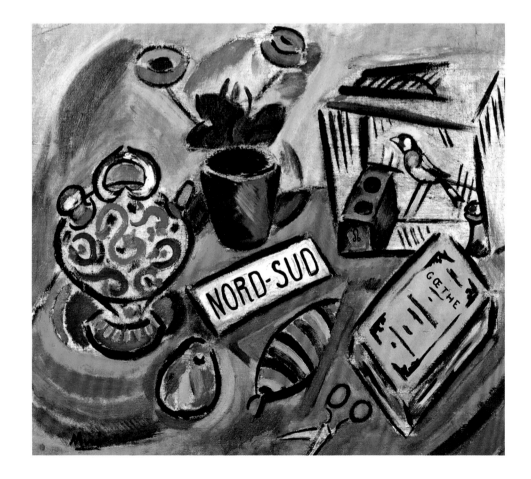

11
Nord-Sud 1917
Oil on canvas
62 × 70
Collection Maeght, Paris

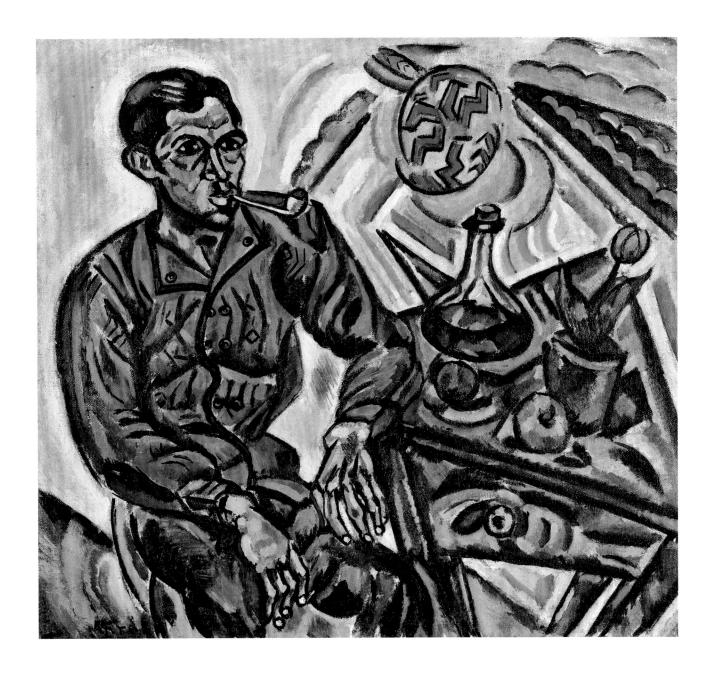

that was never far from the surface of nationalist discourse was briefly revitalised when the statesman Francesc Macià declared the Free Catalan Republic in 1931, before being forced to settle for partial autonomy within the Spanish state. Thereafter, the Civil War and the numbing repression of Franco's nationalist forces shattered any hopes of Catalan regional autonomy, let alone the formation of an independent Catalan state.[5]

To chart Miró's relationship with the changing tides of political Catalanism in these early years is a difficult undertaking. Although he was notoriously reluctant to declare a partisan position, his sympathies were undoubtedly on the left of the political spectrum, as his later commitment to the cause of the Spanish Republic demonstrates. His early letters are filled with enthusiasm for the international aspirations of

Catalan culture, yet he repeatedly registered disdain for the political establishment and the wilful ignorance of the recalcitrant bourgeoisie in his homeland. He waxed lyrical over the literary achievements of the writer Eugeni d'Ors, yet deplored his political compromise with the Lliga and its refusal to support emergent artists.[6] In opposition to the carefully crafted image of an ideal, civilised and harmonious Barcelona, which belied the reality of class conflict, Miró championed the cause of the Catalan people, 'whose boundless creative will gives Spain an impetus which will astonish the world', as he would write on the pochoir issued to raise money for the Spanish Republic during the Civil War (see no.1).[7] Although his vision of the peasantry was a fundamentally mythic construction,[8] it was founded on the resolute conviction that a nation is defined by its people, its language and its cultural traditions

rather than by political elites. For Miró, the Catalan nation existed as an irrefutable fact against the grain of an adverse history. His civic responsibility as an artist, he insisted on numerous occasions, was to affirm that reality through his work, to serve as the voice of his community and to 'negate the negations' of social and political oppression through the example of his life and art. In 1979, on the occasion of his investiture by the Universitat de Barcelona (University of Barcelona) as Doctor Honoris Causa, Miró publicly affirmed his 'conception of the artist as a person with a special civic responsibility'. He continued:

> I understand the artist to be someone who, amidst the silence of others, uses his voice to say something, and who has the obligation that this thing not be useless but something that offers a service to man. For the fact of being able to say something, when the majority of people do not have the option of expressing themselves, obliges

this voice in some way to be prophetic. To be, in a certain sense, the voice of its community … For when an artist speaks in an environment in which freedom is difficult, he must turn each of his works into a negation of the negations, in an untying of all oppressions, all prejudices, and all the false established values.[9]

The question of a Catalan national agenda contained within the domain of the aesthetic defined Miró's political position. There were, to be sure, moments when he was directly engaged with world events. His execution of a mural for the Spanish Republican Pavilion at the 1937 Paris Exposition Internationale (see pp.118–21) was in every sense a political act, as circumstances demanded direct action. Characteristic of his eschewal of partisan rhetoric, however, his protest against Fascism took the form of a Catalan peasant raising his sickle in revolt, a reference to a popular seventeenth-century insurrection by Catalan farmers defying the policies of Philip

13
The Rut 1918
Oil on canvas
75 × 75
Private collection. Courtesy
Giraud Pissarro Segalot

IV during the Thirty Years War.[10] However much the peasant's gesture recalls the raised fist of the Republican salute or the sickle of international socialism, Miró's visual conceit locates the struggle for freedom within a historical continuum that highlights the plight of Catalonia within the Spanish state.

Living in self-imposed exile in Paris during the conflict in his homeland, in 1937 Miró wrote to his New York dealer Pierre Matisse about an interview he had just granted Georges Duthuit, in which he discussed the social repercussions of his work. 'I express myself very violently and strike out very hard at the things we are fed up with', he told Matisse, adding: 'You will readily see who and what I am striking out against.'[11] Specifically, Miró was responding to calls by elite intellectuals and cultural spokesmen on both the Left and the Right for political commitment on the part of artists and writers. His comments to Duthuit left no room for doubt about his position:

The worst thing that could happen would be to put ourselves above the crowd, to flatter it by telling miserable little stories. The present leaders, the bastard products of politics and the arts who claim to be regenerating the world, are going to poison our last sources of renewal. While they talk about nobility and tradition or, on the contrary, about revolution and the proletarian paradise, we see how their little bellies grow and how the fat invades their souls.[12]

Miró was vocal about his contempt for the political co-option of art and artists. For strategic reasons he was careful to remain on good terms with André Breton,[13] the leader of the Surrealist movement who had established a policy of rapprochement with the French Communist Party, but Miró himself was never a party member.[14] He was committed to the idea of revolutionary struggle and social emancipation,

14
Vegetable Garden and Donkey 1918
Oil on canvas
64 × 70
Moderna Museet, Stockholm

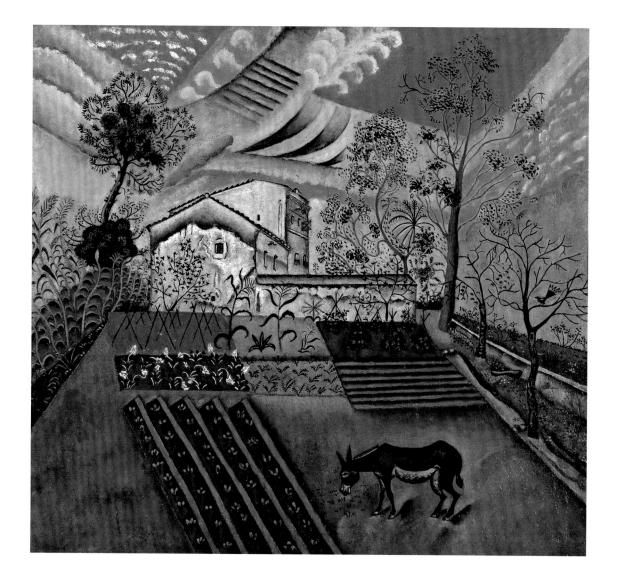

15
**Mont-roig, the Church
and the Village** 1919
Oil on canvas
73 × 61
Private collection

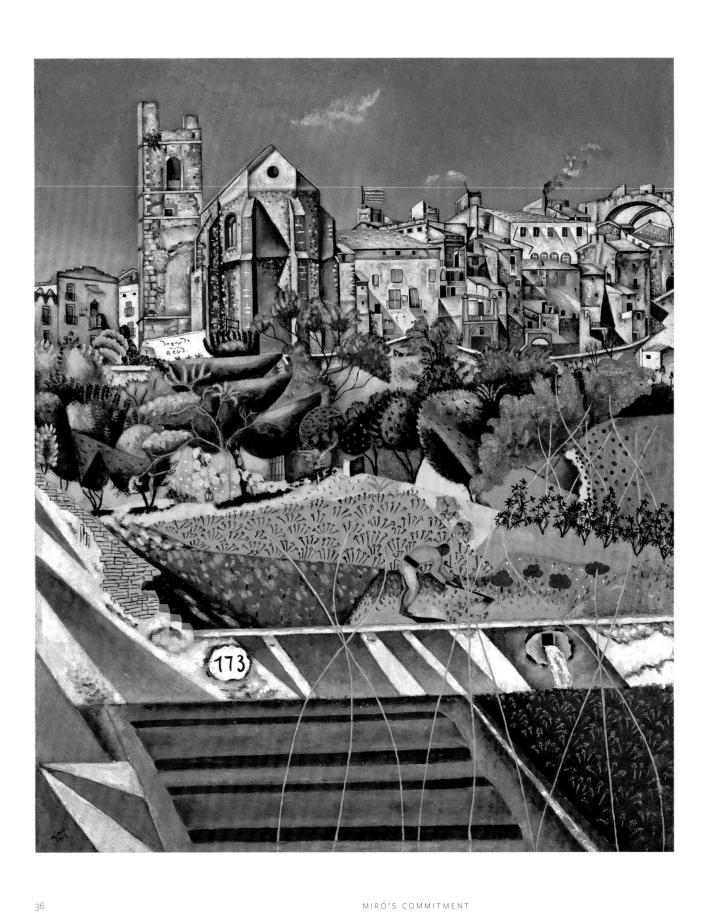

but spoke out against what he called 'social painting' (i.e. Social Realism) as little more than political propaganda.[15] When challenged on the issue of social commitment, he responded that it was naïve to think artists can intervene directly in history.[16] And when in 1929 André Breton, Louis Aragon and Raymond Queneau sent a circular letter to seventy-five members of the Surrealist movement, asking whether they believed in group endeavour and communal action, Miró responded:

> There is no doubt that when action is taken, it is always the result of a collective effort. Nevertheless, I am convinced that individuals whose personalities are strong or excessive, unhealthy perhaps, deadly if you like – that is not the question here – these people will never be able to give in to the military-like discipline that communal action necessarily demands.[17]

What then was the political status of Miró's engagement with the social realities of his day? If political events and social movements were the engine behind his art – the very fact of his Catalan national sentiment unequivocally attests to this – that relationship was highly mediated. When in August 1917, during the period of his military service, Miró's regiment was called upon to quell an uprising by striking workers in Barcelona and the neighbouring town of Sabadell, the artist expressed his repugnance at the thought of firing at the people in his official capacity as an instrument of the state. 'If it were a matter of a war of high ideals,' he confessed to his friend Ricart, 'I would go there willingly like Boccioni and other Italian Futurists.'[18] By the time he returned to the calm of the Catalan countryside a week later, with memories of the revolt imprinted in his consciousness, Miró poeticised the 'solitary life' in the remote village of Siurana, 'the

primitivism of these admirable people, my intensive work, and especially, my spiritual retreat and the chance to live in a world created by my spirit and my soul, removed, like Dante, from all reality'.[19]

The landscapes Miró executed there show no signs of the crisis he had witnessed first hand, except perhaps by its very absence. The only conflict in these works assumes the form of an aesthetic tension between advanced visual strategies deriving from Cézannism and Fauvism and the stasis and solemnity of an ancient village frozen in time. But this is precisely the point. Miró's project was to reconcile the past with the present, to link his vision of an essential Catalonia with the promise of an emergent nation that hoped to participate on the world stage as an equal partner. Obliquely yet decisively, Miró's work bore testimony to an ethos of cultural determinism and national self-definition that rejected the unholy alliances of ideological politics and their challenge to a still fragile national consensus. A populist by nature yet sympathetic to the plight of the working class, he engaged with the social realities of his day precisely by working along their political margins, supplying his countrymen with a series of emblematic images through which they might see their reflection as a people and a nation.

This is not the place to debate the efficacy of Miró's position or to judge whether in fact he played into the politics of bourgeois hegemony in Catalonia. He bitterly complained about the parochialism of his countrymen and their stubborn refusal to embrace modern European culture and advance beyond folkloric clichés. He saw this complacency as one of the greatest impediments to the realisation of a vibrant national culture at home, and recognised the need for young artists to create a united front to combat

provincialism. When in 1918 he and his friends constituted the Agrupació Courbet (Courbet Group) to launch their offensive against the Barcelona artistic establishment, they had a dual purpose in mind: to form an exhibiting society to show their work in Barcelona, Madrid and Girona, and to identify themselves with an artist-revolutionary – Gustave Courbet – who fought on two fronts, for social justice and artistic freedom. For Miró and his colleagues, Courbet's position in the advance guard of French culture and society represented a powerful model for Catalonia.[20]

With the end of the First World War Miró and his friends turned their attention away from Barcelona and towards Paris, which he visited for the first time in the spring of 1920. In a letter to Ricart dated 10 November 1918, written a day before the armistice with Germany was signed, Miró adapted Maréchal Foch's famous battle cry 'fight, fight, fight', and wrote 'Paris, Paris, Paris' in bold script, a clear indication of his cultural militancy and his desire to take the French capital by storm rather than drown in the provincial backwaters of his native city.[21] Two years later, upon his return from Paris and writing from his family farm in Mont-roig, he defiantly declared: 'Definitively, *never again Barcelona*. Paris and the country *until I die* … You have to be an *International Catalan*,' he told Ricart, 'a *homespun* Catalan is not, and never will be, worth anything in the world.'[22] But Miró's self-imposed exile in Paris and the Catalan countryside was also a form of engagement: it afforded him the necessary distance to view his culture from the outside and to broaden, in his words, 'the international repercussions' of his work.[23] As he told the critic Francesc Trabal in an interview published in Barcelona in 1928:

I love my kind of aggressive nationalism, and I think it's much more effective than the lethargy of those Frenchified parasites who never move from here … I'm convinced that as far as nationalism is concerned, it's better to make a lot of noise than sit around crying about it. Instead of singing funeral dirges, our young men should be singing marching songs.[24]

There were, of course, moments when Miró appears to have responded more directly to contemporary events, but even these examples tend to sublimate political engagement within formal practices. His *Tête de paysan catalan* series (*Head of a Catalan Peasant*, see nos.29–32, 34) was executed at the time of Primo de Rivera's dictatorship and the dismantling of Catalonia's governing institutions. It is tempting to read into their schematic figuration an allusion to the Catalan flag waving freely in a resplendent sky, but the works that comprise the series can perhaps more readily be interpreted as ciphers of the expansive force of Catalan nationalism, itself a political gesture. Or again, in 1935–6 Miró executed a series of small paintings on copper and masonite grounds (see nos.48–51, 57–8). These works are noteworthy for their acidic palette and extreme formal distortions, and are generally interpreted as the artist's response to a world in crisis. A more secure political reading is, however, difficult to sustain. Similarly, in Miró's great series of paintings on masonite from the summer/autumn of 1936 (see nos.59–62), executed during the early months of the Spanish Civil War, it is form itself that bears the burden of critical engagement, as Miró violently dismantled the elements that had comprised his figurative vocabulary since at least 1923–4.[25] And in the great *Nature*

16
Self-Portrait 1919
Oil on canvas
73 × 60
Musée Picasso, Paris

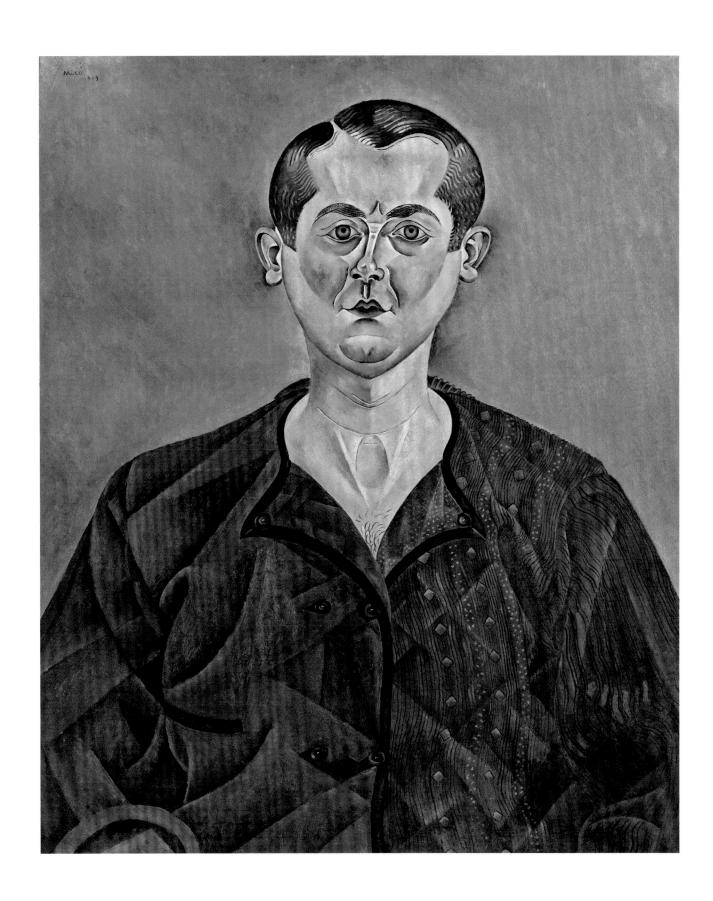

17
La Ferme 1921–2
The Farm
Oil on canvas
132 × 147
National Gallery of Art,
Washington. Gift of
Mary Hemingway, 1987

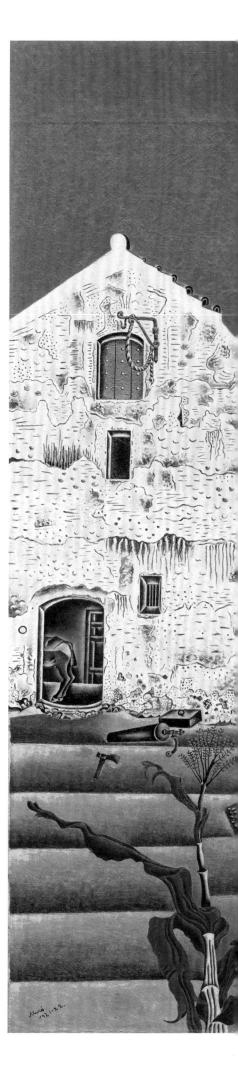

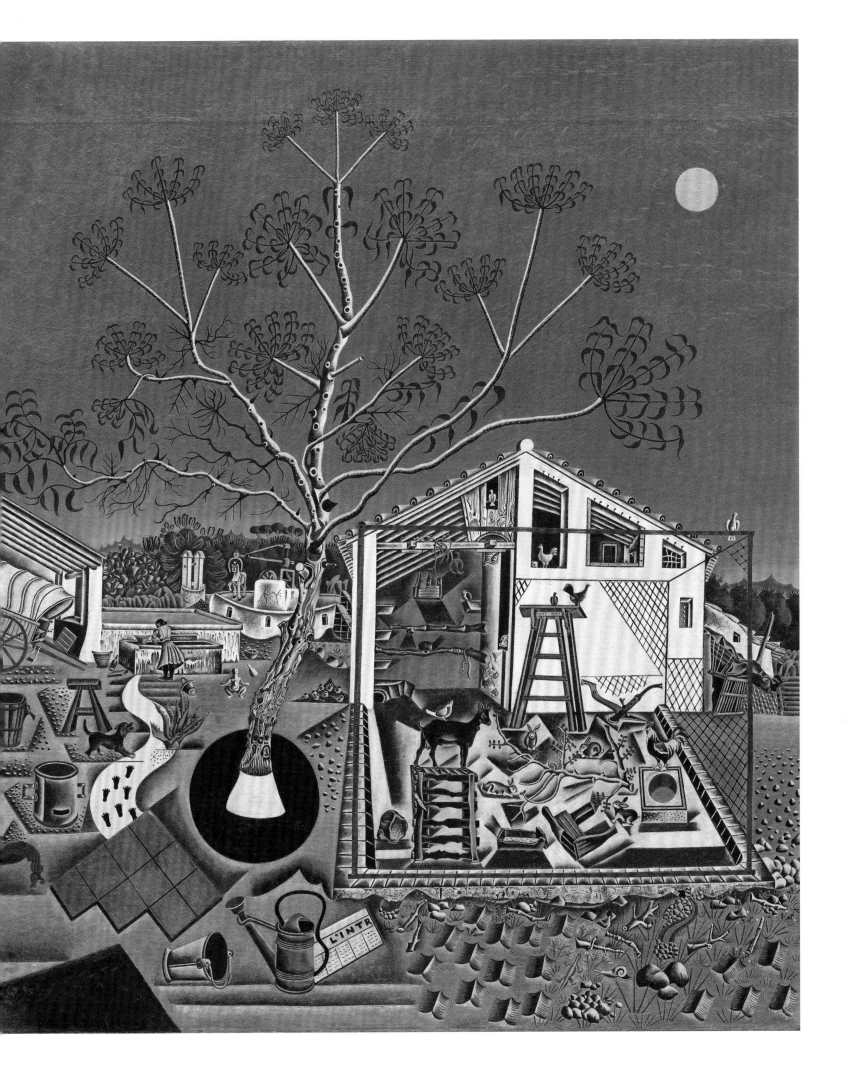

morte au vieux soulier of 1937 (*Still Life with Old Shoe*, see no.73), violence and conflict are again transferred to the aesthetic realm as political content is allegorised through formal relationships rather than subject matter.[26]

Miró's position in these early years – and, indeed, throughout his entire career – might best be described as a politics of the 'resistant form', to borrow the language of French philosopher Jacques Rancière. In his attempt to define the field of aesthetics as a form of metapolitics, Rancière argues that:

> Art is not, in the first instance, political because of the messages and sentiments it conveys concerning the state of the world. Neither is it political because of the manner in which it might choose to represent society's structures, or social groups, their conflicts or identities. It is political because of the very distance it takes with respect to these functions, because of the type of space and time that it institutes, and the manner in which it frames this time and peoples this space.[27]

For Rancière both art and politics are involved in the distribution of 'spaces and times, subjects and objects, the common and the singular'.[28] Insisting that it is 'by dint of its purity that the materiality of art has been able to make of itself the anticipated materiality of a different configuration of the community',[29] he seeks to preserve a space for the autonomy of art as a metapolitical practice, one that is defined not by its negation of the social but by means of its reorganisation of common relations among beings and objects within its differentiated sphere of activity.

There is a passage in Gertrude Stein's *Autobiography of Alice B. Toklas* in which the author recalls an argument she had with her friend Marion Walker concerning the politics of female emancipation. When Walker entreats her to remember the cause of women, Stein responds that she does not at all mind the cause of women, or for that matter any other cause, but 'it does not happen to be her business'.[30] Stein's 'business', of course, was literature, the specialised space where she reconfigured human sexual and gendered relations. That was her sphere of activity; her political position was circumscribed by the conditions of the literary work.

Miró would surely have appreciated Stein's cautionary anecdote about direct social engagement through art. On the cusp of the Second World War, when asked by Duthuit if the creative act is affected by contemporary events, Miró responded unequivocally:

> The outer world, the world of contemporary events, always has an influence on the painter … The forms expressed by an individual who is part of society must reveal the movement of a soul trying to escape the reality of the present, which is particularly ignoble today, in order to approach new realities, to offer other men the possibility of rising above the present.

But he was quick to add that his position was in no way a defence of political disengagement. He continued:

> There is no longer an ivory tower. Retreat and isolation are no longer permissible. But what counts in a work of art is not what so many intellectuals want to find in it. The important thing is how it implicates lived facts and human truth in its upward movement. Pure formal discoveries have absolutely no significance in themselves. One must not confuse the commitments proposed to the artist by professional politicians and other specialists of agitation with the deep necessity that makes him take part in social upheavals, that attaches him and his work to the heart and flesh of his neighbor and makes the need for liberation in all of us a need of his own.[31]

1 Antoni Tàpies, 'Miró de cerca', in *Destino* (Barcelona), 21 April 1973; reprinted in Antoni Tàpies, *El Arte contra la estética*, trans. Joaquim Sempere, Barcelona 1978, p.96.
English translation by the author.

2 In 1968 Miró was honoured with his first retrospective exhibition in Spain, at the Hospital de la Santa Creu in Barcelona. It was initiated by his Parisian dealer, Galerie Maeght, but was organised in Spain from within official circles and Miró was conspicuously absent from the opening. In 1969 *Miró Otro* was organised in response, see William Jeffett and María Luisa Lax's texts in this volume.

3 The defeat of the Spanish American War resulted in the independence of Cuba and the ceding of Spain's colonies (Philippines, Puerto Rico and Guam) to the USA, which had considerable impact in Spain.

4 Miró (Palma) to Josep Vicenç Foix, 19 July 1933, singled out Romanesque painting as an expression of the 'pure' Catalan tradition (in Minguet, Montaner and Santanach 2009, pp.498–9).

5 During the period of transition to democracy in Spain following Franco's death, when dreams of an independent Catalonia were revived, Miró characteristically shifted the terms of separatist politics to a universalist discourse, confiding to one interviewer: 'I'm not in favour of separatism. I'm for Spanish unity, European unity, worldwide unity. The closed world is obsolete. Borders are already causing enough trouble. The closed world is the bourgeois world', in Raillard 1978, p.238.

6 Miró (Barcelona) to Bartomeu Ferrà, [undated] 1914, refers obliquely to the Catalan author's popular philosophical novel *La ben plantada* (1912). Miró (Caldetas) to E. C. Ricart, 31 Jan. 1915, refers to the complete edition of d'Ors' *Glosari* 1906–14, a series of short, didactic texts published in the mouthpiece of

the Lliga Regionalista, *La Veu de Catalunya*, in which he defined the aesthetic, philosophical and political tenets of *Noucentisme*. However, Miró (Mont-roig) to Ricart, 4 Aug. 1918, registers his contempt for d'Ors' official position at the Ministre d'Instrucció Publica. See Minguet, Montaner and Santanach 2009, pp.37–8, 43–5, 54 and 96–7.

7 Text trans. by Peter Watson, in 'Joan Miró', *Horizon*, vol.4, no.20, Aug. 1941, pp.132–3.

8 For a discussion of Miró as a myth-maker see Lubar 2002.

9 Joan Miró, Frederic Mompou, Pierre Vilar, *Doctors Honoris Causa. Acte inaugural del curs 1979–1980*, Universitat de Barcelona, 2 October 1979, trans. in *Joan Miró* 1993, pp.480–1.

10 The Guerra dels Segadors or Reapers' War extended from 1640 to 1659. The Catalan peasantry formed an irregular militia to check the power of Castilian troops stationed in the region during Philip IV's military operations against France. The escalation of the conflict led the head of the Catalan Generalitat, Pau Claris, to proclaim a Catalan Republic and to enter into a strategic alliance with Louis XIII of France. In 1652 Spanish forces captured Barcelona and the French abandoned the Catalan cause. With the Treaty of the Pyrenees in 1659, Catalonia lost its northern counties, including the Roussillon, which was ceded to France, as new national boundaries between France and Spain were established along the Pyrenees. Shortly after Catalan institutions in France were systematically dismantled, while in Spain Philip IV tightened his political and military grip over Catalonia.

11 Miró (Paris) to Pierre Matisse, 12 Feb. 1937, in Rowell 1986, p.147.

12 Georges Duthuit, 'Où allez-vous, Miró?', *Cahiers d'Art*, vol.11, nos.8–10, 1936 [published 1937], in Rowell 1986, p.153.

13 Miró (Barcelona) to Pierre Matisse, 17 Dec. 1934, (in Rowell 1986, p.125)

wrote: 'It seems like good politics to me to be on good terms with him [Breton] for the Surrealists have become *official personalities* in Paris'.

14 Commenting on his refusal to toe the Surrealist line with regard to the Communist Party, especially after 1931 when Breton increasingly demanded political orthodoxy, Miró insisted that he did not 'separate' himself from the Party, but simply did not sign up, which 'didn't stop me thinking that all of us together, poets, filmmakers, painters, could do something in support of the revolution'. See Raillard 1977, p.176.

15 Responding to the question, 'During these years of oppression [i.e. of Franco's dictatorship], weren't you ever tempted to *say* anything directly?' Miró stated unequivocally, 'No. Because one falls into social painting. That's what socialist realism was and it no longer interests anyone.' See ibid., p.102.

16 Miró was responding specifically to an altered copy of his celebrated painting *The Farm* of 1921–2 made by the Spanish pop artist Eduardo Arroyo (b.1937), in which Arroyo indicted Miró and the Catalan people for what he believed was their failure to oppose Franco's regime actively. See ibid., p.54.

17 The responses were published in the Belgian magazine *Variétés*, June 1929; see Rowell 1986, pp.107–8.

18 Miró (Barcelona) to Ricart, 19 Aug. 1917, in Minguet, Montaner and Santanach 2009, p.63.

19 Miró (Mont-roig) to Ricart, [Aug. 1917], in Rowell 1986, p.50. A full version of the letter (proposed as 26 August), in which Miró recalls the events of the previous week, is published in Minguet, Montaner and Santanach 2009, pp.65–6.

20 Romy Golan has described the 'revisionist concern with art-historical lineages' that took root in French cultural discourse of the 1920s. Leftist critics viewed the figures of Courbet and the Le Nain brothers in relation to

radical politics, whereas more conservative cultural spokesmen like Louis Vauxcelles identified Courbet with the soil and the eternal French tradition. Although the constitution of the Agrupació Courbet pre-dates these developments, it is likely that its members had both conceptions in mind, especially in the aftermath of the Russian Revolution and in the turbulent final days of the First World War. See Romy Golan, *Modernity and Nostalgia: Art and Politics in France Between the Wars*, New Haven and London 1995, pp.28, 37, 39.

21 Miró (Mont-roig) to Ricart, 10 Nov. 1918, in Rowell 1986, pp.59–60.

22 Miró (Mont-roig) to Ricart, 18 July 1920, ibid., p.73.

23 Francesc Trabal, 'Una conversa amb Joan Miró', *La Publicitat*, 14 July 1928, ibid., pp.92–8.

24 Ibid., p.97.

25 For an extended consideration of these two series see my essays in Umland 2008, pp.182–7, 200–205.

26 Lluís Permanyer, 'Revelaciones de Joan Miró sobre su obra', *Gaceta Ilustrada*, April 1978, in Rowell 1986, p.293. For a full discussion of the way form bears the burden of political meaning in this work, see Lubar 2003.

27 Jacques Rancière, *Aesthetics and its Discontents*, trans. Steve Corcoran, Cambridge, Mass. 2009, p.23.

28 Ibid., p.25.

29 Ibid., p.33.

30 Gertrude Stein, *The Autobiography of Alice B. Toklas* [1933], New York 1990, p.83.

31 Miró, [Statement], *Cahiers d'Art*, vol.14, April – May 1939, in Rowell 1986, p.166.

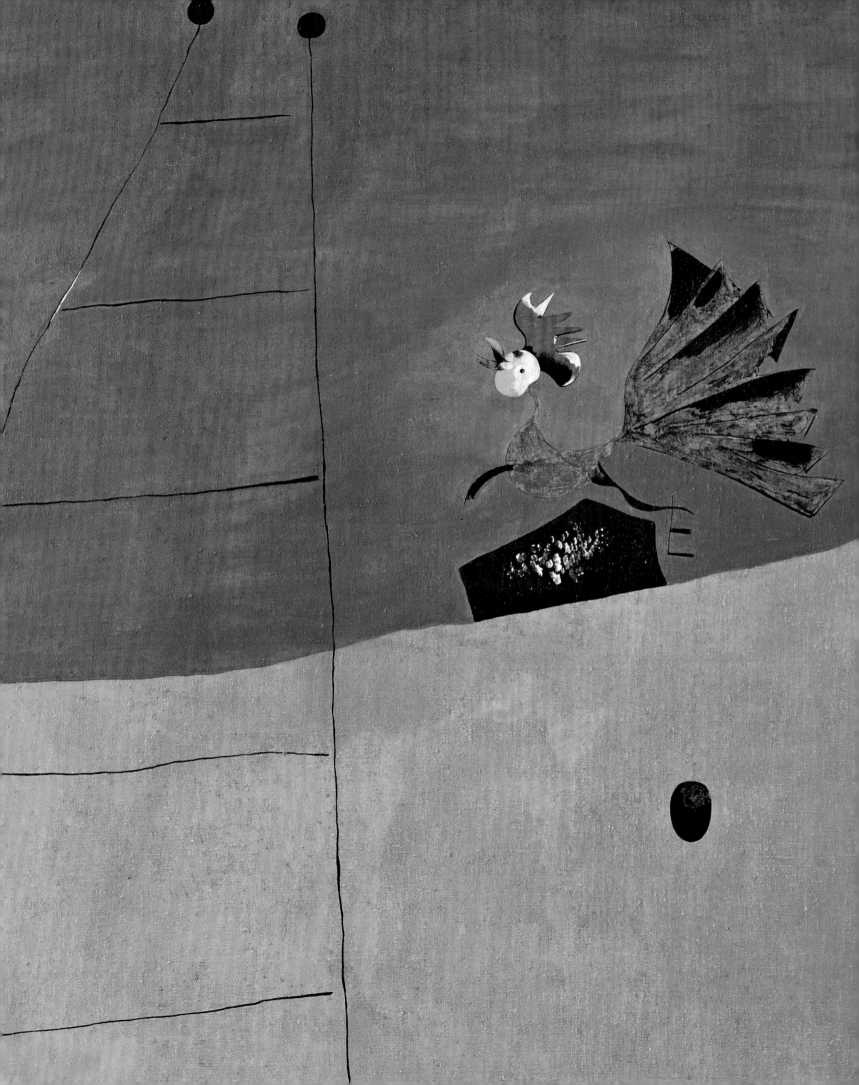

An International Catalan: 1918–25

MARKO DANIEL AND MATTHEW GALE

The first signs of Joan Miró's engagement with political identity can be discerned in his hedonistic scrutiny of familiar landscapes in his earliest mature works, around 1917–18. This interest had deep roots. He had grown up with the resurgence of Catalan culture, so that cultural specificity, locality and autonomy were interwoven.[1] Although he spent most of his childhood in the centre of Barcelona, he identified with the countryside.[2] He attempted, dutifully, to follow his parents' wishes that he enter the city's commercial world, but in 1911 he told his father that his training had been 'two years of imprisonment through which I sacrificed not being able to see the great beauties of nature that I so love'. He regretted 'not listening to my conscience which called me towards painting for which I was born'[3] and, allaying his parents' fears of fecklessness, claimed: 'My aspirations are much more elevated than ending up a Bohemian'.[4]

Indeed, a serious dedication to his art was a hallmark of Miró's whole career. As early as 1915 he quoted Goethe to his friend Enric Ricart: 'He who always looks ahead may sometimes falter, but he then returns with new strength to his task'.[5] This provided a philosophical key to the presence of a book, clearly by Goethe, in the still life completed in 1917 and named after another literary influence, the modernist periodical *Nord-Sud* (see no.11).[6] At that time Miró identified himself with the sort of artist dedicated to landscape painting who 'sees a different problem in every tree and in every bit of sky: this is the man who suffers, the man who is always moving and can never sit still, the man who will never do what people call 'definitive' work. He is the man who always stumbles and gets to his feet again.'[7] While confident in tone,

this emphasis on determination reflects a wider paradigm of the struggling modernist.

The fact that Miró's point of reference was the landscape indicated his interest in going beyond the fashionable *Noucentisme*, the Catalan cultural movement exemplified by Joaquim Sunyer's famous *Pastoral* 1910–11. Sunyer's painting shows a reclining female nude with sheep in a bucolic Catalan landscape, and in 1911 it was acclaimed as the embodiment of a local and Mediterranean classicism.[8] Miró concentrated instead upon the experience of his long summers spent in the countryside, and especially at the house at Mont-roig near Tarragona bought by his parents in 1911. Mont-roig took on a nodal position in his experience and artistic imagination. It stood for eternal values, although viewed through the lens of the international modernism he was encountering in Barcelona.

Soon after he committed himself to a career in painting Miró had the opportunity to see some of the most recent Parisian art in the *Exposició d'Art Cubista* at the Galeries Dalmau in April and May 1912. The gallery was later to become the gathering-point for Parisian artists in exile during the First World War. Miró responded in particular to the palette of Sonia and Robert Delaunay and the Cubist fragmentation of Albert Gleizes. In February 1918 he held his first, gratifyingly controversial, exhibition at the Galeries Dalmau.[9] Though eschewing the urban subject matter of the exiles, his works combined Cubist influences with an increasingly precise style of landscape painting, which he described to Ricart as having 'No simplifications or abstractions ... Right now what interests me is the calligraphy of a tree or a rooftop, leaf by leaf, twig by twig, blade of grass by blade of grass, tile by tile.'[10]

Such comments can be linked to particular paintings. Alongside *The Rut* (see no.13), in 1918 Miró made *Vegetable Garden and Donkey* (see no.14) with its patterned earth and sky. He then tackled the same building more directly in *House with Palm Tree* (see no.2), in late October. Its clear sky and crisp frontality are striking, while its rhyming circular forms (pumpkins, moon, sundial and palm fronds) create compositional structures embedded in reality.[11] As the process of distillation was so time-consuming, he returned to Barcelona with *Mont-roig, the Church and the Village* unfinished, to be completed the following summer (see no.15).[12] At that stage he told Josep Ràfols: 'There is nothing superfluous (no shadows, no reflections, no twilight) – the thing is to *paint it*.'[13] This aesthetic determination to fix the world around him went beyond transient appearance to embrace a more profound reality that demonstrated a deep understanding of the modern world. Familiar elements were both magnified and abbreviated. This was evident in the treatment of the carefully cultivated land given prominence in *Mont-roig, the Church and the Village*, whose productivity was immediate and yet eternal. While Miró was not a peasant farmer, these works laid bare his engagement with the land and its people, with a sense of place and identity that was both timeless and contemporary.

The impetus behind his immersion in the countryside was to some extent determined when Miró's military service brought him close to action. In the week of 13 August 1917 his unit was called to suppress a general strike in Barcelona.[14] These events generated his feeling of disgust with the political situation in Spain that would ultimately direct him towards the wider horizons of Paris. One consequence was that his engagement with Catalan culture was 'decidedly non-partisan';[15] indeed, his letters show him to be repeatedly exasperated at what he saw as the parochialism of Catalonia. When he contributed a drawing of a Cubist nude to the periodical *Arc-Voltaic* in February 1918, therefore, it seems to have been less to do with the anarchist sympathies of its founder, the Catalan poet Joan Salvat-Papasseit than with the magazine's internationalism. In this context Miró espoused what Robert Lubar has aptly termed 'the idea of a transcendent Catalan nationalism rising above partisan and class lines'.[16]

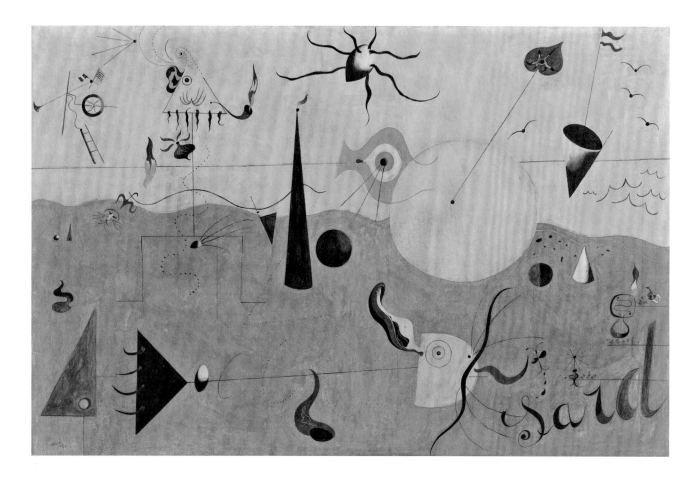

18
Paysage catalan (Le Chasseur) 1923–4
Catalan Landscape (The Hunter)
Oil on canvas
65 × 100
The Museum of Modern Art, New York. Purchase, 1936

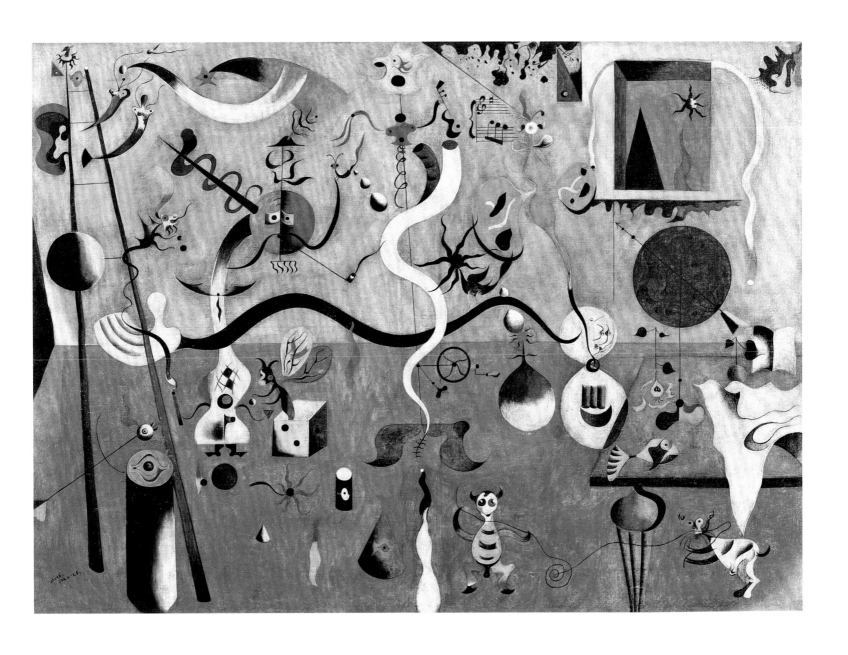

19
Carnaval d'arlequin 1924–5
Harlequin's Carnival
Oil on canvas
66 × 93
Albright-Knox Art Gallery,
Buffalo

20
La Terre labourée 1923–4
The Tilled Field
Oil on canvas
66 × 92.7
Solomon R. Guggenheim
Museum, New York

Thus withdrawal to Mont-roig allowed Miró to direct his attention towards Paris. His move to the country was partly also enforced by the progress of the global influenza epidemic in late 1918. In these circumstances, his isolation tended to reinforce a latent discourse of health in the timelessness of the countryside. Earlier that summer he had already considered 'those who are not strong enough to work from nature to be sick spirits'.[17] A year later he wrote: 'The artist in continuous contact with real life and nature reminds me of the healthy, virile man who has balls, as sung by Walt Whitman, in energetic contact with the glorious womb of the opposite sex and breeding healthy men and athletes who will honour the race'.[18] This earthy (masculine) lustiness was closely connected to Miró's vision of his encounter with nature.

Secure of his position in the world, in 1920 Miró declared his aspiration to be an 'international Catalan'.[19] Both rooted and outward-looking, this was a view he held throughout his life but which he immediately poured into two transformative compositions. His *Self-Portrait* of 1919 (see no.16) was a declaration of intent, in which he turned the scrutiny previously applied to the landscapes and still lifes into a stern self-examination. Equating his solidity with a mountain, one recent interpretation has suggested the portrayal in red to be an embodiment of 'mont-roig' ('mount red').[20] Certainly the taut line and plane deliberately recall the medieval saints that he admired in Barcelona, with their balance of expressiveness and impassivity. Miró presented a strength of vision equalled by the political liberalism implied by the red *garibaldina* shirt.

If the *Self-Portrait* offered a public presence it was in the great painting of Mont-roig, *La Ferme* 1921–2 (*The Farm*, see no.17), that Miró revealed more of his personality. '*The Farm*,' he told the journalist Francesc Trabal in 1928, 'was a résumé of my entire life in the country'.[21] Worked over nine months, the large canvas holds the balance between the detailed observation of nature and the development of his personal vocabulary of signs in the mid-1920s. It is a key painting and remained Miró's touchstone for subsequent work.[22] The cloudless sky provides a foil to the details of the familiar realm of the outbuildings at Mont-roig, with only the moon and a distant line of woodland distracting from this concentrated focus. Again the cultivated earth dominates the foreground, but more so than in earlier paintings. It is alive with creatures both incidental (the snail) and domesticated (the chickens): 'I don't think it makes sense to give more importance to a mountain than an ant,' he remarked.[23] These details are presented with clarity but also stripped to their essence and reassigned their place within the post-Cubist structure. The spreading carob tree has a protective presence even as its central circular bed (counterpoint to the moon) offers a disconcerting glimpse into the void.

Miró showed *The Farm* at the Salon d'Automne in Paris in 1922, but it was its 'atmosphere of festivity and enchantment' in the studio in the rue Blomet that the poet Robert Desnos recalled.[24] It was there, as a neighbour of the painter André Masson in the winters of 1921 to 1925, that Miró entered the poetic and artistic circles of Surrealism that would provide him with impetus for his revision of art. He was certainly aware of André Breton's definition of Surrealism as 'pure psychic automatism by which one proposes to express … the actual functioning of thought'.[25] Using Charles Baudelaire's words, Breton also captured an atmosphere that could be applied to Miró's approach: 'It is true of Surrealist images as

it is true of opium images that man does not invoke them: rather, they "come to him spontaneously, despotically".[26]

As many have remarked, the watershed came in *La Terre labourée* (*The Tilled Field*, no.20), the painting that followed *The Farm* in 1923. Writing once again to Ràfols, Miró claimed: 'I have managed to break absolutely free of nature and the landscapes have nothing whatever to do with outer reality. Nevertheless, they are more *Mont-roig* than had they been painted *from nature*.'[27] The house, tree, productive earth and inquisitive animals all remain in *The Tilled Field* but distilled even further, as essences. Miró was swept along by the audacity of his rapidly changing production: 'At times I am seized with a panic like that of the hiker who finds himself on paths never before explored.'[28] However, he was reconciled to paintings developing: 'Trees with ears and eyes and a peasant with his *barretina* and rifle, smoking a pipe.'[29] This phrase actually conflates *The Tilled Field* and the even more open

Paysage catalan (*Le Chasseur*) (*Catalan Landscape* (*The Hunter*), no.18). The eye and ear of his *Self-Portrait* have migrated to the tree in *The Tilled Field*, confirming the intense identification of painter and place.[30]

The echoes continue in *Catalan Landscape* (*The Hunter*), where the triangular-headed hunter, complete with flaming gun, flaming pipe and spurting genitals, wears the *barretina* – the red Phrygian cap of liberty. The carefully delineated universe that was evident in *The Farm* has become, by accelerated stages, a yellow and salmon-pink, stage-like space of fantastic interaction. The fish on the land and the conical flagged boat in the sea are at once specific and totally reinvented. Should there be any question of the geographical location of these works, they carry the French and Catalan flags to signal the enriching cultural exchange that Miró was experiencing. In the summer of 1924 he wrote to Michel Leiris, one of the rue Blomet circle: 'you and all my other writer

21
Personnage lançant une pierre à un oiseau 1926
Person Throwing a Stone at a Bird
Oil on canvas
73.7 × 92.1
The Museum of Modern Art, New York

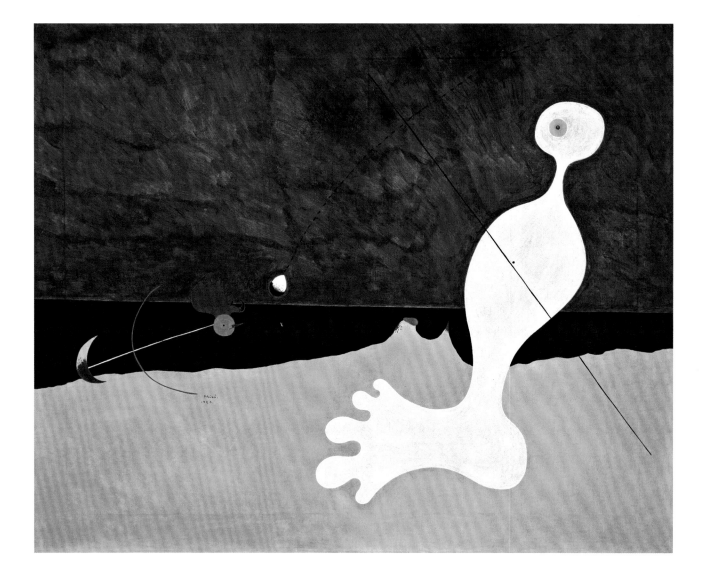

friends have given me much help and improved my understanding of many things.'[31]

After years of integration there has been a growing tendency for historians to detach Miró from Surrealism. He did not sign the Surrealists' political manifestos; he is notable for his absence among the signatories of *La Révolution d'abord et toujours!*, the manifesto that, briefly, promised collaboration between the movement with the Communist *Clarté* group in 1925.[32] Whether this absence was in itself a significant statement is difficult to establish. There is perhaps no better measure of Miró's artistic allegiance to the movement, however, than the reproduction of *Catalan Landscape* (*The Hunter*) in the periodical *La Révolution surréaliste,* in July 1925, when André Breton launched the first part of his polemic 'Le Surréalisme et la peinture' with the famous statement: 'The eye exists in its savage state.'[33] Picasso was Breton's yardstick (as he was, to some extent, for Miró), but the publi-

cation of Miró's recent painting immediately before Picasso's *Three Dancers* could hardly have been more prominent. Soon Breton would call Miró 'the most "surrealist" of us all'.[34]

In some respects it is the atomised detail of *Carnaval d'arlequin* (*Harlequin's Carnival*, no.19) that most deserves the term 'surreal' among Miró's works of this moment. It was shown in the first Surrealist exhibition at the Galerie Pierre in late 1925. In another stage-like space the scaffolding of signs indicates a fantastic encounter: the ear and eye now grasp the huge ladder (an early 'ladder of escape'), a bearded and moustachioed man smokes a pipe, while a yellow-headed stick-woman with a guitar floats among music, stars and insects. Pictorial hierarchy is replaced by an all-over detailing that gives equal prominence to each area – a strategy that would return (along with the vocabulary of forms) in the *Constellations* of 1940–1. Chiming with the poetic values of fellow Surrealists, the exploitation of the unexpected – in

22
Chien aboyant à la lune
1926
Dog Barking at the Moon
Oil on canvas
73 × 92
Philadelphia Museum of Art.
A. E. Gallatin Collection, 1952

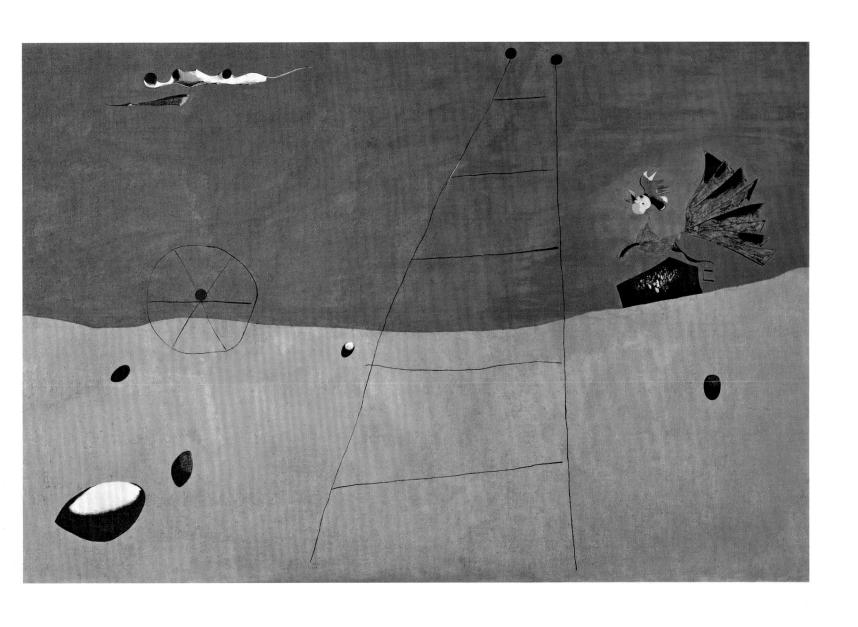

23
**Paysage (Paysage
au coq)** 1927
*Landscape (Landscape
with Rooster)*
Oil on canvas
131 × 196.5
Fondation Beyeler,
Riehen/Basel

Paysage (Le Lièvre) 1927
Landscape (The Hare)
Oil on canvas
130 × 195
Solomon R. Guggenheim
Museum, New York

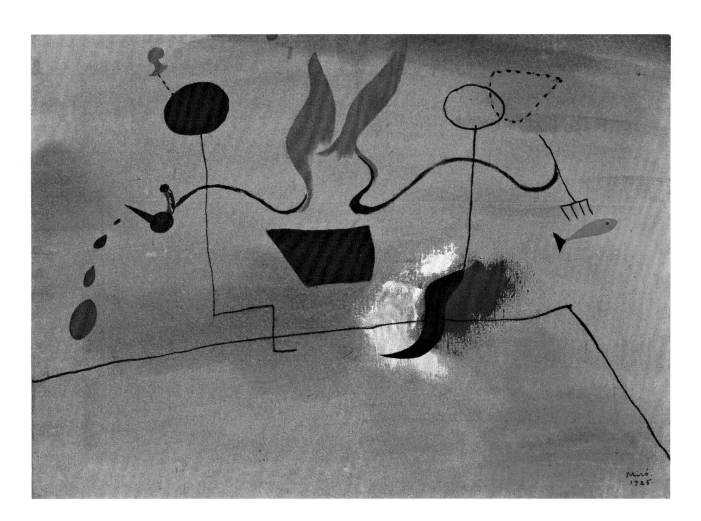

25
Le Repas des fermiers 1925
The Farmers' Meal
Oil on canvas
33.5 × 46.5
Private collection

imagery, scale, and colouring – allowed Miró to achieve this complex interaction against the grain of his longer-term tendency towards simplification.

This tendency was already apparent in *Catalan Landscape* (*The Hunter*) and may be discerned, as an ebb and flow between detail and openness, in the *Tête de paysan catalan* series (*Head of a Catalan Peasant*, see nos.29–32, 34).[35] They show an emblematic form for the figure that becomes structural, with the body and face standing in for one another, and only the details (hat, beard, pipe) establishing the focus. This may have been encouraged by the example of Picasso's famous curtain for the ballet *Mercure* (which Miró attended with him on 14 June 1924), on which the word *étoile* stood in for stars.[36] Miró's series uses similar abbreviated signs, which extend into other works in which the peasant may be discerned to a greater or lesser degree. These include the partially finished *Peinture* [*Le catalan*] 1925 (*Painting* [*The Catalan*], no.33), in which the *barretina* is palette-shaped, and dimmer echoes in the eyes of *Peinture* (*Tête*) 1927 (*Painting* (*Head*), no.36) and the residual figure of *Peinture* 1927 (*Painting*, no.37).

It remains possible that the *Head of a Catalan Peasant* series has a specific connection with the politics of the time. While the painter was reticent to sign manifestos, this series defied the suppression of Catalan identity that followed the seizure of power by the dictator Primo de Rivera in 1923. Beyond the associated sketch,[37] the 1924–5 paintings – both through their imagery and their titles – declare Miró's allegiance. In the interview published in Barcelona in 1928, he went out of his way – and not for the last time – to stress his Catalan identity. Addressing the suggestion that he had succumbed to the attractions of Paris, he was vehement: 'I can assure you that I am happiest in Catalonia, in Mont-roig, which I feel is the most Catalonian place of all.'[38] To this he added: 'Everything I've ever done in Paris was conceived in Mont-roig without even a thought of Paris, which I detest.'[39]

This dedication to Mont-roig found expression in the *Animated Landscapes* of 1926–7, in which aspects of the paintings made at the beginning of the decade were re-imagined. They show Miró taking up the flat planes of colour and isolated form anticipated in *Catalan Landscape* (*The Hunter*), but the details have been drained away to

**Nature morte (Nature
morte à la lampe)** 1928
*Still Life (Still Life
with Lamp)*
Oil on canvas
89 × 116
Private collection

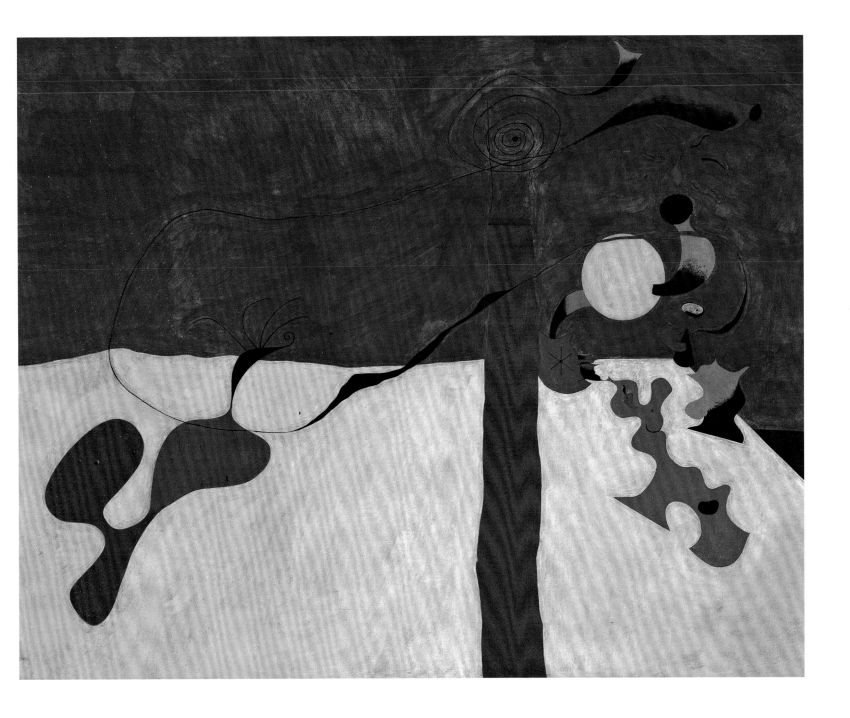

give greater strength to those that remain. Accompanying a ladder, a dog barks at the moon (a detail from *The Farm* made into its own subject); a cockerel accompanies another, more spindly, ladder; a hare squats, perplexed by a spiral flight (nos.22–4). These very simplified forms are strengthened by their arrangement on the strongly coloured grounds of Miró's imagination. Verisimilitude was long relinquished, but reality remains as something intangible, reinvented, dreamlike. This last quality is also apposite, as many in this remarkable group appear to be nocturnes. It is not clear if this was deliberate, but the possibilities of night-time seem provocative. The

night hides under the cloak of darkness but reveals those who cautiously venture out: the animals reclaiming the natural world for their own concerns and mysterious actions. Beyond this, the nocturne appears as if it were a fundamental acknowledgement of Surrealism: a way of showing the irrational and the undisclosed, the mysterious and the unconscious. It is not merely by chance that *Chien aboyant à la lune* (*Dog Barking at the Moon*) accompanied Leiris's 1927 review of the writings of the Elizabethan alchemist John Dee, as both suggested a closed system of signs giving on to a parallel world.[40]

27
Peinture 1927
Painting
Tempera and oil on canvas
97.2 × 130.2
Tate. Purchased with
assistance from the Friends
of the Tate Gallery 1971

1 Miró's schooling was conducted in Spanish (see 'Joan Miró, escriptor català', in Minguet, Montaner and Santanach 2009, p.21). Although the standardisation of Catalan, by Pompeu Fabra in *Normes ortogràfiques* (1913), was finalised when the painter was already 20, it was a project in progress since 1889 with Fabra's journal *L'Avena* (see Robert S. Lubar, 'Art and Anarchism in the City of Bombs', in Robinson, Falgàs and Lord 2006, p.110). This rather circumscribes Tomás Llorens's interesting view (Llorens 2008, pp.22–3, n.4) that Miró's command of Catalan shows 'a deliberate choice clearly motivated by nationalist militancy'.

2 According to the account given to Jacques Dupin (in Rowell 1986, p.45), one grandfather was a cabinet-maker and the other a blacksmith. His mother was from Mallorca, where he holidayed as a child. His father's watchmaker's shop went under the unexpected name of 'El Acuarium' (The Aquarium).

3 Miró (Barcelona) to Miguel Miró (Palma), 2 April 1911, in Minguet, Montaner and Santanach 2009, p.35. He was apprenticed to the chemists Dalmau i Oliveres.

4 Miró (Barcelona) to Miguel Miró (Palma), 9 April 1911, in Minguet, Montaner and Santanach 2009, p.36.

5 Miró (Caldetas) to E.C. Ricart, 31 Jan. 1915, in Rowell 1986, p.48. Miró's copy of *Eridon y Amina* (1909) remains in his library (as noted in Minguet, Montaner and Santanach 2009, p.38).

6 The juxtaposition of German and French references at the height of the First World War, together with the European interchange signalled by the periodical's title, demonstrated a cultural cosmo_politanism distinct from Miró's instinctive support for the Allied cause.

7 Miró (Mont-roig) to J.F. Ràfols, 13 Sept. 1917, in Rowell 1986, p.51.

8 For the poet Joan Maragall's praise of Sunyer's painting see Robert S. Lubar,

'Miró's Mediterranean: Conceptions of Cultural Identity', in *Joan Miró* 1993, pp.25–48.

9 Josep Junoy, who made an acrostic word puzzle for Miró's 1918 exhibition invitation, had published *Arte y Artistas* to coincide with the 1912 Cubist show. For these events see for instance Christopher Green, 'The Foreign Avant Garde in Barcelona, 1912–1922', in *Homage to Barcelona: The City and its Art 1883–1936*, exh. cat., Hayward Gallery, London 1985, pp.182–92, and Robert S. Lubar, 'Cubism, Classicism and Ideology: the 1912 *Exposició d'Art Cubista* in Barcelona and French Cubist Criticism', in Elizabeth Cowling and Jennifer Mundy (eds.), *On Classic Ground: Picasso, Léger, de Chirico and the New Classicism 1910–1930*, exh. cat., Tate Gallery, London 1990, pp.309–23.

10 Miró (Mont-roig) to Ricart, 16 July 1918, in Rowell 1986, p.54. Llorens 2008, pp.29–41 also emphasises the role of landscape.

11 Miró (Mont-roig) to Ricart, 27 Oct. 1918, in Rowell 1986, p.58.

12 Miró (Mont-roig) to Ricart, 9 July 1919, in Rowell 1986, pp.60–1.

13 Miró (Mont-roig) to Ràfols, 21 Aug. 1919, in Rowell 1986, p.63.

14 See Robert Lubar's text in this volume.

15 Lubar 1993, p.44.

16 Lubar 1993, p.45; see also his 'Joaquín Torres-García y la formación social de la vanguardia en Barcelona', in *Barradas / Torres-García*, exh. cat., Galería Guillermo de Osma, Madrid 1991, pp.19–32.

17 Miró (Mont-roig) to Ràfols, 11 Aug. 1918, in Rowell 1986, p.57.

18 Miró (Mont-roig) to Ricart, 9 July 1919, in Rowell 1986, pp.60–1. From the moment of its purchase around 1911 (when he went there to recover from typhoid) Miró associated Mont-roig with health; in late 1918 he stayed on there in order to avoid the influenza epidemic that had reached Barcelona; see Miró (Mont-roig) to Bartolomeu Ferrá, 1 Nov. 1918,

Minguet, Montaner and Santanach 2009, p.107. It was at Mont-roig that Miró's father died in July 1926; see Miró (Barcelona) to Picasso, 14 July 1926, ibid., p.297.

19 Miró (Mont-roig) to Ricart, 18 July 1920, in Rowell 1986, p.73.

20 Labrusse 2004, pp.199–220, who reads the red shirt as pyjamas. See also p.29 n.36.

21 Francesc Trabal, 'Una conversa amb Miró', *La Publicitat*, 14 July 1928, in Rowell 1986, p.93.

22 For examples of Miró's use of *The Farm* as a point of reference see Teresa Montaner's text in this volume.

23 Trabal 1928, in Rowell 1986, p.93. The details, especially those of the stony ground, set the tone for Salvador Dalí's paintings of five years later; see Joan M. Minguet Batllori, *El Manifest Groc: Dalí, Gasch, Montanyà i l'antiart*, Barcelona 2004, pp.63–5.

24 Robert Desnos, *Cahiers d'Art*, vol.9, no.1–4, 1934, p.28; for rue Blomet, where Miró sublet Pablo Gargallo's studio while the latter taught in Barcelona in the winter, see Miró's memories recounted to Dupin, in Rowell 1986, pp.100–4.

25 André Breton, *Manifesto of Surrealism* [1924], in *Manifestoes of Surrealism*, trans. Richard Seaver and Helen R. Lane, Ann Arbor 1969, p.26.

26 Ibid., p.36.

27 Miró (Mont-roig) to Ràfols, 26 Sept. 1923, Rowell 1986, p.82.

28 Ibid.

29 Miró (Mont-roig) to Ràfols, 7 Oct. 1923, Rowell 1986, p.83.

30 The hairs on the tree's trunk echo the chest-hairs exposed by the open-neck shirt of the *Self-Portrait*.

31 Miró (Mont-roig) to Leiris, 10 Aug. 1924, Rowell 1986, p.86.

32 'La Révolution d'abord et toujours!', in *La Révolution surréaliste*, no.5, 15 Oct. 1925, pp.31–2; Max Ernst and André Masson did sign. This issue of *La*

Révolution surréaliste reproduced two Mirós, including *The Tilled Field* (p.10).

33 Breton, 'Le Surréalisme et la peinture', in *La Révolution surréaliste*, no.4, 15 July 1925, pp.26–30, in André Breton, *Surrealism and Painting*, trans. Simon Watson Taylor, London 1972, p.1.

34 Breton 1972, p.36.

35 See Christopher Green's text in this volume.

36 The performance is noted in Miró (Mont-roig) to Picasso, 15 Nov. 1924, Minguet, Montaner and Santanach 2009, p.278.

37 See Christopher Green's text in this volume.

38 Trabal 1928, in Rowell 1986, p.93. This is the first time he emphasises the linguistic significance of using the name 'Joan'.

39 Ibid.

40 Michel Leiris, 'La monde hierglyphique', in *La Révolution surréaliste*, no.9/10, 1 Oct. 1927, pp.61–3.

Miró's Catalan Peasants

CHRISTOPHER GREEN

Some time after 23 March 1925, Joan Miró completed a painting now in the Moderna Museet, Stockholm, to which he gave the deadpan title *Tête de paysan catalan* (*Head of a Catalan Peasant*, no.34). This is the last of a series of five paintings, four of them with the same title but one, now in the Thyssen-Bornamisza Collection in Madrid, that Miró called *Paysan catalan à la guitare* 1924 (*Catalan Peasant with Guitar*, no.30).[1] All are images of that most telluric of subjects, the peasant, and feature the peasant's *barretina* of Catalonia. In *Catalan Peasant with Guitar* a rudimentary sign for a smoking, music-making Catalan peasant, with a big upside-down heart, seems on the point either of emerging wraithlike from the deep blue of the picture's space, or of vanishing into it. Such a sign, also faceless, but now without guitar, pipe, heart or legs, is found again in the Stockholm *Head*, but here it has almost entirely vanished into the airy, swirling blues of the picture-space. Miró seemingly has robbed his sign, signifying jovial peasant vivacity, of its capacity to signify anything but a metaphysical idea.

That this *Head* was painted after 23 March 1925 is known because what appears to be Miró's first sketch for it is drawn in pen on a cutting from the front page of the French newspaper, *Le Matin*, of that date (no.28).[2] This and the dates inscribed on the other paintings in the series place it as the last, and appear to give a clear sequence, based on the moment of inception, so that in 1993 it was proposed that numbering be added to their titles following these dates: *Head of a Catalan Peasant I, II, III* and *IV* (nos.29, 31, 32 and 34, respectively).[3] *Catalan Peasant with Guitar* was excluded from this re-titling, as it had been almost completely from critical writing on the series as a whole.[4]

One reason for this is the comfortable fit between one of the most famous early critical pieces on Miró, Michel Leiris's article of 1929 for *Documents*, and the account of the series left embedded in the literature by Miró's biographer, the poet Jacques Dupin. In 1929 Leiris developed a compelling analogy between Miró's practice and the meditative practices of 'certain Tibetan aesthetes', where a garden, say, is reduced mentally 'leaf by leaf' until finally sky and land are erased too and all that is left to 'see and contemplate' is 'the void'. For Dupin, the *Catalan Peasant* series is *the* demonstration from the 1920s of that process, wherein one moves from the fullness of the small painting once in the collection of César de Haucke (no.31), by way of the relatively small canvas once owned by Roland Penrose and now owned by Tate and the Scottish National Gallery of Modern Art (no.32), finally to the large-scale, nearly empty Stockholm *Head* (no.34).[5]

However, the numbering initiated by the dates on the canvases tends to sabotage this attractively simple idea, because the earliest *Head*, in the National Gallery of Art, Washington DC, is so empty against its yellow background (no.29).[6] The only other one of the series to be dated 1924 is, in fact, the guitar-playing peasant, and only these two are included in a sketchbook list where Miró records the canvases he took back to Paris from Mont-roig after the summer of 1924.[7] Both, it is clear, were completed at Mont-roig before the ex-de Haucke painting with all its details: its inquisitive insects and its erupting moon.[8] The tidy picture of progress towards the void is thrown into still more disarray by the existence of a ragged loose-leaf drawing stuck into the sketchbook that contains all the drawings related to the

Head of a Catalan Peasant
1925 (detail of no.34)

series.[9] It is a drawing which anticipates almost all the details of the ex-Penrose painting, from the hanging hairs of the beard to the diamond pattern of its unconcealed linear grid. The painting is dated 1925, but the drawing is inscribed in an oddly archaic script with the date 10 March 1924, and so seems to have been sketched before Miró's departure from Paris to Mont-roig: before the Washington *Head*. Moreover, when *Catalan Peasant with Guitar* is brought into the series its starting point has to be taken back even further, because this peasant has been almost excerpted from the major Mont-roig painting *Paysage catalan* (*Le Chasseur*) (*Catalan Landscape* (*The Hunter*), see no.18), which was begun in summer 1923.[10] Indeed, in the most developed of the drawings for *Catalan Landscape* (*The Hunter*) Miró adds alongside the hunter a faintly sketched sign in dotted lines forming a cross topped by a *barretina*, the basic sign of the *Catalan Peasant* series as a whole.[11] The very end of the process of etherealisation seems to have been realised at the beginning.

It is clear, ultimately, that the tension between an earthy and a celestial peasant, summed up by the confrontation between *Catalan Peasant with Guitar* and the near-empty Stockholm painting, was a factor right through the series, from start to finish.[12] Indeed, around the same time as the appearance of that ghost of a sign beside the peasant hunter in the drawing for *Catalan Landscape*, Miró made a casual naturalistic sketch of the head of a peasant with *barretina*, which seems to mark the moment when the possibility of isolating just the head emerged, though postcards of Catalan peasants probably supplied the germ of the idea even earlier.[13] This fleshy head exudes corpulent earthiness, but it too, like the drawing of the hunter, is paired with just a hint of the flimsy abstracted sign that would hold the series together: the crossed lines inscribed over it.

What seems to have happened was not a simple, single-track movement towards the void, but an oscillation between the desire to fill and the desire to empty the picture space, between the emptiness of the yellow *Head* and the fullness of the ex-de Haucke *Head*, an oscillation whose movement was anticipated from the start. Leiris, in fact, never suggested that only one direction was possible. For him, the void fixed a new starting point: once the details of the world had been thought away, they were, one by one, to be brought back into being. Miró too, it seems, never saw the void as an ending: it was a state from which to depart as well as towards which to

28

Sketch for **Head of a Catalan Peasant** on the front page of *Le Matin* newspaper, 23 March 1925
Fundació Joan Miró, Barcelona

29

Tête de paysan catalan
1924
Head of a Catalan Peasant
Oil and crayon on canvas
146 × 114
National Gallery of Art, Washington. Gift of the Collectors Committee, 1981

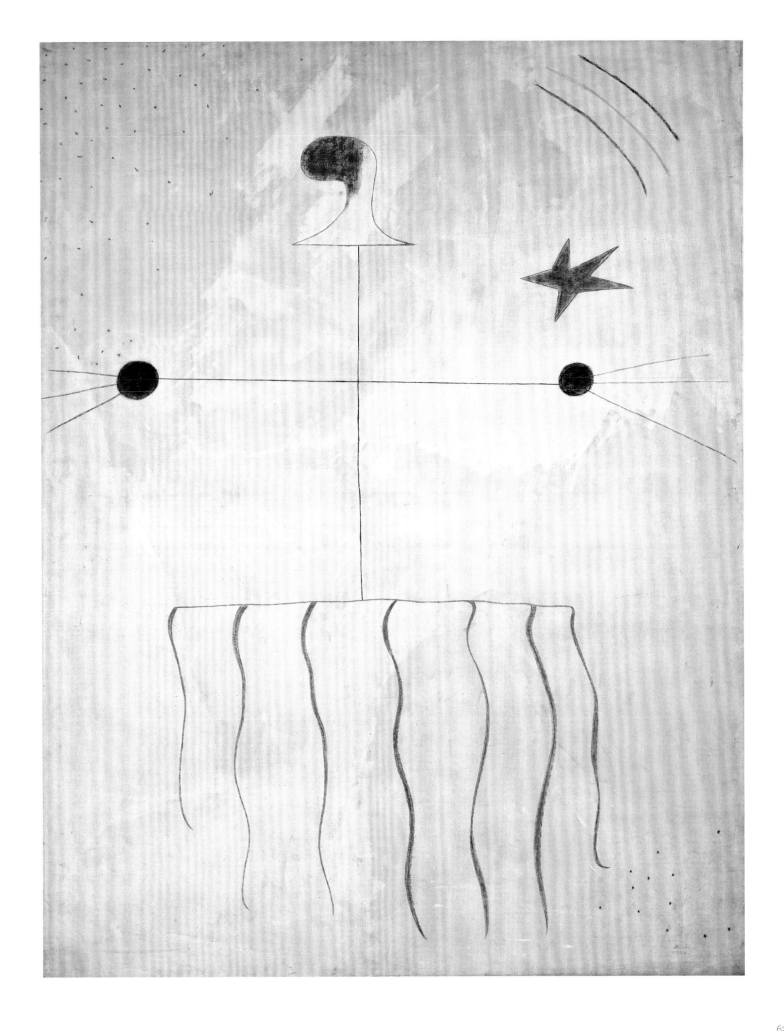

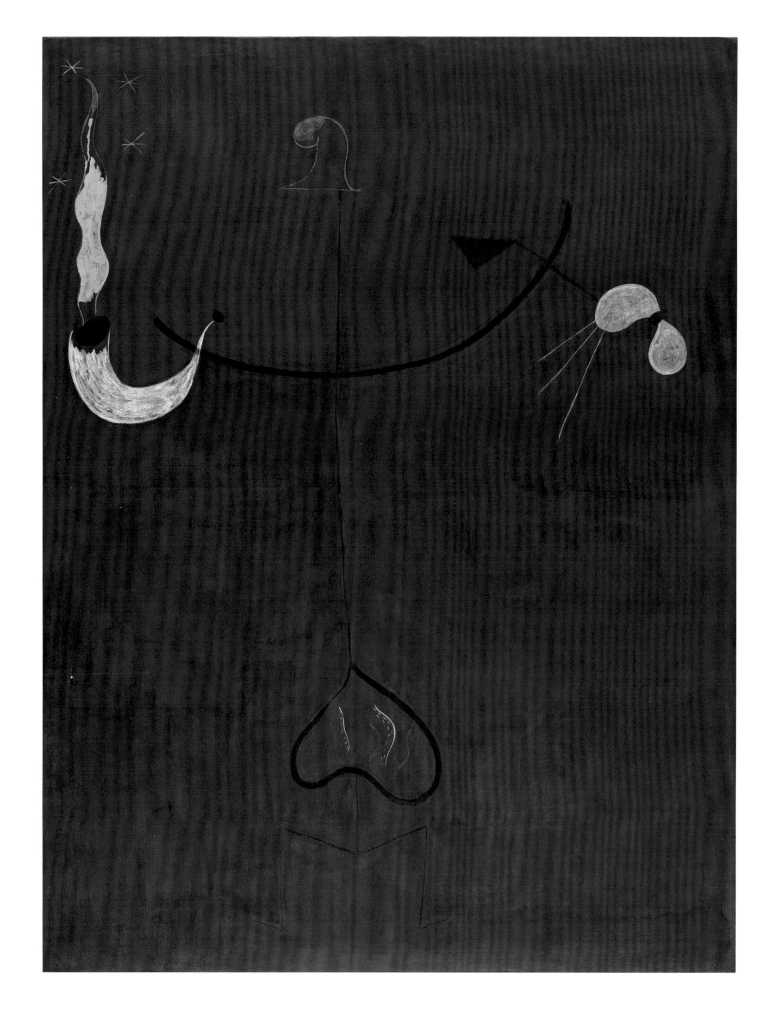

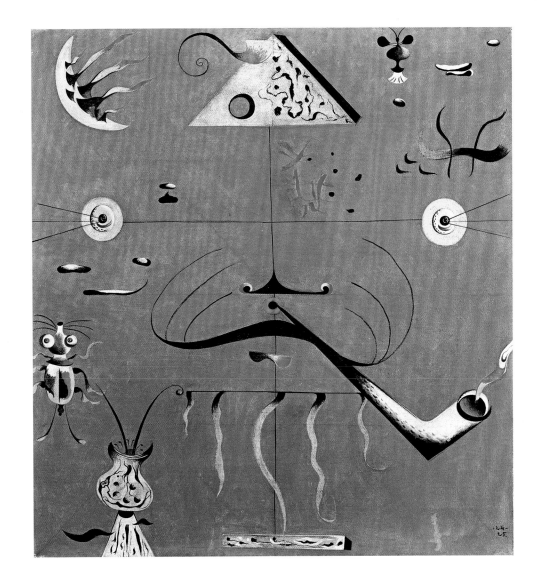

move. In every case, however, the void remains. It threatens all the peasants with extinction. The void is a force.

The drawings that survive for the four *Heads* (there is no drawing directly for the guitar-playing peasant) are remarkably close to the paintings.[14] Many of the sketchbook drawings are inscribed with the size of the canvas (for instance, standard canvas size 80F for the Stockholm painting) and the colour of the background. Miró separates his sketchbook sign-making from his meticulous recording of the format and colour he gives the void. The peasant, realised first in the sketches, is a presence that threatens to disappear; the void, realised last on the canvas, is an absence that is insistently, tangibly there, for it is rendered in extraordinarily material terms. Miró's first step in work on all the canvases of 1924–5 was to prepare his own highly absorbent ground, building it up with a spatula to create a rough, uneven surface. In the Stockholm painting he then used sweeping strokes to activate the surface, applying colour in a medium so thinned with turpentine that it mostly soaked away into the white ground

leaving swirls of dry, fresco-like colour deposit on the surface. In *Catalan Peasant with Guitar* he produced a densely worked, deep blue ground, suggestive of a very different void, as still as deep water.[15] In every case, as in all the so-called 'dream paintings' of the mid-1920s, he created spaces in which colour and sign work together, the void experienced *in* the material.[16]

The interactive tension between Miró's telluric peasant subject reduced to the trace of a sign and the tangible presence of the voids to which he gives body and colour alerts us to the different levels on which these paintings can all be read. It is worth going back to the drawing for the Stockholm *Head of a Catalan Peasant* with which I began, for in reading the page from the newspaper, *Le Matin*, which is its support (no.28), different potential regions of meaning open up which actually connect with the different levels on which the schematic peasant image can also be read, concrete as well as metaphysical. It might seem that the act of turning the newspaper page upside-down robs it of significance. But it may be that this very act was a response to what is there; one

32
Tête de paysan catalan
10 March 1925
Head of a Catalan Peasant
Oil on canvas
92 × 73.2

Tate. Purchased jointly with
the Scottish National Gallery
of Modern Art with assistance
from the Art Fund, the Friends
of the Tate Gallery and the
Knapping Fund 1999

33
Peinture [Le catalan] 1925
Painting [The Catalan]
Oil and pencil on canvas
100 × 81
Centre Pompidou, Paris.
Musée national d'art moderne /
Centre de création industrielle

that signals an engagement with, not a retreat from, the brutal world of fact as well as the forces that challenge it.

Two of the three columns featured make a pair. One is headed 'Almanac and Superstition', the other 'Rome Celebrates the 6th Anniversary of the Foundation of Fascism'. The first concerns the fateful properties of the number thirteen: it is a reminder of the irrational and the magical. In the second, the Fascist deputy Farinacci is quoted: 'Fascism is stronger than ever'; and the Italian dictator Mussolini is quoted on the arrival of spring weather as a sign of hope for Fascism's future. The first invokes Miró the mystic, a Miró alert, like Leiris, to the magic of numbers; the second places the painting firmly within its worldly situation: a post-1918 Europe where the aspirations of Catalans were threatened by authoritarian government. On 13 September 1923 Primo de Rivera had seized power in Spain. Mussolini's seizure of power in Italy provided the model for his coup. 1924, the year of the first two paintings of the *Catalan Peasant* series, had

seen the consolidation of Primo de Rivera's centralising policies in Catalonia and the official suppression of the Catalan language. Miró's drawing is a private note to himself; it is not a public work. But it is obviously open to us to read his decision to inscribe his peasant on this particular newspaper page turned upside-down as a gesture of defiance, however internalised. Bearing in mind Mussolini's remarks on the coming of hope with the coming of spring weather, it is worth noting the weather report at the top of the page: 'The wintry period continues. North Easterly wind.' To invert the article on superstition and the number thirteen would have had its own, very different resonances. The Stockholm *Head of a Catalan Peasant*, in its highly etherealised form, emerges from a newspaper cutting which in part invokes the fateful and the mystical; and yet, simultaneously, the image is rooted in a dangerous, threatening reality – the reality in which Catalan peasants actually lived – even as he escapes into the blue of the void.

34
Tête de paysan catalan
1925
Head of a Catalan Peasant
Oil on canvas
147 × 115
Moderna Museet,
Stockholm. Bequest of
Gerard Bonnier, 1989

It has been commonplace to situate the *Catalan Peasant* series in relation to the embattled position of Catalan nationalism in the mid-1920s. In this scenario they are the sequel to the Catalanism of Miró's early landscapes and the prelude to *Le Faucheur* (*The Reaper*), painted for the Spanish Republican Pavilion at the Paris Exposition Internationale of 1937: the Catalan peasant as a symbol of resistance to Fascism in all its 1930s forms (see pp.118–21). Interpretations of the series have oscillated between the political and the meta-physical, with the metaphysical taken beyond the void to the most esoteric extremes. A distinctly credible argument has been mounted for reading the peasant as figured in the ex-de Haucke and the ex-Penrose paintings (nos.31 and 32) – an open structure projected onto the sky – in relation to the Kabbalah. The beard formed of long hairs perfectly separated from each other, the single hair growing out of his forehead, the eyes radiant and shining, these features and more conform to descriptions of the 'Ancient One', God in Heaven, in the most important books of the Kabbalah. The connections are astonishingly close.[17]

Yet could this literally be an illustration of the 'Ancient One', when Miró himself is very possibly his 'Catalan peasant'? Miró might dissolve his own subjectivity in his painting of the

1920s to produce images in which we, his spectators, can recognise our own compulsions, and yet there is enough reason to suggest that, on one level, the *Catalan Peasants* are displaced self-portraits.[18] First, there is the fact that their hieratic frontality so strikingly echoes the frontality of the 1919 *Self-Portrait* (see no.16). Second, there is the fact that when Miró painted himself again in *Autoportrait I* of 1937–8 (*Self-Portrait I*, see no.76), he returned to that frontality once more, this time isolating the heads. Third, there is the fact that the frail spine of *Catalan Peasant with Guitar* stands upon legs which form the capital letter 'M'.

The *Catalan Peasants*, both as a mystical image carrying reverberations of the Kabbalic 'Ancient One' and as an image of pipe-smoking, guitar-playing vitality, connect directly with the mystical and the earthy in Miró, and so does the hidden political subtext. The oscillations between the emptying and filling of pictorial space, the tensions between the material and the immaterial, the coexistence of the political with the metaphysical, all these contradictions that come into conflict in the *Catalan Peasants* episode of 1924–5 give us, in the end, a shifting, equivocal image of the man who produced them: a representation, veiled yet intermittently distinct, of Joan Miró.

1 This article is an updated and condensed sequel to my essay 'Un campesino catalán entre los campesinos catalanes: El "Campesino catalán con guitarra" de Miró y la serie del Campesino catalán de los años 1924–1925', Green and Malet 1997. The foundation of that essay was my entry on the Thyssen-Bornemisza painting in Christopher Green, *The Thyssen-Bornemisza Collection: The European Avant-gardes: Art in France and Western Europe, 1904–c.1945*, London 1995, pp.312–21. I would like to record my debt to the late Emil Bosshardt, then conservator of the Thyssen-Bornemisza Collection, with whom I worked on *Catalan Peasant with Guitar* at Lugano. I would also like to record my thanks to Victòria Combalia for her encouragement and support in the early stages of work on the original essay.

2 There are two drawings for the painting both held in the Fundació Joan Miró in Barcelona. That on *Le Matin* 23 March 1925 is FJM 552. The other is sparer, and still closer to the deployment of signs in the painting: FJM 617b in notebook 591–668 and 3129–3130, repro. in Malet 1988, no.264, p.88. This sketchbook was among those dubbed 'the Montroig notebooks' by Carolyn Lanchner; 'Peinture-Poésie', Its Logic and Logistics' in Lanchner 1993, pp.15–82, especially pp.29–42.

3 Lanchner 1993, pp.36–7.

4 Before the publication of my entry in Green 1995 (pp.312–21), the only

commentator to include *Catalan Peasant with Guitar* in the series was the Swedish critic Ulf Linde ('Huvud av Katalansk Bonde', in *Donation Gerard Bonnier*, exh. cat. Moderna Museet, Stockholm 1989, p.30). A reason for its exclusion from the series, besides the inconvenience of its divergent titling, was certainly the fact that the application of a glossy natural resin varnish by restorers, probably in the early 1970s, almost destroyed the painting, which has been resurrected by Emil Bosshardt's removal of the varnish and carefully researched restoration.

5 Michel Leiris, 'Miró', in *Documents*, vol.1, no.5, 1929, pp.263–4. Dupin 1962, pp.158–60. Later Leiris noted that he learned of the practices of Tibetan ascetics through the writing of the traveller Alexandra David-Neel, see Michel Leiris, *La Règle du jeu*, vol.3, Paris 1966, pp.14–15. See also Labrusse 2004, pp.218–21.

6 Dupin modifies his analysis in the second edition of his monograph, but stresses that the dates on the canvases are completion dates and do not record the sequence of the paintings' conception. See Dupin 1993, 2003, p.125.

7 The list is FJM 613b, repro. in Malet 1988, no.259, p.87. I comment on this list in Green 1995, p.314.

8 Matthew Gale points out that the two smaller *Heads* (together with the related *Painting* [*The Catalan*], no.33) are squared up and evidence suggests that they were executed over a relatively long

period of time in Paris, while the three large canvases, painted in Mont-roig, are not squared up. This underlines the differences in Miró's practice in each place, as well as the different ways in which he could negotiate the gap between an initial idea and its realization.

9 The drawing is FJM 639, in notebook 591–668 and 3129–3130, repro. in Malet 1988, no.263, p.88, and in Green and Malet 1997, p.61, fig.12.

10 Umland dates the beginning of work on *Catalan Landscape* (*The Hunter*) to between July and September 1923, in Umland 1993, p.323.

11 This drawing is FJM 654a, in notebook 591–668, repro. in Green and Malet 1997, p.67, fig.15c.

12 The coexistence in Miró's work between the earthy and the ethereal has been a key factor in the work of Margit Rowell on the artist. See especially Rowell 1993.

13 The naturalistic drawing is FJM 642, repro. in Green and Malet 1997, p.22, fig.4. Miró sent Picasso a postcard of a *barretina*-wearing peasant with pipe very comparable to this on 29 December 1922. It is titled: 'Catalunya – Tipo del pais – Catalogne – Type du pays' (Musée Picasso Archive), see Minguet, Montaner and Santanach, p.258.

14 Miró made a painting titled *Le Repas des fermiers* (*The Farmers' Meal*, see no.26) in 1925. A drawing for it (FJM 619b, repro. in Malet 1988, no.266, p.88) includes a drinking Catalan peasant which may be a starting point for the Thyssen-Bornemisza painting. It is

discussed in Green 1995, pp.316–17.

15 For a full account of the complex process that led to the blue background of *Catalan Peasant with Guitar*, see Green 1995, pp.312–21. For more on the backgrounds, see Isabelle Monod-Fontaine, 'Note sur les fonds colorés de Miró (1925–1927)', in Baumelle 2004, pp.70–5.

16 A particularly eloquent and revealing analysis of the interaction between background and the writing of signs is found in Krauss 1972, pp.11–38.

17 R.T. Doepel, 'Zoharic imagery in the work of Miró (1924–1933)', in *South African Journal of Culture and Art History*, vol.1, no.1, 1987. Doepel is at his most convincing when dealing with the ex-de Haucke *Head*. In particular the connections between it and five chapters from the Sefer-Ha-Zohar, which he points out, was available in a French edition of 1906–11, and was one of the most important books of the Kabbalah. Here the 'Ancient One' is seen as a vast structure in the sky, and besides the beard and single hair, has eyes without brows that radiate and shine. He even holds in his hand a 'fire container', as the peasant holds a pipe.

18 Others have come to the same conclusion. See also, for instance, Lanchner on the hunter in Lanchner 1993, p.37, and Palermo 2008, p.61.

35
Peinture 1925
Painting
Oil on canvas
100 × 81
Museo Nacional Centro de
Arte Reina Sofía, Madrid

36
Peinture (Tête) 1927
Painting (*Head*)
Oil on canvas
147.3 × 114.6
Collection Nahmad,
Switzerland

37
Peinture 1927
Painting
Oil on canvas
129 × 97
Centre Pompidou, Paris.
Musée national d'art
moderne / Centre de
création industrielle.
On long loan to Musée d'art
moderne de Lille Métropole,
Villeneuve-d'Ascq

The Tipping Point: 1934–9

MARKO DANIEL AND MATTHEW GALE

The idea of Spain as a proving ground for international politics during the 1930s is still axiomatic. For many, the 1936–9 Civil War and the defeat of the Second Spanish Republic stood for the struggle and the defeat of the people: the heroic determination of individuals failed by the compromise, connivance or cowardice (depending on the viewpoint) of British and French governments set upon non-aggression and the divisive appeasement of the conservative forces of Franco, Mussolini and Hitler. Add to the heady mix of undoubted bravery and political radicalism the romance of a roster of art world figures swept up in events – Federico García Lorca, Ernest Hemingway, Dolores Ibárruri (known as La Pasionaria), George Orwell, Pablo Picasso, Robert Capa and many others – and the story appears to be easily told. However, beside the mythology lies the far more complex layering of events, the factionalism and opportunities taken (and lost) that are interwoven in these histories.[1]

For some, in the fraught moment of Franco's invasion from Africa in July 1936, matters were clear-cut. Benjamin Péret, a virulent anti-Catholic who set out to fight for the Republic, wrote to his fellow Surrealist André Breton on 11 August: 'If you could see Barcelona as it is now – adorned with barricades decorated with burnt-out churches, only their outside walls standing – you would be, like me, exultant.'[2] Although heading back to France, his colleague André Masson had spent two years in Spain pouring his outrage at events into passionate paintings.[3] More nakedly political was the work of the young Communist painter André Fougeron, whose *Martyred Spain* 1937 would adopt the propagandising language of Social Realism. Miró knew all these Frenchmen

and rejected each approach in different ways. He dismissed Social Realism both politically and aesthetically, as he did not feel that the language of horror could be so explicit and at the same time serve an aesthetic purpose.[4] Writing to Pierre Matisse from Paris in early 1937, he commented: 'We are living through a terrible drama, everything happening in Spain is terrifying in a way you could never imagine.' Despite this, he concluded: 'If it were not for my wife and child … I would return to Spain.'[5] His view of events, coloured by his wife's recent arrival in Paris, appears as much threatened by the Fascist insurgency as by the leftist revolution that it unleashed in Catalonia.[6] Miró was not, however, uncommitted. In an interview in 1936 he suggested: 'In great periods the individual and the community march together.'[7] Acknowledging that this was no longer the case, he made a seemingly contradictory observation: 'What I am told about these operations leaves me completely indifferent. The changes that take place in my consciousness happen without my knowledge. I am guided by the events that are located in front of me, I later realize, and that compel me to act as I do.' This was a matter of percolation: without choosing to comment, his work was responsive to his times. In earthy language, he added: 'A painting, after all, comes from an excess of emotions and feelings. It's nothing more than a kind of evacuation'.[8]

If the roots of the Civil War reach back to the persisting feudal social structure across Spain, the situation in Catalonia was circumscribed by regional aspirations. The flowering of Catalan culture, seen especially in the artistic, economic and

Nocturne 1935
(detail of no.48)

political agenda of *Noucentisme*, was restricted under the dictatorship of Miguel Primo de Rivera (1923–30), who placed an emphasis on national unity.[9] When the Second Spanish Republic was established in 1931, Primo de Rivera, the monarchy and conservative laws were all swept away and there was an explosion of opportunities under the new Prime Minister and leader of the Republican Left Party, Manuel Azaña. Radical anti-clerical, egalitarian, financial, educational and agrarian reforms were debated in the first parliamentary sessions of the Cortes, while Anarchists, Anarcho-syndicalists, Carlists, Communists, Radicals, Republicans, Socialists and others vied for influence. Separatist aspirations were immediately manifest in Francesc Macià's declaration of the Catalan Republic within a Spanish Federation on 14 April 1931, although this was quickly modified to an autonomous Generalitat enshrined in the Statute of Nuria in June.

That the Second Republic had unleashed these forces at a time of market collapse, following the Wall Street Crash of 1929, piled economic problems on top of the political ones. Feeling this financial pressure personally, in 1932 Miró began to reduce his annual periods in Paris to short visits, dividing his year instead between Mont-roig and Barcelona in the hope of weathering the storm.[10] As a result, he was a significant presence associated with ADLAN (Friends of New Art), founded by his friends Joan Prats, Josep Lluís Sert and

others as a means of showing contemporary art in the city (their first exhibition was Alexander Calder's *Circque Calder* 1926–31). Among the select ADLAN adherents, Miró's own work was seen more often than it had been over the past decade.[11] He also contributed a statement on the ADLAN Picasso exhibition in January 1936, saying that the works represented 'the profound research into the qualities of human values, the spirit of man's revolt in the face of life and the effort of escape from imposed reality.'[12]

The slaloming political course of the Second Republic threatened any stability. Government reshuffles succeeded one another at a dizzying rate and the anarchists urged direct (and violent) action and boycotts of what they considered to be futile electoral processes. Miró reflected upon this when he included a cartoon on the subject from *La Publicitat* (showing the initials of the Iberian Anarchist Federation on a ballot urn and a detached hand holding a gun) in one of his February 1933 collages (no.38). National and possibly international politics (notably Hitler's elevation to Chancellor of Germany at the end of January) gave impetus to this work. By the time that Miró used this collage for *Peinture* of 10 June 1933 (*Painting*, no.39), the political message had been totally disguised, although the preparatory process reveals his sublimated response to the precarious political climate.[13]

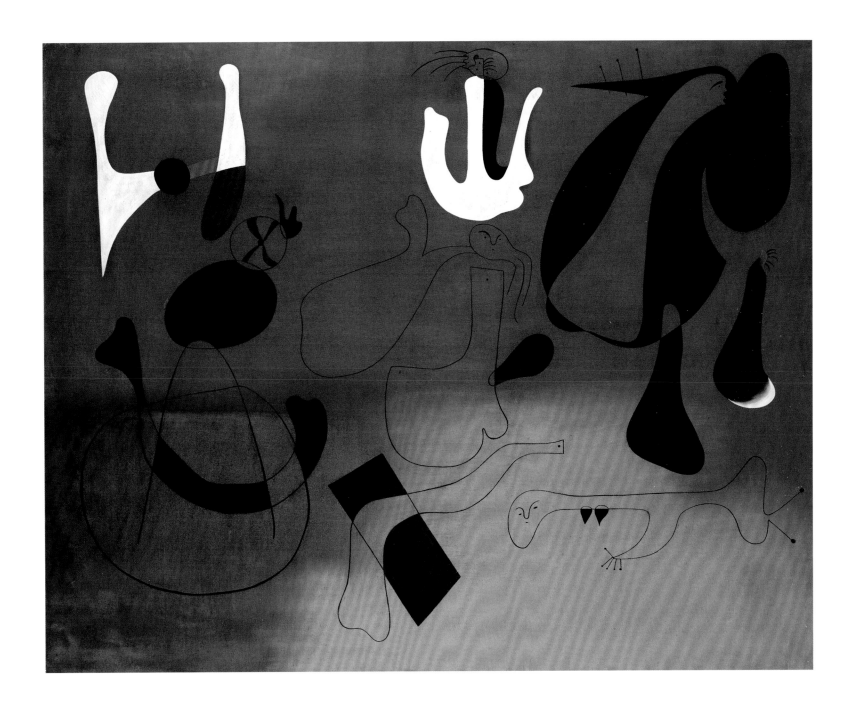

38
Preparatory collage for
Peinture (*Painting*) 1933
Graphite pencil and
collage on paper
47.1 × 63.1
Fundació Joan Miró, Barcelona

39
Peinture 1933
Painting
Oil on canvas
130 × 162
Wadsworth Atheneum,
Hartford

In the following year, with economic pressures and conservative resistance to radical reform, a new government was elected, made up of the centrist Radical Republican Party under Alejandro Lerroux and the coalition group CEDA (Confederación Española de Derechas Autonomas) led by José Maria Gil Robles. The appointment of quasi-Fascist ministers from CEDA led to public protests. On 5 October 1934, the miners of Asturias in northern Spain, radicalised by Anarcho-Syndicalists, went on strike and occupied Oviedo, but a parallel rising in Madrid, led by the socialist Francisco Largo Caballero, failed. The following day a General Strike brought Barcelona to a standstill and saw, that evening, Lluís Companys's declaration of a Catalan Republic within the Spanish Federal Republic. It is believed that Companys himself, as President of the Generalitat and leader of the Esquerra Republicana de Cataluña (ERC, the Republican Left of Catalonia), recognised the precarious nature of this move. The army garrison in the city was duly mobilised, political activities and press freedom were severely curtailed, Catalan autonomy suspended and Companys imprisoned. The Asturian miners resisted until 19 October against the combined forces of Regulars (volunteer units from Morocco) and Foreign Legion troops, notorious for their savagery, that were mobilised for the first time on the Iberian Peninsula under orders from Generals Manuel Goded and Francisco Franco.

Although Masson was in Barcelona in October 1934, Miró was at Mont-roig. At the beginning of the month he had planned to be in the city for Dalí's exhibition and then travel on to Zurich;[14] but by 12 October what he called the 'sad events' had prevented him from leaving his family.[15] Even from the countryside he was aware of the army's bombardment of the Generalitat, and the wider conditions of suppressed insurrection. The tensions of this moment appear to be captured in his group of large, extraordinarily coloured pastels on paper (nos.41–6). On 12 October he told Pierre Matisse about these new works: 'I will give them titles, since they are based on reality'.[16] The fact that he inscribed almost all of them 'Octobre 1934', and ensured that this was specified in the caption when one was published in Barcelona two months later, confirms that this 'reality' encompassed the turbulent events on the streets.[17] While they may at first appear child-like in their exaggerated physiognomy, these are violent bodies (one, no.42, takes the form of a gun-stock) as well as being highly sexualised, demonstrably phallic and vaginal. They have the swollen heads of protestors and victims; Miró called them his 'savage paintings'.[18]

Under Lerroux's coalition there was an increasing movement to the right in the central Spanish and local Catalan administrations. The curtailment of basic liberties and the violence on the streets led to the period being dubbed the 'bienio negro' ('the black biennium'). However, the institution of the Republic was sufficiently strong for Lerroux to be forced to resign in a corruption scandal that further destabilised the right-wing government. The new administration quickly collapsed and a general election was called for 16 February 1936. In the run-up, Manuel Azaña instigated the formation of the Frente Popular (Popular Front), an electoral coalition of left-wing parties and political organisations which stood against a right-wing alliance, the Frente Nacional Contrarrevolucionario (Counter-revolutionary National Front), and a centrist bloc. With a slim majority, the Popular Front obtained sixty per cent of the seats in the Cortes and Azaña became leader of the new government; in May he was elected President. Part of the appeal of the Popular Front was the promise of an amnesty for those imprisoned in

40
**Flama en l'espai i
dona nua** 1932
Flame in Space and Nude
Oil on wood
41 × 32
Fundació Joan Miró,
Barcelona.
Gift of Joan Prats

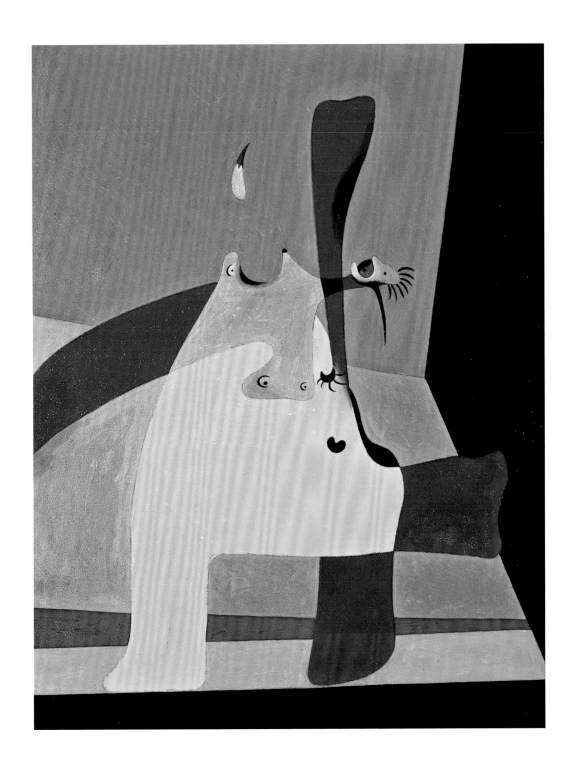

**Flama en l'espai i
dona nua** 1932
Flame in Space and Nude
Oil on wood
41 × 32

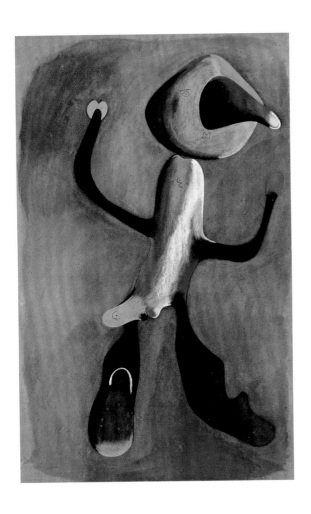

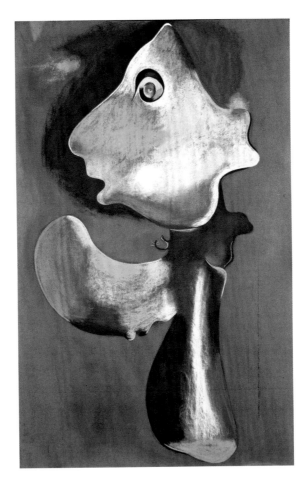

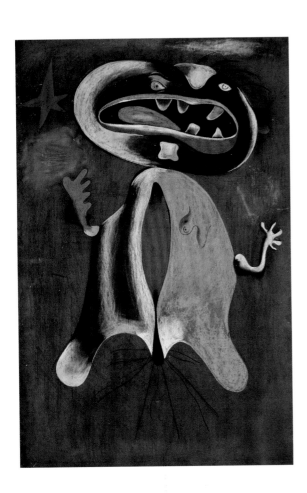

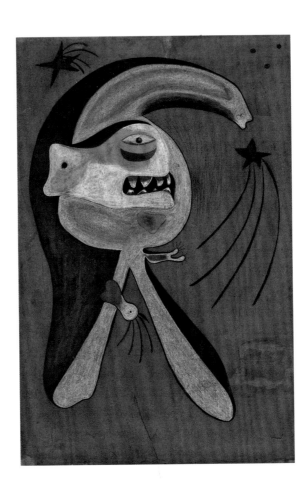

41
Personnage 1934
Figure
Pastel on velours paper
106.3 × 70.5
Centre Pompidou, Paris
Musée national d'art
moderne / Centre de
création industrielle

42
Personnage 1934
Figure
Pastel on velours paper
107 × 72
Private collection

43
Femme 1934
Woman
Pastel, charcoal and
graphite with smudging
and scraping, on tan wove
paper, mounted along
edges on a wood stretcher
107.1 × 71.4
Art Institute of Chicago.
Lindy and Edwin Bergman
Collection

44
Personnage 1934
Figure
Charcoal, pastel and pencil
on velours paper
107 × 72
Collection of Emilio
Fernández. On loan to
the Fundació Joan Miró,
Barcelona

45
Femme 1934
Woman
Pastel on velours paper
107.9 × 71.1
Frederick R. Weisman Art
Foundation, Los Angeles

46
Personnage 1934
Figure
Pastel on velours paper,
mounted on canvas
108 × 72.8
Musée des Beaux-Arts de
Lyon. Bequest of J. Delubac

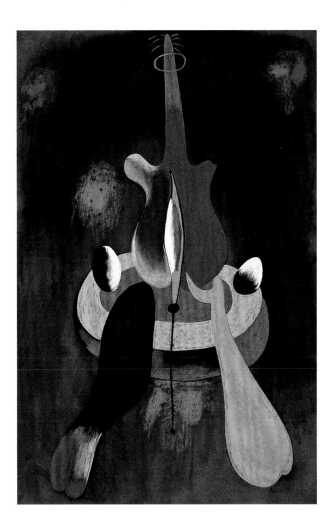

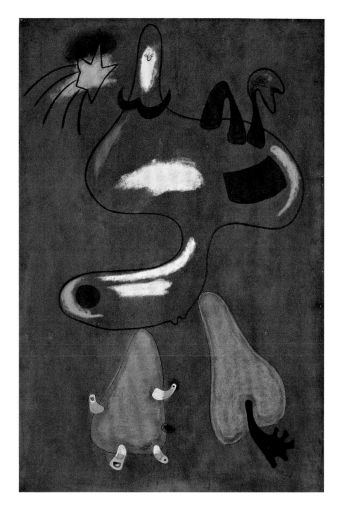

1934, which ensured the support of some anarchists. The reinstatement of previously devised liberties followed: in Catalonia this resulted in the re-election of the released Companys as President of the Generalitat on 29 March. This renewed impetus towards radical reform exasperated and, in turn, radicalised the Right. With violent attacks and counter-attacks by Falangists (led by Primo de Rivera's son José Antonio) and leftists alike, the political situation spiralled inexorably out of control. The assassination of right-wing politician José Calvo Sotelo on 13 July proved to be the catalyst. Anti-Republican military forces under Franco's leadership rose up on 17 July 1936, marking the start of the Civil War.

Witnessing these events at close quarters, Miró found the means to express the bleak outlook of the *bienio negro* in the acidic colouring of the twelve copper and masonite paintings of the end of 1935 and the beginning of 1936.[19] While shifting between the contrasting supports (copper resulting in a glossy finish and masonite given to matt), they share an atmosphere of confusion. Where he had previously imagined peasants in harmony with their surroundings, etiolated personages confront blasted landscapes under threatening

skies. By inscribing the dates of their creation on the back, Miró lent the series a diaristic structure. He also gave them narrative titles that confirm the abiding sense of disjuncture: *Figures devant un volcan* (*Figures in Front of a Volcano*, 9–14 October 1935, no.48) was followed by *Homme et femme devant un tas d'excrements* (*Man and Woman in Front of a Pile of Excrement*, 15–22 October, see no.4). Although indicating natural phenomena, the belching volcano and rearing excrement evoke an ominous disharmony. The seemingly calmer *Nocturne*, made between 9 and 16 November, features puny (though sexually charged) personages and a hole in the ground that suggests an opening in reality itself (no.49).[20] Though grandly identified, the ironically titled *Les Deux Philosophes* (*The Two Philosophers*), painted during the last days of the election campaign early in 1936 (4–12 February), appear no better equipped to understand this wasteland than the figures in previous works (no.50).

Quite how this diary of imagery reflected Miró's response to his times is impossible to gauge with certainty, but it is telling that Jacques Dupin has called these works 'the most precise expression of the artist's inner world invaded by

47
Le Repas des fermiers
3 March 1935
The Farmers' Meal
Oil on cardboard
73 × 104
Private collection

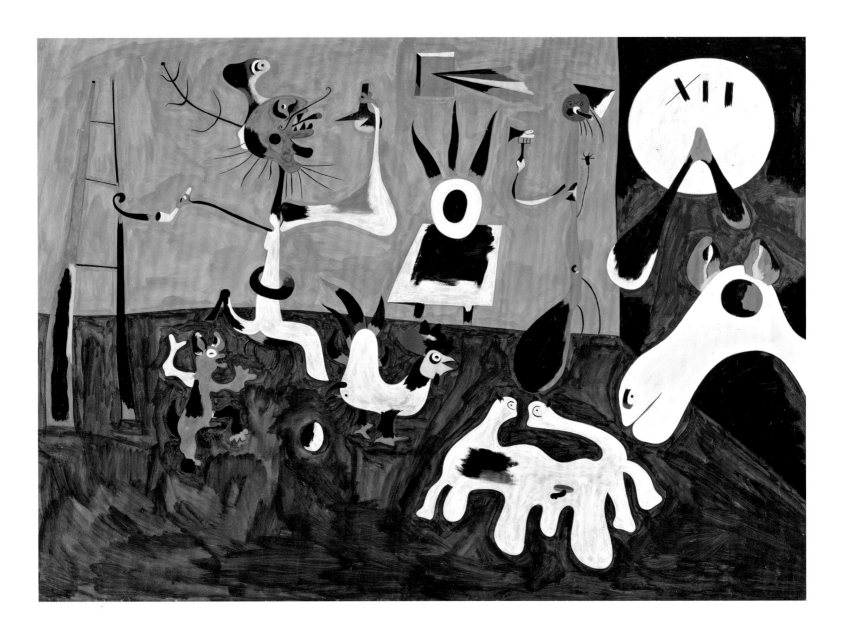

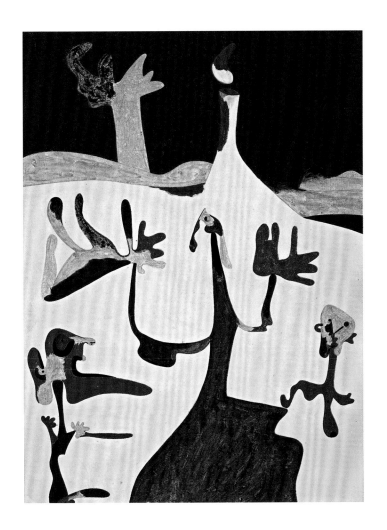

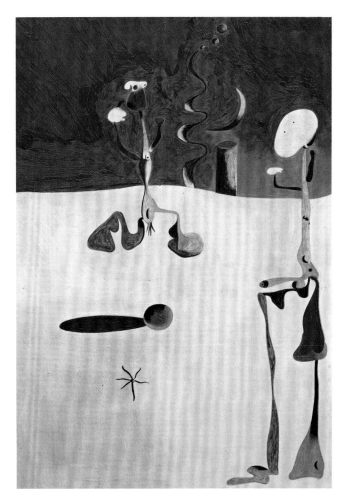

48
**Figures devant
un volcan** 1935
*Figures in Front of
a Volcano*
Tempera on masonite
40 × 30
Private collection

49
Nocturne 9–16 November 1935
Nocturne
Oil on copper
42 × 29.2
The Cleveland Museum of Art.
Mr and Mrs William H.
Marlatt Fund

demons and monsters'.[21] One key seems to lie in the title of a painting made just before *The Two Philosophers*, called *Figures devant une métamorphose* (*Figures in the Presence of a Metamorphosis*, 20–31 January 1936). To the left of the quizzical figures nature appears to be reinventing itself, though the result remains unnamed. Significantly, after painting a congregation of six *Personnages assis* (*Seated Personages*, 10–21 March, no.51) Miró used the term 'metamorphosis' again for a sequence of collages with drawing that interrupted his output of paintings during the fortnight 23 March to 4 April 1936 (nos.52–6).[22] Not surprisingly for Miró, the collages are of a completely different form to the paintings, but seem to be linked to them in the unexpected juxtapositions generated by the newspaper images and stencils superimposed on large-scale heads. The newspapers used in these collages were from the previous autumn, and some feature single mug shots that suggest criminals or victims marginalised in the *bienio negro*.

On returning to the copper and masonite paintings, Miró brought the figures closer-to and placed them within more modulated, though still lunar, landscapes. That their world is profoundly out of kilter is confirmed in the return of the favoured figure in *Paysan catalan au repos* of 17–25 April 1936 (*Catalan Peasant Resting*). Far from the farmer or hunter painted a decade earlier, the peasant squats before his ponderous horse and under a blackening sky; whether he is exhausted by defeat or victory is not clear. The portentous series concludes with *Deux personnages amoureaux d'une femme* (*Two Personages in Love with a Woman*, 29 April – 9 May, no.57) and *Personnages et montagnes* (*Personages and Mountains*, 11–22 May, no.58). In the former, diminutive males continue to pay obeisance to spindly females while the heavy-headed figures of the latter, garishly coloured in red and yellow, recall those of the pastels of 1934. Just as in that earlier sequence, the bodily distortions of these paintings distantly recall the example of Francisco de Goya's reflections of the state of Spain.[23]

50
Les Deux Philosophes
4–12 February 1936
The Two Philosophers
Oil on copper
35.6 × 49.8
Art Institute of Chicago.
Gift of Mary and Leigh Block

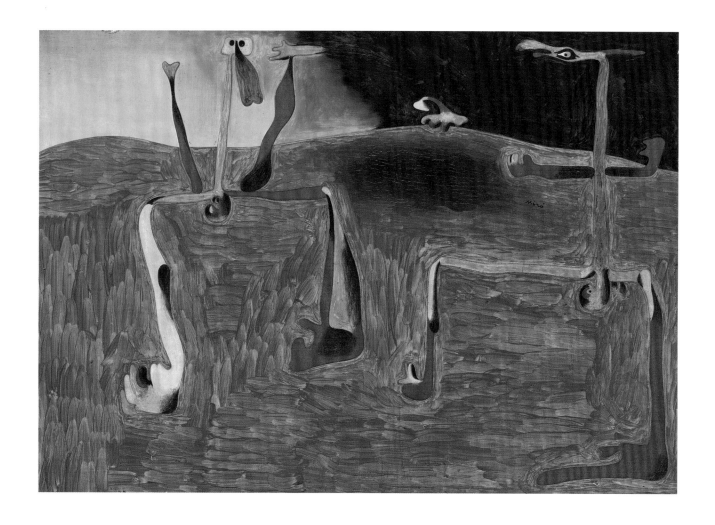

51
Personnages assis
10–21 March 1936
Seated Personages
Oil on copper
44.1 × 34.9
Private collection

After attending the International Surrealist Exhibition in London in June, Miró returned to Mont-roig and took up sheets of masonite, the same humble support used for *Personages and Mountains*, for twenty-seven works made between mid-July and mid-October 1936.[24] These are paintings of great material and physical presence (nos.59–62). While the acidic colours continue, they are controlled by the brown of the composite panel and the dominance of black and white.[25] The assembly of signs is no longer presented as narrative – each work is simply entitled *Peinture* (*Painting*) – and their materiality emphasises their rudimentary construction: the masonite panel is matched by white paint trowelled on like plaster and tar-like blacks laden with sand. These encrustations balance other traces of actions – smears, pittings, punctures and drips – that bear witness to a physical handling of the work that is far more strenuous than the still

elegant linear interventions would suggest. The result is rather like the controlled violence of a boxing match or the evidence of a struggle. Miró wrote of the masonite paintings a little later: 'it is clear that I had reached a very dangerous impasse, from which I could see no escape'.[26]

Of course it was the struggle for Spain itself to which these paintings seem to relate. Miró began them just days before the military uprising spread to the Peninsula on 18 July 1936, and for which Franco had garnered immediate support from Mussolini and Hitler.[27] Miró continued the twenty-seven paintings across the first fourteen weeks of the war, which encompassed the Soviet Union's delayed support of the Republic in September.[28] The intervening months had seen the rebellion trigger a brutal revolution among the supporters of the Republic. In Barcelona, churches were burned and factional militias – especially anarchist and communist –

52
Métamorphose
23 March – 4 April 1936
Metamorphosis
Pencil, watercolour,
India ink and collage of
newspaper on paper
48 × 64
Collection of the
Pierre and Tana Matisse
Foundation, New York

53
Métamorphose
23 March – 4 April 1936
Metamorphosis
India ink, watercolour,
pencil, decal and collage of
newspaper on paper
48 × 64
Collection of Richard and
Mary L. Gray and the
Gray Collection Trust

54
Métamorphose
23 March – 4 April 1936
Metamorphosis
Pencil, India ink, collage of
newspaper and decal on
paper
63.5 × 47
Private collection. Courtesy
Galerie Zlotowski, Paris

55
Métamorphose
23 March – 4 April 1936
Metamorphosis
Pencil, watercolour, collage,
decal and stencil on paper
64 × 48
Collection of the
Pierre and Tana Matisse
Foundation, New York

56
Métamorphose
23 March – 4 April 1936
Metamorphosis
Pencil, India ink,
watercolour, collage of
newspaper, decal
and stencil on paper
59 × 47.8
Courtesy Galerie
Gmurzynska, Zurich

enacted an assault upon the establishment that was both liberating and terrifying. These opening weeks of revolutionary fervour unsettled the middle classes, generated the stories of anti-clerical atrocities that filled the conservative press abroad, and bolstered support for the rebellious Generals. It necessitated such fact-finding trips as the mission undertaken by Miró's friends Christian and Yvonne Zervos and Roland Penrose, under the guidance of Prats, to verify the care and respect that the Republic showed towards cultural artefacts.[29]

While it is possible to read Miró's physical assault on the masonite boards as indicative of the anguish with which he faced the war, his explicit statements are full of characteristically anodyne reports of well-being at Mont-roig. In early August he told Matisse: 'despite the current events, my work has followed an almost regular rhythm.'[30] Both 'despite' and 'almost' might

be significant here,[31] as Miró was working furiously to produce an average of two masonites a week. One of the earliest of these (no.59) is also one of the most energetic, with its blue arc plastered over heavy white amid a seething assembly of forms. A similar dispersal of the composition is controlled by the spatial line that is found in a work from the middle of the sequence (no.60).[32] Although more encrusted with material, the later works (nos.61–2) are increasingly controlled and may suggest that Miró had overcome the initial shock of events.[33] Once the masonites were complete, he went to Paris to show them for a single day (13 November 1936). They were celebrated there, as he told Prats, 'with Sardana dances in honour of Spain and Catalonia' before being sent on to New York.[34] The moment of celebration is significant for its reference to popular tradition in the midst of turmoil. Miró would not return to Spain until 1940.

People were, of course, heading in the opposite direction. Gomez, the fictional Spanish painter in Jean-Paul Sartre's *Roads to Freedom*, felt compelled to leave for Spain after he 'had read of the fall of Irun, in *Paris Soir* … then he went out, bare-headed and without an overcoat, as though he were going to buy cigarettes at the Dôme: he had not returned'.[35] In Britain, 127 of the 149 responses gathered by Nancy Cunard in *Authors Take Sides on the Spanish Civil War*, 1937, supported the Republic.[36] Many joined the International Brigades.

Miró would also have returned, were it not for his family.[37] Instead, after painting *Nature morte au vieux soulier* (*Still-Life with Old Shoe*, see no.73) between 24 January and 29 May 1937,[38] he placed his art at the service of the Republic. He made *Le Faucheur* (*The Reaper*, see pp.118–21), painting directly on the celotex panels of the six-and-a-half-metre-high stairwell around which the visit to the Spanish Republican Pavilion revolved. As Miró wrote 40 years later:

> I participated in the Spanish Pavilion of the Paris exhibition of 1937 because I wanted to show my human solidarity with what it represented … I presented the great panel "Catalan Peasant in Revolt", which I painted on a scaffolding directly in the very space of the building. I first made a few light sketches to know vaguely what I needed to do but … the execution of this work was direct and brutal.[39]

In contrast to the deflated *Catalan Peasant Resting* of 1936, *The Reaper* extended the motif of the militant peasant that the visitor would already have encountered in the sickle-bearing female figure of Julio González's *Montserrat*, which guarded the entrance to the Republican Pavilion (see no.75). Both artists used references to the land and the peasant as a way of rooting political statements in popular symbolism.

The figure of *Montserrat* made reference to the eponymous mountain range in Catalonia, with its powerful symbolic connotations, just as Miró's mural appealed to the Catalan Reapers' Revolt of 1640. Where González's *Montserrat* held a sickle in one hand and in the other an infant, clutched against her chest like a shield in a gesture that is simultaneously protective and defiant, Miró's *Reaper* was boldly energetic. In an interview in New York at the height of the Cold War, Miró commented:

> Of course I intended it as a protest. The Catalan peasant is a symbol of the strong, the independent, the resistant. The sickle is not a communist symbol. It is the reaper's symbol, the tool of his work, and, when his freedom is threatened, his weapon.[40]

On the staircase leading to the mural, the visitor was greeted with a quotation from *Don Quixote*: 'One should risk one's life for liberty.'[41] One reason for citing Cervantes may have been to evoke Miguel de Unamuno's recent defiance of Franco's severely war-wounded general, Millan Astray. At the Nationalists' celebration of the Festival of the Hispanic Race on 12 October 1936, Astray had exhorted the audience with his battle cry 'Viva la muerte!' ('Long live death!'). Unamuno, revered Rector of the University of Salamanca, responded by comparing Astray to Cervantes (also famously wounded): 'A cripple who lacks the spiritual greatness of Cervantes … is wont to seek ominous relief in seeing mutilation around him … for that reason he wishes to see Spain crippled, as he unwittingly made clear.'[42] The philosopher died at the end of 1936 but perhaps his rebuttal of Francoism was evoked in *The Reaper*.

Certainly defiance and mutilation were powerful ingredients in what might be called the 'Spanish Pavilion style' created in

57
**Deux personnages
amoureux d'une femme**
1936
*Two Personages in Love
with a Woman*
Oil on copper
26 × 35
Art Institute of Chicago.
Gift of Mary and Leigh Block

58
**Personnages et
montagnes** 11–22 May 1936
Personages and Mountains
Tempera on masonite
30 × 26
Private collection

The Reaper and Picasso's Guernica. Miró was among the many artists drawn to Picasso's painting, though The Reaper was too close, both in time and space, to show its impact.[43] During the period in which both huge works existed side by side, their modernist language must have been astonishing. Visiting the Pavilion, the painter Amédée Ozenfant wrote simply: 'Our present period is great, dramatic, dangerous. Guernica is worthy of it.'[44] Another visitor, the collector Peter Watson, saw The Reaper as Miró 'protesting with all the weapons at his command'.[45] While the American painter G.L.K. Morris feared for the demands of the impersonal that the mural placed on Miró: 'an area so vast must have been a trial to one whose poise and style were still on the verge of rising from such recent ruins'.[46]

The legacy of this style is evident in the graphic immediacy of Miró's Untitled [Head of a Man] made in December 1937 (see no.143), as much as in the powerful acidity of Picasso's contemporary Weeping Woman 1937. Miró may have heeded the assessment of the writer Carl Einstein, who in May 1938 acknowledged his talent but expressed concern that 'the dream is too limited … in the face of the violence of current events'.[47] Among the works of 1938–9 are some of Miró's most urgent, vulnerable and desperate images. Though occasionally armed, his personages are more often victims of unseen attackers – as in Femme fuyant l'incendie (Woman Fleeing from a Fire, see no.86) and Femme en révolte (Woman in Revolt, see no.88) – or their struggle is matched by complex poetic titles. Thus Femme poignardée par le soleil récitant de poèmes fusées en formes géometriques du vol musical chauve-souris crachat de la mer (Woman Stabbed by the Sun Reciting Rocket Poems in the Geometrical Shapes of the Musical Bat Spittle Flight of the Sea, no.68) and the great canvas alarmingly entitled Jeune fille moitié brune moitié rousse glissant sur le sang des jacinthes d'un camp de football en flammes (Young Girl with Half Brown Half Red Hair Slipping on the Blood of Frozen Hyacinths of a Burning Football Field, see no.92) make allusions that generate a wider atmosphere of threat.

Miró made the last three of these works, together with the monumental Femme assise II (Seated Woman II, no.67), between February and April 1939, as he observed the final moments of the Civil War from France. The fall of Barcelona on 26 January had triggered an exodus of Republicans into France, with half a million people crossing by 10 February.[48] The fall of Madrid on 28 March brought Franco international recognition as leader of the legitimate government. In July, as the wider conflict in Europe loomed large, Miró also made a sequence of canvases that he called Le Vol de l'oiseau sur la plaine (The Flight of a Bird over the Plain, nos.65–6), which seemed to return to lyricism but for the fact that the birds in their darkened skies allude to the bombers that had devastated Guernica, Barcelona and Madrid. Faced with these insurmountable events, it was all he could do to continue to paint; yet even in these circumstances some works stand out as signs of desperation and of hope. Among the canvases that he made in 1939–40 was a small composition in which a figure gesticulated wildly. The hand is finely drawn against the open ground, but this is the only detail that survived a much later revision of the canvas: in 1974, after thirty-five years of the dictatorship, Miró returned to the canvas and overpainted the figure with a huge black head with a single, cyclopic red eye (see no.10) that challenges the viewer to look hard at the impenetrable blackness. The hand, still gesturing, survives from the last throes of the Republic; the black head all but obliterates it, as if standing for the long years of darkness.

59
Peinture 1936
Painting
Oil, casein, tar and sand
on masonite
78 × 108
Collection Nahmad,
Switzerland

60
Peinture 1936
Painting
Oil, casein, tar and sand
on masonite
78 × 108
Collection Nahmad,
Switzerland

61
Peinture 1936
Painting
Oil, casein, tar and sand
on masonite
78 × 108
Collection Nahmad,
Switzerland

62
Peinture 1936
Painting
Oil, casein, tar and sand
on masonite
78 × 108
Collection Nahmad,
Switzerland

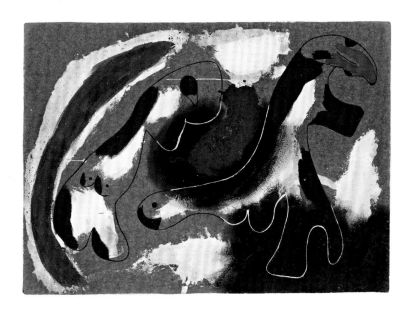

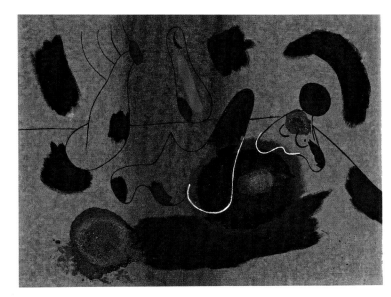

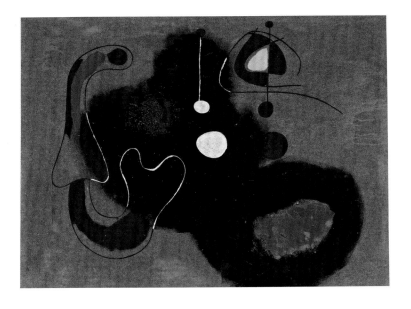

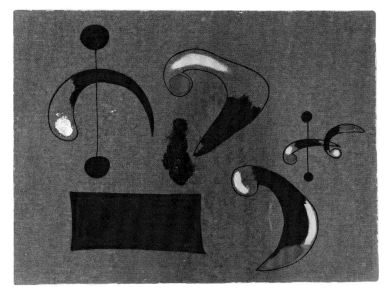

1 For standard accounts of the Spanish Civil War, for which much remains contentious, see Hugh Thomas, *The Spanish Civil War*, London 1961, 2001; Paul Preston, *The Coming of the Spanish Civil War: Reform, Reaction and Revolution in the Second Republic*, London 1978; Anthony Beevor, *The Spanish Civil War*, London 1982, 2001; and Paul Preston and Julián Casanova, *La Guerra civil española*, Madrid 2008.

2 Péret to André Breton, 11 Aug. [1936], in Claude Courtot, *Introduction à la lecture de Benjamin Péret*, Paris 1965, trans. and ed. in Rachel Stella, *Death to the Pigs: Selected Writings of Benjamin Péret*, London 1988, p.182.

3 See Marko Daniel, 'Masson in Spain', in *André Masson: The 1930s*, exh. cat., Salvador Dalí Museum, St Petersburg, Florida 1999, pp.25–36.

4 Social Realism, favoured by Stalin, was debated in the 'Querelle du réalisme' of 1936; Miró dismissed the position in his late interview with Georges Raillard. See Robert Lubar's text in this volume.

5 Miró (Paris) to Pierre Matisse, 12 Jan. 1937, in Rowell 1986, p.146. Pilar and Dolores arrived on 16 Dec. 1936, according to Miró (Paris) to Pierre Matisse, 18 Dec. 1936, ibid., p.133.

6 Forty years later, Miró told Raillard that, as his sister had married 'an imbecile on the extreme right', he had left under threat of being arrested by the Federación Anarquista Iberica (Raillard 1977, p.112). He did not mention that his brother-in-law was murdered; quite apart from the horror of this event, the family was consequently vulnerable.

7 Georges, Duthuit, 'Où allez-vous, Miró?', *Cahiers d'Art*, no.8–10, 1936 [published 1937], in Rowell 1986 p.153.

8 Ibid., p.154.

9 Though the use of the Catalan language had been subject to many instances of legal repression since the Nueva Planta decrees (1700–1716), the dictatorship of Primo de Rivera saw, among other things, Spanish introduced as the only language of official discourse and of instruction in schools; see Francesc Ferrer i Gironès, *La Persecució política de la llengua catalana: història de les measures preses contra el seu ús des se la Nova Planta fins avui*, Barcelona 1985. That these repressions were not strictly enforced is evident, for instance, from the publication in Catalan of the so-called *Manifest Groc* (actually the *Manifest Antiartístic Català*) by Dalí, Sebastià Gasch and Lluís Montanyà in March 1928. See Minguet 2004, pp.156–8, for Gasch's report on getting it passed by the local government censors.

10 His father had died in 1926, leaving Miró responsible for his mother and sister. He and Pilar Juncosa married in 1929; their daughter Dolores was born the following year.

11 For ADLAN see Maria Lluïsa Borràs, *Record de Joan Prats*, exh. cat., Fundació Joan Miró, Barcelona 1995, pp.14–17, and Minguet 2000, pp.40–3, as well as recent discussions by Jordana Mendelson ('Against Logic: The Exposició Logicofobista in Catalonia') and William Jeffett ('Joan Miró and ADLAN'), in Robinson, Falgàs and Lord 2006, pp.361–8, 369–74.

12 The statement was recorded for broadcast on 13 Jan. 1936, though it had been prepared before Christmas as Miró (Barcelona) to Christian Zervos, 19 Dec. 1935. See Christian Derouet, 'Miró à Zervos, une correspondance promotionelle', in Derouet, *Cahiers d'Art: Musée Zervos à Vézèlay*, Paris 2006, p.110, which carries the text for publication in *Cahiers d'Art*, no.7–10, 1935, p.242.

13 See Fanès 2007, pp.209–14; Anne Umland, 'Paintings Based on Collages', in Umland 2008, pp.116–21.

14 Miró (Mont-roig) to Joan Prats, 29 Sept. 1934 (referring to Dalí's exhibition at Galeries d'Art Catalonia, 2–4 Oct.) and 3 Oct. 1934 (referring to his contribution to *Abstrake Malerei und Plastik*, Kunsthaus Zurich, 11 Oct. – 4 Nov. 1934), in Minguet, Montaner and Santanach 2009, pp.534–6. For Dalí's flight to Paris and New York, see Matthew Gale, 'Les Mystères surréalistes de New York', in *Dalí & Film*, exh. cat., Tate Modern, London 2007, pp.132–9.

15 Miró (Mont-roig) to Joan Prats, 12 Oct. 1934, in Minguet, Montaner and Santanach 2009, p.537.

16 Miró (Mont-roig) to Pierre Matisse, 12 Oct. 1934, in Rowell 1986, p.124.

17 For a detailed discussion see Anne Umland, 'Pastels on Flocked Paper', in Umland 2008, pp.150–5. The publication of *The Man with a Pipe* in *D'Aci i d'Allà* in December is discussed by Greeley 2006, p.34. This was the same issue that carried Magí Cassanyes's 'Dalí', which acknowledged the latter's fascination with Hitler (the subject of his 'trial' by the Surrealists on 5 Feb. 1934); see Greeley, 'Dalí's Fascism; Lacan's Paranoia', *Art History*, vol.24, no.4, Sept. 2001, pp.465–92.

18 Although 'savage' is linked to different series, the identification with the pastels was suggested by Jacques Dupin 2004, p.186.

19 For the indications of them being anticipated in 1934, see Robert S. Lubar, 'Small Paintings on Masonite and Copper', in Umland 2008, pp.182–7.

20 The effect (while echoing the top of the distant tower) is comparable to that of the dark planting hole around the tree in *The Farm*. Lubar (Umland 2008, p.184) offers an alternative reading of the ellipse as the shadow of the ball. The sequence is broken at this point by a trip known by cards Miró sent to Picasso and to Prats from Prague (30 Nov. 1935) and to Cassanyes and Prats from Berlin (6 and 7 Dec.), in Minguet, Montaner and Santanach 2009, pp.558–61.

21 Dupin 1992, p.199.

22 Dupin 1992, p.202, identifies metamorphosis as the abiding theme of the paintings. This was also the moment of the sculpture *Object of Sunset*, 20 March 1936 (no.122); see Kerryn Greenberg's text in the volume.

23 Goya's imagery was used by all sides in the Second Republic and the Civil War; for a recent discussion, see Miriam Basilio, '"Goya Saw This, We See This": Goya in the Spanish Civil War', in Jordana Mendelson (ed.), *Magazines, Modernity and War*, Madrid 2008, pp.99–115.

24 The London exhibition opened on 11 June; he sent a card to Prats the next

63
[Figures] 1936
Gouache and India ink on paper
41.3 × 32.1
Collection Nahmad, Switzerland

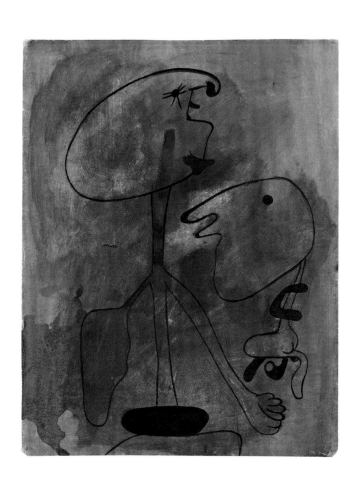

THE TIPPING POINT: 1934–9

64

Tête 2 October 1937
Head
Oil, collage and towel
on celotex
121.8 × 91.4
Fundació Joan Miró,
Barcelona

day (Minguet, Montaner and Santanach 2009, p.563).

25 Robert S. Lubar ('Paintings on Masonite', in Umland 2008, p.200) notes that the painter was probably already referring to this series in Miró (Barcelona) to Pierre Matisse, 28 April 1936, trans. Lanchner 1993, p.66. Each composition was laid down in preparatory drawings in Miró's sketchbook, to which Teresa Montaner has been able to link all but one of the paintings.

26 Miró, notes, 1941, FJM 4415b, trans. in *Joan Miró* 1993, p.339.

27 Lubar (in Umland 2008, p.200, n.3) lays out the evidence for timing, beginning with a letter to Pierre Loeb (13 July 1936, unpublished) when the paintings may have been under way. It is worth noting that this was the day of Calvo Sotelo's assassination.

28 Stalin's letter to Largo Caballero (21 Sept. 1936) indicated his backing for the Republic under restricted terms; see Gerald Brenan, *The Spanish Labyrinth*, London [1943] 1960, p.324. Lubar (in Umland 2008, p.200, n.3) notes that the projected completion date was 15 Oct. 1936, see Miró (Barcelona) to Pierre Matisse, 28 Sept. 1936, in Rowell 1986, p.125.

29 The Zervoses and Penrose visited in October 1936 (see Christian Zervos and Roland Penrose, 'Art and the Present Crisis in Catalonia', in *Catalan Art from the Ninth to the Fifteenth Century*, London 1937, pp.28–36). The following year, after an exchange of letters in *The Times* towards the end of July questioning the conditions of artworks

in Spain, the Spanish ambassador to London formally invited Sir Frederick Kenyon, former Director of the British Museum, and James G. Mann, hispanist and Keeper of the Wallace Collection, to visit Republican Spain. Their report, combining scholarly authority with mass appeal, subsequently appeared not just in *The Times* (3 Sept. 1937) but also in the journal of the Office Internationale des Musées under the title 'La Protection du patrimoine artistique en Espagne' (*Mouseïon*, no.37–8, 1937, pp.183–192). See also Isabel Argerich and Judith Ara (eds.), *Arte protegido. Memoria de la Junta del Tesoro Artístico durante la Guerra Civil*, Instituto del Patrimonio Cultural de España 2009. For Prats's role see Maria Lluïsa Borràs, *Record de Joan Prats*, exh. cat., Fundació Joan Miró, Barcelona 1995, pp.17–18.

30 Miró (Mont-roig) to Pierre Matisse, 9 Aug. 1936, trans. in Umland 1993, p.322.

31 Lubar (Umland 2008, p.200) emphasises 'despite'.

32 Lubar (ibid., p.200, n.13) lists the sequence established by Montaner from the numbered drawings; these are nos.5 and 12 (CR 540, 553).

33 Ibid. These are nos.15 and 17 (CR 544, 546).

34 See Miró (Paris) to Prats, 13 Nov. 1936, in Minguet, Montaner and Santanach 2009, p.566.

35 Jean-Paul Sartre, *L'Age de la raison*, [1945], trans. Eric Sutton as *The Age of Reason*, London 1947, Harmondsworth 1961, p.40.

36 'Authors Takes Sides on the Spanish Civil War', 1937, published by *The Left Review*;

see Valentine Cunningham, *British Writers of the Thirties*, Oxford 1989, pp.28–9. For Cunard's role see Anne Chisholm, *Nancy Cunard*, Harmondsworth 1981, pp.316–20.

37 Miró (Paris) to Pierre Matisse, 12 Jan. 1937, in Rowell 1986, p.146.

38 See Robert S. Lubar, 'Still Life with Old Shoe', in Umland 2008, p.231 n.23, and his earlier Lubar 2003. See also Teresa Montaner's text in the present volume.

39 For *The Reaper* and *Aidez l'Espagne*, see Teresa Montaner's text and the Introduction in this volume. Miró (Paris) to Prats, 19 May 1937 (Minguet, Montaner and Santanach 2009, p.574) announces that he will begin the mural in a few days; the Pavilion opened on 12 July. Fernando Martín Martín, *El pabellón español en la Exposición Universal de Paris en 1937*, Seville 1982, p.117.

40 Aline B. Saarinen, 'A Talk with Miró about his Art', *New York Times*, Section 2, 24 May 1959, p.17.

41 Noted in Marko Daniel, 'Spain: Culture at War', in *Art and Power: Europe under the Dictators 1930–45*, exh. cat., Hayward Gallery, London 1995, p.66. This juxtaposition was almost certainly the work of Josep Renau, who masterminded the Pavilion's scheme.

42 Luis Portillo, 'Unamuno's Last Lecture', in *Horizon*, vol.4, no.24, Dec. 1941, pp.394–400.

43 For his visit to Picasso's studio while *Guernica* was under way, see Teresa Montaner's text in this volume. Robin Adèle Greeley (2006, pp.39–45) explores the notion that Miró's assassination of

painting's 'bourgeois humanist heritage' was manifest in *The Reaper*.

44 Amédée Ozenfant, 'Notes d'une touriste à l'Exposition', *Cahiers d'Art*, vol.12, 1937, pp.242–3, trans. John Willett in *Art and Power* 1995, p.118.

45 Peter Watson, 'Joan Miró', in *Horizon*, vol.4, no.20, Aug. 1941, pp.131–3.

46 G.L.K. Morris, 'Miró and the Spanish Civil War', in *Partisan Review*, no.4, Feb. 1938, pp.32–3, republished in Rose 1982, p.121.

47 Sebastià Gasch, 'Unes declaracions sensacionals de Carl Einstein. Miró i Dalí. L'art revolucionari. El rol dels intellectuals', *Mérida*, 6 May 1938, p.4, trans. to Spanish in Uwe Fleckner, *Carl Einstein: La Columna Durruti y otros articulos y entrevistas de la Guerra Civil Española*, Barcelona 2006, p.29. Einstein was fighting in Spain for much of the war; he knew Miró through the circle of *Documents*.

48 Nancy Cunard reported for *The Guardian* from the border and on the terrible conditions of the refugee camps, see Chisholm 1981, pp.331–6. Optimistically, or perhaps simply naively, Miró had recently expressed the view that it would end with the 'annihilation of the Fascist monster', in Miró to Pierre Matisse, 2 Jan. 1939, in Dupin, Lelong-Mainaud and Punyet Miró 2007 [np].

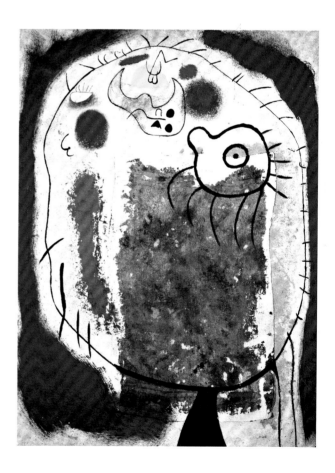

65
**Le Vol de l'oiseau sur
la plaine II** July 1939
*Flight of a Bird over
the Plain II*
Oil on canvas
81 × 100
Collection Nahmad,
Switzerland

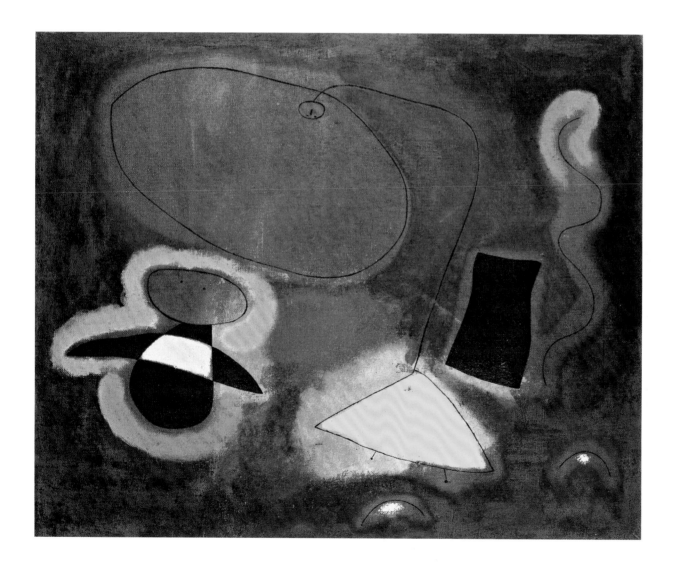

66
**Le Vol de l'oiseau sur
la plaine III** 1939
*Flight of a Bird over
the Plain III*
Oil on canvas
89 × 116
The Solomon R. Guggenheim
Museum, New York.
Gift of Evelyn Sharp, 1977

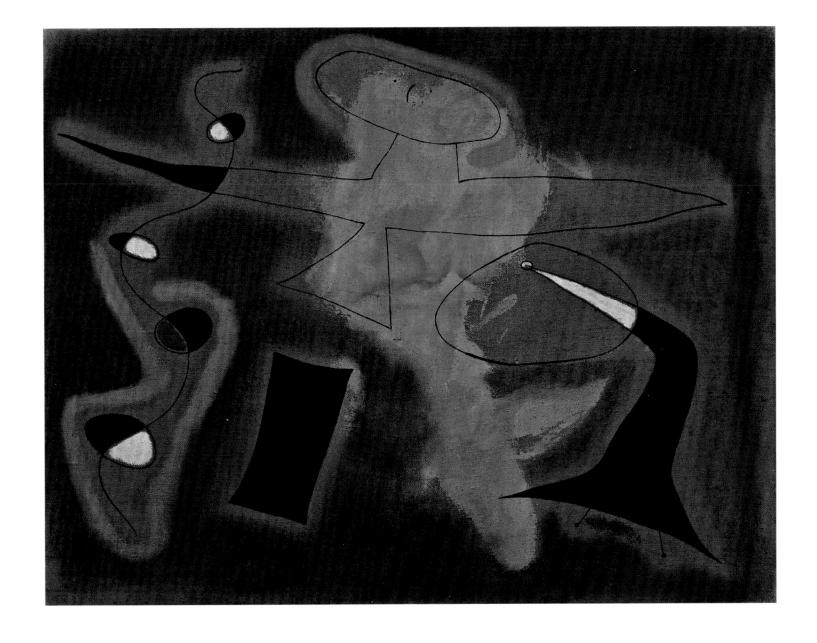

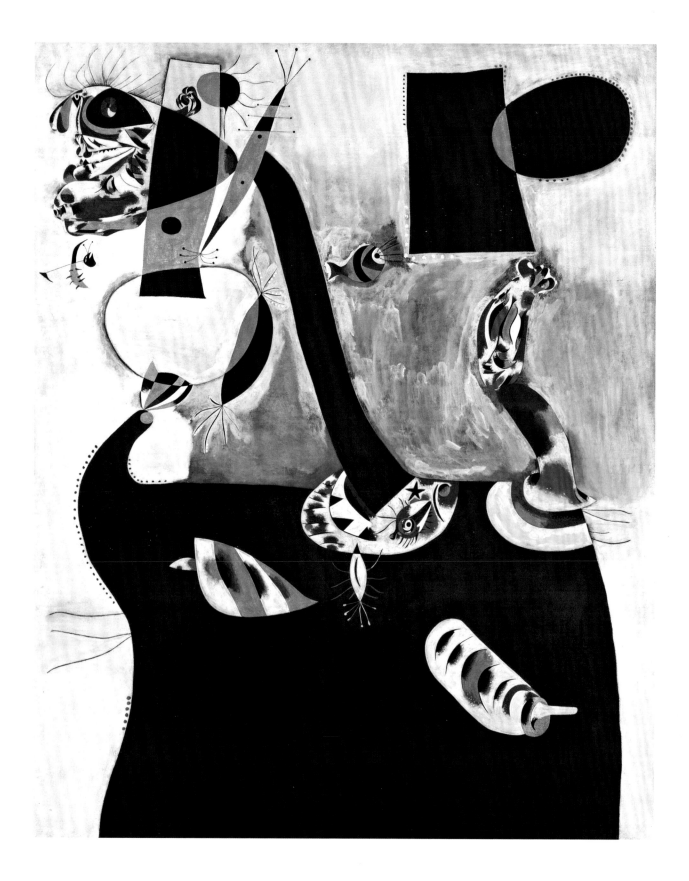

67
Femme assise II 1939
Seated Woman II
Oil on canvas
162 × 130
Peggy Guggenheim
Collection, Venice

68

Femme poignardée par le soleil récitant de poèmes fusées en formes géométriques du vol musical chauve-souris crachat de la mer 1939
Woman Stabbed by the Sun Reciting Rocket Poems in the Geometrical Shapes of the Musical Bat Spittle Flight of the Sea
Gouache and oil wash on paper
40.7 × 33
Private collection

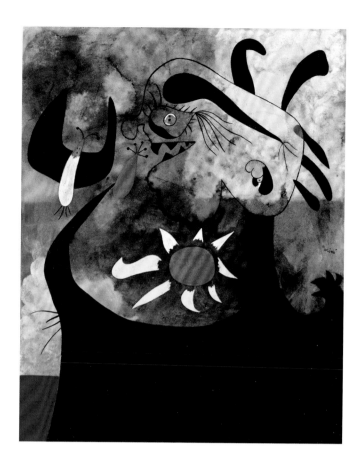

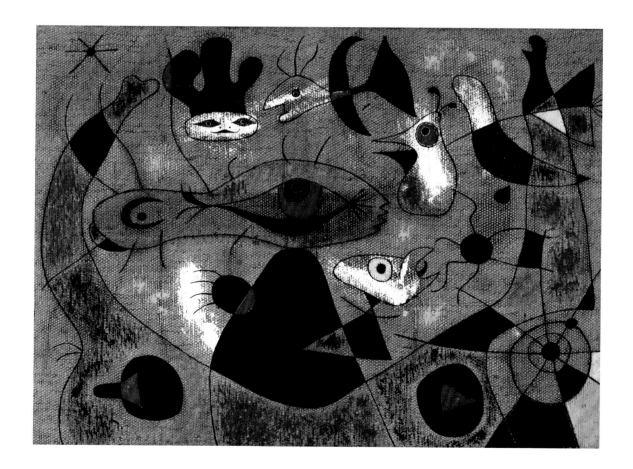

69

Une goutte de rosée tombant de l'aile d'un oiseau réveille Rosalie endormie à l'ombre d'une toile d'araignée 1939
A Drop of Dew Falling from the Wing of a Bird Awakens Rosalie Asleep in the Shade of a Cobweb
Oil on burlap
65.4 × 91.8
University of Iowa Museum of Art. Purchase, Mark Ramney Memorial Fund

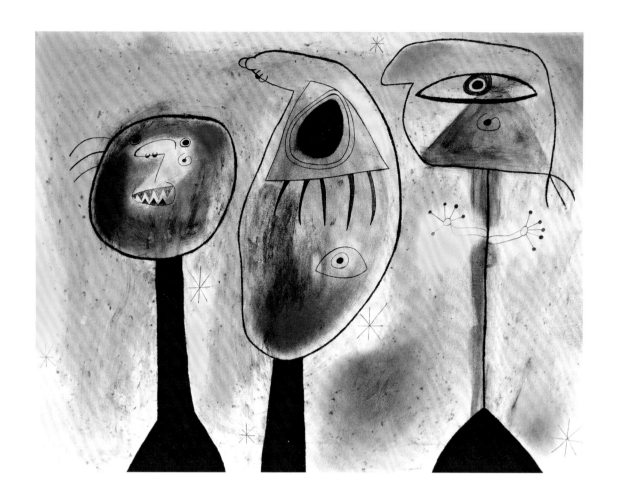

70
**Personnages dans
la nuit** 1942
Figures in the Night
Charcoal, colour chalk and
strawberry jam on paper
50 × 65
Private collection

71
**Le Réveil de Madame
Bou-Bou à l'aube**
1939 – 29 April 1960
*The Awakening of Madame
Bou-Bou at Dawn*
130 × 162
Ceil Pulitzer

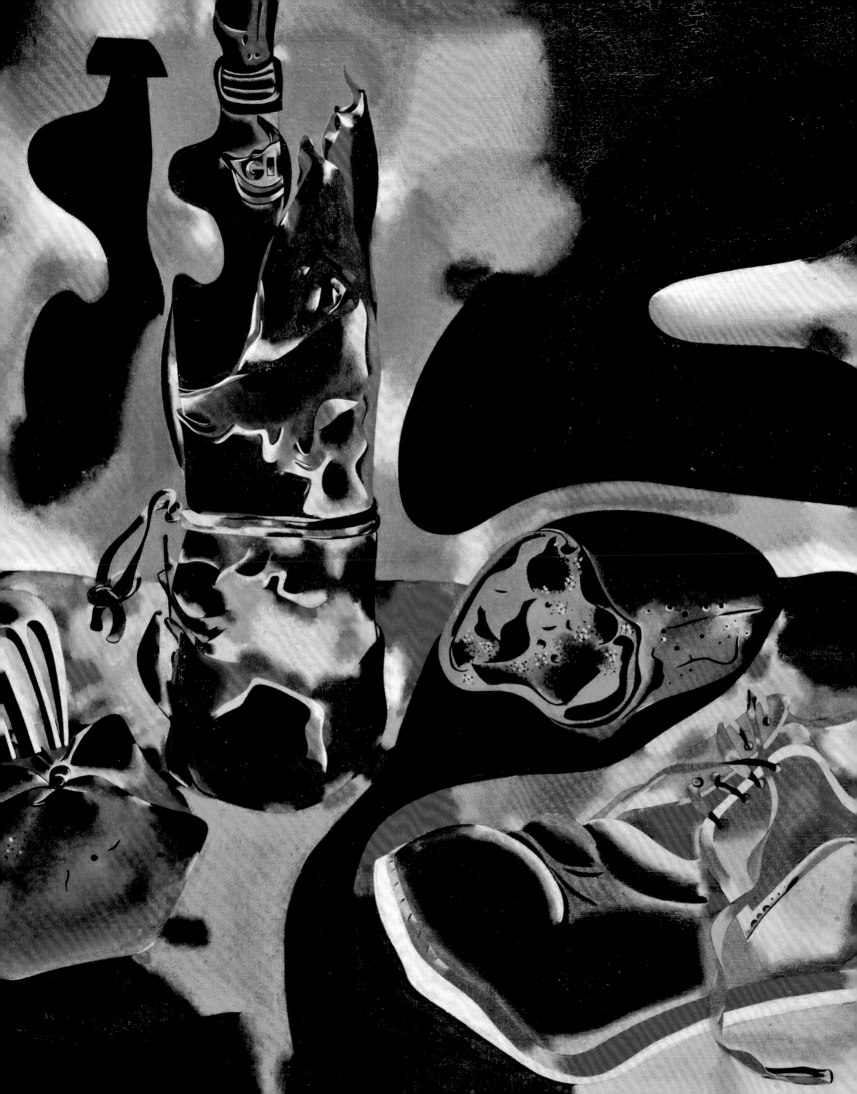

The Profound and Poetic Reality

TERESA MONTANER

In the autumn of 1936, when he was at the point of completing his series of paintings on masonite, Joan Miró sent a letter from Barcelona to his art dealer Pierre Matisse, saying

> As you predict clairvoyantly in your letter, I don't deny that one day I will plunge in again and set out on the discovery of a *profound* and *objective* reality of things, a reality that is neither superficial nor Surrealistic, but a deep poetic reality, an extrapictorial reality, if you will, in spite of pictorial and realistic appearances. The moving poetry that exists in the humblest things and the radiant spiritual forces that emanate from them.[1]

A month after making this statement Miró travelled to Paris with the intention of showing his summer's work to a French audience,[2] but due to the rapid progress of the Spanish Civil War he decided to remain in France, where he was later joined by his wife and daughter. Thus began a period of exile that would continue until the middle of 1940.

Lacking an ideal workspace, the artist began a series of poetic texts on which he continued to work, with some interruptions, until 1939.[3] At the same time he endeavoured to resume the projects he had left behind in Barcelona, but was thwarted by the dramatic events being played out in Spain and the fact that he was outside his own country. He therefore decided to put into practice his idea of penetrating deeper into the reality of things.

On 12 January 1937 Miró wrote to Pierre Matisse again, telling him that he was going to begin work on some 'very realistic' still lifes. A month later, in another letter, he remarked that he was now working on one and described the elements involved: '1 empty gin bottle wrapped in a piece of paper with string around it; 1 large dessert apple; 1 fork stuck into this apple; 1 crust of black bread; 1 old shoe.'[4] All this he sketched out in the margin of the front page of the Paris newspaper *Le Jour*, 22 January 1937, where an article appeared that referred to the difficulties encountered by refugees seeking asylum in foreign embassies in Madrid (no.72).[5] In the same letter he wrote to Matisse:

> I am going to push this painting to the limit, for *I want* it to hold up against a good still life by Velázquez. It is somewhat reminiscent of *La Ferme* [*The Farm 1921–2*, see no.17] and *Nature morte – Le gant et le journal* [*Still Life – The Glove and the Newspaper* 1921] – less anecdotal than the first and more powerful than the second. No sentimentalism. Realism that is far from being photographic, and also far from the realism exploited by some of the Surrealists. Profound and exciting reality.[6]

In late March Miró expressed considerable confidence: 'The work is going very well; the still life will soon be finished; this painting is completely absorbing me, and I believe that along with *The Farm* it will be the capital piece of my oeuvre – which I nevertheless hope to surpass later.'[7]

Continuing to work directly from reality, at the end of May Miró completed the painting and titled it *Nature morte au vieux soulier* (*Still Life with Old Shoe*, no.73). The everyday objects that he had arranged on the table and copied so painstakingly had been transformed by a particular treatment of colour, light and shade into a landscape where tragedy was apparent, despite there being no specific element that

Still Life with Old Shoe
(detail of no.73)

directly evoked it.[8] In comparing this work with Spanish still lifes, it is possible that Miró was thinking of the illusionistic lighting of the Baroque more than his virtuosity in copying reality – without categorising the type of realism in which Miró was immersed. It is nevertheless interesting to highlight the parallels that exist between the attention to detail in some of the elements in *Still Life with Old Shoe* and their counterparts in paintings from his early period, especially *The Farm*. In fact, he referred to *The Farm* on various occasions, in relation not only to *Still Life with Old Shoe*, but also to other works of the same period.

The discipline required to copy from life took Miró back to his early days as an artist. Just as he had done after his exhibition at the Galeries Dalmau in 1918 – when he had copied in meticulous detail the landscapes of Mont-roig that would lead to *The Farm* – Miró now turned again, with the same humility, to simple still-life objects. He knew, as he had in that earlier moment, that the effort of spending hours in front of his model, reproducing its external appearance, would bring him closer to the poetic and symbolic reality of things.[9]

Referring to *Still Life with Old Shoe* some years later, Miró wrote to James Thrall Soby:

Despite the fact that while working on the painting I was thinking only about solving formal problems and getting back in touch with a reality that I was inevitably led to by current events, I later realized that without my knowing it this picture contained tragic symbols of the period – the tragedy of a miserable crust of bread and an old shoe, an apple pierced by a cruel fork and a bottle that like a

burning house, spread its flames across the entire surface of the canvas.[10]

His return to realism and the tragedy he saw in the still life both contribute to the fact that this work has sometimes been interpreted as a political statement and has even been described as 'Miró's *Guernica*'.[11] However, the artist himself always explained it by reference to an inner need sparked off by historical events.

Just as he had done in Barcelona when he attended the Cercle Artístic de Sant Lluc, in Paris Miró decided to strengthen his artistic discipline at the same time as working on this piece by attending the Académie de La Grande Chaumière and the Colarossi and Ranson academies, where he drew from life.[12] These sessions produced more than a hundred drawings of nudes, some of which led to much more complex works. Here, the artist allowed his most intimate feelings to surface, distorting these figures and torturing them to the point of creating phantasmagorical beings, much closer to the 'savage paintings' he made between 1934 and 1936 than to *Still Life with Old Shoe*.

Miró's immersion in realism did not stop him from taking time to respond to political demands. Once he had completed *Still Life with Old Shoe* he agreed with the Republican government to paint a large mural, *Le Faucheur* (*The Reaper*), for the Spanish Republican Pavilion at the Paris Exposition Internationale of 1937 (pp.118–21), a painting that would be placed very close to Picasso's *Guernica* (no.74).[13]

After this interlude, Miró returned to his quest for the 'profound reality of things' with the execution of *Autoportrait I* (*Self-Portrait I*, no.76), on which he worked from late 1937 to

73
Nature morte au vieux soulier
24 January – 29 May 1937
Still Life with Old Shoe
Oil on canvas
81 × 116
The Museum of Modern Art, New York. Gift of James Thrall Soby, 1970

72
Sketch for **Still Life with Old Shoe** 1937 in the margins of *Le Jour* newspaper, 22 January 1937
Graphite pencil on printed paper
7.5 × 12.7
Fundació Joan Miró, Barcelona

A PROFOUND AND POETIC REALITY

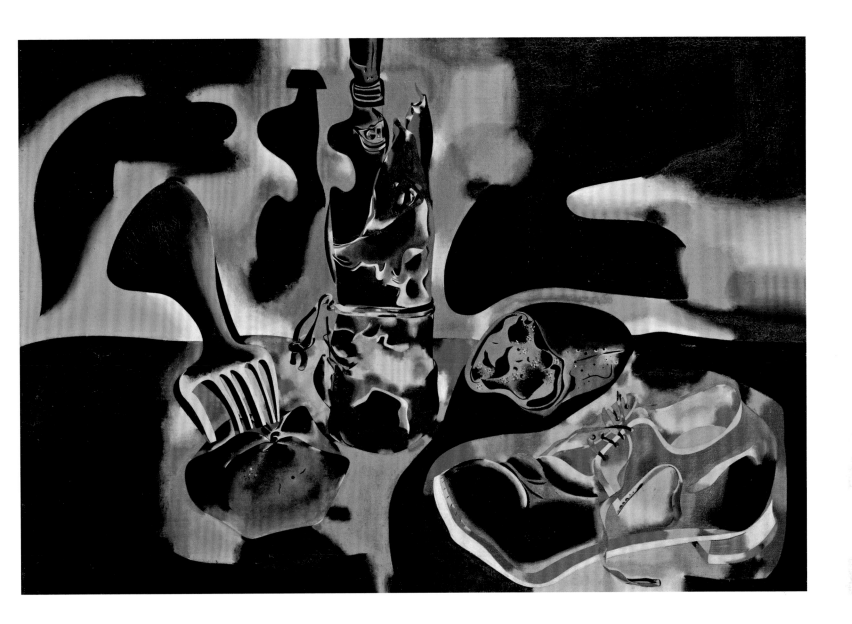

early 1938. For this he used a magnifying mirror, enlarging his face by as much as three times and drawing a detailed bust on a carefully prepared, coloured ground. On this surface, Miró's face, like the visionary portraits of William Blake, is transformed into flames revealing a cosmic image of the artist.[14] On completing this work, Miró himself thought that it might well be the most important of his life.[15]

At this point, Miró still hoped that the conflict might turn in favour of the Republican government. But towards the end of 1938 the Republican army suffered defeat in the Battle of the Ebro and Franco's troops advanced on Barcelona. Motivated by a feeling of solidarity with his country, the artist decided to start a new portrait based on *Self-Portrait I*, a copy of which he had commissioned.[16] Now, however, he fuses the idea of *Self-Portrait I* with that of landscape.

Miró started one of the first surviving sketches of this project (nos.78–9) by attaching a photographic reproduction of *Self-Portrait I* to the centre of a larger sheet of heavy paper and extending some of the lines beyond the edge of that image so that his shoulders become the rocky outcrops of a landscape with an escape ladder while the top of his head sprouts a twig on which a kind of bird is perched.[17] On this sheet he wrote:

great simplicity | in the masses, very moving | very tragic
a representative work | like *The Farm* | in which has | taken
place an entire revolution
like an Easter Island head
the ladder | of escape
a head | placed | as if on | a landscape (on a plain) | with
buttonholes in | the shape of a sex [organ] or | spiders
yellow jacket
Holy Mary
the sleeves like | the crags of Montserrat[18]

The comparison with *The Farm* here has various objectives: on the one hand it reinforces his identification with Catalonia, also seen in the fusing of his portrait with the mountains of Montserrat, a place of great spiritual and symbolic importance for the Catalan people. On the other hand, it emphasises how the realisation of a process of synthesis was similar to that begun with *The Farm*. These intentions would find expression in a series of sketches for portrait-landscapes, dated 30 and 31 December 1938 and 2 January 1939, in which reality is entirely contained in the symbol (no.80).[19] Through this process of transformation, Miró manages to 'escape the reality of the present' so as to discover, as he declared to George Duthuit in an interview for *Cahiers d'Art*, 'the religious essence, the magic sense of things'.[20]

Anticipating the occupation of France by the German army, in 1940 Miró returned to Spain, leaving the copy of his self-portrait in Paris, intending to recover it later. He continued working on this project up to 1942, starting from the same concept only, now that the Spanish Civil War was over, replacing the landscape of Montserrat with that of Mont-roig.[21] A growing need to change his own work led Miró in the last drawings of the series to recall his whole life through symbols and symbolically expressed memories. Commenting on one of these, he wrote:

The rectangle below the eye symbolises the memory of the yellow shirt I had planned for my self-portrait 25 years ago; this is why it has to have a yellow side. The sort of molar projecting from this rectangle symbolises the spirit of the large canvases of 1933. The ball on the clothing on the left symbolises maximum nakedness, a ball against a blue sky like the one I did. Make the memory of the *Dog Barking at the Moon* truly vivid. Make this canvas impressive. The tracks under the ladder symbolise the ploughed earth of a landscape. Go to the patio of La Llotja and look at the sculpture with an owl in its hand.[22]

It is thought that all the drawings Miró produced between 1938 and 1942 for this second portrait express a feeling of political resistance,[23] the early ones through the metamorphosis to which the artist subjected his self-portrait, fusing it with such an iconic place as Montserrat, a month before Franco's army took the city of Barcelona on 26 January 1939 (no.80); and the later ones through their compositional resolution. One of these is drawn on a five-year-old sheet of newspaper carrying news from the front during the Spanish Civil War (no.77).[24] The other is drawn on a bereavement envelope, the artist's self-portrait positioned alongside an upside-down stamp of Franco.

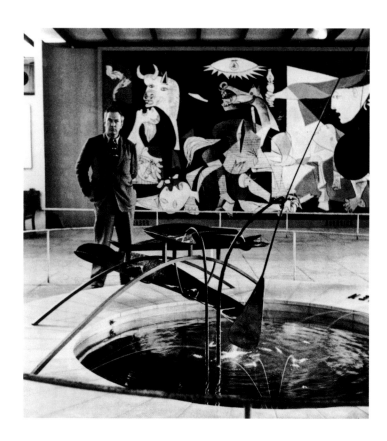

74
Hugo P. Herdeg
Alexander Calder with his
Mercury Fountain and
Pablo Picasso's **Guernica**
at the Spanish Republican
Pavilion, Paris Exposition
Internationale, 1937
Calder Foundation,
New York

75
François Kollar
Julio González's
La Montserrat at the
Spanish Republican
Pavilion, Paris Exposition
Internationale, 1937
La médiathèque de
l'Architecture et du
patrimoine, Paris

A PROFOUND AND POETIC REALITY

76
Autoportrait I 1937–8
Self-Portrait I
Pencil, crayon and oil
on canvas
146.1 × 97.2
The Museum of Modern Art,
New York. James Thrall
Soby Bequest

But Miró had not ceased thinking in the painting. Before realising these last sketches for a self-portrait, in July 1940, on his return to Spain – with the country now under the Franco regime – Miró began planning what would have been his final work in relation to *The Farm*. This was to be a large canvas in memory of the Civil War. However, it was never actually completed, and all that survives is a few jottings in assorted notebooks. He conceived the piece as a response to *Guernica*, counterbalancing the tragedy represented in Picasso's painting with a new and more encouraging reality:

Produce a large canvas (like Pablo's) but in a different spirit, one of escape and looking to the eternal side of life. Make use of the injured child I did on one of the sides. In the background some half-ruined houses in flames. In the foreground a terrified peasant, also like the one I've done before. On the rubble a cockerel like the one I've done. In the sky a plane in the form of a phantasmagorically shaped bird, in the spirit of Brueghel or Hieronymus Bosch. A barking dog. On the other side of the canvas a man with a mule or ox ploughing the land, the eternal side, a plant coming forth from the land and growing. Birds in the branches of the trees playing instruments, reminiscent of Marc Chagall. The furrows of the ploughed land. A blue sky. Some men-monsters emerging from the phantasmagorical bird and throwing bombs.[25]

Miró's need to transcend the earthly had led him during these years to focus again on artists who had been a source of inspiration in his early career, such as Hieronymus Bosch, Jan Brueghel, Odilon Redon, Blake and Marc Chagall.[26] Like these predecessors, he understood that a reality exists that is more real than the visible world, and it was this new and more encouraging vision that he wished to offer to humanity. Starting in 1938–9, Miró had already begun to introduce elements of symbolic representation into his work, like the bird and the escape ladder, that allude to a feeling of ascending, to the act of transcending the world. To this end he sketched out a landscape in which the human and the eternal are highly visible. And while earthly forms are found in many of the works he produced during the war years, he now turned to purer things to express the spiritual: a tree coming forth from the earth, ploughed land and the music of birds.

After his experience with *The Reaper* in the Republican Pavilion, and in the hope of reaching a wider audience with his paintings, Miró decided to execute the proposed painting as a mural:

For the large canvas in memory of the war, do it on approximately the same scale as *Guernica*. Put in a cockerel and a wolf gnawing bones. Look a lot at the great Romanesque paintings … use the cockerel already done for *Verve*; treat it like *The Farm*, like a replica of it.[27]

As in *The Farm*, Miró intended the large canvas about the war to represent a synthesis of his past, a deep process that launched the future development of his work. With this proposal, he initiated a profound project of self-revision that

77
Sketch for a self-portrait, 14
March 1942, on a page from
La Vanguardia newspaper
from 12 February 1937
Graphite pencil on
printed paper
25 × 26.5
Fundació Joan Miró,
Barcelona

78
A reproduction of **Self-Portrait I** superimposed on the above sketch demonstrating the match of registration marks and the continuity of lines from one to the other
Fundació Joan Miró, Barcelona

79
Sketch for a self-portrait, 1938
Graphite pencil on paper
36.5 × 35.5
Fundació Joan Miró, Barcelona

once again led him back to his origins, to the landscape of Mont-roig, to past experiences. 'My work', Miró noted at this moment, 'need not be of the present, but of the past – at the source of the pure expression of spirit – and of the future. Like symbols of a pure religion.'[28] Unlike Picasso, whom he had visited in his studio in the rue des Grands Augustins when he was working on *Guernica*,[29] Miró did not seek to condemn but to understand what had happened.

> This canvas should now slowly work itself into my mind (1940) and when the time comes, prepare it in white and leave it in the studio in front of me so that it continues working inside me; start from this white surface and let it create images in my mind that I will then draw and study on paper and on other canvases, just like Picasso with *Guernica*, starting to draw on the final canvas only once this process has taken place. A process completely different from that of Picasso whose starting point was reality; I shall start with

the mind and the *white surface* of the canvas. To produce this large canvas, look at my old work. Look at the 1940 Matisse catalogue. All my work is summed up in it. Work for years on it.[30]

Miró never produced any drawings for this canvas. His return to Mont-roig in the summer of 1941 and his reconnection with the landscape, together with a process of reviewing that would continue for a number of years, made him feel it was artificial to continue producing realist pieces. With the *Constellations* series, which he finished painting that same summer, he systematised a language of symbols and signs that he had first introduced in *Self-Portrait I*, a language that was much more in tune with the period of uncertainty in which he now lived. The effort of copying from reality had helped him to take this step forward. When, in 1960, Miró managed to complete the self-portrait he simplified it in the extreme (no.82). He would never return to realism again. His painting had now reached poetic plenitude.

A PROFOUND AND POETIC REALITY

80
Sketch for a
portrait-landscape,
31 December 1938
Graphite pencil on paper
16.9 × 21.9
Fundació Joan Miró,
Barcelona

81
Sketch for a
self-portrait, 1938
Graphite pencil on paper
23.3 × 27
Fundació Joan Miró,
Barcelona

1 Miró (Barcelona) to Pierre Matisse, 28 Sept. 1936, in Rowell 1986, p.126.
2 Miró's series of paintings on masonite were shown for a few hours on 13 November at the Galerie Pierre in Paris, and immediately afterwards sent to Pierre Matisse in New York. The event was very well attended, and *sardana* music was played as a tribute to Catalonia and Spain.
3 Reproduced in Malet 1988, pp.189–94, nos.727–44.
4 Miró (Paris) to Pierre Matisse, 12 Feb. 1937, in ibid., p.147.
5 Robert S. Lubar points out a possible connection between Miró's situation in exile and the article published on the front page of the newspaper, in '*Still Life with Old Shoe*, 1937', in Umland 2008, p.231.
6 Miró (Paris) to Pierre Matisse, 12 Feb. 1937, in Rowell 1986, p.147.
7 Miró (Paris) to Pierre Matisse, 21 March 1937, in Rowell 1986, p.157.
8 For an exhaustive interpretation of *Still Life with Old Shoe*, see Balsach 2007, pp.189–204; Labrusse 2004, pp.54–63; and Lubar in Umland 2008, pp.214–17.
9 Miró (Paris) to Pierre Matisse, (12 Feb. 1937, in Rowell 1986, p.147) while painting *Still Life with Old Shoe*, writes: 'To look nature in the face and *dominate* it is enormously attractive and exciting. It's as though by the strength of your eyes you bring down a panther at your feet in the middle of the jungle. | This down-to-earth undertaking, this brushing of the ground, will give me new possibilities and allow me to find a new and more powerful impetus for further escapes.'

He enclosed a newspaper cutting that gives strength to his view with a quotation by Odilon Redon: 'My most fertile routine, the one most necessary to my development, is to copy reality directly, attentively reproducing the objects of external nature in their most particular and accidental aspects. After making the effort to do a meticulous copy of a pebble, a blade of grass, a hand or a profile, I then need to let myself go to the representation of an imaginary world. Nature, thus measured out and infused, becomes my source, my leaven, my ferment.'
10 Miró (Barcelona) to James Thrall Soby, 3 Feb. 1953, in Rowell 1986, p.232.
11 Dupin 1993, p.210.
12 Although Miró only mentions attending the Académie de La Grande Chaumière, in his notes we also find references to life-drawing sessions at the other two academies, as well as a pad of used sketching vouchers from the Académie Colarossi (FJM 1646 and FJM 1519).
13 Miró also designed the postage stamp commissioned by the Comisaría de Propaganda to be sold for one franc with the slogan 'Aidez l'Espagne' and included in the magazine *Cahiers d'Art*, no.4–5, 1937 (see no.1), as well as a poster in support of the Republican cause for the CSI (Centrale Sanitaire International) that was never produced.
14 David Lomas also suggests Van Gogh's self-portrait as a possible influence. For an interpretation of Miró's visionary self-portraits, see Lomas 2000, pp.187–213.
15 Miró (Paris) to Pierre Matisse, 4 March 1938, in Rowell 1986, pp.158–9.

16 *Self-Portrait I* had been reproduced in the magazine *Verve*, no.5–6, Spring 1939, as an illustration to Marcel Raval's article 'L'homme et son modèle'. Miró kept a squared-up copy of this image amongst his drawings, which suggests Freesz, a collaborator of the architect Paul Nelson, may have used the reproduction to transfer the image onto canvas.
17 We are aware that Miró had a photograph of *Self-Portrait I* 1937–8 as he enclosed it when he wrote to Pierre Matisse on 7 April 1938 (Rowell 1986, p.159). He must have kept a copy himself. A process of reconstruction confirms that, as well as the lines extending into the landscape, there are registration marks on the drawing (FJM 1660) that locate the corners of the photograph (no.78).
18 Notes distributed across the drawing (FJM 1660) (no.79). Some parts (indicated here in brackets) would have been obscured by the imposition of a reproduction of *Self-Portrait I* at the centre of the sheet. It reads, top left: 'gran simplicitat | en les masses ben emocionant | ben tràgica | una obra representat[iva] | com la fer[me] | en la que h[i hagi] | passat tota [la revolució]'. Under image: '[Com un cap de l'Ile de Pâques]'. Middle right: 'l'échelle de | l'évasion | cap | posat | com sobre | un paisatge (sobre una plana) | amb els traus en | forma de sexe o | aranyes | gec groc | Sta. Maria | les manegues [sic] com | rocs de Monserrat [sic].'
19 Reproduced in Malet 1988, pp.189–94, nos.727–44. No.80 in this volume is FJM 1531.
20 Georges Duthuit, 'Réponse à une enquête', in *Cahiers d'Art*, no.1–4, 1939,

in Rowell 1986, p.166.
21 Miró, Notes (1940–41), FJM 4448.
22 Miró, Notes, FJM 1879.
23 Lomas 2000, pp.196–7, 210–13.
24 It was probably the headline of this article, 'La lucha en el frente de Aragón' ['The battle on the Aragon Front'] in the Barcelona newspaper *La Vanguardia* of 12 February 1937, that led Miró to make this drawing some years later (FJM 1842).
25 Miró, Notes (1940–41), FJM 4448–4475 (FJM 4454a).
26 Other references to artists of magic realism, such as Henri Rousseau and James Ensor, are also found among Miró's work materials of this period. Malet 1988, p.205, no.791.
27 Miró, Notes (1940), FJM 4393–4397 (FJM 4395b).
28 Miró, Notes (1940), FJM 1774.
29 Miró referring to *Guernica*, in *Guernica-Legado Picasso*, Museo del Prado, Madrid 1981, p.5.
30 Miró, Notes (1940), FJM 4393–4397 (FJM 4395b and FJM 4396a).

82
Autoportrait
1937–8 – 23 February 1960
Self-Portrait
Oil and pencil on canvas
146.5 × 97
Collection of Emilio
Fernández. On loan to the
Fundació Joan Miró,
Barcelona

**Femme entendant de
la musique** 1945
Woman Hearing Music
Oil on canvas
130 × 162
Private collection

84
Deux baigneuses
February 1936
Two Bathers
Gouache on paper
49 × 65
Collection El Conventet,
Barcelona

85
Portrait IV June 1938
Oil on canvas
130 × 97
Collection of Samuel
and Ronnie Heyman,
New York

86
Femme en révolte 1938
Woman in Revolt
Watercolour and pencil
on paper
57.4 × 74.3
Centre Pompidou, Paris.
Musée national d'art
moderne / Centre de
création industrielle

87
**Femme nue montant
l'escalier** March 1937
*Naked Woman Going
Upstairs*
Charcoal on card
78 × 55.8
Fundació Joan Miró,
Barcelona

88
Femme fuyant l'incendie
5 April 1939
Woman Fleeing from a Fire
Gouache, India ink, pencil
and pastel on paper
33 × 41
Santa Barbara Museum of Art.
Gift of Wight S. Ludington

89
Untitled 3 March 1938
Watercolour and pencil
on paper
53.5 × 43
Private collection

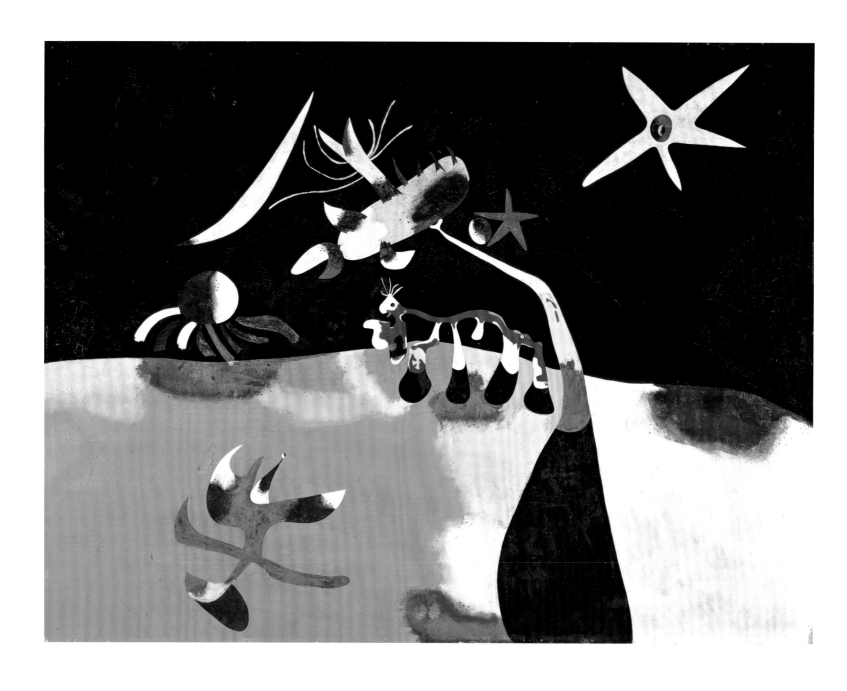

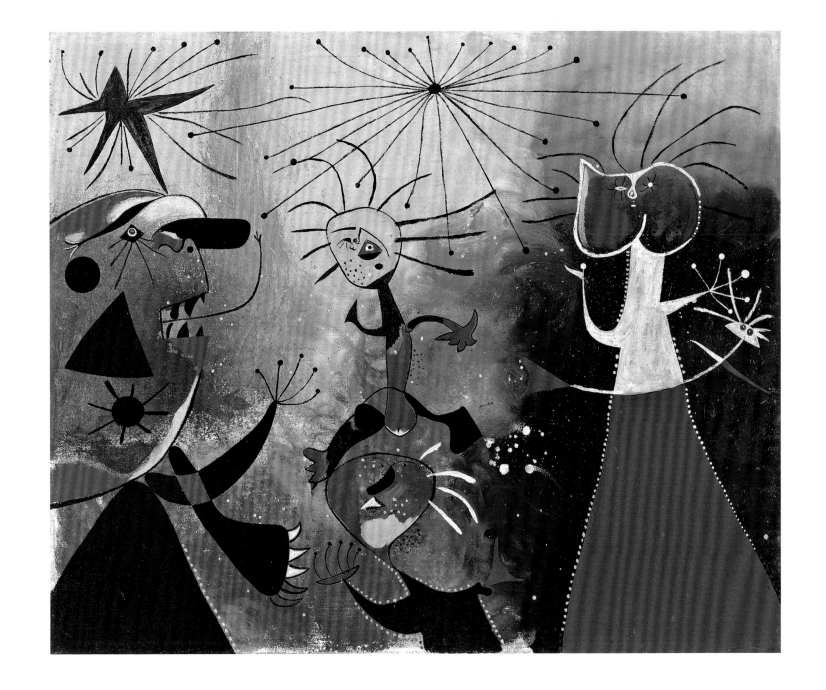

**Jeune fille moitié brune
moitié rousse glissant
sur le sang des jacinthes
gelées d'un camp de
football en flammes**
14 March 1939
*Young Girl with Half Brown,
Half Red Hair Slipping on
the Blood of Frozen
Hyacinths of a Burning
Football Field*
Oil on canvas
130 × 195
Collection of Batsheva and
Ronald Ostrow

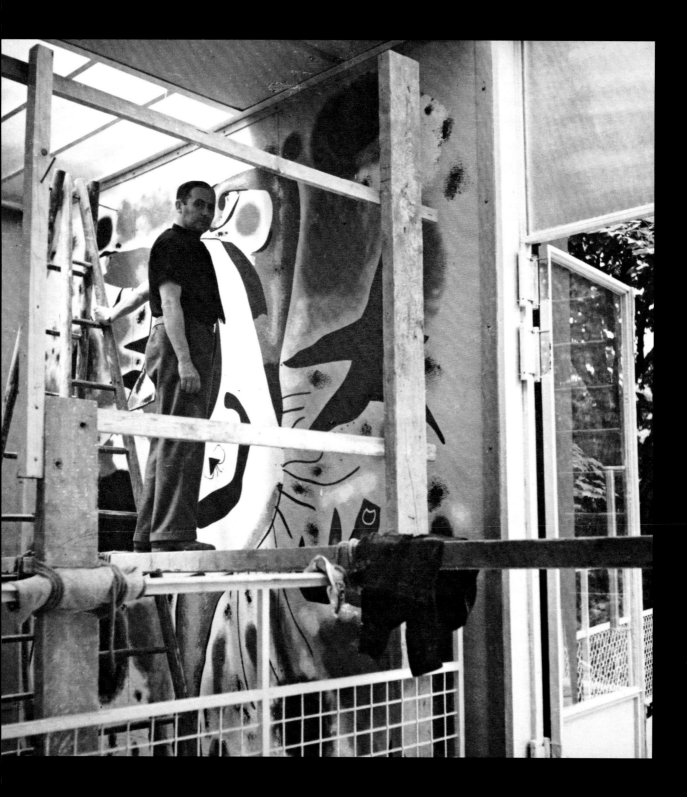

Spanish Republican Pavilion, 1937

Miró painting *Le Faucheur*
(*The Reaper*) in the stairwell of
the Pavilion at the Paris Exposition
Internationale, 1937

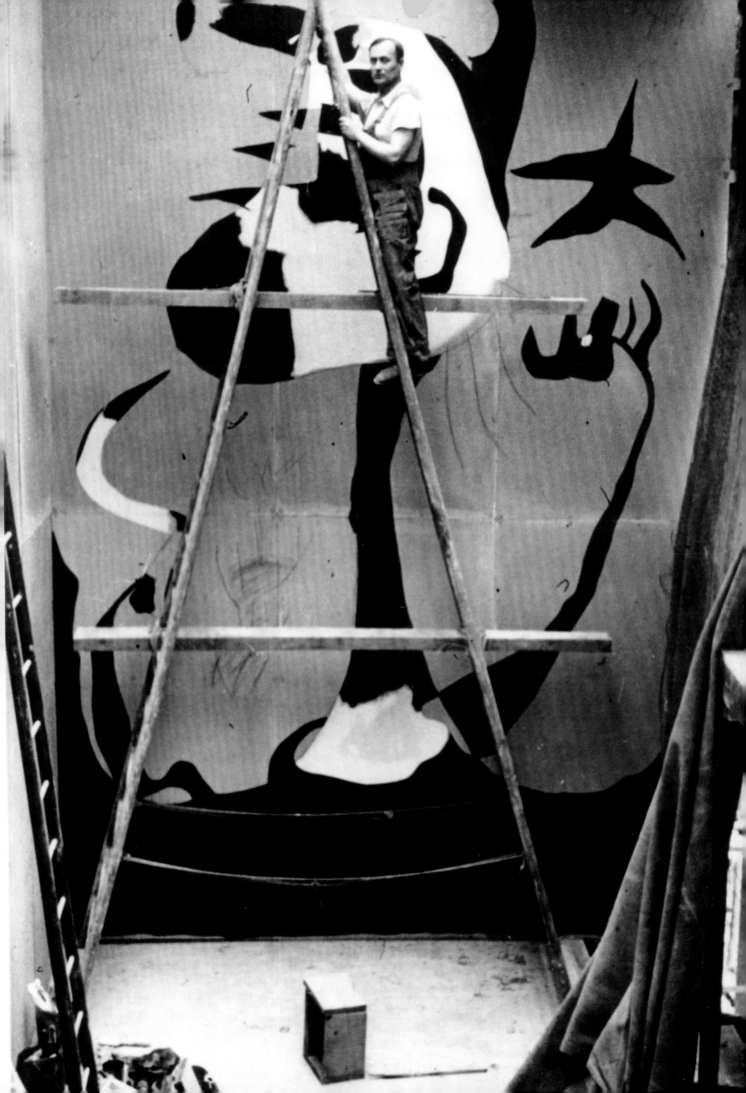

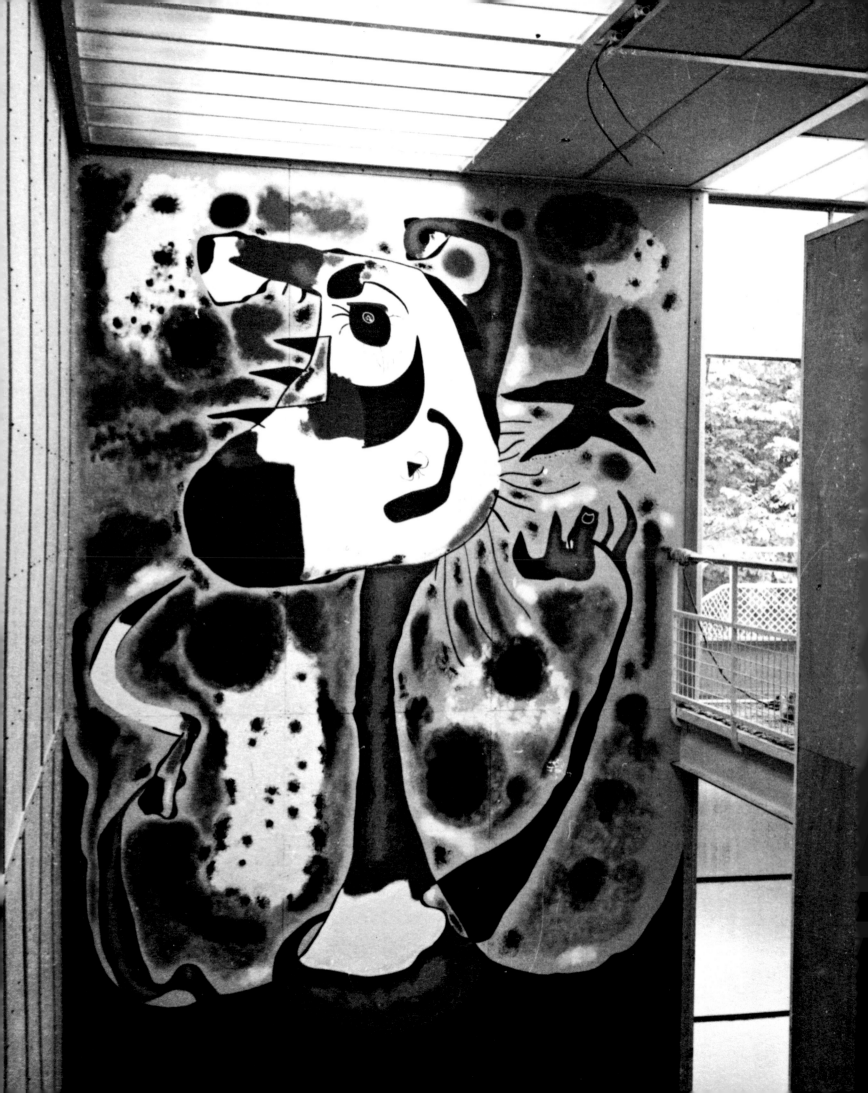

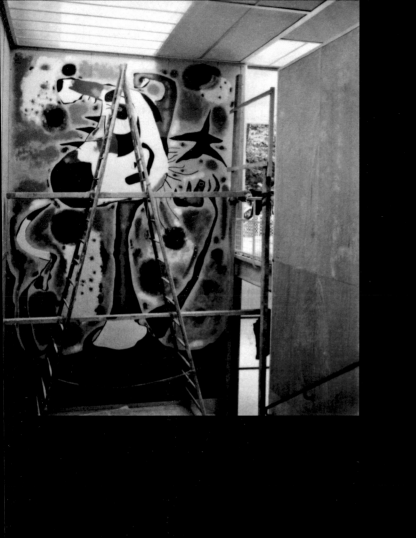

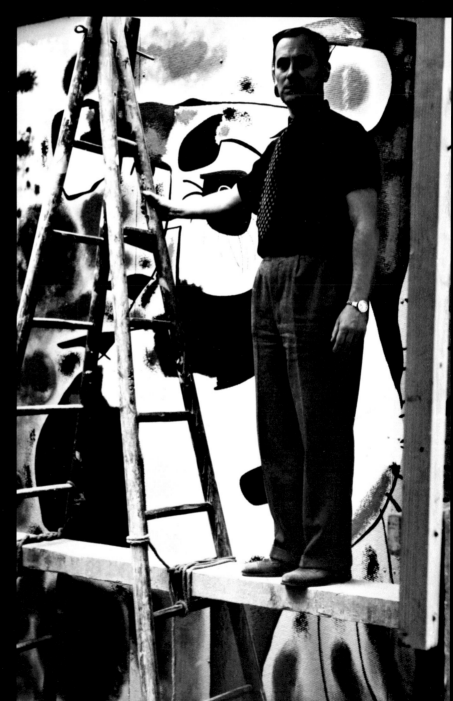

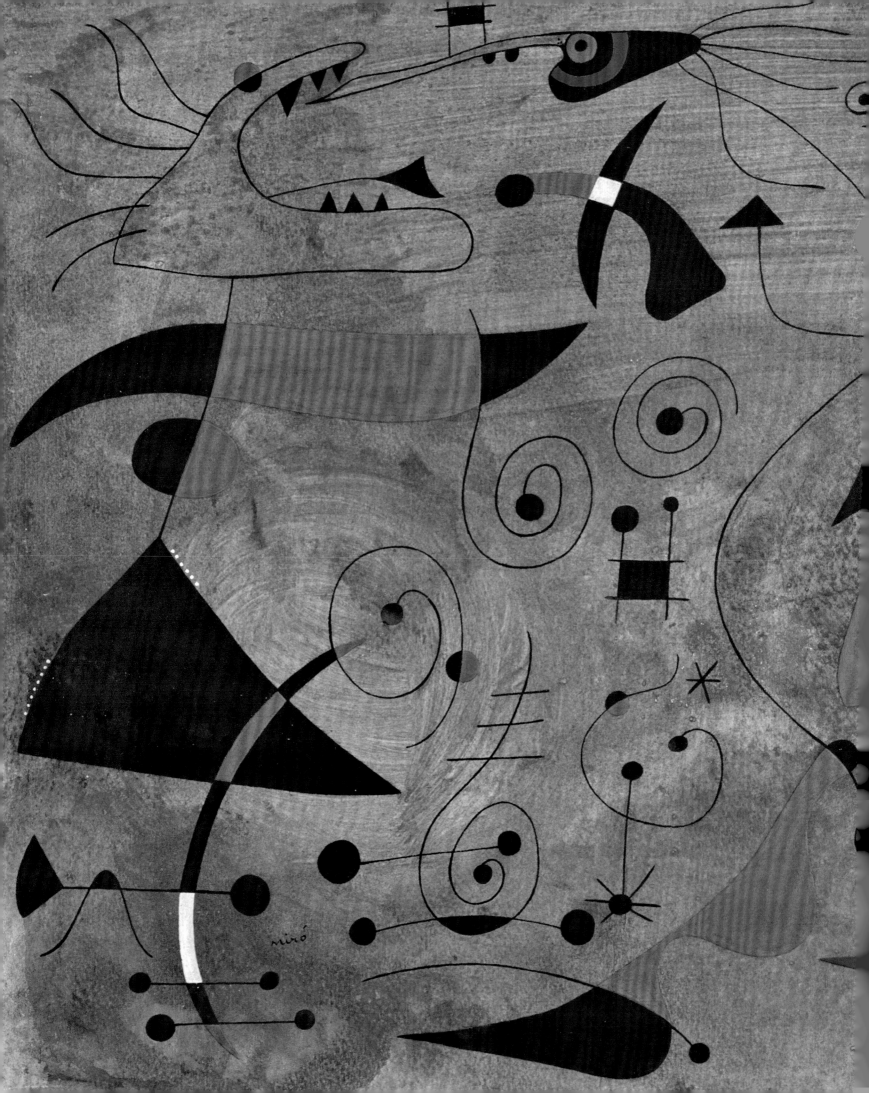

From *Constellations* to the *Barcelona Series*

MATTHEW GALE

Woman and Birds
(detail of no.98)

When the writer Raymond Queneau encountered Miró at Varengeville-sur-Mer on 24 August 1939 he marvelled at the artist's calm amid the preparations for war. This was the day of French mobilisation after the surprise announcement of the Nazi–Soviet Non-Aggression Pact that did so much to ensure that war in the West would follow in September. 'Miró painted', Queneau recalled. 'But I never saw a single canvas. I tried to get him to talk. But it was impossible. I set traps for him. But he did not succumb. I like Miró very much.'[1] Among the works held back from Queneau were oils on rough burlap and gouaches with mottled grounds. The gouaches, though not explicitly concerned with the celestial, provide a preamble to the *Constellations*, the series, begun in 1940, that Miró immediately called 'one of the most important things I have done'.[2]

As nocturnes, the *Constellations* suggest an attuning to darkness that allows greater perception.[3] This is found in the promise of light in *Le Lever du soleil* (*Sunrise*, no.93), the first and simplest of the series, completed on 21 January 1940. It is evident in the smoky black of *L'Échelle de l'évasion* (*The Escape Ladder*, see no.9) and the velvety cerulean of *Personnages dans la nuit guidés par les traces phosphorescentes des escargots* (*Figures at Night Guided by the Phosphorescent Tracks of Snails*, no.94), the second and third paintings. Around this time, Miró wrote to his dealer Pierre Matisse: 'I have reached a high degree of poetry – a product of the concentration made possible by the life we are living here'.[4] Though bolstered by the exemplary presence of Georges Braque and the architect Paul Nelson, life in Varengeville was restrained.[5] On 4 February Miró added the well-known mapping-out of the as yet unnamed series:

I am now working on a series of 15 to 20 paintings in tempera and oil, dimensions 38 × 46, which has become very important. I feel that it is one of the most important things I have done, and even though the formats are small, they give the impression of large frescoes … I can't even send you the finished ones, since I have them all in front of me the whole time – to maintain the momentum and mental state I need in order to do the entire group.[6]

Certain aspects of this account are characteristic: the format, approximate number and timing (he allows three months) are foreseen. Miró proceeded methodically and his precise dating shows his steady productivity, with ten to fourteen days between each painting.[7] There do not appear to have been any preparatory drawings but the series was built through recurring structures. The main figure in *Sunrise*, for instance, is echoed by the positioning of the ladder in *The Escape Ladder*, and both are accompanied by ancillary figures, hairy and upward-craning, wedged into the lower right-hand corner. In the ensuing *Figures at Night Guided by the Phosphorescent Tracks of Snails* a tall figure and a stacked red and black form occupy this position.

If the transformation of one element into another remains consistent with a lifetime's practice, Miró's mention of the 'mental state' is suggestive of his response to current events. With the fall of Madrid the year before, on 28 March 1939, the total defeat of the Spanish Republic had been sealed. By that time Miró had prepared a forthright response to the questionnaire 'Is the creative act affected by contemporary events?' in *Cahiers d'Art*: 'If the powers of backwardness

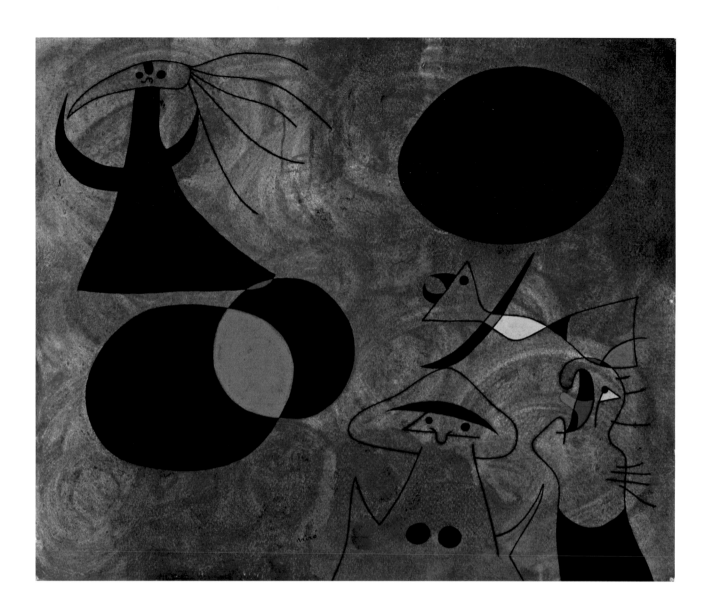

93
Le Lever du soleil
21 January 1940
Sunrise
Gouache and oil wash
on paper
37.8 × 45.6
Toledo Museum of Art.
Gift of Thomas T. Solley

known as Fascism continue to spread … that will be the end of all human dignity.' He observed: 'There is no longer an ivory tower. Retreat and isolation are no longer permissible'. He then spoke of 'the deep necessity that makes him [the artist] take part in social upheavals, that attaches him and his work to the heart and flesh of his neighbour and makes the need for liberation in all of us a need of his own.'[8]

Family life with his wife and daughter encouraged withdrawal to Varengeville that summer, however this statement was surely neither made, nor forgotten, lightly. Five months elapsed between the fall of Madrid and the invasion of Poland that brought France and Britain to declare war in September 1939. Miró, like so many others, was caught in the eerie inertia of the phoney war that followed. He knew that his close friend Joan Prats had 'suffered greatly' in a Francoist prison;[9] he must have witnessed Braque's temporary break from painting because of the 'turbulence' of the times.[10] Miró's response was to work and the 'mental state' of the

Constellations may have been to extend that 'deep necessity [to] take part in social upheavals' that had fired his contribution to the Spanish Republican Pavilion in 1937. The imagery can be seen to extend that of his lost mural *Le Faucheur* (*The Reaper*, see pp.118–21), whose head was seen against the starry sky, and that of his colleague Alberto Sánchez Pérez whose giant sculpture (also lost) was optimistically entitled *The Spanish People Have a Path that Leads to a Star* 1937.

Some of this is embedded in the very choice of nocturnal subjects, which suggests both a withdrawal from, and a secretive subversion of, the rational world of daylight hours. This emerges in the *Constellations* made in March–April 1940. They include the fantastically titled *Femme à la blonde aisselle coiffant sa chevelure à la lueur des étoiles* (*Woman with Blonde Armpit Combing her Hair by the Light of the Stars*, no.95) and the closely related *L'Étoile matinale* (*Morning Star*, no.96) with its strikingly anxious five-eyed head.[11] The vocabulary of signs that permeate the series is established at this

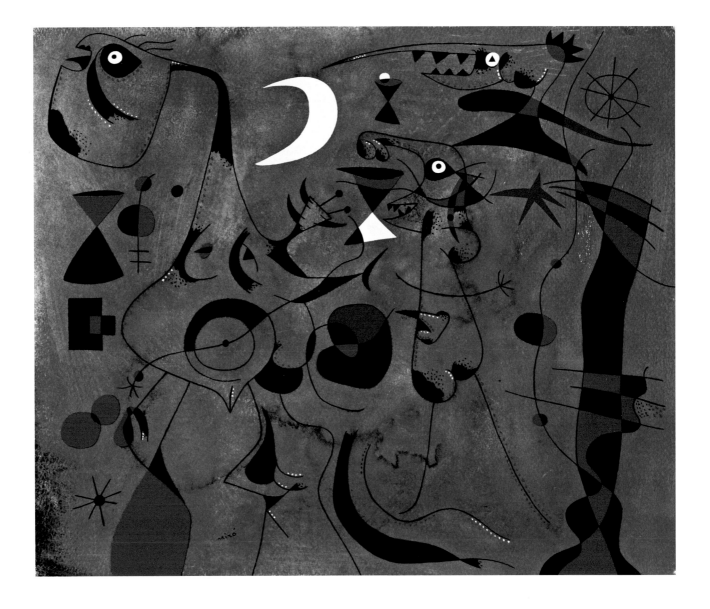

moment: the crescent moon, uneven Mironian star, spidery star and spiral. The figures parade in the foreground, but their bodies are drawn with an etiolated line reminiscent of Gaudí's wrought-iron work.

The creatures are notably hostile. In *Femme et oiseaux* (*Woman and Birds*, no.98) Miró seems to revert to a parallel developed in the 1939 paintings entitled *Le Vol de l'oiseau sur la plaine* (*Flight of a Bird over a Plain*, see no.65–6). His comfortable swooping birds can equally be seen as surrogates for the bombers that had filled the skies of Spain. This seems to be substantiated by the newspaper fragment that Miró kept, from *L'Oeuvre* of 9 July 1939, dealing with an air race between France, Britain and Germany and reported as if presaging conflict.[12] These anxieties appear even more acute in *Personnage blessé* (*Wounded Figure*, no.97) dated 27 March, which is the only one of the series in which the spectral central figure is frankly male. The title holds back from identifying a soldier but the large, Klee-like arrow pins down

the disfigured man's trailing foot to suggest the wounding as an Achilles' heal. The reality of hostilities had not yet taken hold across Europe, but, coincidentally perhaps, Miró's dating marks the anniversary of the last day of the Republic.

The defeat of Republican Spain was, once again, of personal concern for Miró in the first half of 1940 as he faced the choice of exile or return. Although his energies were concentrated in the *Constellations*, it seems that he also began to think about the images that would become the *Barcelona Series* of lithographs eventually printed in 1944. Both their technique and imagery have their roots in this earlier moment. Braque apparently recommended the use of lithographic transfer paper based on the experience of Marie Laurencin, who valued the flexibility of conceiving prints directly as the need arose. Miró seems to have obtained supplies from Roger Lacourrière, with whom he had worked in Paris, before returning to Spain.[13] The imagery betrays all of his misgivings over events there. In black and white,

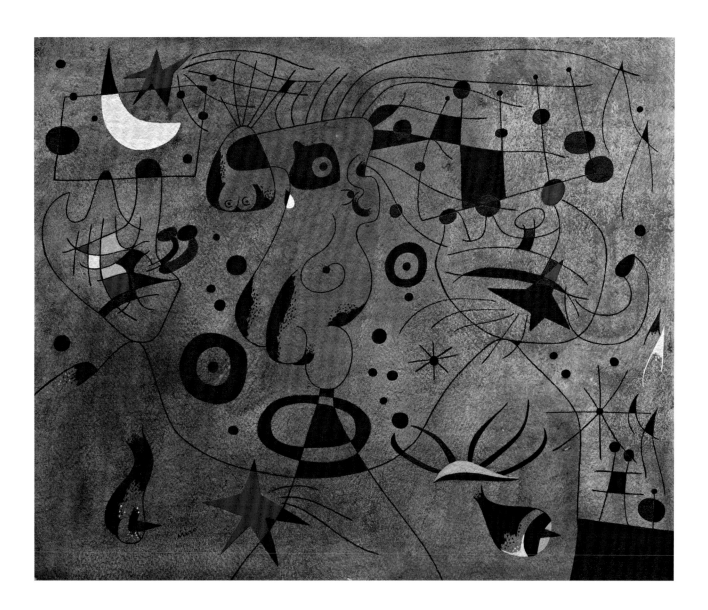

95
**Femme à la blonde aisselle
coiffant sa chevelure à
la lueur des étoiles**
5 March 1940
*Woman with Blonde Armpit
Combing her Hair by the
Light of the Stars*
Watercolour and gouache
over graphite
37.9 × 45.8
Contemporary Collection
of The Cleveland
Museum of Art

the swollen-headed figures of the *Constellations* warp even more towards the monstrous as they fill up the picture surface (nos.107–10).

Though there are no specific traces of the genesis of the *Barcelona Series*, it is possible that their format is echoed in the introduction of vertical compositions in the *Constellations* made in April and May 1940. The delicacy of *Danseuses acrobates* (*Acrobatic Dancers*), the first vertical composition, is remarkable given that the Germans launched attacks on the Netherlands and Belgium on 10 May; surrender came on 14 May, the date that Miró inscribed on the painting. The encirclement of Allied troops was soon played out at Dunkirk along the Channel coast from Varengeville. Braque left for the south and, on 20 May, Miró set out for Spain.[14] Two days earlier, André Gide recorded the summer night in his diary: 'Everything swoons and seems to be enraptured in the light of an almost full moon … I think of all those for whom this so beautiful night is the last'.[15]

It has been remarked that Miró continued the *Constellations* in Mallorca 'as though nothing had happened'.[16] However, even the date on *Le Chant du rossignol à minuit et la pluie matinale* (*The Nightingale's Song at Midnight and Morning Rain*), 4 September 1940, speaks volumes. The rhythm had been broken. Into the intervening four months he had packed: escape south to Perpignan, anxious re-entry into Spain, and avoidance of Barcelona (on Prats's advice) before reaching the haven of Pilar's family in Palma at the end of July.[17] After the long gap Miró certainly needed the earlier works at his elbow. Despite these vicissitudes, the completed paintings and stocks of paper had come out of France and in his contemporary notebooks Miró indicates how the groundwork for each composition was set by cleaning his brushes on the next sheet.[18] Even his lifelong practice of inscribing his titles in French expressed the series' continuity and, while shadowed with foreboding, *The Nightingale's Song at Midnight and*

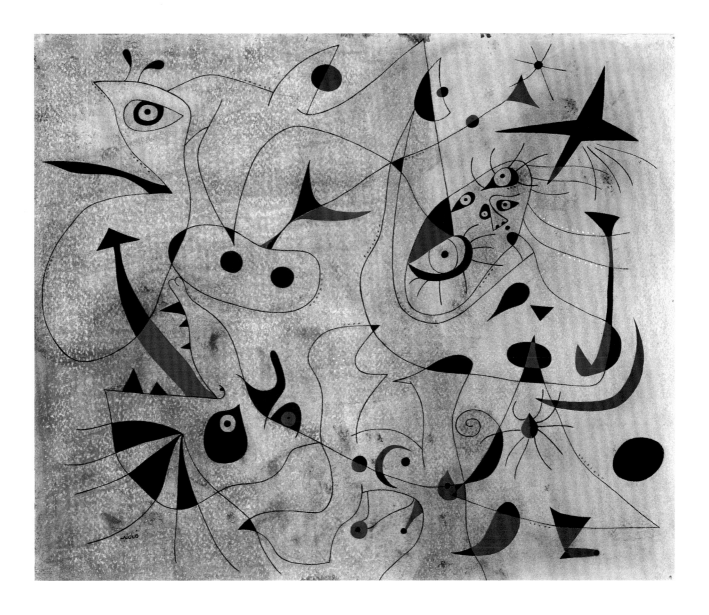

Morning Rain nevertheless suggests reprieve. It also shows how the Palma paintings would become more dense: signs swarm around the crescent moons and uneven stars, substantiating Miró's claim that any element introduced demanded another to maintain the balance.[19]

At various stages he associated this complexity with different sources of inspiration: musical, spiritual and visual. For several years Miró had been immersed in the music of J.S. Bach.[20] Its structure and purity may in turn have assumed an identification with freedom by association with Pablo Casals's famous recordings of the *Cello Suites* from exile in London and Paris in 1936–9. Bach was, therefore, both time-less and symbolic of the creativity threatened by the regime. This association with music can also be linked to spiritual qualities. The second Palma painting, *Le 13 l'échelle a frôlé le firmament* (*On the 13th the Ladder Brushed the Firmament*), makes play (just as the second Varengeville painting did) with the ladder as an image of aspiration towards a higher

consciousness and as a 'link between the terrestrial and the celestial'.[21] This evokes the claim of one of the painter's favourite poets, Gustavo Adolfo Bécquer, 'I am the unknown ladder that unites heaven and earth', and leads back to the thinking of the medieval Mallorcan mystic, Ramon Llull, whose imagery long interested the artist.[22] It is perhaps surprising that Miró later added the claim that the *Constellations* were 'based on reflections in water. Not naturalistically – or objectively – to be sure'.[23] This conjunction may make tangential reference to the cardinal elements,[24] while it also suggests an all-encompassing experience of space created in looking down and looking up. When Miró reflected on the possibility that he might be restricted to drawing with a stick in the sand or the smoke of his cigarette in the air, he emphasised an artistic compulsion (even under repressive circumstances) while also positioning himself physically and conceptually at the centre of a creative scheme.[25]

By the end of 1940 Miró had made fourteen *Constellations*,

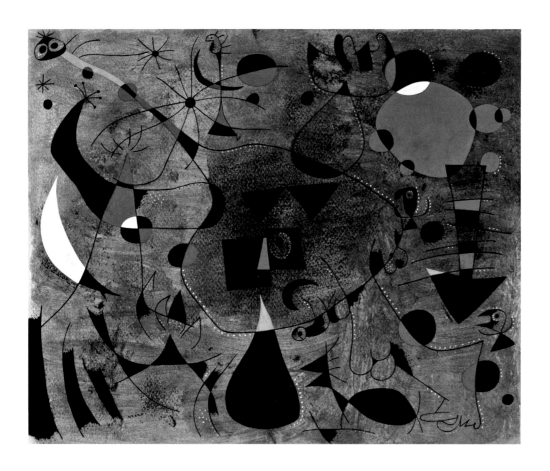

97
Personnage blessé
27 March 1940
Wounded Figure
Gouache and oil wash
on paper
38 × 46
Private collection

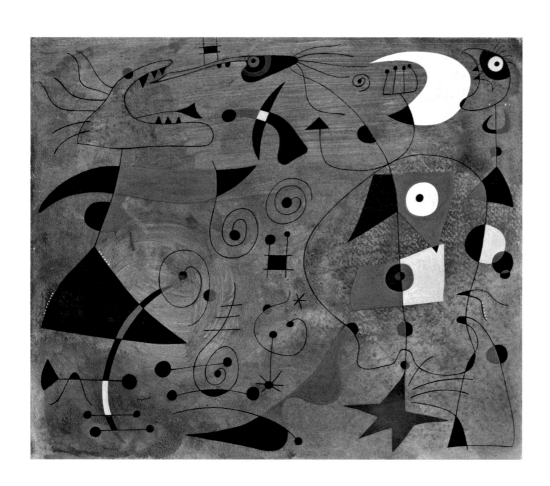

98
Femme et oiseaux
13 April 1940
Woman and Birds
Gouache and oil wash
on paper
38.1 × 45.7
Colección Patricia Phelps
de Cisneros

concluding with *La Poétesse* (*The Poetess*, 31 December, no.99). As the gaps between each extended, those made in 1941 became astonishingly complex, rightly fulfilling the boast made a year before that 'they give the impression of large frescoes'.[26] In *Le Réveil au petit jour* (*Awakening in the Early Morning*), the fifteenth of the series (27 January 1941), the figures gaze up at a sky laden with stars, moons and phalluses (no.100). It is followed by three works that may be the high-points of the series: *Vers l'arc-en-ciel* (*Toward the Rainbow*, 11 March, no.101), *Femmes encerclées par le vol d'un oiseau* (*Women Encircled by the Flight of a Bird*, 26 April, no.102) and *Femmes au bord du lac à la surface irisée par le passage d'un cygne* (*Women at the Edge of the Lake Made Iridescent by the Passage of a Swan*, 14 May, no.103). The continuing prominence of women as the central focus for Miró's imagination is made lyrical in these works, where they are sexually dominant but also parallel the grotesques of the *Barcelona Series*.

As he had stockpiled the *Constellations*, Miró's dating of *Women at the Edge of the Lake* exactly a year after the last of the Varengeville paintings suggests a time for reflection. This anniversary may also have stimulated the change of tempo, as *L'Oiseau-migrateur* (*The Migratory Bird*, no.104) followed on 26 May and *Chiffres et constellations amoureux d'une femme* (*Ciphers and Constellations in Love with a Woman*, no.105) on 12 June. They appear almost celebratory and the title of the June painting – the only one to specify 'constellations' – seems to signal release, encouraging one commentator to see the earthy woman as achieving an incorporeality 'on the verge of sexual climax'.[27] Flushed with colour and energetic line, this sparkle-eyed woman brings a hieratic finality to the series, as if the *Constellations* were being brought to a close with exposure to light.

Perhaps Miró did mean to stop the series there, with ten works each completed in Varengeville and Palma. However, in the summer of 1941 he felt confident enough in the political situation on the mainland to return to Mont-roig for the first time since 1936.[28] There, amidst the familiar landscape ('so strong and vigorous'),[29] he completed three further *Constellations* that act as a coda to the series. The titles reinforce the visual luxuriance of an enchanted erotic realm: *Le bel oiseau déchiffrant l'inconnu au couple d'amoureux* (*The Beautiful Bird Revealing the Unknown to a Pair of Lovers*, 23 July 1941), *Le Crépuscule rose caresse le sexe des femmes et des oiseaux* (*The Pink Dusk Caresses the Sex of Women and Birds*, 14 August 1941) and *Le Passage de l'oiseau divin* (*The Passage of the Divine Bird*, no.106) finished on 12 September 1941. From the anxiety of the early works, this final painting may provide resolution though this is not unequivocal. The 'divine bird' itself remains disconcertingly toothed and retains the form that Miró had given to the bird/planes of 1939. Furthermore, a snake-like creature crossing the composition to the left suggests a saboteur in this prelapsarian vision of Mont-roig.[30]

If the finale of the *Constellations* suggests a (threatened and threatening) eroticised return to his roots in Mont-roig, Miró's bitterness at the state of Spain was pouring into the *Barcelona Series* that he began there. The two series share a unity of vision: sexually charged women and uncertain men, together with animals and birds of varying degrees of aggression, populate open spaces punctured by stars or moons. His method for the fifty black-and-white drawings (nos.107–10) was, however, rather different. They are direct, even fierce, in their simplicity, and the step up in size and limitation to monochrome sharpens the critical bite. As Roland Penrose wrote in guarded allusion to the aftermath of the Civil War, 'The Suite discloses the same anger which had been provoked by the continuous deterioration of the international situation'.[31]

Miró's cast of characters here looks back to Alfred Jarry as a template for political satire. In 1937 Picasso had evoked

Jarry's brutal character, Père Ubu, in his etching *The Dream and Lie of Franco*, and the staging of *Ubu enchaîné* had been framed as a call to action against Fascism.[32] At that moment Miró had made *Portrait of Mère Ubu* for a Surrealist appreciation of the author[33] and, by 1941, the dictatorial couple provided models for the ambiguous conflation of oppressor and victim in his lithographs (no.110). The figures' isolation in space enhances the sense of the bodily distortions and, though heavy-limbed and heavy-headed, they crane their necks as if scanning the sky in expectation. This was a current pose of defiance and vulnerability, seen equally in *Aidez l'Espagne* and Picasso's *Guernica*, and implicitly linked to the threat of mass aerial bombardment utilised against civilian populations in the Civil War.[34] The raw power of Miró's imagery in the *Barcelona Series* may, therefore, have been stoked by confronting the scars of conflict (whether recounted or mute) found on returning to Mont-roig.

The drawings for the lithographs were part of a productive wave of draughtsmanship in 1941–2. He prepared them all at once using slightly glazed transfer paper to fix details with precision (nos.107–10).[35] In the eventual lithographic process, however, tonal details suffered. Certain plates include decorative borders and advertisements found at the print workshop but their delicacy is difficult to discern in the final prints. It may be to this that he alluded when he wrote in his notebook: 'I am afraid that the things I wanted to print in ink on paper to serve as a point of departure won't be strong enough.'[36] However, as Miró himself supervised the process with care and reinforced elements on the stone, he must have accepted this loss of subtlety in exchange for the greater density of attack (see nos.6 and 14).

Despite their common origins, the techniques of the *Constellations* and the *Barcelona Series* seem to point to different ambitions and audiences. In March 1944 wartime conditions allowed plans to be made for shipping the *Constellations* from Lisbon to the Museum of Modern Art in New York where the artist specified that they must be shown together in chronological order so as to 'explain my evolution and my state of mind'.[37] Miró also requested that the titles on the reverse be visible and, from the consistent information and figurative framing, it seems that he must have prepared these elegant inscriptions at one sitting for this purpose.[38] While these plans matured, Prats arranged for Miró to print the *Barcelona Series* at the Miralles workshop, where the extraordinarily limited edition of five with two sets of proofs was completed by 15 May 1944.[39] Their character was far from what was acceptable to the new cultural conservatism, and their display within Spain took on a clandestine nature.[40] Probably due to the impact of the death of his ailing mother on 27 May, Miró declined to exhibit in the city soon after,[41] so that it fell instead to Prats to display the lithographs in his home which, as a meeting-place for artists and intellectuals, allowed them to permeate the city's culture by stealth (see no.116). Significantly, their production outran the transatlantic shipping arrangements so that all five sets of the *Barcelona Series* were added to the *Constellations* when they eventually left in July.[42]

In November, Pierre Matisse took over the works from the Museum of Modern Art and prepared an exhibition for January 1945 that would overwhelm New York. Although showing only sixteen of the *Constellations*, he told the artist: 'You have attained an unprecedented degree of poetic intensity, and in the colours as in the line a dazzling mastery.'[43] In the following year, André Breton told an interviewer that from the evidence of the series, 'no Surrealist artist has shown greater capacity for renewal, nor moved further forward in the confirmation of his mastery, than Miró, who unfortunately is still held in Spain'.[44] More lyrically and at the time that he affirmed the series title, Breton later recalled the arrival of the *Constellations* in New York: 'their sudden impact was to consume the tearing wind and the black night, these are our own constellations.'[45]

99
La Poétesse
31 December 1940
The Poetess
Gouache and oil wash on paper
38 × 46
Private collection

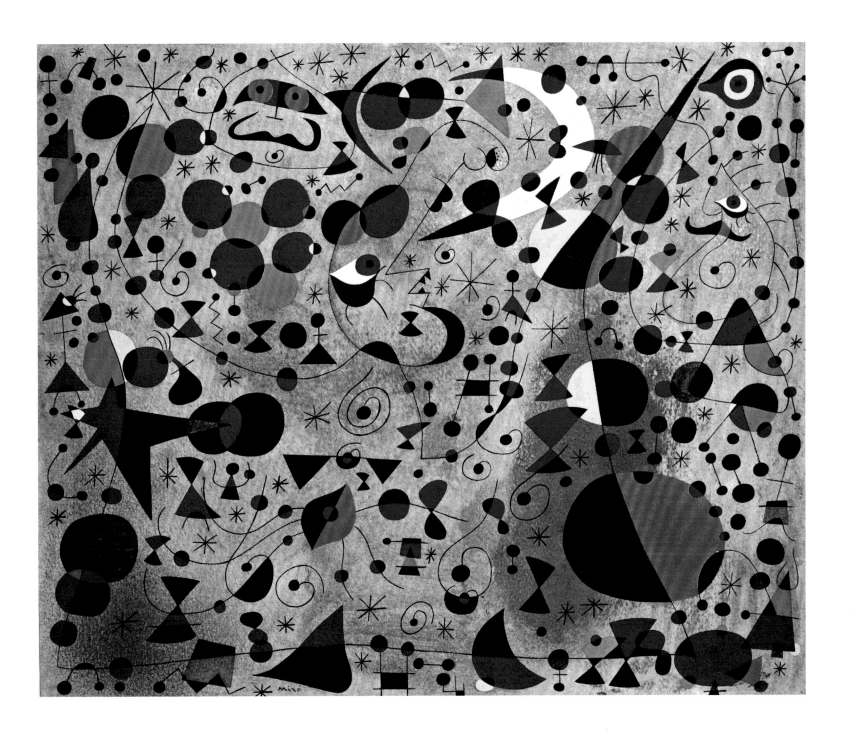

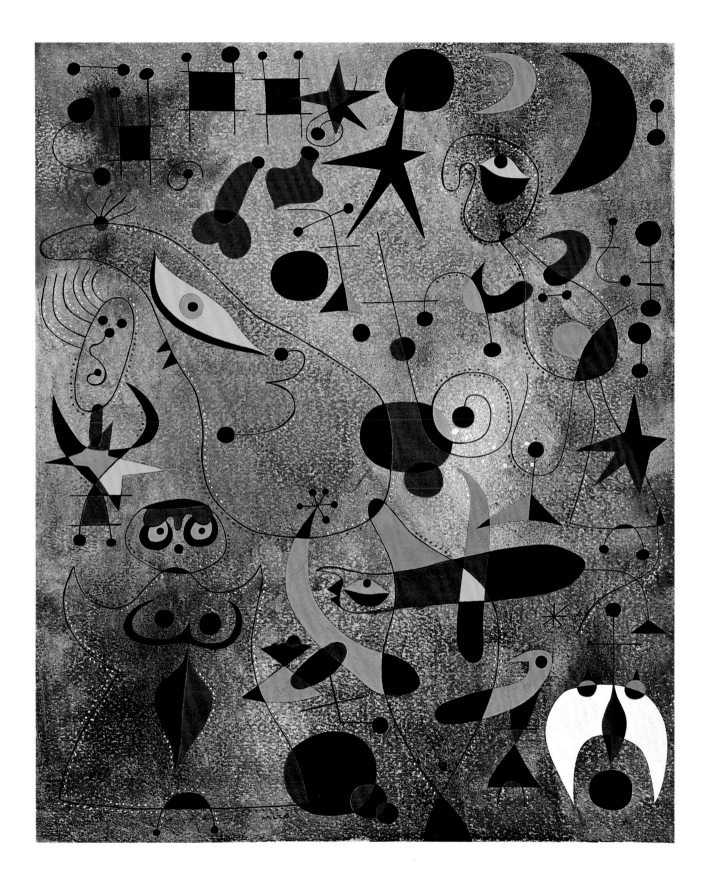

100
Le Réveil au petit jour
27 January 1941
*Awakening in
the Early Morning*
Gouache and oil wash
on paper
46 × 38
Kimbell Art Museum, Fort
Worth, Texas. Acquired with
the generous assistance of
a grant from Mr. and Mrs.
Perry R. Bass

101
Vers l'arc-en-ciel
11 March 1941
Toward the Rainbow
Gouache and oil wash
on paper
46 × 38
Metropolitan Museum
of Art, New York.
Jacques and Natasha
Gelman Collection, 1998

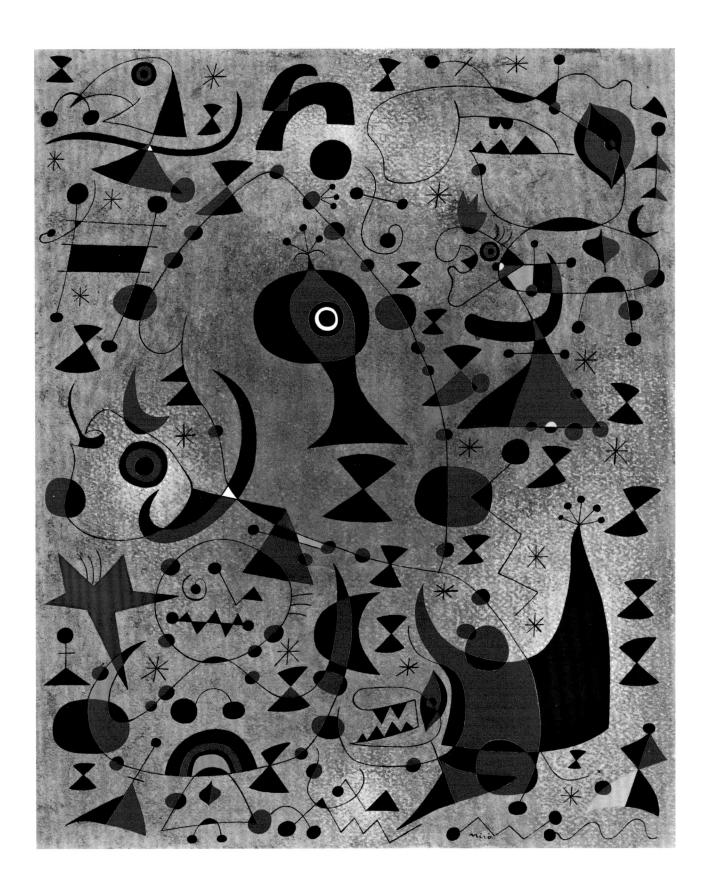

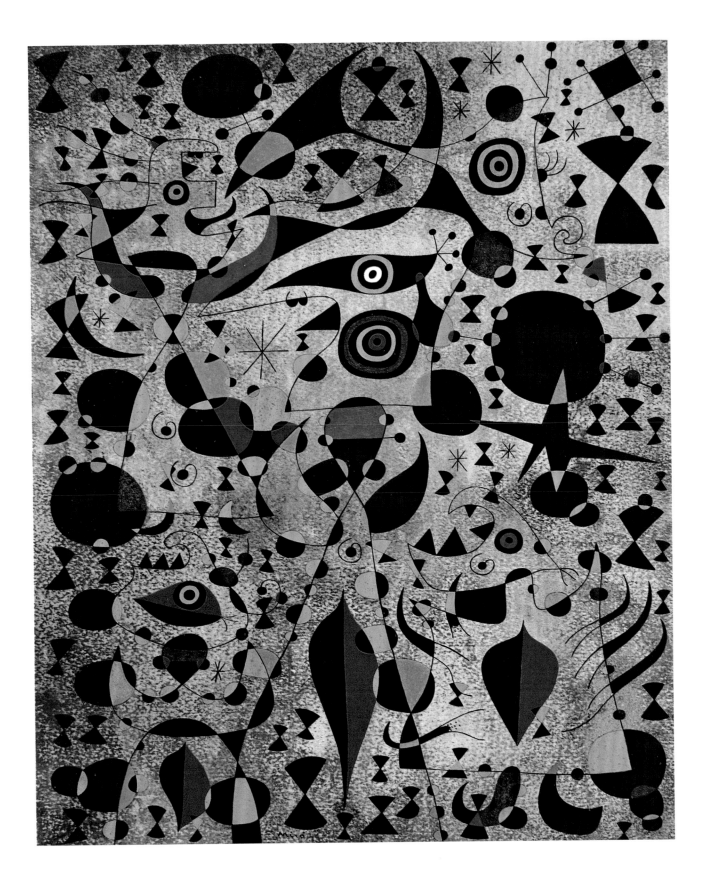

102
Femmes encerclées par le vol d'un oiseau
26 April 1941
Women Encircled by the Flight of a Bird
Gouache and oil wash on paper
46 × 38
Private collection. Courtesy Galerie 1900–2000, Paris

103
**Femmes au bord du lac
à la surface irisée par
le passage d'un cygne**
14 May 1941
*Women at the Edge of
the Lake Made Iridescent
by the Passage of a Swan*
Gouache and oil wash
on paper
46 × 38
Private collection

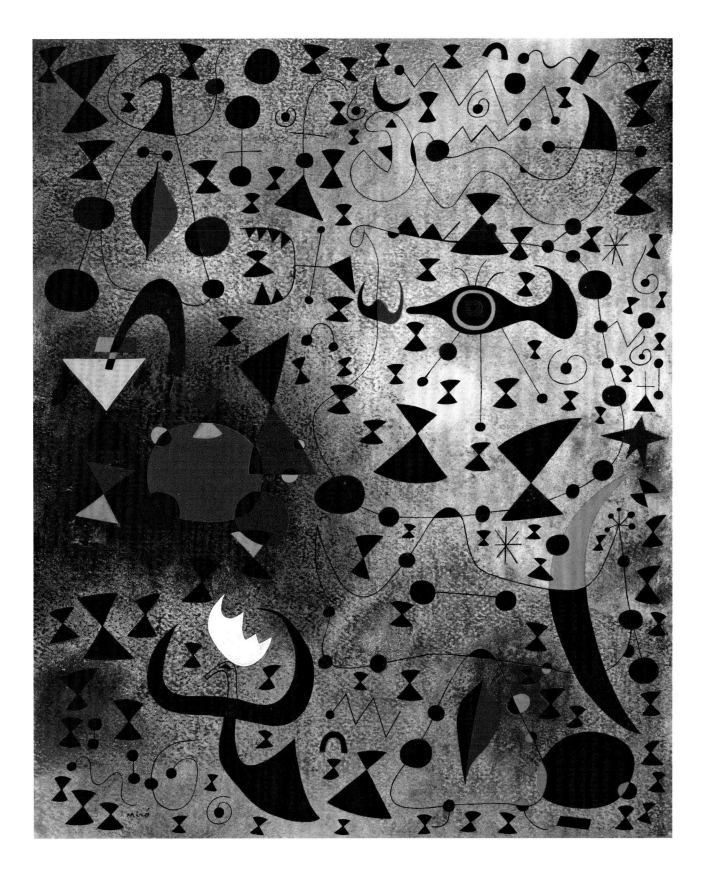

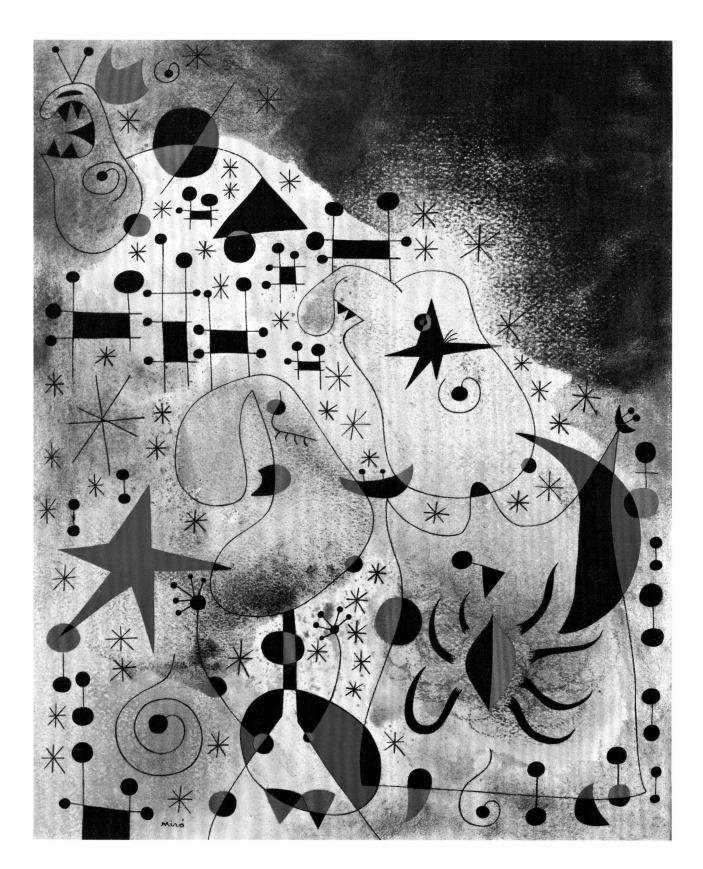

104
L'Oiseau-migrateur
26 May 1941
The Migratory Bird
Gouache and oil wash
on paper
46 × 38
Private collection

105
Chiffres et constellations amoureux d'une femme
12 June 941
Ciphers and Constellations in Love with a Woman
Gouache and oil wash
on paper
46 × 38
Art Institute of Chicago.
Gift of Mrs. Gilbert
W. Chapman

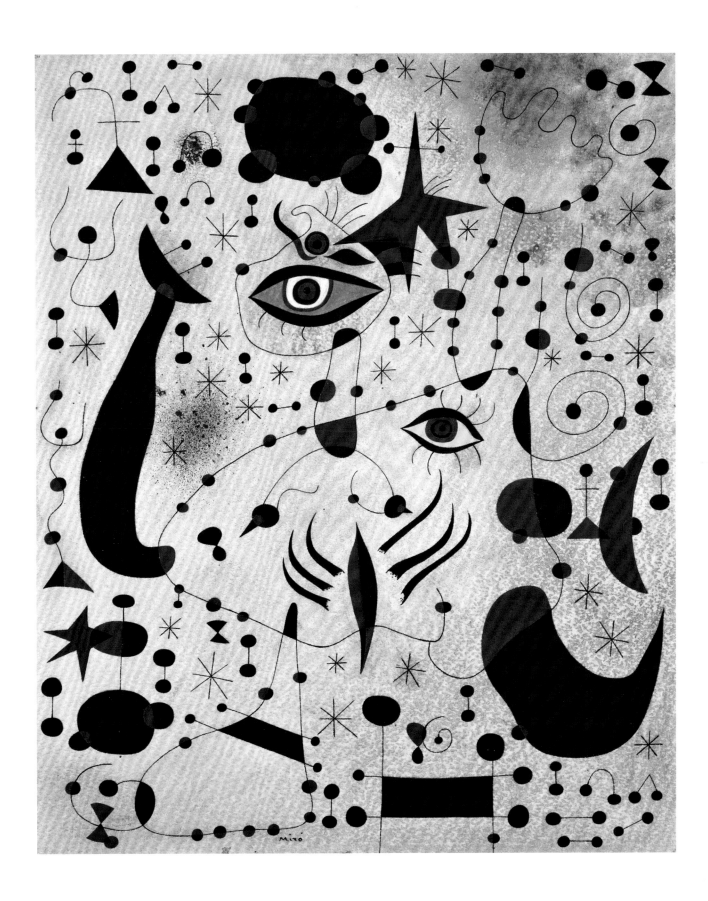

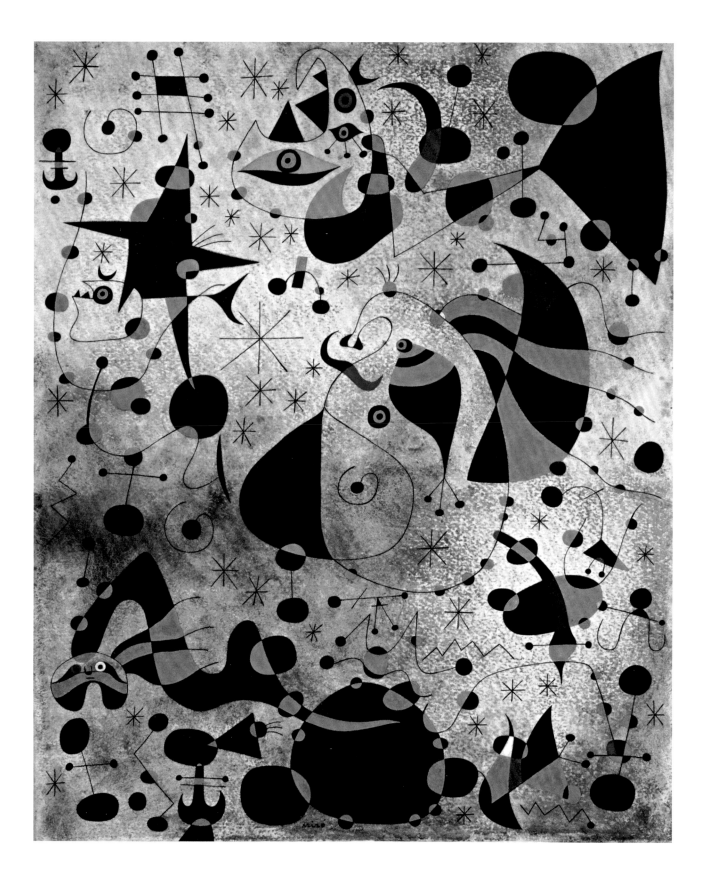

106
**Le Passage de l'oiseau
divin** 12 September 1941
*The Passage of
the Divine Bird*
Gouache and oil wash
on paper
45.7 × 37.8
Toledo Museum of Art.
Purchased with funds from
the Libbey Endowment,
Gift of Edward
Drummond Libbey

1 Raymond Queneau, *Joan Miró, ou, Le Poète préhistorique*, Paris 1949, p.3. Miró and his family were at Le Clos des Sansonnets in Varengeville by 27 July 1939 (letter to Domènec Escorsa; see Minguet, Montaner and Santanach 2009, p.594). Miró and his family had holidayed at Varengeville in 1937 and 1938; Queneu was mobilised while on holiday there on 24 August (see Jean Hélion, *Lettres d'Amérique: Correspondance avec Raymond Queneau, 1934–1967*, Paris 1996, p.152). He refers to *Femmes aux chevelures défaités salutant le croissant de la lune* painted that day, repr. in *Cahiers d'Art*, nos.3–4, 1940, p.41, (Dupin and Lelong-Mainaud 2000, no.615).

2 Miró (Varengeville) to Pierre Matisse, 4 Feb. 1940, in Rowell 1986, p.168.

3 Miró worked into the night as indicated by the inscription 'de 11 hr à minuit' on seven drawings made on 6 March 1940 (the day after completing the fifth *Constellation*); they are all in Fundació Joan Miró (FJM 1890, 4522a, 1891, 1892a, 1893, 1896, 1897, repro. in Malet 1988, pp.208–9). Roland Penrose (1970, pp.181–93) discusses night, 'rich in ambiguities and confusions', as a primary theme. Hammond (2000, p.40) notes that Miró's father was an amateur astronomer.

4 Miró (Varengeville) to Pierre Matisse, 12 Jan. 1940, in Rowell 1986, p.168.

5 Miró wrote to Josep Lluís and Moncha Sert of 'concentration' and 'near isolation', [late 1939], in Minguet, Montaner and Santanach 2009, p.596, no.443.

6 Miró (Varengeville) to Pierre Matisse, 4 Feb. 1940, in Rowell 1986, p.168.

7 The pattern is broken around *Femmes sur la plage* (*Women on the Beach*, 15 Feb. 1940), completed only three days after the third but followed by an eighteen-day gap to the dating of *Woman with Blonde Armpit Combing her Hair by the Light of the Stars* (5 March 1940). He seems to have pinned down each new sheet in the same way, as is indicated by the pin holes at the corners and the sides of each *Constellation*.

8 Miró, *Cahiers d'Art*, Apr.–May 1939, p.73, trans. in Rowell 1986, p.166. For this moment see also William H. Robinson, 'The Fall of the Republic', in Robinson, Falgàs and Lord 2006, pp.474–81.

9 Miró (Varengeville) to Domènec Escorsa, 28 Jan. 1940, in Minguet, Montaner and Santanach 2009, p.601.

10 Braque (Varengeville) to Paul Rosenberg, 6 Oct. 1939, cited in Alex Danchev, *Georges Braque: A Life*, London 2005, p.206.

11 Miró reserved *Morning Star* for his wife, Pilar, and did not send it to be exhibited by Pierre Matisse in 1945, which explains why he often (rightly) writes of a series of twenty-two works.

12 *L'Oeuvre*, 9 July 1939: 'Les aviateurs française, britannique et allemande se rencontreront demain au-dessus du territoire belge. Mais ce ne sera qu'un carrousel' (FJM no.791, repro. in Malet 1988, p.205). I am grateful to Teresa Montaner for discussing this material with me. See also her essay in this volume for a further echo of the bird/plane image.

13 According to Joan Prats (quoted in Borràs 1984, p.4) Miró had worked with Lacourrière on etchings in 1938.

14 Dupin 1962, p.356.

15 André Gide, 18 May 1940, in *Journals 1889–1949*, trans. and ed. Justin O'Brien, Harmondsworth 1967, p.642.

16 Dupin 1962, p.356.

17 Extrapolating from Miró (Perpignan) to Pierre Matisse, 6 June 1940, Anne Umland places Miró in Perpignan 'by 1st June' and crossing into Spain around 8th June (Umland 1993, p.335). They went to Miró's sister in Tona rather than to Barcelona (according to Prats, in Borràs 1984, p.4). By 31 July Miró was dating drawings in Palma (e.g. FJM 1802, 1803, 1804, 1807, 1808, 1812a, 1814a).

18 Pilar Miró (Palma) to Prats, 14 Aug. 1940 (Minguet, Montaner and Santanach 2009, p.603) refers to the arrival of a package – perhaps of art supplies – left at Rouen. The preparation from one sheet to the next is noted in Catalan notebooks, Rowell 1986, pp.185, 187.

19 Miró quoted in Dupin 1962, p.358.

20 Bach (and Mozart) are cited in 'Où allez-vous, Miró?', *Cahiers d'Art*, nos.8–10, 1936 [published 1937], trans. in Rowell 1986, p.152; and Miró (Varengeville) to Francesc Trabal, 2 Dec. 1939, in Minguet, Montaner and Santanach 2009, p.597. In Palma Miró planned a series inspired by music heard in the Cathedral (see no.83).

21 Rosa Maria Malet, 'From the Murder of Painting to the *Constellations*', in Malet and Jeffett 1989, p.22. *On the 13th the Ladder Brushed the Firmament* is dated 14 Oct. 1940.

22 Gustavo Adolfo Bécquer, *Rima*, 5:17, in Rimas y Leyendas, (1868), Madrid 1978, p.18. For Llull see, for instance, David Hopkins, 'Ramon Llull, Miró and Surrealism', *Apollo*, vol.138, no.382, Dec. 1993, pp.391–4; Carme Escudero i Anglès, 'Theatrum chemicum: Miró and the art of transmutation', in Anglès, Bravo and Malet 1994, pp.365–84; M.J. Balsach 'Symbolic Images of the Primordial World: Joan Miró and the Parade of Obsessions' in *Joan Miró* 2001, pp.161–8, and Balsach 2007.

23 James Johnson Sweeney, 'Joan Miró; Comment and Interview', *Partisan Review*, Feb. 1948, in Rowell 1986, p.210. Miró may have depoliticised his references for his American audience.

24 Margit Rowell discusses the elemental reading in 'André Breton et Joan Miró', in Agnès Angliviel de la Beaumelle, Isabelle Monod-Fontaine and Claude Schweisguth (eds.), *André Breton: La beauté convulsive*, exh. cat., Musée national d'art moderne, Centre Pompidou, Paris 1991, p.181.

25 Recalled in 1978 in an interview with Lluis Permanyer, in Rowell 1986, p.294. Whether deliberately or not, Miró's image recalls the legend of the death of Archimedes while drawing in the sand. Hammond (2000, pp.22–7) gives a brief, dramatic account of Mallorca's immediate fall to the army in 1936, the arrival of the Italian Fascists and the atmosphere in 1940.

26 Miró (Varengeville) to Pierre Matisse, 4 Feb. 1940, in Rowell 1986, p.168.

27 William Jeffett, 'A "Constellation" of Images: Poetry and Painting, Joan Miró, 1929–41', in Malet and Jeffett 1989, p.37.

28 His mother had moved there during the Civil War and was a cause for grave concern when Mont-roig was overrun in 1939; noted in Miró (Paris) to Pierre Matisse 2 Jan 1939, reproduced in Dupin, Lelong-Mainaud and Punyet Miró 2007, [p.30].

29 Miró (Mont-roig) to Prats, 8 Aug. 1941, in Minguet, Montaner and Santanach 2009, p.608, no.451.

30 A similar snake appears in *The Beautiful Bird Revealing the Unknown to a Pair of Lovers*.

31 Penrose 1970, p.108.

32 Picasso's *The Dream and Lie of Franco* is dated 8 Jan. 1937. *Ubu enchaîné* was produced by Sylvain Iktine with sets by Max Ernst, Théâtre des Champs-Elysées, on 22–26 September.

33 For *Portrait of Mère Ubu* (in *Ubu enchaîné*, Paris 1937) see Isidre Bravo, 'A theatre man named Joan Miró', in Anglès, Bravo and Malet 1994, trans. p.355. Various books by Jarry survive in Miró's library held at the Fundació Joan Miró including *Gestes et opinions du Docteur Fustroll*, Paris 1923, and *L'Amour absolu*, Paris 1932; I should like to thank Sònia Villegas for confirming these details.

34 Epitomised by the anonymous and undated English-language *Guernica* published to document the city's destruction (see facsimile in *De Gernika a Guernica*, Barcelona 2007, vol.1) and the anonymous poster of a dead child seen against a squadron in the sky, entitled *Madrid: The 'Military' Practice of the Rebels*, Imperial War Museum.

35 The paper, which is wetted in the process, allows the stone to be an intermediary phase, so that the final print is in the same orientation as the original. Miró notes various experiments with the paper in his notebooks, Rowell 1986, pp.177–8.

36 'Working Notes 1941–42', in Rowell 1986, p.178.

37 Miró's friend Paulo Duarte (Lisbon) to Philip L. Goodwin (Museum of Modern Art), 5 March 1944, in Umland 1993, p.336. As noted above, twenty-two were sent as Pilar's *Morning Star* did not go to New York.

38 They have the same order ('Joan Miró', title, location, date) and graphic flourishes (e.g. the spiral below the title), though each framing element is unique. Miró's Academia Cots ledger (FJM 4269–83) confirms these precise details but, as it also seems to have been made *post facto*, must share a source in a (lost) document or diary.

39 Miró (Barcelona) to Duarte, 15 May 1944 (in Umland 1993, p.359, n.665), and Miró (Barcelona) to the printer Enric Tormo [May 1944], (in Minguet, Montaner and Santanach 2009, p.641). Limits on material may have been a consideration as the edition ran to approximately 400 sheets of paper.

40 For a recent discussion of Francoist censorship see José Ángel Ascunce Arrieta, 'Ideologisation Tools in the Press during Franco's Early Years: Vértice as an Example', in Jordana Mendelson (ed.), *Magazines, Modernity and War*, Madrid 2008, pp.161–78.

41 Miró (Barcelona) to Carles Soldevila (Galeria Argos), 30 July 1944, in Minguet, Montaner and Santanach 2009, p.643. His mother's ill health may have been among the reasons for Miró's return to Barcelona in 1942.

42 Duarte (Lisbon) to Goodwin, 10 July 1944 (in Umland 1993, p.336), sent 22 paintings, 7 ceramics and 250 lithographs, due to dock in Philadelphia between 23 and 30 July.

43 Matisse (New York) to Miró, 17 Jan. 1945, in Umland 1993, p.336. The Pierre Matisse Gallery exhibitions were *Joan Miró: Ceramics 1944, Tempera Paintings 1940 to 1941, Lithographs 1944*, 9 Jan.–3 Feb. 1945, and *Joan Miró: 1944 Lithographs*, 5–25 Feb. 1945.

44 André Breton interview with Jean Duché, in *Le Littéraire*, 5 Oct. 1946, republished in *Entretiens*, Paris 1969, trans. in André Breton, *Conversations: The Autobiography of Surrealism*, trans. Mark Polizzotti, New York 1993, p.200.

45 André Breton, *L'Oeil*, Dec 1958, republished by Pierre Matisse in the facsimile edn, 1959. See also Marc Rolnick, *Miró Constellations: The Facsimile Edition of 1959*, exh. cat., Neuberger Museum, State University of New York 1983.

107
Barcelona Series (III)
1944
Lithographic pencil and
Indian ink on transfer paper
63.5 × 47.5
Fundació Joan Miró,
Barcelona

108
Barcelona Series (VII)
1944
Lithographic pencil
on transfer paper
63.5 × 46.3
Fundació Joan Miró,
Barcelona

109
Barcelona Series (XVI)
1944
Lithographic pencil
on transfer paper
60.2 × 44
Fundació Joan Miró,
Barcelona

110
Barcelona Series (XXII)
1944
Lithographic pencil
on transfer paper
62.8 × 45.8
Fundació Joan Miró,
Barcelona

111
Femme et fillette devant le soleil 30 November – 19 December 1946
Woman and Little Girl in Front of the Sun
Oil on canvas
145.8 × 114.1
Hirshhorn Museum and Sculpture Garden, Smithsonian Institution, Washington DC. Gift of the Joseph H. Hirshhorn Foundation, 1972

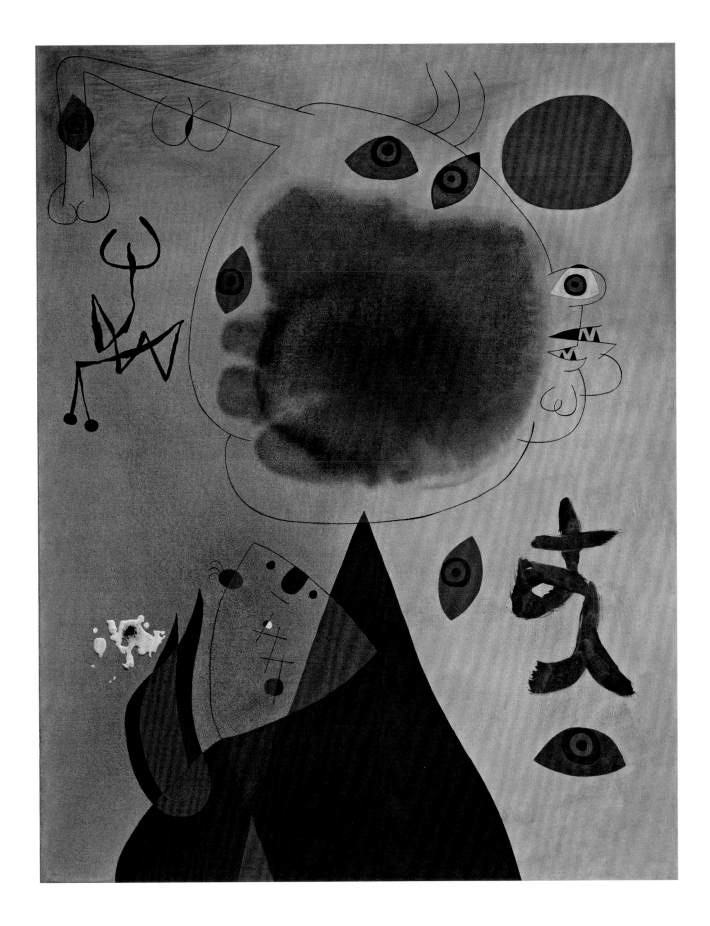

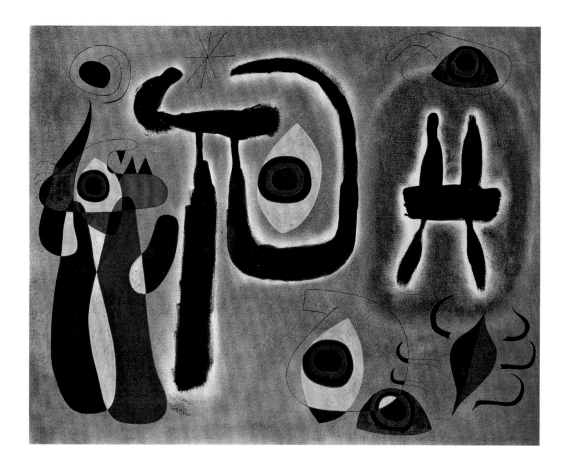

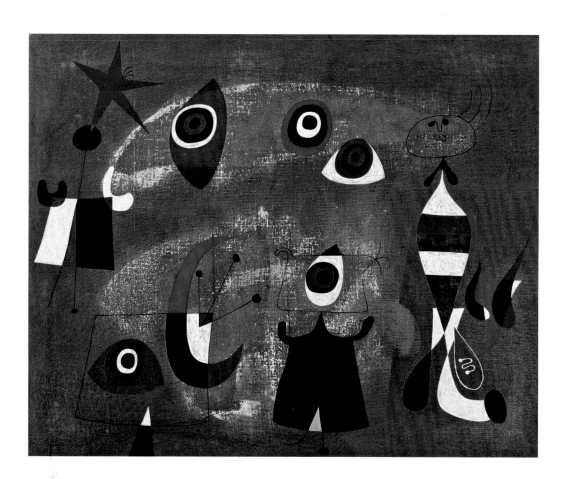

114
**Femmes, oiseau au clair
de lune** October 1949
*Women and Bird in
the Moonlight*
Oil on canvas
81.3 × 66
Tate. Purchased 1951

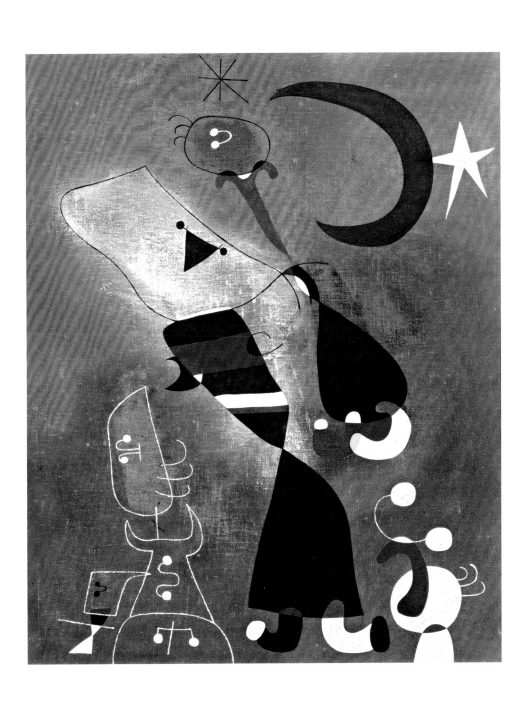

Forms of Commitment or Commitment without Form: The Other Miró

JOAN M. MINGUET BATLLORI

Of all Catalans, there is none that has been able to surpass you in their empathy, their living unity with our age-old vitality and their sense of universality. For us, not only are you a generous benefactor but remain an example of what we could become by virtue of determined ambition and self-improvement.[1]

This letter, written on 18 July 1948, twelve years after Francisco Franco's fascist uprising against the Republic, is very interesting for a number of reasons. Josep Carner was a highly esteemed poet who had been one of the principal writers of the *Noucentisme* movement – part of the early twentieth-century regeneration of Catalan culture – and went on to establish himself as a key figure in Catalan culture and society. In 1945 Josep Irla, President of the Generalitat de Catalunya – Catalonia's government in exile – made him a government minister. Without doubt, his enthusiastic message regarding Miró's work in support of the Catalan cause has a clear political significance.

In his letter Carner not only writes as a poet, praising Miró for his cultural work, but he also displays a clear passion for what his painter colleague had done for Catalonia as a universal artist: through his commitment to the Republic in war time and through his support in the years following the collapse of democracy in Catalonia and in Spain.[2] It seems obvious to me that when Carner wrote this letter to Miró he was recalling the artist's participation in the Spanish Republican Pavilion at the 1937 Paris Exposition Internationale. Projects such as *Le Faucheur* (*The Reaper*, pp.118–21) and *Aidez l'Espagne* (literally, *Help Spain*, no.115) were clear and constant examples of the artist's 'Catalanity', as was his persistent desire to be known by his Catalan forename, 'Joan', and not by its Spanish translation. But Carner must also have had more recent events in mind. For example, we know that four days before he wrote his letter Miró had received a visit from another Catalan writer, Armand Obiols, probably sent by Carner himself to ask the artist to donate one of his works to be sold in order to fund the *Revista de Catalunya*, a prestigious publication in 1930s Catalonia that was now experiencing a revival in exile.[3]

Miró had won the esteem of many exiles, like Carner, and also of many important cultural figures who had remained in Spain or who had returned to the country after spending time in exile. While, from France, Picasso played an enormously significant symbolic role (as we know, the creator of *Guernica* was the artist who caused the greatest problems and annoyance to the Franco regime), Miró played a guiding role for new generations of artists and intellectuals emerging from the arid cultural landscape of the dictatorship. These figures, many of them encouraged by Joan Prats, would visit the artist's studio seeking advice, requesting some form of collaboration or simply wishing to share a few valuable moments with the master. The painter Joan Ponç described these encounters 'as a sacred visit to a sacred place'[4]. Through Miró's studio passed figures who would come to play a paramount role in both the Catalan and Spanish cultures of resistance, including Joan Brossa, Pancho Cossío, Modest Cuixart, Josep Palau i Fabre, Benjamín Palencia, Joan Ponç and Antoni Tàpies. In fact, Brossa, Tàpies, Ponç and Cuixart, along with others such as Arnau Puig, Joan Josep

145

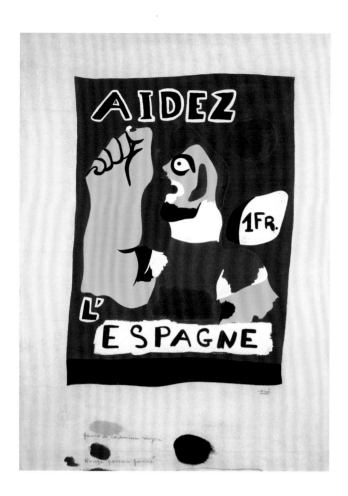

115
Aïdez l'Espagne 1937
Help Spain
Sketch for pochoir,
gouache on paper
57 × 43.2
Collection Zervos, Vézelay

Tharrats and Juan Eduardo Cirlot, formed the *Dau al Set* (Seven-Spotted Die) group and magazine, which had clear Surrealist tendencies and provided a platform for a debate between Dalí's oneirism and Miró's automatism. During the 1940s and the early 1950s, despite the clandestine atmosphere in which he had to move, Miró acquired a symbolic role, becoming a unique reference point and forming a bridge between the effervescence of the Catalan artistic avant-garde prior to the Spanish Civil War and the cultural devastation and restrictiveness of the post-war period.

It was an appreciation of this symbolic role in support of cultural freedom and active resistance inside and outside the country that Carner was expressing in 1948. Miró's involvement in a number of pro-democratic causes never ceased: he lent support through his work, his presence and his name. As his participation was often anonymous, it is difficult to establish a list of his donations, the meetings he attended or his acts of complicity. Nevertheless, a number of them may be recalled here: his collaboration with the Catalan magazine *Poesia*, published in secret by Josep Palau i Fabre, of which more later; his 1947 contribution to another magazine, *Ariel*, written in Catalan (a language then restricted by the dictatorship) producing a drawing, published in the December issue,

as a full-page illustration to accompany René Char's poem 'Complainte du lézard amoreux'; his continuous involvement with the Club 49 group which, in Barcelona in the 1950s and 1960s, organised numerous events of cultural resistance, many of them with Miró's acquiescence or, indeed, actual presence;[5] his donation of a work from his personal collection to be auctioned with the proceeds going to the victims of the dramatic floods that occurred in the province of Barcelona on 25 September 1962;[6] his design for the cover of protest singer Raimon's 1966 record *Cançons de la roda del temps*; his participation on 12 December 1970 in the sit-in staged at the monastery of Montserrat by a number of artists and intellectuals in protest at the so-called 'Trial of Burgos', a military court held by the regime to try sixteen ETA members; his donation of a work to the Museum of Solidarity opened in Santiago de Chile in May 1972;[7] his signing of the 'Manifest de solidaritat amb l'Assemblea de Catalunya' ('Manifesto of solidarity with the Assembly of Catalonia') in 1975, along with other artists and intellectuals such as Josep Lluís Sert, Tàpies and Salvador Espriu;[8] his donation of 5,000 francs as an expression of solidarity and support for the Liga de Mutilados e Inválidos de la Guerra de España en el Exilio (providing support for those injured in the Spanish Civil War and living in exile) in 1977;[9] his donation of a new work for

the establishment of the Salvador Allende Museum of
Resistance in May 1980;[10] and not forgetting the posters
he designed free of charge, the drawings he produced for
independent or underground publications and the events
he attended to lend symbolic support.

Forms of commitment

Was the commitment suggested by these and other actions
expressed in Miró's work? It is clear that he was not a propa-
ganda artist, nor did he use realism to condemn or provoke.
Despite his very personal commitment to freedom and
democracy, especially for his own people suffering under
the yoke of an appalling dictatorship, he continued to remain
loyal to his strange and complex world of symbols and his
vocabulary of signs. However, at certain points in Miró's
iconographic programme his figures and his characters
appear to undergo a metamorphosis or fusion and create in
the viewer a tension that seems to come from somewhere
beyond Miró's usual creative realm.

The series of lithographs known as the *Barcelona Series*,
for example, is very interesting in this respect. Published in

1944, Miró had worked on these since 1939. The artist had
recently produced his *Constellations*. While working on the
Barcelona Series he also produced other pieces (the majority
associated with the representation of a woman, a bird, against
the sun or at night, as well as other characters associated
with stars, the moon, the ladder of escape, etc.) in which
forms appear to be very similar if not the same as those
in the group of fifty black and white lithographs of the
Barcelona Series. Thus, the vocabulary of forms is similar but
the relationships between them do not appear to flow with
the same logic. In the *Barcelona Series* the characters are
more distorted, with eyes that are obsessive and menacing
or otherwise sad: in lithograph XVII (no.117), for instance,
the main character is terrifying. The series appears to be populated
by monsters and vulnerable beings, as if a metaphor for the
situation in which the people of Barcelona, Catalonia and
Spain found themselves at that time.

The contrast between the *Constellations* and the *Barcelona
Series* demonstrates how Miró's work arises out of a dialogue
– or debate, struggle or conciliation – between reality and the
world of imagination. In the 1930s some tormented, elongated
figures burst into this debate, announcing or denouncing the
fratricidal war between the Spanish Republic and the Fascist

uprising. It appears that reality was so powerful, so immanent, that the artist could not escape it.[11] However, Miró's response to the onset of the Second World War was different. He withdrew and returned to his imaginary world, to his own pictorial reality. In the *Constellations* the artist, who was now approaching fifty, definitively condenses his repertoire of signs that originated long before and had since become fixed in the global perception of contemporary art.

One of the most iconic pieces of the *Constellations* series has the descriptive title *L'Échelle de l'évasion* 1940 (*The Escape Ladder*, see no.9). Ladders or stairs had already featured in Miró's work, but here their presence has a double meaning that extends to all the *Constellations*: escape is a stage of elevation, of artistic overcoming, while at the same time expressing a flight from an ominous reality. Miró was to return to this reality in the *Barcelona Series* and at other moments of his career.

During the 1960s, Miró sharpened his political commitment, both in his work and outside it. There is one painting that stands out in this respect: *Mai 68* (*May 68*, no.120), composed between May 1968 and December 1973. The title of the piece and the time of its conception leave no doubt that Miró is focusing on the representation and evocation of an important moment: the rebellion of youth. His painting expresses this, especially in the hands that appear to be printed on the canvas and in the apparently formless and informal brushstrokes that proliferate throughout the composition. Years later, he would say of this piece: 'I believe that the very title of the work and the years with which it is dated say it all: *May 1968*. A sense of drama and expectation in equal measure: what it was and what remained of that unforgettable rebellion of youth, not uncharacteristic of our time.'[12]

The handprints on the canvas recall the handprint in red ink that he had placed on issue thirteen of the Catalan magazine *Poesia* (1944–5), an underground publication run by the poet Josep Palau i Fabre. Miró's red hand was printed over the Catalan translation of 'Lettre du Voyant' by French poet Arthur Rimbaud. *Poesia* was written in Catalan at a time when the language was restricted by the dictatorship. It published medieval texts, poems by contemporary Catalan writers such as J.V. Foix, Carles Riba, Salvador Espriu and Palau himself, and translations of Stéphane Mallarmé, Paul Eluard, Rimbaud and André Breton, among others.[13] That hand, like those on the canvas dedicated to the May 1968 protests in France, acquired a clear anti-establishment meaning. Miró had placed his handprints on canvas on other occasions, though perhaps not with the intention of protesting; in *May 68*, however, his intention is clear. Furthermore, some of the black brushstrokes and the lines of ink that drop down the canvas (Miró's own version of drip painting) bear similarities to the gestural doodling Miró produced in Barcelona on the windows of the Colegio Oficial de Arquitectos de Cataluña y Baleares (Association of Architects of Catalonia and the Balearics) for the *Miró Otro* exhibition in 1969.

118
Josep Llorens Artigas leaning
against Joan Miró and Josep
Llorens Artigas's **Wall of
the Moon** 1958, UNESCO
Headquarters, Paris, 1958
Time & Life Pictures

Miró's participation in *Miró Otro* is relevant in itself, and his actions and work for the exhibition can be read in various ways. Above all, this was an alternative exhibition that brought recognition to Miró as a Catalan artist, at a distance from institutional art.[14] Quite apart from the ground-breaking manner of presenting the artist's career in parallel with the political events of his time (the *Barcelona Series* was exhibited there, for example), Miró performed something akin to a happening. The night before the opening, in collaboration with the group of architects who had organised the exhibition, he produced an ephemeral painting on the windows of the building, on which the architects had already prepared background sketches with inscriptions, some of them clearly political and in support of freedom for Catalonia (pp.176–9). Some weeks later, on 30 June 1969, Miró himself destroyed the paintings. There had been some controversy over whether or not Miró should destroy them. A debate was held at the Colegio de Arquitectos itself (chaired by the critic Alexandre Cirici with a panel including Jacques Dupin, Joan Prats, Joan Brossa, Baltasar Porcel, Pere Portabella and others) to discuss whether the paintings should be erased as a response to the institutional system of art, or whether they should be retained for the city. Miró was in favour of the first option.[15]

The triptych *L'Espoir du condamné à mort* 1974 (*The Hope of a Condemned Man,* see no.159) has a double significance in terms of Miró's commitment. Firstly, it is the expression of a venerable old man in his eighties, committed

to freedom in a country impassively witnessing the execution of a young anarchist, Salvador Puig Antich, on 2 March 1974. The supposed escape seen in the *Constellations* gives way to a renewed attitude of commitment to freedom. Miró was working on the triptych before the execution of the young Catalan and, in his conversations with Georges Raillard, stated that he had finished the work on the very day of the execution; he may in fact have finished it some days earlier, as he himself stated in another interview,[16] but the harmony with the final meaning of the triptych was total. In a note written by the artist on 14 December 1973, three months before Antich's execution, Miró had named the work *L'Espoir du prisonnier* (*The Prisoner's Hope*),[17] and its composition was radically different from that of the far more lyrical *L'Espoir du navigateur* (*The Navigator's Hope*), for example.

What is also interesting about this triptych is that Miró openly expressed his desire for his work to be associated with one of the final victims of the Franco dictatorship. The triptych is another example of the ongoing rejuvenation of his painting. The three backgrounds crossed by a thin black line and the warm colour notes that accompany it demonstrate that Miró continued to know where the pictorial modernity of his time was to be found. The chromatic sparseness and formal simplicity are not at odds with the undeniable capacity for metaphor. Like the highly symbolic series of burnt canvases produced around the same time, in a clear break from the established system, *The Hope of a*

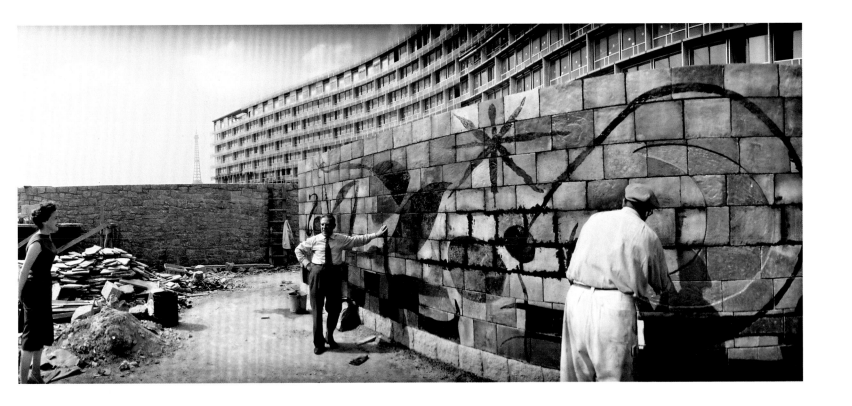

Condemned Man succeeds in creating a powerful and shocking atmosphere.

Beyond artistic circles: Reaching out to the masses

A detailed analysis of Miró's work makes it possible to trace the interaction between his pictorial world and the world around him. He worked with certain forms or signs that allowed him to show diverse realities, or at least enabled those who viewed his paintings to perceive alternative worlds. Different points of tension emanate from a vocabulary which is very similar, perhaps even identical, from one artwork to the next. But there is another way of reading Miró's commitment as a desire for transformation: a determination to participate in the democratisation of society, in other words to 'socialise' his work rather than restrict his influence to the limited world of art.

This ambition appears to be supported by various activities, not necessarily linked to each other, but all of which have in common the desire to come closer to the masses – or rather, that the masses should come closer to his work. The first of four examples examined here is his mural work: in particular his participation in the new UNESCO building in Paris, for which, together with Josep Llorens Artigas, he created *Le Mur du soleil* (*The Wall of the Sun*) and *Le Mur*

de la lune (*The Wall of the Moon*), unveiled in November 1958 (no.118). Of course, as so often happens with Miró, his creations are open to various interpretations, but in this case, as with his desire to experiment in other media such as ceramics, there is a will to go beyond the art gallery and the specialist museum. Moreover, unlike previous murals he had worked on, the UNESCO murals gave Miró the opportunity to bring his work out into a public space in Paris, a city that had been so closely associated with his career, and to produce work for an institution whose fundamental objective is to preserve culture at a global level. A year after the unveiling of the murals, Miró declared: 'Mural painting interests me because it requires anonymity, because it reaches the masses directly and because it plays a role in architecture.'[18]

The second and very significant creative act in the socialisation of Miró's work is the aforementioned 'happening' that took place at the *Miró Otro* exhibition. The fact that a serious painter like Miró, little given to scandal, should express his work with the aid of a broom on the windows of such a central building as the Colegio de Arquitectos in Catalonia's capital city had a significant creative impact. The work remained in a public space for three months, acting as a provocation both to the artistic tastes of the authorities and to a large number of citizens. Miró knew that his art was not easy for an audience that had been isolated for so many years from the changing

120
Mai 68
May 1968 – December 1973
May 68
Acrylic and oil on canvas
200 × 200
Fundació Joan Miró,
Barcelona

119
Volem l'Estatut 1977
We Want the Statute
Oil and pencil on paper
75.5 × 56
Museu d'Història
de Catalunya

trends of western culture. But for him, far from being negative, this was an incentive: the opportunity to create maximum impact among passers-by, many of whom would never enter an art gallery to view his paintings and sculptures.

Thirdly, there was an activity in which Miró regularly engaged from the late 1960s that allowed him to blend in with his surroundings and reach a larger audience: this was his work as a poster designer. There were of course precedents for this (back in 1919 he had designed a poster for the magazine *L'Instant*, which was never printed), but now his engagement with such work was widespread as he produced a large number of posters and poster designs for institutions and popular initiatives of all kinds. His 1977 design for a poster with the slogan 'Volem l'Estatut' ('We want the statute', no.119) showed his support for a campaign by the Assemblea de Catalunya (Assembly of Catalonia) demanding that Catalonia should have its own government institutions. Although the poster was never printed, for Miró this piece was of enormous personal and ideological significance.[19] The poster suggests an interesting political interpretation: in the words 'Volem l'Estatut' the two final letters drop down towards the right so that the first thing the viewer reads is 'Volem l'Estat' ('We want the state'), that is, for Catalonia to have its own state. Miró left nothing to

chance, so it is inconceivable that he did not have enough space to fit the entire phrase on the page. Given his profound sense of Catalan identity, it seems clear that he was deliberately championing an audacious political option.[20] Other examples include his propaganda poster for the Catalan dictionary, *Diccionari Català*, published by Editorial Salvat (1968); his poster design for a literary competition in honour of the Catalan linguist Pompeu Fabra on the centenary of his birth (1968); and the poster he produced for the 75th anniversary of Barcelona Football Club (1974).

Miró's work as a poster artist and as a social artist developed more forcefully with Franco's death and during the slow transition towards democracy that followed. He went on to collaborate actively with various institutions, almost always with a clear political agenda. In 1976 he designed a poster to celebrate the publication of *Avui*, the first Catalan language newspaper to appear since the time of the Republic, and in 1977 a poster advertising the highly significant Congrés de Cultura Catalana, with the name of the congress in his own handwriting above the four stripes of the Catalan flag. Miró's international posters are also relevant in this context. While the majority were of a strictly professional nature (mainly advertising exhibitions, either his own or

121
Francesc Català-Roca
Performance by La Claca of
Mori el merma featuring
Miró's puppets
Photographic Archive F.
Català-Roca, Col·legi
d'Arquitectes de Catalunya

group shows) there were, however, some exceptions, such as the poster for UNESCO's 1974 human rights campaign, which was printed in Spanish, French and English, and another for Amnesty International in 1976.

Finally, Miró's collaboration with the theatre was significant in giving his work a greater social impact. This occurred during the years immediately following the death of Franco, a period of transition to parliamentary democracy when many of the key figures of the dictatorship remained in power. Miró collaborated with the theatre company La Claca, founded in 1968 by Joan Baixas and Teresa Calafell, to produce the show *Mori el Merma* (loosely, 'Death to the Bogeyman') – a recreation of Alfred Jarry's *Ubu Roi*. Miró designed and painted the set, the masks and the large puppets worn by the actors. Members of La Claca worked on the piece from December 1976, constructing the puppets (the company had initially specialised in puppet theatre) after Miró's designs; in March 1977 he painted the puppets at the group's workshop in Sant Esteve de Palautordera. The show was premièred in Palma de Mallorca and transferred to the Gran Teatre del Liceu in Barcelona, where it was performed from 7 to 12 June 1978 before embarking on a successful world tour. The show was magnificent and extremely Mironian, firstly in the imaginative quality of the staging – it was like watching a moving painting by Miró – and secondly as a result of his affinity with La Claca's idea of creating a new version of Jarry's play (on which he had worked many years earlier) and transforming it into a metaphor on dictators. To some extent *Mori el Merma* became a turning point in the way Catalan society viewed Miró, and the press went out of its way to talk about the artist as never before. Through his theatrical work and the repercussions this particular play had over the two years it was performed, Miró again succeeded in socialising his work.[21] For him, theatre was important. He recognised at the end of his career that it was, paradoxically, through theatre that his personal language, his signs and his artistic ideas achieved their greatest dissemination.[22] With *Mori el Merma* he had connected with street art, a thriving art form in Catalonia at that time.

Miró's continued work as a poster artist, his public works for Barcelona (the airport mural, the ceramic paving of *Pla de l'Os* in La Rambla and the *Dona i ocell* (*Woman and Bird*) sculpture, for example), his record sleeve designs and the many other adaptations of his paintings and other art forms all helped bring his art to a mainstream audience. They were an attempt to make his brushstrokes, his figures and his language of signs into a popular art form, demonstrating his commitment to society, a commitment without concession founded on Miró's long-held belief that the revolution of form can, by provoking, awaken a sleeping public.

1 Josep Carner (Brussels) to Miró, 18 July 1948 (Fundación Pilar i Joan Miró, Palma de Mallorca).

2 Salvador Dalí, also a Catalan and a renowned artist, had not only shown no loyalty to the legitimate government, but had been in the United States since 1939; when he returned to his country of birth in 1948, he lost no time in gaining the approval of the Franco dictatorship.

3 Miró donated a work to support the *Revista de Catalunya*; it was probably one of the pieces that he had rejected for the exhibition to be held at Galerie Maeght between 19 November and 18 December 1948, though it appears that they did not manage to sell it. See Montserrat Casals i Courturier, *Mercè Rodoreda: Contra la vida, la literatura*, Barcelona 1991, pp.142–3; Minguet 2000.

4 *Joan Ponç*, exh. cat., Galeria René Metrás, Barcelona 1972.

5 Club 49 was formed by members of Barcelona's middle classes interested in culture, many of whom in the 1930s had also been members of the ADLAN (Friends of New Art) group or of the architects' group GATCPAC. These included Joan Prats, Sixte Illescas, Joaquim Gomis and Sebastià Gasch.

6 Miró (Mont-roig) to Joaquim Buxó, Presidente de la Diputación de Barcelona, 2 Oct. 1962, in Minguet,

Montaner and Santanach (eds.), *Epistolari català de Joan Miró*, vol.2, forthcoming.

7 Salvador Allende (Santiago de Chile) to Miró, 5 May 1972, wrote: 'I should like to thank you, Maestro, for the wonderful canvas you have given to the people of Chile. It will be a permanent symbol of your understanding and generous friendship.' He also informs Miró that he is to be awarded the medal and rank of Gran Oficial by the Chilean government. (Fundació Joan Miró, Barcelona).

8 The Assemblea de Catalunya (Assembly of Catalonia) was a clandestine organisation composed of different sectors from the world of politics and culture and which organised a Congress of Catalan Culture held in 1977, in the post-dictatorship period. Miró was Honorary Vice President of the Congress and designed the poster for the event.

9 Enrique Guillamón (Bordeaux) to Miró, 22 April 1977 (Fundació Pilar i Joan Miró, Palma de Mallorca). The letter reads: 'Our comrades will never forget Joan Miró's acts of solidarity, unlike those who have forgotten us with vain excuses.'

10 Hortensia Bussi de Allende (Mexico) to Miró, 29 May 1980 (Fundació Pilar i Joan Miró, Palma de Mallorca).

11 Miró (Paris) to Pierre Matisse, 12 Jan. 1937: 'I would have attempted to escape

reality entirely – and create a new reality, with new figures and fantasmagoric beings, but ones filled with life and reality', in Rowell 1986, p.146.

12 Santiago Amón, 'Tres horas con Joan Miró', *El País Semanal*, 18 June 1978, in Rowell 1986, p.300.

13 Miró had previously published some drawings in issues 3 and 5 of the magazine.

14 The exhibition, at the Colegio Oficial de Arquitectos de Cataluña y Baleares, Barcelona, from 30 April to 30 June 1969, was quite unlike the retrospective held the previous year in the same city, whose opening ceremony Miró did not attend in order to avoid Manuel Fraga Iribarne, the Spanish Minister of Information and Tourism. For *Miró Otro* see the text by William Jeffett in this volume.

15 On this debate, see various articles published in the Barcelona press: Alexandre Cirici, 'Noticiari', *Serra d'Or*, 15 June 1969; José M. Moreno Galván, 'Joan Miró pone su signo en Barcelona', *Triunfo*, 10 May 1969; ibíd., 'Miró auto-destructor … yo protesto', *Triunfo*, 12 July 1969; Rafael Santos Torroella, '¿Otro Miró?', *El Noticiero Universal*, 14 May 1969. See also the text by María Luisa Lax in this volume.

16 Hahn, 'Interview Joan Miró', in *Art Press*, no.12, 1974, p.5.

17 Fundació Joan Miró, FJM 1072.

18 Yvon Taillandier, 'Je travaille comme un jardinier…', *XXe siècle*, 15 Feb. 1959, in Rowell 1986, p.252.

19 Raillard 1978, pp.232–3.

20 I should like to thank Joan Manuel Tresseras, former Minister of Culture of the Generalitat de Catalunya, for discussing this matter with me, specifically in the context of the purchase of the original of the poster and its donation to the Museu d'Història de Catalunya in September 2010.

21 Joan Baixas to Miró, 16 Dec. 1980, wrote: 'With this final outing we have ended Mori el Merma's commitments and have taken the puppets to the Foundation.' (Fundació Pilar i Joan Miró, Palma de Mallorca).

22 Miró said: 'In Spain and often outside, people know me through museum postcards. With Merma, they realise that I am a living painter.' In the same interview he showed his enthusiasm for the work: 'I was passionate about these puppets. They belong to the carnival tradition, the processions of giant puppets. A puppet can be made to say anything, with a mobility in the attack that has no need of words or explanations.' René Bernard, 'Miró à L'Express: la violence libère', *L'Express*, 4 September 1978.

Project for a Monument: Miró's Sculpture

KERRYN GREENBERG

KERRYN GREENBERG

In December 2007, thirty-two years after General Franco's death, Spain passed the Law of Historic Memory requiring the removal of all monuments to the man who had ruled the country between 1939 and 1975.[1] While largely symbolic, since most of the commemorations of the dictator had already been dismantled, this law proved highly divisive and fuelled the debate around the future of Franco's most important monument, *Valle de los Caidos* or *Valley of the Fallen* (no.124). Built between 1940 and 1958 to honour the memory of those who died during the Spanish Civil War (1936–9), *Valley of the Fallen* is intrinsically connected to Franco who not only ordered its construction, but is also buried there alongside an estimated 34,000 Nationalist and Republican soldiers.[2] While statues can be banished to basements, this huge mausoleum cannot be easily removed or ignored.

The decree announcing Franco's decision to create the monument, dated 1 April 1940, a year after his defeat of the Republic, vividly reveals the official line about his place in history:

> The dimension of our Crusade, the heroic sacrifices involved in the victory and the far-reaching significance which this epic has had for the future of Spain cannot be commemorated by the simple monuments by which the outstanding events of our history and the glorious deeds of Spain's sons are normally remembered in towns and villages. The stones that are to be erected must have the grandeur of the monuments of old, which defy time and forgetfulness.[3]

Built to honour the dead, record a moment of history and reinforce the primacy of Franco's political power, *Valley of the Fallen* is venerated and reviled for its enduring historic significance. It is the epitome of a monument in its most extreme form.

In 1951, a decade after the foundation of this grandiose structure, Joan Miró began working on a very different kind of 'project for a monument'. His humble and precarious compositions of found objects were assembled quickly, with much left to chance. The mangled forms, broken and discarded elements and awkwardness of the constructions challenge rather than celebrate any perceived power of mankind. Although he made many large-scale works in his lifetime, Miró never stopped questioning definitions of the monument, nor did he fail to subvert its conventional functions and aesthetics.

In the late 1920s Miró made relief constructions by combining found objects and nailing them to wooden supports. His experiments with composition, texture and line became increasingly complex in the 1930s, with a greater range of materials – bones, beads, corks, bells, padlocks, cake tins, wire netting, shells and burnt wood – and an emphasis on colour, particularly red, blue and yellow. These works, which he called 'painting-objects', were included in the numerous exhibitions that highlighted the new concern with Surrealist objects promoted by André Breton and Salvador Dalí. Although Miró had a rather detached relationship to the Surrealist movement, he was attracted to the 'unprecedented structural and semantic possibilities that were discovered

through experiments with randomness, dreams, or automatic writing'.[4] He was, however, as William Jeffett notes, unlike the other Surrealists in that he 'situated the source of inspiration outside himself, in nature. The experience he expressed was that of receptive wakefulness, rather than of sleeping; the daydream rather than the nightmare.'[5]

L'Objet du couchant 1935–6 (*Object of Sunset*, no.122), once owned by Breton, is one of Miró's most well-known sculptures from this period. A rusted element from a gas burner, with a chain attached, is embedded into the top of a Carob tree stump alongside a bedspring tangled in string. The stump is a visceral red with a black shape, resembling an eye or vagina, painted on one of its cut ends, emphasising the sexual and violent connotations of the other elements.[6] Writing of the conception of such objects in 1936, Miró explained:

> I never think about it in advance. I feel myself attracted by a magnetic force toward an object, and then I feel myself being drawn toward another object which is added to the first, and their combination creates a poetic shock – not to mention their original formal physical impact, which makes the poetry truly moving, and without which it would have no effect.[7]

After years of exile in Paris, working in small temporary spaces with limited materials, Miró yearned for a large studio where he could work in multiple media, including sculpture and ceramics.

In a notebook begun in July 1941 on his return to Mont-roig he wrote, 'it is in sculpture that I will create a truly phantasmagoric world of living monsters; what I do in painting is more conventional.'[8] In subsequent years the objects that he found while walking along the seashore near Mont-roig or in the mountains in Mallorca would become the 'magic spark' he needed in order to begin.[9] In his working notes from 1941–2 he reminded himself, 'when sculpting, start from the objects I collect, just as I make use of stains on paper and imperfections in canvases – do this here in the country in a way that is really alive, in touch with the elements of nature.'[10] Miró's *Projet pour un monument* sculptures from 1951 (*Project for a Monument*, no.123) do just that. In one, a small white towel hook is attached to the top of an iron spike sticking out of a bone that is fixed to a large round stone painted with gouache and oil. Resembling a person, with a hooked nose and two small eyes, elongated neck, torso and base, the sculpture combines natural and found objects. In another, a rusted iron rod supports a piece of dried, worn and curling leather reminiscent of a sail or old shoe, but also evoking a face through its two punctures (eyelets for shoelaces, perhaps) and gaping hole below. Although these works are made from quite different found objects, their compositions are remarkably similar. In each, three main elements are stacked vertically giving the impression of a head, torso and support; a structure that mimics and subverts those of official monuments.[11]

In scale, materiality and composition Miró's projects for monuments could be described as humble and insignificant,

123
Projet pour un monument
1951
Project for a Monument
Iron, porcelain hook,
gouache and oil on bone
45 × 20 × 14
Fundació Joan Miró,
Barcelona

124
Valle de los Caídos
Valley of the Fallen
Near San Lorenzo de
El Escorial, Spain, 1959

PROJECT FOR A MONUMENT

125
La Fourche 1963
The Pitchfork
Iron and bronze
507 × 455 × 9
'The Labyrinth', Fondation
Maeght, Saint-Paul de Vence

especially in light of those constructed in Spain after the Civil War and elsewhere in Europe following the Second World War. While monuments tend to glorify the victorious and commemorate the brave and the fallen, Miró's projects from the 1950s celebrate nature and the everyday, reminding us of the fragile balance between man and the natural world. Paradoxically, they are deliberately unstable.

Miró was prolific in the 1960s. In addition to creating dozens of bronzes, he made several large sculptures, including *La Fourche* 1963 (*The Pitchfork*) for 'The Labyrinth' in the gardens at the Fondation Maeght in Saint-Paul de Vence (no.125). A vast iron pitchfork balances precariously at an angle on top of a flat triangular piece of bronze with a circular cutout, derived from the seat of a traditional Mallorcan outhouse,[12] resting on a bronze pillar. Measuring more than five metres high and positioned on the edge of the hill, *The Pitchfork* elevates the ordinary in a way comparable to Claes Oldenburg's oversized sculptures of everyday objects. In its absurdity and precariousness this work is humorous, but it also celebrates common farming implements and bodily

functions and, through scale alone, exalts the peasant's connection to the land.

After completing works for 'The Labyrinth' at Fondation Maeght, Miró returned to a smaller scale, making several sculptures with bulbous protrusions and phallic shapes in 1966 that are reminiscent of prehistoric fertility figures, like the Venus of Willendorf, and share the sexualised contours of Louise Bourgeois' sculptures from the same period.[13] As Rosalind Krauss has argued: 'Modern sculptors, from Rodin to Brancusi, accepted the fragment, which they reconceived as the burgeoning germ of the bodily whole'.[14] While the fragment is frequently associated with classical sculptures that were vandalised with the Fall of Rome,[15] Bourgeois's and Miró's truncated bodies appear to hark back to prehistory. Miró's interest in Paleolithic cave paintings began in the 1920s, and he made a special visit to Altamira in 1957 while preparing two ceramic murals for the UNESCO building in Paris (see no.118).[16] The types of objects that he collected, his emphasis on the spiritual, natural and universal, his system of signs, vocabulary of forms, and techniques involving handprints and

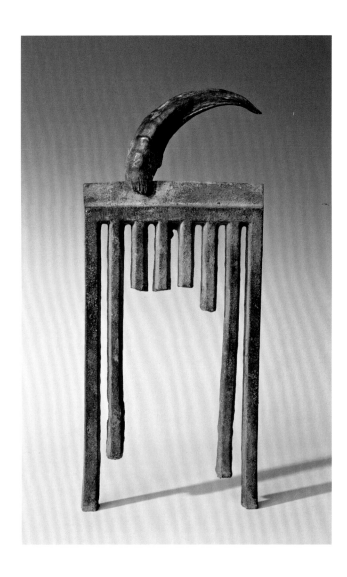

126
Femme 1966
Woman
Bronze
41.5 × 18 × 3.5
Fundació Joan Miró,
Barcelona

127
Constellation silencieuse
1970
Silent Constellation
Bronze
68.5 × 34 × 15
Fundació Joan Miró,
Barcelona

128
Tête 1968
Head
Bronze
42.5 × 26 × 16
Fundació Joan Miró,
Barcelona

129
Tête 1968
Head
Bronze
43.5 × 24.5 × 9
Fundació Joan Miró,
Barcelona

incisions, all confirm that early forms of expression offered critical inspiration.

Miró sought to give life to inanimate things and created works that appear natural, even when they include man-made elements.[17] The individual characteristics of the broken pots, honeycombs, gourds, animal horns, wooden crates, stones, pastries, egg boxes and other miscellaneous items, once assembled and cast in bronze, are subsumed and often only identifiable on close inspection. These ordinary objects are defamiliarised and transformed through fragmentation, unexpected combinations and the casting process.

In *L'escala de l'ull que s'evadeix* 1971 (*The Ladder of the Escaping Eye*, no.131), an animal's ribcage sits on a stone, and a ladder, possibly originally made from sticks, balances precariously on top, twisting slightly towards the sky and crowned by a small seashell. This work offers the viewer a visionary fantasy with multiple possibilities, the ladder standing for 'flight, for escape, but also for elevation'.[18] Other small bronze sculptures like *L'Équilibriste* 1970 (*The Tightrope Walker*, no.133) and *Personnage et oiseau* 1966 (*Figure and*

Bird, no.132) offer similar incongruous combinations that are fanciful, escapist and unexpectedly grounded.

Although Miró did not have monumental ambitions for many of these sculptures, he never abandoned the idea of the monument. In 1963 he made a work titled *Projet pour un monument: Maquette pour Lune, Soleil et une Étoile* (*Project for a Monument: Model for Moon, Sun and one Star*) out of plaster, wood and cardboard, and he returned to it in 1967 when the city of Chicago commissioned a sculpture for the Brunswick Plaza. Although that commission was later cancelled, Miró considered producing it for a public space in Barcelona and even exhibited the model at the Hospital de la Santa Creu in 1968 under the title *Projet pour un monument pour la ville de Barcelona* 1967 (*Project for a Monument for the City of Barcelona*). A bronze version of this work was later installed outside the Fundació Joan Miró overlooking Barcelona (no.134), and in 1981 the sculpture designed many years earlier was unveiled in Chicago, where it is known as *Miss Chicago*.[19]

At almost eleven metres high, *Miss Chicago* is simultaneously cosmic and worldly. With its concrete base and green,

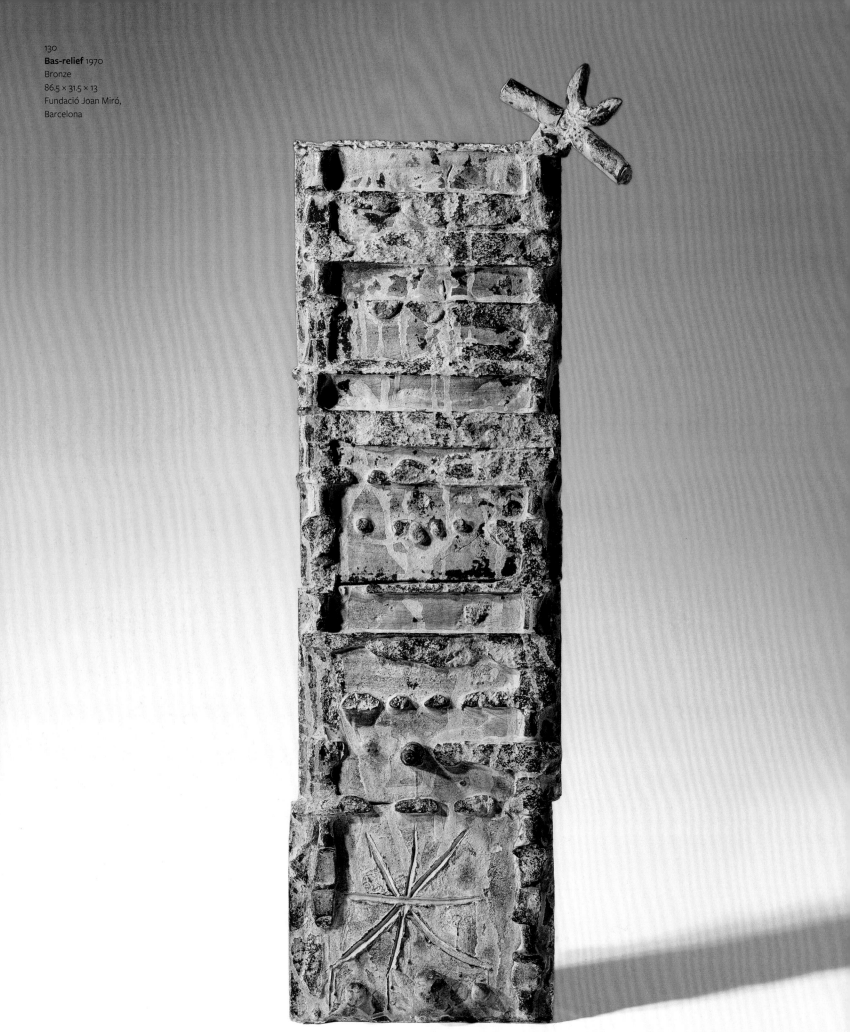

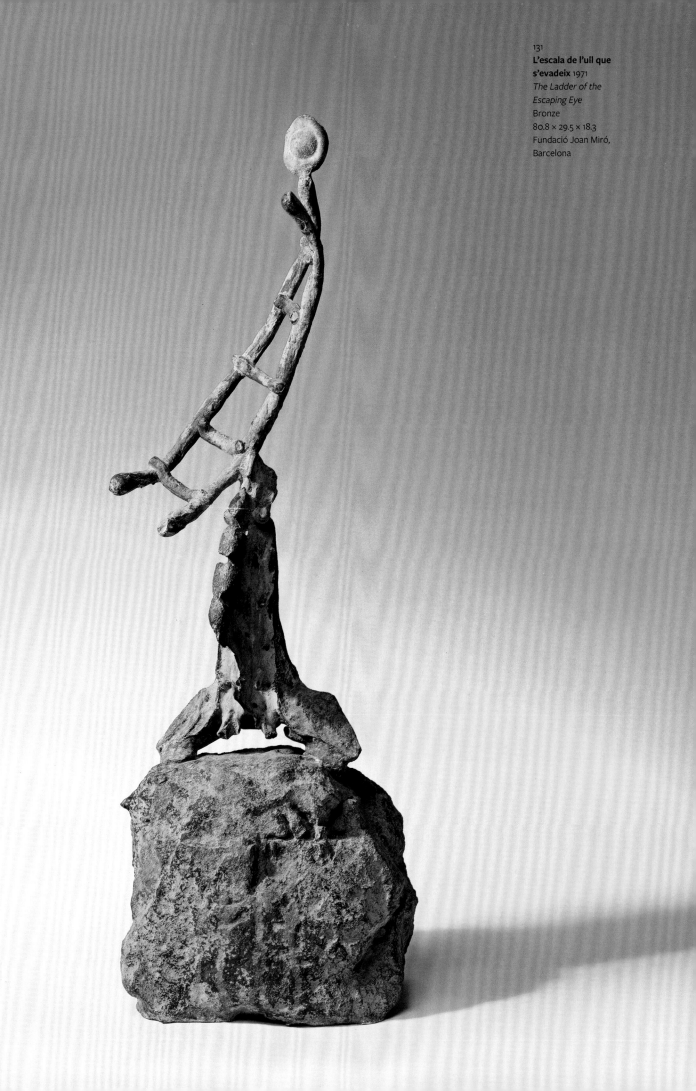

131
L'escala de l'ull que s'evadeix 1971
The Ladder of the Escaping Eye
Bronze
80.8 × 29.5 × 18.3
Fundació Joan Miró, Barcelona

red, blue, gold and black ceramic inlays, the influence of Antoni Gaudí's reverence for nature and commitment to Catalonia are unmistakable. This sculpture evokes celestial imagery and common objects. The bell-shaped base, around which visitors sit and rest, symbolises the female form, which Miró associated with the earth. The indented shapes may represent the sun, moon or female sex, while the face of the sculpture is derived from the ceramic hook familiar from the *Project for a Monument* sculptures of 1951. The fork emanating from the top of the head could be read as a crown, the individual lines representing rays of light. However, this 'crown' can also be interpreted, as Emilio Fernández Miró points out, as 'the four stripes of the Catalan flag'.[20]

As this shows, Miró frequently revisited and enlarged existing sculptures. On a grand scale, *Project for a Monument* in painted synthetic resin (1972) and in bronze (1981) are the 'living monsters' that he had always wanted to produce. The influence of Mallorcan terracotta figurines and *siurells* (white whistles with brightly coloured designs), which Miró collected and kept in his studio, is undeniable. Some of these sculptures also prefigure the puppets that he designed in collaboration

with the theatre troupe La Claca for the production *Mori el Merma* in 1978 (loosely, 'Death to the Bogeyman', no.135). Based on Alfred Jarry's dictatorial character, Père Ubu, this production alluded to Franco's death in 1975.[21] Ubu is vulgar, gluttonous, dishonest, cruel, cowardly and stupid. In these terms, Miró's *Project for a Monument* from 1972 is less about commemorating the everyday than about recalling the tyranny inflicted by the regime and the resilience of Catalan culture and creativity.

By the 1970s Franco was in decline, both politically and physically. In June 1973 he relinquished the role of Prime Minister to Luis Carrero Blanco and, although he remained Head of State and Commander-in-Chief of the Military Forces, it became possible to imagine a different political order. The Spanish State had been declared a monarchy in 1947, but Franco reserved the right to name the king and delayed the selection until 1969. Miró made *Sa majesté le roi* (*His Majesty the King*), *Son altesse le prince* (*His Highness the Prince*) and *Sa majesté la reine* (*Her Majesty the Queen*) in 1974 (no.136) not long after Juan Carlos de Borbón was announced as Franco's successor. The titles of these

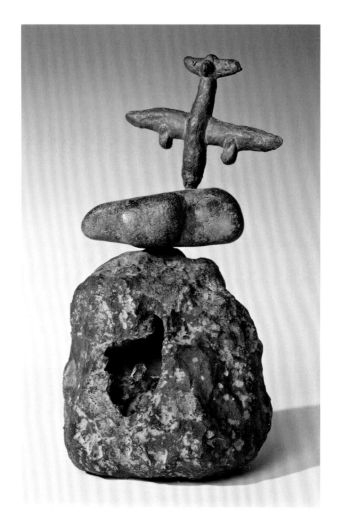

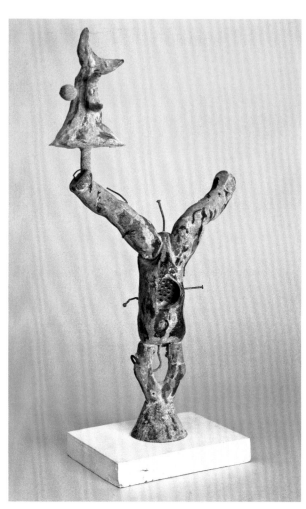

132
Personnage et oiseau 1966
Figure and Bird
Bronze
47.5 × 26 × 20
Fundació Joan Miró,
Barcelona

133
L'Équilibriste 1970
The Tightrope Walker
Bronze and steel
53 × 28 × 13
Tate. Purchased 1982 /
Fundació Joan Miró,
Barcelona

134
**Projet pour un monument
pour la ville de Barcelona
(Lune, soleil et une étoile)**
1968
*Project for a Monument
for the City of Barcelona
(Moon, Sun and one Star)*
Bronze and cement
375 × 94 × 94
Fundació Joan Miró,
Barcelona

sculptures are no coincidence, and their precarious execution and fragility is in itself a powerful rejection of the patriarchal idea of monumentality as much as it is a comment on the politics of that moment.

As with Bourgeois's *Personages* of 1945–6, Miró's *Majesties* can be associated with totemic figures, archaeological finds, tribal fetishes, weaponry and utilitarian objects. *His Majesty the King* rests on a rusty stud attached to a piece of timber that was once part of a mill. The raw and aged wood is splashed with blue and yellow paint that drips down the sides, resembling Miró's *Feux d'artifice* (*Fireworks*) triptych of the same year (see no.160). A flimsy square of bronze foil with a painted black eye stands for the head. *His Highness the Prince* is made of a smaller, lighter piece of wood, which may also have been a farming implement. This sculpture is more delicate, but still crudely constructed. A rectangular void is painted red, an animal horn nailed to the top, and a black painted stick protrudes from the 'body' like the handle

of an axe. *Her Majesty the Queen* is predominantly black with bands of minimal colour and no adornment. These elongated totemic forms are radical in their simplicity, humble in their materiality and unstable in their construction, affirming 'the instinctual forces Miró associated with nature, and which he held up in opposition to the false sophistication of modern society'.[22]

While Miró made several sizeable public sculptures during his long career, he initially avoided working on an excessively large scale, stating that it 'could be a sign of mediocrity the way it is in towns that want to build big things, without giving a thought to the greatness of spirit they might contain'.[23] His motivation was not to conceive a monument that would 'defy time and forgetfulness' or confront and dominate people,[24] but rather to create environments for ordinary people and objects that were immediate and impulsive, that were, as Margit Rowell argued, 'emptied of conventional meanings or allusions and purified to a primordial presence'.[25]

135
Francesc Català-Roca
Miró painting puppets for
Mori el merma, 1977
Photographic Archive
F. Català-Roca, Col·legi
d'Arquitectes de Catalunya

136 (left to right)
Son altesse le prince 1974
His Highness the Prince
Acrylic on wood and horn
203 × 19 × 56
Fundació Joan Miró,
Barcelona

Sa majesté la reine 1974
Her Majesty the Queen
Acrylic on wood and nails
210 × 9.3 × 12.5
Fundació Joan Miró,
Barcelona

Sa majesté le roi 1974
His Majesty the King
Acrylic on wood and bronze
254 × 22.5 × 43
Fundació Joan Miró,
Barcelona

1 This law required local authorities to remove statues or plaques of the dictator and his supporters and change road names associated with the regime. It also offered redress to victims or the relatives of those who were killed or 'disappeared' during the Civil War and its aftermath.
2 The number of people buried in Valley of the Fallen is heavily contested. In October 2009 the Spanish parliament approved a proposal to conduct a census of the bodies and to pay for their exhumation and reburial.
3 Paul Preston, 'The Man who would be Emperor', in *Franco: A Biography*, London 1993, p.351.
4 'Introduction', in Rowell 1986, p.11.
5 Jeffett 1989, p.9.
6 The carob tree is widely found in Mont-roig and the dry regions of Mallorca. It features in many of Miró's most important works, such as *The Tilled Field* 1923–4 (see no.20), and signifies his rootedness to Catalonia. During the

Spanish Civil War and the post-war years, in which Spain was relatively isolated, the carob took on a special significance in the production of foodstuffs that could not be easily imported, such as coffee.
7 Miró (Barcelona) to Pierre Matisse, 28 Sept. 1936, in Rowell 1986, p.126.
8 'Working Notes, 1941–42', ibid., p.175.
9 In a notebook begun at Mont-roig in July 1941 Miró wrote: 'use things found by divine chance: bits of metal, stone etc., the way I use schematic signs drawn at random on the paper or an accident … that is the only thing – this magic spark – that counts in art'; ibid., p.191.
10 'Working Notes, 1941–42', ibid., p.175.
11 In Barcelona, such structures are epitomised by the sixty-meter high monument to Christopher Columbus, erected in 1888, that dominates the lower end of La Rambla.
12 Coyle, Jeffett and Punyet Miró 2003, p.35.

13 In 1947 Miró spent nine months in New York working on a mural for the Cincinnati Terrace Plaza Hotel. During this time he met Louise Bourgeois, who was bilingual and moved easily in the émigré culture of New York. They were aware of each other's work and, whilst their motivations were very different, both artists consistently showed an interest in the female form, sexuality and fertility.
14 Rosalind Krauss, 'Body (Part)', in *Louise Bourgeois*, exh. cat., Tate Modern, London 2007, p.60.
15 Ibid.
16 Miró and Artigas began two vast tile works (3 × 15m and 3 × 7.5m) for UNESCO's headquarters in 1955 and completed in 1958. See Stich 1980.
17 Yvon Taillandier, 'Je travaille comme un jardinier…', *XXe siècle*, 15 February 1959, in Rowell 1986, p.253.
18 This is how Miró in 1978 described the ladder that features in *Harlequin's Carnival* 1924–5. Lluís Permanyer,

'Revelations by Joan Miró about his Work', *Gaceta Ilustrada* (Madrid), April 1978, in Rowell 1986, p.291.
19 Fernández Miró and Ortega Chapel 2006, pp.122–5, nos.110 and 112.
20 Emilio Fernández Miró, 'Introduction', in Fernández Miró and Ortega Chapel 2006, p.17.
21 Miró made several sculptures that refer directly to Ubu, such as *La Père Ubu* 1974.
22 Jeffett 2003, p.57.
23 'Working Notes, 1941–42', in Rowell 1986, p.185.
24 According to Robert Morris, monumental art 'confronts and dominates people [and] all great monuments celebrate the leading faith of the age – or, in retrospect, the prevailing idiocy', Robert Morris, *Continuous Project Altered Daily: The Writings of Robert Morris*, The MIT Press, London 1993, p.171.
25 Rowell 1986, p.10.

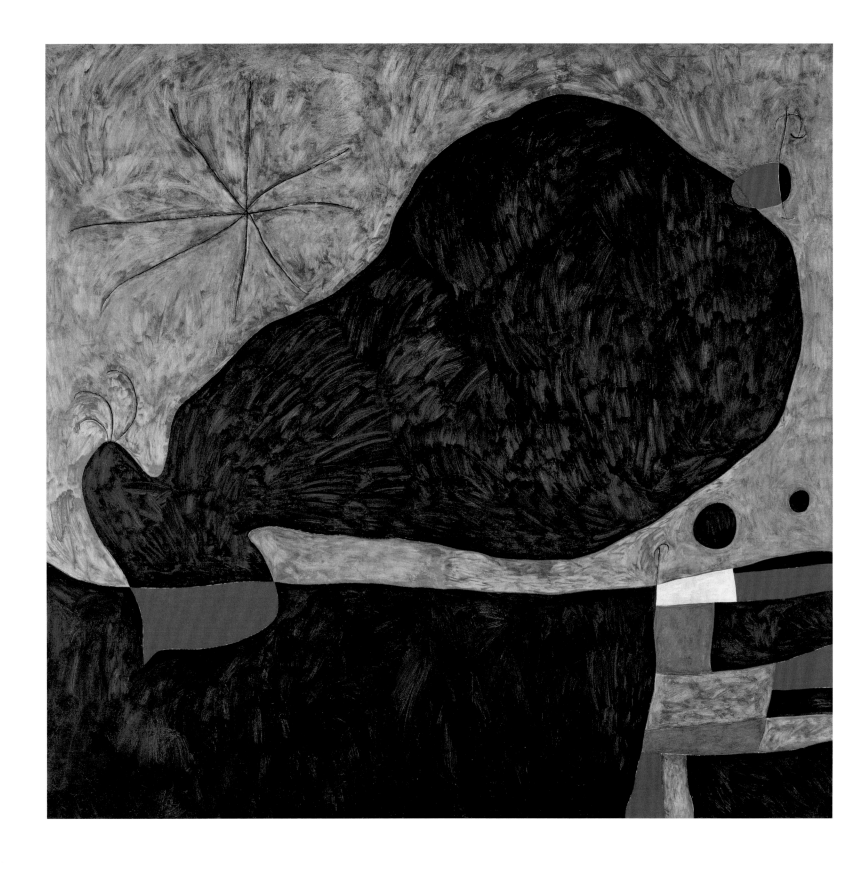

PROJECT FOR A MONUMENT

137
Message d'ami
12 April 1964
Message from a Friend
Oil on canvas
262 × 275.5
Tate. Purchased with
assistance from funds
bequeathed by Miss H.M.
Arbuthnot through the
Friends of the Tate Gallery

138
Paysage 1974
Landscape
Oil on canvas
216 × 174
Private collection

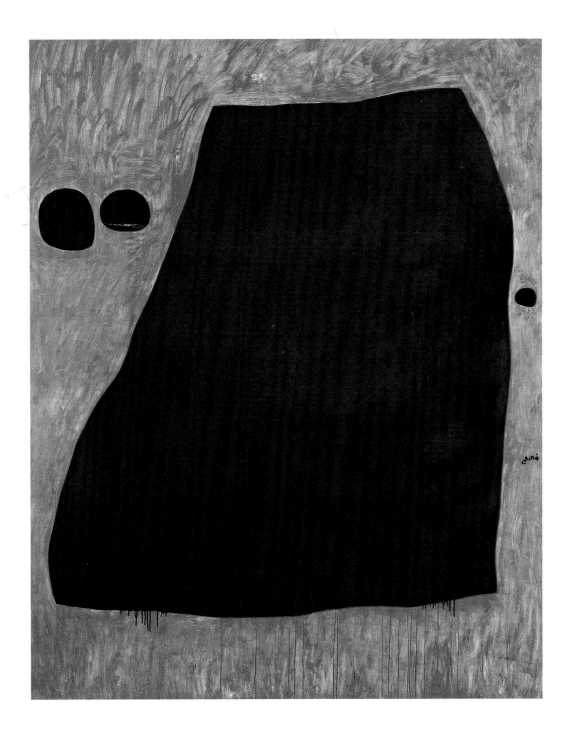

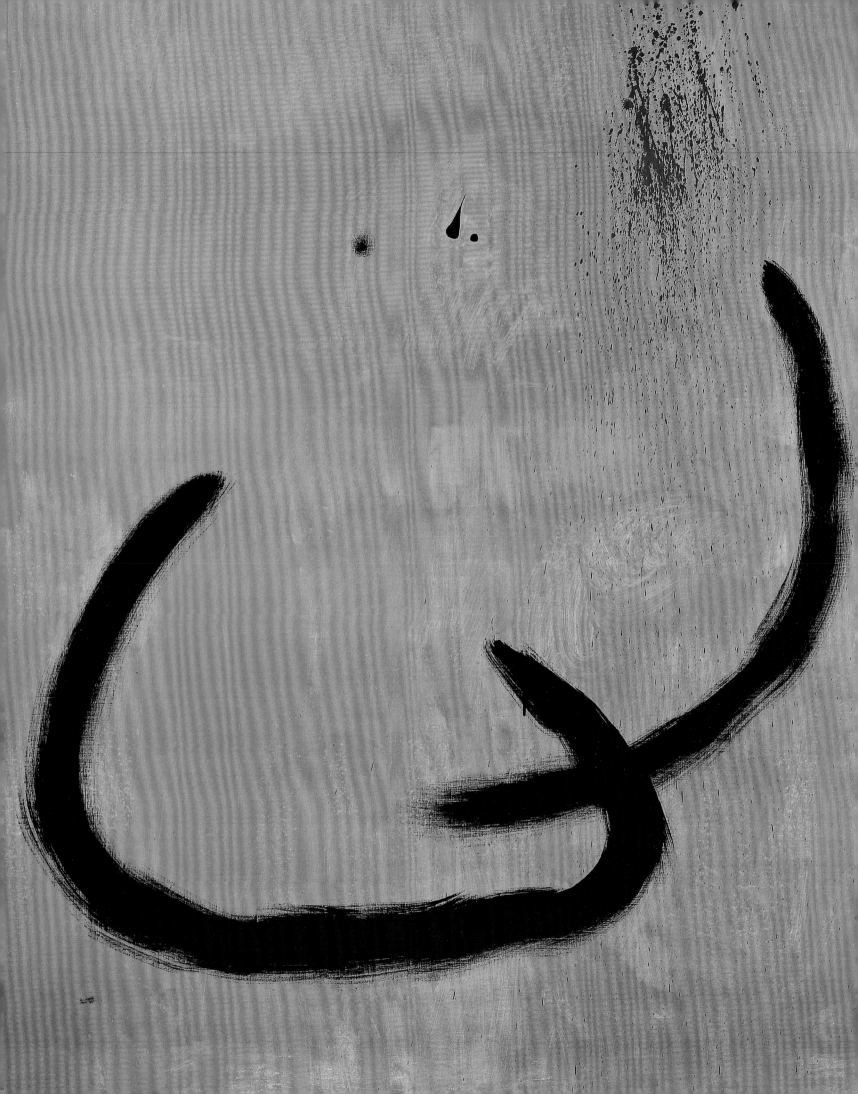

The Civic Responsibility of the Artist

MARÍA LUISA LAX

In the autumn of his life, Joan Miró described the artist 'as a person with a special civic responsibility', whose voice should speak for the silent, whose work should be emancipatory.[1] On the occasion of his honorary degree at the Universitat de Barcelona (University of Barcelona) in 1979 he wrote: 'I understand the artist to be someone who, amidst the silence of others, uses his voice to say something, and who has the obligation that this thing not be useless but something that offers a service to man.' This essay examines the evolution of Miró's civic commitment from the 1950s, under Franco's regime and during the transition to democracy. The dictatorship entailed political, cultural and social repression, along with Spain's impoverishment and international isolation until 1955. The regime, nevertheless, officially promoted modern Spanish art so as to project an image abroad, albeit fictitious, of cultural and political normality.

As a result, art and power were intricately intertwined. Art and artist were regarded as political tools and there were repeated official attempts to capitalise on Miró. Time and again Miró was enticed to participate in national and international exhibitions organised with government support, with awards and with official appointments. Elusive, Miró resisted all such advances. Due to political interests Spain's Cultural Relations Office (Dirección General de Relaciones Culturales or DGRC), part of the Ministry of Foreign Affairs (Ministerio de Asuntos Exteriores or MAE), decided to incorporate modern art as part of the Spanish contribution to the 25th Venice Biennale 1950. On 29 April of that year Miró was listed as one of the artists to be included; but the curator Enrique Pérez Comendador later reported that 'although efforts were made to obtain works by Miró, this could not be achieved.'[2]

The DGRC was extraordinariiy keen for Miró to feature at the 9th Milan Triennale in 1951. This was to be followed by a 'cultural exhibition' of Miró's work in Spain, 'in some *prestigious public building*', if not in the Ministry itself. The architect José Antonio Coderch, in charge of the Spanish Pavilion, was assisted by Rafael Santos Torroella and his wife María Teresa Bermejo in selecting exhibits for the Triennale.[3] As director of Ediciones Cobalto, Santos Torroella had organised the first Miró exhibition in Spain after the Civil War and had published his first Spanish monograph. However, Santos Torroella, who was subject to political repression, had no passport and it was Bermejo who went to Paris to handle the loan of works by Miró. Suspicious of the underlying political dimension of the Triennale, Fernand Clayeux, Director of the Galerie Maeght (the artist's French dealer), refused to lend works by Miró to the Spanish government. Instead, out of friendship, the artist helped Bermejo obtain two of his works from the Italian collector Carlo Frua De Angeli although only one of these – *Femme, oiseau, étoiles* 1942 (*Woman, Bird, Stars*) – was actually exhibited (no.139).[4]

The Spanish Pavilion combined the Romanesque with contemporary art (Miró, Ángel Ferrant, Eudald Serra, Jorge Oteiza and Josep Guinovart), ceramics (Josep Llorens Artigas and Antoni Cumella), photography (Joaquim Gomis and Joan Prats) and craftwork. The exhibits also included limited edition books, a collection of poems by Federico García Lorca – *Homenaje a García Lorca* – and another one by Santos Torroella – *Altamira*.[5] Miró's involvement was no doubt due to his friendship with Santos Torroella and Bermejo, and with some

of the other participants such as Prats, Gomis, Artigas and Ferrant, rather than out of sympathy with the aims of the DGRC.

Although the Milan Triennale included artists who supported Franco's regime, other participants had belonged to groups such as ADLAN (Friends of New Art) or the School of Altamira, which championed the avant-garde. Miró had also been associated with these groups. Prats and Gomis, both members of ADLAN, along with Santos Torroella and Bermejo, had created a bridge between the pre-war and post-war periods by founding the group Cobalto 49 in 1949, which had led to a cultural renewal, as exemplified by the presence of García Lorca's work in the Spanish Pavilion. Perhaps out of loyalty to the spirit of ADLAN, which proposed 'protecting and encouraging any expression of risk that entailed a desire for improvement',[6] Miró took the risk of participating in the Triennale out of a desire to expand Spain's restricted artistic and cultural horizons.

Unfortunately, Clayeux's reservations turned out to be well founded. According to Coderch: 'the Spanish Pavilion's modern presentation and the presence there of an artist like Miró, of comparable value to the defector Picasso, proved to be a revelation and the best political argument in favour of our nation'.[7] Political significance also permeated the DGRC's gratitude to Miró for having succeeded in overcoming 'difficulties in ensuring that the exclusive conditions of sale of his paintings should not be an obstacle to their presentation at the said Competition; this Department has agreed to show its appreciation and to give you its thanks for your patriotic and personal cooperation.'[8] One can easily deduce that the regime interpreted lack of cooperation as anti-patriotic; but, in a Spain subjected to tyranny, Miró nevertheless declined to cooperate further.

That same year an official commitment to modern art informed the First Hispano-American Biennial (BHA) in Madrid even though these competitions, organised by the Institute of Hispanic Culture (ICH), only admitted new art rather reluctantly 'in order to present a façade of cultural freedom to the world outside'.[9] This having been said, in May 1951 the prospective list of those selected included Miró, Pablo Picasso and Salvador Dalí, along with artists representing a variety of different trends. In September, the poet Leopoldo Panero, Secretary General of the BHA, announced the invitation and participation of Miró. However, the exhibition opened without his work on 12 October 1951, Columbus Day (Día de la Hispanidad) and the quincentenary of the birth of Isabella I of Castile. Picasso had encouraged a boycott with a manifesto criticising the affront of celebrating Spain's past glories in a country that was dying of hunger, and he had warned artists that participating in this event was tantamount to collaborating with the Franco regime. Dalí, however, supported it.[10]

Another attempt was made to present an exhibition of Miró's work at the 26th Venice Biennale in 1952, but the Spanish committee was again unsuccessful in its bid. According to Rodolfo Pallucchini, Secretary General of the Venice Biennale, 'a Parisian gallery that collects Miró's works' had proposed organising a solo exhibition outside the Spanish Pavilion. However, the Biennale rejected the idea to avoid slighting Spain.[11] On the occasion of the inauguration of the 26th Biennale, Francisco Matarazzo, president of the São Paulo Biennial, started to lay the foundations of the second Brazilian Biennial of 1953. In September 1952, Matarazzo suggested that the Spanish representation should focus on Miró, a proposal that was supported by the ICH. Juan Ramón Masoliver, the curator appointed by the ICH, asked the Catalan artist to take part and reported that Miró had agreed.[12] However, in collusion with his art dealer Pierre Matisse, Miró deliberately hampered his own participation.

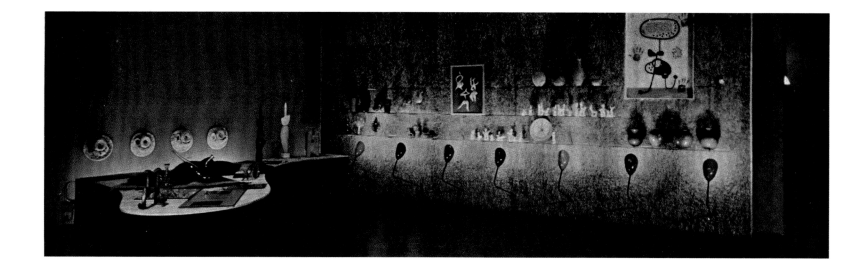

He wrote to Matisse in December: 'You will receive a letter from Madrid about the São Paulo Biennial; you know my opinion regarding collaboration in the pavilions of certain countries. Perhaps you could approach Mr Matarazzo directly and suggest the idea of exhibiting in a separate pavilion, independent of the rest'.[13] In August 1953, Alfredo Sánchez Bella, director of the ICH, admitted: 'With regard to Miró, it has been completely impossible to persuade him to take part in the Biennial. He has all his work in the hands of "art dealers", but I am sure that as far as he is concerned, there would not have been the slightest problem."[14] Nevertheless, Sánchez Bella did not give up. He sent telegrams to Matisse and Matarazzo informing them of Miró's participation, and even wrote to the artist asking him to intervene with Matisse.[15] In the end, Miró prevented the inclusion of his work, considering participation 'an absolutely inadvisable moral gesture'.[16]

In July 1953, Pallucchini proposed that Spain should mount displays by Dalí and Miró at the 27th Venice Biennale devoted to Surrealism.[17] Given the complete lack of progress in obtaining works by Miró for the Spanish Pavilion by the Ministry of Foreign Affairs, in December 1953 the Biennale officially invited the artist to put together a separate retrospective.[18] Miró agreed and asked to borrow his 1919 Self-Portrait (see no.16) from Picasso, explaining that it would be exhibited in a different room from that of the Spanish Pavilion, otherwise Miró would have refused.[19] Nevertheless, intent on exhibiting Miró in the Spanish Pavilion, the DGRC involved the Spanish embassy in Paris in order to obtain loans from the Galerie Maeght. They also asked Juan Ainaud de Lasarte, Director of Municipal Art Galleries in Barcelona, to intervene with Miró, though unsuccessfully.[20] On 3 June 1954, Luis García de Llera, Director of the DGRC, personally reiterated to Miró these requests for the loan of works. In addition, he offered him an exhibition in Madrid.[21] Faced with the dilemma of extracting

works from his retrospective at the Biennale, in June 1954 Miró suggested exhibiting his graphic work but turned down the Madrid exhibition: 'I am totally convinced that in both Madrid and Barcelona my work would be greeted with complete indifference.'[22] After receiving the International Prize for Graphic Art at the Biennale, Miró stated: 'Never ever have I presented myself at any official exhibition. Mine have been on a personal basis, with my name alone, which is enough'.[23]

In July 1954, García de Llera asked Miró for a 'good collection of your ceramics' for the 10th Milan Triennale.[24] Miró bluntly refused: 'After my recent participation in the last Venice Biennale, I think it better to abstain for a long period from any collaboration in international collective exhibitions.'[25] Nor did he exhibit at the 1955 BHA in Barcelona, although a selection of works by Picasso from collections in Barcelona was included.[26] Panero declared: 'We are deeply sorry to say that [Miró] is not coming; we have done all that we could but I accept that we have failed.'[27]

A new relative cultural openness in Spain had allowed the creation of the Museo Nacional de Arte Contemporáneo (National Museum of Contemporary Art) in 1951, whose director, José Luis Fernández del Amo, sought to collaborate with contemporary artists in order to update the rather conservative collection it had inherited from the Museo de Arte Moderno (Museum of Modern Art) in Madrid. In 1956 he proposed to Miró that a room should be devoted to his work, a major exhibition should be held and that he should create a frieze for the museum. None of these projects materialised.[28]

In 1958 the Spanish press reported that Miró had been awarded the Guggenheim Prize and went on to suggest that there should be a tribute to him in Spain.[29] Perhaps either to emulate or outdo this prize, on 1 April 1959 it was announced that Franco had awarded Miró the Gran Cruz de Alfonso X el

Sabio.[30] On 18 May 1959 the US President, Dwight Eisenhower, presented the Guggenheim Prize to Miró at the White House in Washington in the presence of José María de Areilza, the Spanish Ambassador. According to Miró, the Ambassador used this opportunity to try 'to persuade me and win me over', but without success.[31] Although the regime had problems getting Miró to accept the award of the Gran Cruz, according to a report by Areilza it capitalised on the artist winning the Guggenheim Prize: 'This event has had major repercussions in the press … the fact that Spain should have had such an obvious presence in the White House can only be highly beneficial both artistically and from every viewpoint, given the importance of the artist being honoured.'[32]

Public opposition to Franco's dictatorship intensified in the 1960s and Miró supported it. On 21 March 1966 Miró was elected to the Spanish Royal Academy of Fine Arts (RABASF) but publicly refused to enter if Picasso did not enter first. He refused to release a work for the Academy's museum and declined to take his seat.[33] Coincidentally, March 1966 also saw the formation of the Sindicat Democràtic d'Estudiants de la Universitat de Barcelona (Barcelona University Democratic Students Union) at the Capuchin Monastery in Sarrià. While this had the support of intellectuals, it ended with the police storming the building. The fines levied on those who took part were paid by donations from intellectuals and artists. Miró, Picasso, Alexander Calder, Max Ernst, Wifredo Lam and Roberto Matta donated works of art, and Jean-Paul Sartre and Simone de Beauvoir gave manuscripts for an auction organised by the writers Jean Cassou, Jacques Dupin and Michel Leiris at the Palais Galliera in Paris.[34]

Although Miró was already in his seventies, his civic commitment remained unabated. For example, he fostered Catalan culture by designing record sleeves for Raimon (1966 and 1977) and for Maria del Mar Bonet (1974), both distinguished performers of *Nova Cançó*, a symbol of Catalan culture and commitment to democracy. Miró also collaborated

with Comisiones Obreras (CCOO), a bastion of the workers' movement and the fight against Franco. Despite being banned in 1967, it organised acts of protest and succeeded in gaining the support of intellectuals, such as filmmaker Pere Portabella.[35] At the initiative of CCOO, Portabella and the editor Xavier Folch asked Miró to design a poster for 1 May 1968 and he agreed enthusiastically.[36] Barcelona's Civil Governor issued warnings about the distribution of 'fundamentally communist' propaganda that called for demonstrations, and made clear his intention to suppress any subversive initiative.[37]

In 1968 the many events inspired by Miró's seventy-fifth birthday culminated in an exhibition organised by Barcelona city authorities at the former Hospital de la Santa Creu. Miró refused to attend the press conference and the opening ceremony on 19 November, which was presided over by two ministers. The artist justified his absence on 'doctor's orders', although his intention was to avoid the officials.[38] In December 1968 intellectuals from all over Spain, including Miró, sent a letter to the Minister of the Interior denouncing torture, requesting a public enquiry and expressing their concern about the adoption of more repressive measures.[39]

In December of that same year, in Barcelona, the Colegio Oficial de Arquitectos de Cataluña y Baleares (Association of Architects of Catalonia and the Balearics or COACB) began organising the exhibition *Miró Otro* with collaborators that included the Studio PER (Josep Bonet, Cristian Cirici, Lluís Clotet and Oscar Tusquets). This ideologically loaded exhibition took shape under the state of exception decreed on 24 January 1969 to repress protests following the death of the student Enrique Ruano. Conceived in opposition to the official attempt at the Hospital de la Santa Creu to integrate the artist within the system, one of its aims was 'to oppose the falsely idyllic or inoffensive image that is usually given of the painter with the revulsive force and the significance of protest he holds within himself.' Thus, the three sections of *Miró Otro* – covering the pre-war, Spanish Civil War and

140
**Goutte d'eau sur
la neige rose** 1968
*Drop of Water on the
Rose-Coloured Snow*
Oil on canvas
195.5 × 130.5
Private collection

141
**Cheveu poursuivi par
2 planètes** 1968
*Hair Pursued by
2 Planets*
Acrylic on canvas
195 × 130
Collection Gallery K.A.G.
On loan to the Fundació
Joan Miró, Barcelona

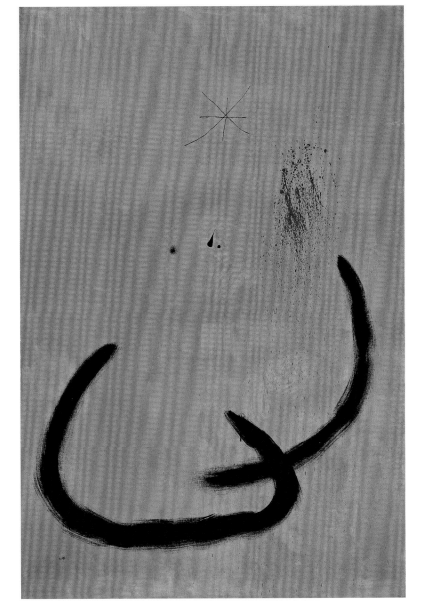

post-war periods – highlighted the nonconformism, transgression and dissent underpinning his work.[40] Miró executed a huge painting on the windows of the COACB headquarters on 28 April 1969, against a background of 'Catalan inscriptions in support of the freedom of Catalonia', prepared by architects from Studio PER (see pp.176–9).[41] Loyal to the unconventional spirit of this exhibition, Miró erased his painting on 30 June.[42] The short film by Portabella entitled *Aidez l'Espagne* (literally, *Help Spain*), recalling the Spanish Civil War, was withdrawn from the exhibition for fear of censorship.[43]

The political and social crisis that ensued after the military trial of sixteen ETA members led to a sit-in by around three hundred intellectuals in the monastery of Montserrat from 12 to 14 December 1970. Miró arrived on the afternoon of 12 December.[44] On 13 December the intellectuals formed a permanent assembly and approved a document, co-signed by Miró amongst others, calling for amnesty and the abolition of the death penalty. The authorities accused the assembly of unleashing a campaign to discredit Spain and on 14 December demanded that they vacate the premises.[45] On 18 December, the *Baleares* newspaper published statements, attributed to Miró and his wife, asserting that they had gone to Montserrat under a misapprehension, believing that they were attending a purely cultural activity.[46] Miró publicly denied this, stating that he had attended voluntarily as an expression of the feelings he had held throughout his life.[47] National and international pressure succeeded in forcing Franco to commute the Basque militants' death penalties.

On 7 November 1971 the Assembly of Intellectuals of Montserrat, in which Miró had participated, signed the founding document of the Assemblea de Catalunya (Assembly of Catalonia), a platform that brought together diverse groups in opposition to the Franco regime. In 1975 Miró backed the Assembly of Catalan Intellectuals and their project to hold a Catalan Culture Congress (CCC).[48] The

following year, Miró became one of the Honorary Vice Presidents of the CCC and, in 1977, he designed a poster to mark the end of the Congress.[49] Throughout the seventies and eighties, as during the Second Spanish Republic, posters became ideological weapons wielded, in this case, in support of Catalan culture and human rights, UNESCO and Amnesty International. In 1975, before Franco's death, Miró agreed to donate a lithograph in a limited edition to be sold on behalf of Amnesty International in New York. At this time, the organisation was still banned in Spain. Miró's artwork, together with those of fourteen other artists, featured in international exhibitions such as *Artistes per l'amnistia* at the Fundació Joan Miró, which opened to the public on Human Rights Day (10 December 1976) to commemorate Prisoners of Conscience Year.[50]

The death in 1975 of Franco, whom Miró identified with Alfred Jarry's grotesque character Père Ubu, did not put an immediate end to oppression.[51] Miró and La Claca theatre group created *Mori el Merma* (loosely, 'Death to the Bogeyman'), inspired by Jarry's play, *Ubu Roi*. The première at the Barcelona Liceo theatre on 7 June 1978 was dedicated to Els Joglars, another theatre group that had suffered repression for their production of *La Torna* (1977), which evoked the execution of the anarchist Salvador Puig Antich. Miró greeted the audience, accompanied by members of La Claca, wearing or carrying masks with the mouth silenced by a red band, the emblem of the campaign for freedom of expression. While not exempt from criticism for distorting Jarry's work, the première of *Mori el Merma* at the Liceo was a manifestation of dissent.[52]

Miró had spurned the siren call of the Franco dictatorship and remained loyal to the ethical principles to which he gave expression in his doctor 'honoris causa' investiture speech at Universitat de Barcelona, 1979. Incorruptible, he chose the Catalan and democratic option: an option that was sometimes public, sometimes discreet, but always unshakeable.[53]

142
Sketch for the mural executed on the windows of the Colegio Oficial de Arquitectos de Cataluña y Baleares for *Miró Otro* exhibition, 1969
Ink and wax
15.5 × 176
STUDIO PER, arquitectos

1 Joan Miró, 'Lliçó introductòria sobre la concepció cívica de l'artista', acceptance speech, Universitat de Barcelona, Barcelona 2 Oct. 1979, pp.9–11, trans. in Joan Miró 1993, pp.480–1.

2 Document on the Venice Biennale, 29 April 1950; Enrique Pérez Comendador, 'España en la Bienal Internacional de Venezia', June 1950 (Archivo del Ministerio de Asuntos Exteriores y Cooperación (AMAE), AMAE-R-4837-1-2).

3 José Antonio Coderch (Madrid) to Rafael Santos Torroella, 30 March 1951, repr. in Jaume Vidal, 'Más allá de la escritura', in Rafael Santos Torroella, exh. cat., CBA/Residencia de Estudiantes, Madrid 2003, pp.106–7. DGRC (Madrid), MAE proceedings, 9 March 1951; list of Triennale objects, 1951; Coderch (Barcelona), report on the Triennale, June 1951 (AMAE-R-4838-1-2, 5).

4 With the help of Coderch, Santos Torroella subsequently obtained a diplomatic passport that enabled him to travel to Milan. María Teresa Bermejo, interview with the author, 28 July 2010.

5 Rafael Santos Torroella, Altamira, Barcelona, 1949, illustrated by Miró, Llorens Artigas and Ferrant, with a cover by Mathias Goeritz.

6 ADLAN, Manifest dels Amics de l'Art Nou, Barcelona 1932.

7 Coderch (Barcelona), report on the Triennale, June 1951 (AMAE-R-4838-1-2, 5).

8 DGRC (Madrid), memorandum to Miró, 30 July 1951 (AMAE-R-4838-2).

9 Antoni Tàpies, Memoria personal. Fragmento para una autobiografía, Barcelona l983, p.243..

10 Leopoldo Panero (Madrid) to J.P. Lojendio, 8 May 1951; DGRC (Madrid) to the ICH, 14 May 1951 (AMAE-R-4263-22). L. Figuerola-Ferretti, 'La Bienal Hispanoamericana de Arte, a punto', in Arriba, 16 Sept. 1951. Panero declared: 'We have invited and are counting on the participation of … Dalí, Zabaleta and most certainly that of Miró.' Miguel Cabañas, 'La primera Bienal Hispanoamericana de Arte', thesis, Universidad Complutense, Madrid 1991, pp.1–18, 633–73.

11 Rodolfo Pallucchini (Venice) to Luis García de Llera, 29 July 1953 (AMAE-R-4837-8).

12 Marqués de Prat de Nantouillet (Rio de Janeiro) to the Minister of Foreign Affairs, 22 Sept. 1952; DGRC (Madrid), official letter to the director of the ICH, 3 Nov. 1952; Director of the ICH (Madrid), official letter to the DGRC, 14 Nov. 1952; ICH report, 17 Jan. 1953 (AMAE-R-4259-5).

13 Miró (Paris) to Pierre Matisse, 7 Dec. 1952, Pierpont Morgan Library-Pierre Matisse Gallery Archives (PML-PMGA).

14 Alfredo Sánchez Bella (Madrid) to the Marqués de Prat de Nantouillet, 13 Aug. 1953, in Cabañas 1991, pp.1675–7.

15 Sánchez Bella (Madrid) to Miró, 21 Oct. 1953, Fundació Pilar i Joan Miró (FPJM); Pierre Matisse (New York), telegram to Francisco Matarazzo, 6 Nov. 1953 (PML-PMGA).

16 Miró (Barcelona) to Pierre Matisse, 20 Oct. 1953 (PML-PMGA).

17 Pallucchini (Venice) to García de Llera, 29 July 1953 (AMAE-R-4837-8).

18 García de Llera (Madrid) to Pallucchini, 17 Oct. 1953; Pallucchini (Venice) to García de Llera, 1 Nov. 1953 (AMAE-R-4837-8). Giovanni Ponti (Venice) to Miró, 28 Dec. 1953 (FPJM).

19 Pallucchini (Venice) to Miró, 22 Jan. 1954 (FPJM). Miró (Paris) to Pablo Picasso, 6 May 1954 (Musée National Picasso, Paris).

20 Juan Ainaud (Barcelona) to García de Llera, 22 May 1954 (AMAE-R-4837-8). A. Maeght (Paris) to Miró, 28 May 1954 (FPJM).

21 García de Llera (Madrid) to Miró, 3 June 1954 (FPJM).

22 Miró to García de Llera, 7 June 1954; José Rojas (Paris) to DGRC, 25 June 1954 (AMAE-R-4837-8).

23 'El triunfo de Miró en la Bienal de Venecia', in La Vanguardia Española, 20 June 1954.

24 García de Llera (Madrid) to Miró, 8 July 1954 (FPJM).

25 Miró (Barcelona) to García de Llera, 13 June 1954 (AMAE-R-4837-8).

26 Miguel Cabañas, Artistas contra Franco, Mexico 1996, p.128 and further information provided to the author by Cabañas.

27 Del Arco, 'Mano a Mano. Leopoldo Panero', in La Vanguardia Española, 10 Sept. 1955.

28 J.L. Fernández del Amo, three letters to Miró, [1956], 28 Feb. 1956, and [1956] respectively; Miró (Barcelona) to Fernández del Amo, 5 Feb. 1956. Archive of Museo Nacional Centro de Arte Reina Sofía, 2846-2849.

29 Ángel Zúñiga, 'Notas Españolas', in La Vanguardia Española, 18 Oct. 1958.

30 Boletín Oficial del Estado, 2 April 1959.

31 Santiago Amón, 'Joan Miró: Tengo una gran confianza en la fuerza creadora de la nueva España', in El País, 4 May 1978.

32 Germán Baraibar (Bogota) to J.M. Ruiz, 25 May 1959; J.M. Areilza (Washington) to the MAE, 18 May 1959 (AMAE-R-5802-93).

33 RABASF (Madrid) to Miró, 22 March 1966; Miró (Barcelona) to Javier Sánchez, 4 March 1968; César Cort to the Academy (Madrid), 9 Jan. 1971; RABASF, secretariat communiqué, 22 Feb. 1971. Archivo Real Academia de Bellas Artes de San Fernando. Del Arco, 'Mano a Mano. Jacques Dupin. Joan Miró', in La Vanguardia Española, 1 April 1966.

34 Tàpies 1983, p.408. Tad Szulc, 'Art Auction Aids Fined Spaniards', in The New York Times, 27 June 1966.

35 Elionor Sellés, 'Moviment obrer, canvi polític, social i cultural', thesis, Universitat de Barcelona 2005, pp.223–4.

36 Pere Portabella, interview with the author, 27 April 2010.

37 'Nota del Gobierno Civil sobre pretendidas manifestaciones', in La Vanguardia Española, 30 April 1968.

38 Raillard 1978, p.208.

39 Julián and Tàpies 1977, pp.209–17.

40 Julio Schmid (Barcelona) to collaborators, 16 and 17 Dec. 1968; Luis Domenech (Barcelona) to collaborators, 24 Jan. 1969; Julio Schmid (Barcelona) to Alexandre Cirici, 25 Feb. 1969; 'Exposició Miró: Objecte i caràcter de l'exposició' (Barcelona), 26 Feb. 1969. (Document signed by the members of Studio PER, Tàpies, Portabella, Alexandre Cirici Pellicer and Prats.) Col·legi d'Arquitectes de Catalunya (COAC). For more on Miró Otro see Willam Jeffett's text in this volume.

41 Raillard 1978, pp.208–9. Francisco Gironella (Barcelona) to Xavier Echarri, 29 April 1969 (COAC). Cristian Cirici, interview with the author, 26 April 2010.

42 'I was very moved and very interested in the exhibition that was devoted to me at the College of Architects and am delighted with the success it has achieved. Please accept my congratulations and thanks and pass them on to all the organisers. In order to remain true to the spirit of this exhibition, I intend to destroy the external mural painting myself, on the last day of the exhibition' (Miró (Paris) to Javier Subías Fages, 24 May 1969, in Ramón M. Puig, 'Miró, otro', in Cuadernos de arquitectura, no.72, 1969)

43 COACB, document 'Proposta de resolució sobre les pel·licules d'en Portabella per a l'exposició Miró', undated, but created later than 7 July 1969 (COAC). Cristian Cirici, interview with the author, 26 April 2010.

44 Barbara Catoir, Conversations with Antoni Tàpies, Munich 1991, p.115.

45 'Desalojan el convento de Montserrat las personas que se recluyeron voluntariamente', in ABC, 15 Dec. 1970.

46 'Joan Miró acudió a Montserrat engañado', in Baleares, 18 Dec. 1970.

47 'Miró estuvo voluntariamente en Montserrat', in Diario de Mallorca, 19 Dec. 1970.

48 Julián and Tàpies 1977, pp.222–33. The so-called Congress lasted nearly three years and included campaigns to promote the official use of Catalan and the revival of Catalan institutions.

49 'Congrés de Cultura Catalana', in La Vanguardia Española, 12 Oct. 1976. p.29.

50 Edith Gross, Andrew Blane (New York) to Miró, 26 April 1975; Gross [New York] to Miró, 18 June 1975; Lillian Hellman, Muhammad Ali (New York) to Mr and Mrs Matisse, 17 Sept. 1976; Francesc Vicens (Barcelona) to Blane, 28 July 1976 (all PML-PMGA). A limited edition of seventy-five lithographs plus five artist's proofs was printed by Adrien Maeght, Paris. A first edition of three thousand posters was also printed.

51 Raillard 1978, p.237.

52 J.I., 'Joan Miró: "Ja els hem fotut"', in Tele/eXpres, 9 June 1978; Enric Canals, 'Espectáculo de Joan Miró y el grupo Claca en el Liceo de Barcelona', in El País, 11 June 1978; Martí Farreras, 'Mori el Merma', in Tele/eXpres, 12 June 1978.

53 Josep Faulí, 'Un catalán en ejercicio', in Destino, 15 June 1978.

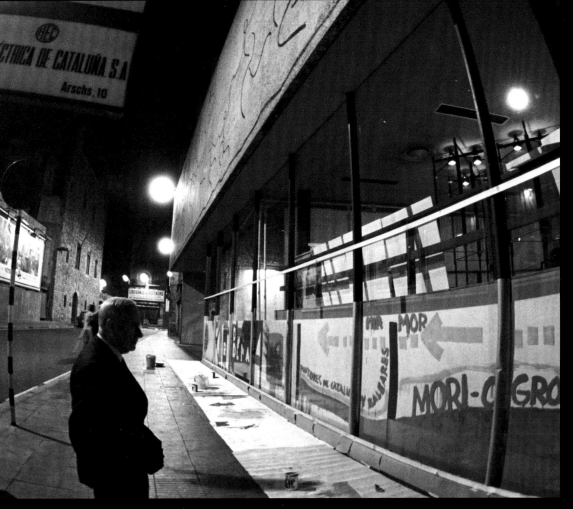

Miró Otro, 1969

Miró painting the windows of the
Colegio Oficial de Arquitectos de
Cataluña y Baleares (Association
of Architects of Catalonia and the
Balearics), April 1969 , and scraping
the work off in June 1969.

Photographs by Francesc
Català-Roca (colour) and
Colita (black and white)

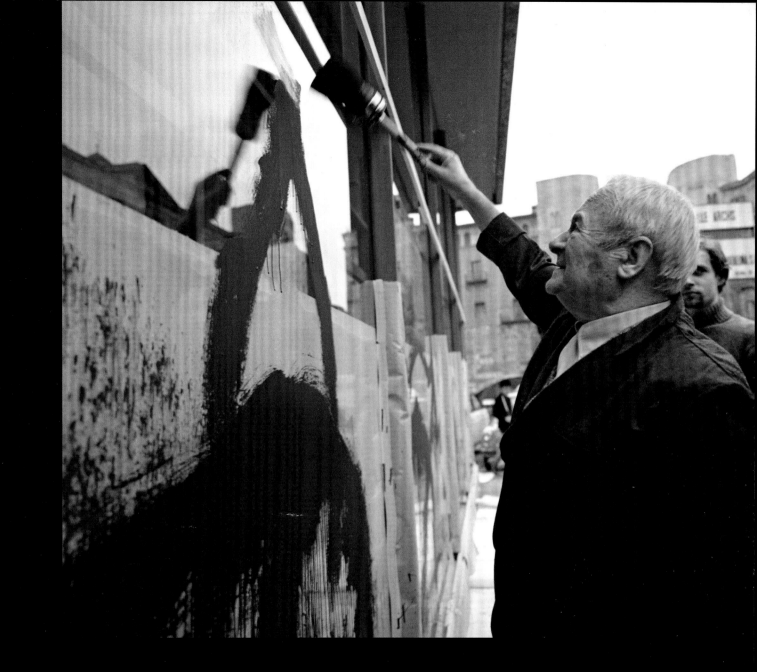

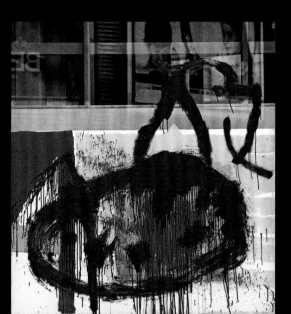

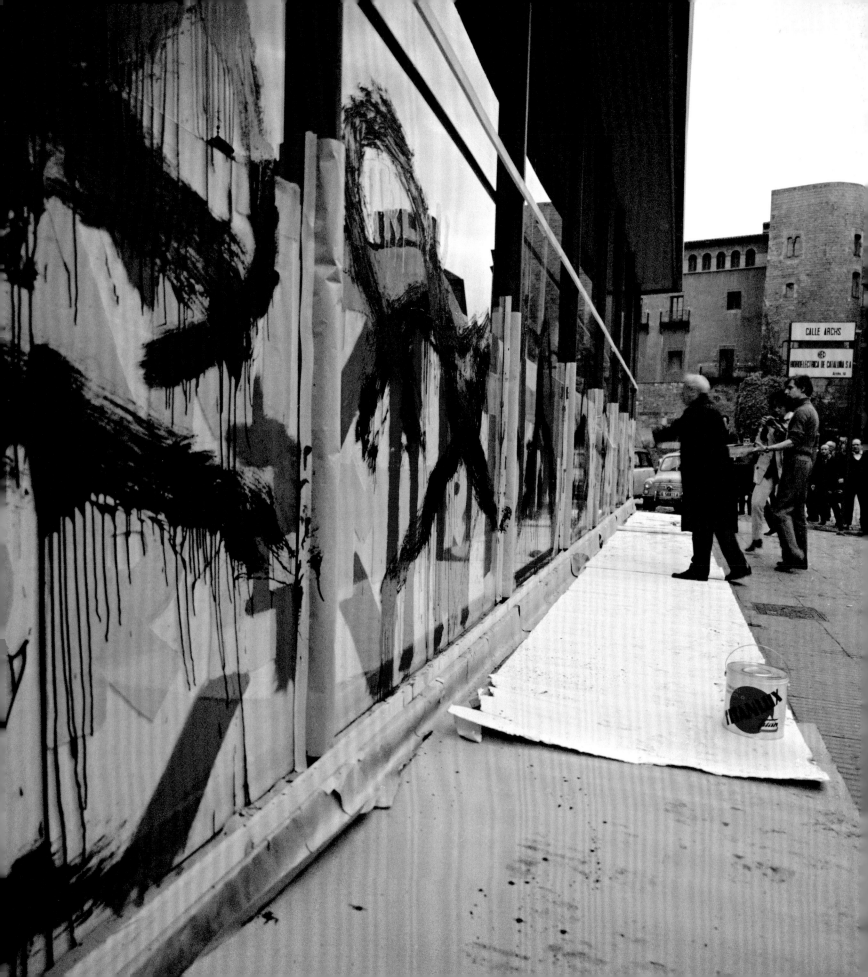

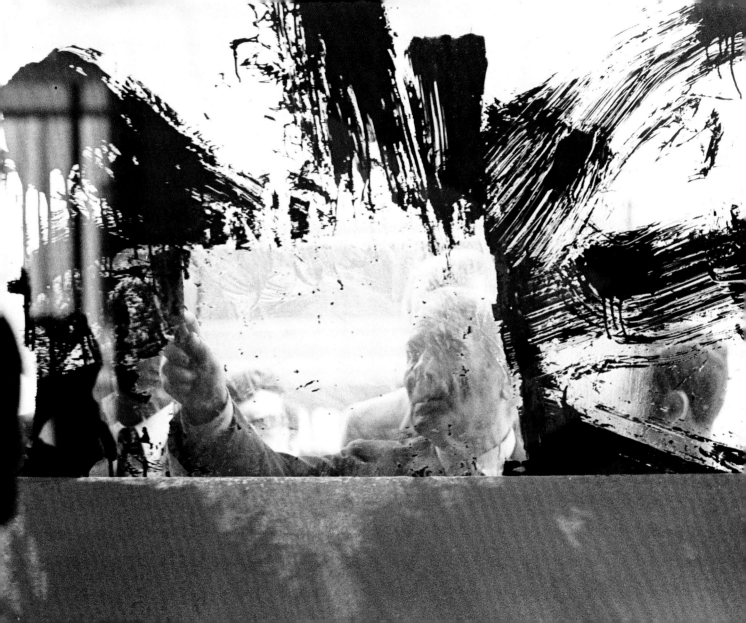

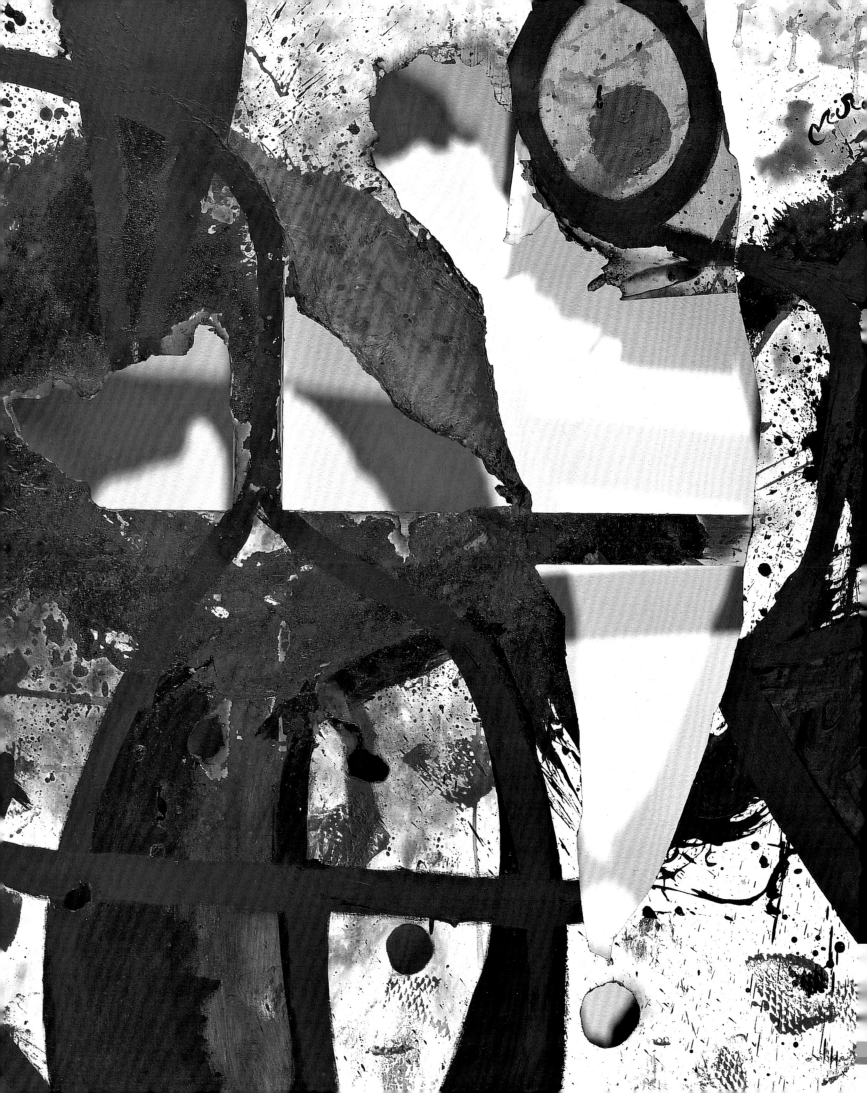

From *Miró otro* to the *Burnt Canvases*

WILLIAM JEFFETT

Avant-garde art refuses to be considered as a place of non-theoretical and non-practical experience, and instead claims to be the model for a privileged mode of knowledge of the real, a moment of subversion of the hierarchized structure of the individual and society, and thus an instrument of true social and political action.[1]

During the 1960s and early 1970s Miró returned to the project he had defined forty years earlier as 'the assassination of painting'. His intention was to assert the centrality of his work in contemporary art, and to deny its institutionalisation by the art market and by museums. He reaffirmed the political relevance of his earlier engagement with Surrealism and its roots in the anti-art of Dada. Although in Spain he exhibited very little in any official capacity, Miró's international presence provided him with a platform from which to denounce the repressive and authoritarian regime of General Francisco Franco.

Two aspects of Miró's work most clearly demonstrate his artistic and intellectual resistance to the regime. His only major exhibition in Spain during this period was the retrospective held in Barcelona at the Hospital de la Santa Creu from December 1968 to January 1969. Organised by the Fondation Aimé et Marguerite Maeght in Saint-Paul de Vence, where it had been shown between July and September 1968, the exhibition was a conventional survey of his oeuvre, brought to the city with the assistance of the Ajuntament de Barcelona (City Hall). Shortly thereafter, a group of young architects associated with Colegio Oficial de Arquitectos de Cataluña y Baleares (Association of Architects of Catalonia and the Balearics) invited the artist to stage the alternative *Miró otro*, a project which would challenge the conventional structure of exhibitions and explicitly associate his work with the political and cultural resistance of the younger generation.[2] The alternative exhibition featured two elements: a radical display showing the 'other' aggressive and politically committed Miró (including anti-artworks like collage and reproductions), and an ephemeral mural executed in collaboration with the architects, on the windows of the rationalist building. Perhaps, here, Miró responded to the younger painter Eduardo Arroyo's 1967–9 series *Miró refait* (*Miró Remade*), which had appropriated Miró's style into a critical realism depicting political repression.[3]

A similar dual presentation featured at Miró's next important exhibition at the Grand Palais in Paris in 1974. Though a retrospective, he devoted half of the exhibition to new, provocative works designed to demonstrate his vitality and to engage with the current political struggle. A key feature was a new group of specially made *Toiles brûlées* (*Burnt Canvases*, nos.145–9), in which he rejected traditional conceptions of art and used artistic gestures in a poetic and political affirmation of liberty. Miró made sure that these were given special emphasis in the final room and in his comments to journalists.[4]

Burnt Canvas II 1973
(detail of no.146)

Miró otro, Colegio Oficial de Arquitectos de Cataluña y Baleares, Barcelona, 1969

Miró otro was drawn largely from Miró's and other private collections. It was conceived in collaboration with Studio PER, made up of the architects José Bonet, Cristian Cirici, Luis Clotet and Oscar Tusquets. The exhibition design consisted of a rationalist frame constructed from planks of wood, recalling the example of Josep Lluís Sert's Spanish Republican Pavilion for the 1937 Paris Exposition Internationale. Consequently the exhibition focused on Miró's more anti-artistic works and those which demonstrated his political commitment: photographic reproductions stood in for works that were not available, including the lost Republican mural *Le Faucheur* (*The Reaper*, also known as *Catalan Peasant in Revolt,* see pp.118–21). In keeping with the climate of the moment, the show offered a reappraised interpretation of Miró and his work.[5] The first section, 'Period of Formation and Discovery', included the 'period of formation', the 'surrealist phase' and

the 'period of the Republic'. The second section, the 'Interruption of the War', consisted mainly of photographs and a film by the young Catalan experimental filmmaker Pere Portabella. The third section rejected a sanitised view of the artist and proposed a more aggressive and politically committed Miró. It consisted of 'the conjunction of images which reach the consumer' and 'the image of Miró fabricated with the intent of integration'. There followed, as a demonstration of the other Miró, 'Kitsch deriving from Miró' and a part given over to 'contemporary avant-garde'. This revealed his influence on younger artists, here represented by Eduardo Chillida, Jordi Gali, Ángel Jové, Manolo Millares, Joan Ponç, Antonio Saura, Antoni Tàpies, and Joan-Pere Viladecans.[6] Some critics came to wonder whether the exhibition was merely a fashionable gesture, and exactly how 'this' view of Miró differed from the one recently presented in Barcelona.[7]

Even more provocative was the mural that Miró and the students clandestinely executed on the seventy-metre-wide windows of the building, below Picasso's concrete frieze of

143
Untitled [Head of a Man]
11 December 1937
Gouache on black paper
65.4 × 50.5
The Museum of Modern Art, New York. Richard S. Zeisler Bequest, 2008

This work was reproduced as the poster for *Miró otro*

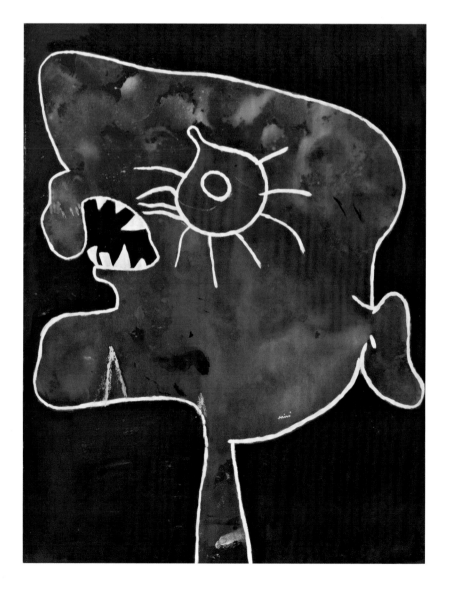

1962, in the five days prior to the opening on 1 May 1969. The gesture of mirroring the format of Picasso's frieze in an ephemeral work placed Miró firmly alongside the vitality of the younger generation. Limiting themselves to red, yellow, blue and green, the architects painted abstract shapes and slogans supporting Catalan independence and denouncing political repression on the exterior glass, with large sheets of paper unrolled across the inside so that they were visible from the street. One such slogan read '*mori ogro*' ('death to the ogre'). Beginning work in the early hours of 28 April, two days before the private view, Miró applied large black marks of paint to the exterior of the glass. The public opening was strategically scheduled for 1 May, the first anniversary of the revolutionary student riots in Paris. Though Miró and the students avoided attracting attention while painting the windows, they made sure the work was extensively documented by the photographers Francesc Català-Roca, Oriol Maspons and Colita, and filmed by Portabella (*Miró L'altre* 1969). The mural remained on view until the exhibition closed on 30 June, when its careful removal, begun by Miró himself, was also documented (see pp.176–9).[8]

The mural prompted a polemic in the press. Some regretted that a work by Miró would be lost. Català-Roca recalled that the artist's only condition was that it would be destroyed when the exhibition finished so that no profit could be made from it.[9] Miró himself later remembered:

> The young architects had wanted to make a shocking exhibition, an attack, the opposite of an official exhibition … [F]or the young architects, I was there … I painted on the pavement … What interested me, was

the instantaneous gesture, [executed] on a prepared ground, where there were inscriptions in Catalan in favour of freedom for Catalonia.[10]

While local cultural administrators, like Josep Lluís Sicart, predictably wanted to preserve the work, it was perhaps more surprising that the architects, especially Clotet, also contemplated preserving it with a second layer of glass,[11] and Alexandre Cirici suggested relocating the windows themselves.[12] Other figures from the Barcelona art world, including Llorens Artigas, Miguel Gaspar and Juan Perucho, understood Miró's position, although Louis Aragon, from the distance of Paris, misread their destruction as a form of political censorship: 'It is a crime to want to efface a moment of the human spirit … any form of iconoclasm is to be condemned because it permits the return of barbarism.'[13] This was particularly odd as it had been Aragon who had defended Miró's 'defiance of painting' in 1930.[14]

Joan Miró, Grand Palais, Paris, 1974

Miró's 1974 retrospective in Paris included over three hundred works, half of which were recent paintings, bronzes, ceramics and tapestries, many made especially for the exhibition. He sought to make a violent impact, strikingly with the series of five burnt paintings that were a central component of the final room. Two of these were suspended above the heads of the viewers so that both the fronts and the backs of the canvases (on which Miró had inscribed the dates) could be seen.

144
Francesc Català-Roca
Miró looking through
Burnt Canvas V, 1974
Photographic Archive
F. Català-Roca, Col·legi
d'Arquitectes de Catalunya

These paintings were not simply a gratuitous gesture, as he had devoted careful consideration to their production. They were made in Tarragona between 4 and 31 December 1973, with Josep Royo, who also helped to make the tapestries (*Sobreteixims*) prominently featured in the display. Following the example of *Miró otro*, their production was documented in a film by Francesc Català-Roca (*Miró 73. Toiles brûlées* 1973). Each painting in the series passed through a number of stages: first the canvases were cut with a knife and punctured with sharp objects; paint was then applied and petrol was poured over them and ignited. Further paint was applied and again burned with considerable care, a wet mop used for control and a blowtorch for concentration on specific areas. Miró then walked on each painting with the surface face down, after which a second phase of cutting took place, this time with scissors. He painted the surface with his fingers and punched holes in it, tilting the canvas to allow the wet paint to drip. From behind, he cut away some of the burnt fragments. A final stage included another application of paint and the nailing down of the burnt fragments to the stretcher bars, now exposed and scorched.[15] Revealing the stretcher bars, the architecture underlying the illusion of painting, recalled how Miró, in the 1920s, similarly had allowed the traces of the stretcher bars to show through in the field of paint covering the canvas. Català-Roca's film concluded with the works shown outdoors, where it was possible to look through the voids at the natural landscape (no.144). Thus Miró laid bare the structure of representation and, simultaneously, denied it by suggesting that the subject of art was the presentation of the real and not an illusion. In this way he also challenged the commodification of painting by the art market.

Inspection of Miró's annotations shows that he had prepared the process with care. He referred to them as 'burnt and lacerated canvases' and listed four phases: 'I: Pour colours', 'II: Cuts', 'III: Tear and hang it' and 'IV: Black Spots'. He reinforced the sense of violence by adding comments such as 'with rage' and 'improvise with rage', underlined in red.[16] In another note

to himself, titled '5 burnt canvases' and dated '12/ɪx/73', Miró wrote: 'It is important how they were extinguished if they were already finished and afterwards burn them and re-work them, the fact, gesture, moral of burning (?).'[17] Although he mainly worked in oil paint, he executed these in acrylic, presumably a better medium for the unusual technique. Another note by the artist reveals this choice and his intention to exhibit the series in Paris, concluding 'if these oil colours don't dry look into water-based colours'.[18]

The point of departure for the series, in the context of the violent political unrest of the period, is indicated in another note on a press clipping titled 'Hooliganism in Madrid' ('Gamberrada en Madrid'), where the caption to a photograph reads: 'The windows of the principle façade of the Madrid Stock Exchange appear broken by stones, thrown by youths of both sexes, who hurled fireworks and cans of paint, as well as breaking the windows. The damage was of little material importance.' Miró's own notes suggest that this image was a source of inspiration: 'Treat the big white canvases that I have in Son Boter [his studio] in this spirit. Burn them partially. Throw stones at them and stab them to break them open. Cut them into pieces. Pour on pots of paint. Walk on top of them.' A final annotation suggested further modifications: 'sew on fragments', 'hang things' and 'hang the dried cat'!'[19]

In his catalogue essay for the Paris exhibition, Jacques Dupin considered the artist's recent work, stressing the importance of Miró's 'assassination of painting' and claiming that with the burnt canvases 'he has chosen the violence of the fire as his accomplice and partner'.[20] In the judgement of critic Jeanine Warnod, in 'recovering the Dada spirit, [Miró]

again questions painting which, according to him, is in "a state of decadence since the period of the caves"'.[21] As Miró told her, fire was also a material to be deployed: 'And then there is the struggle with the elements, earth and fire. And the unforeseen, that is very seductive, as much in the firing of ceramic as in the improvisation of textile assemblages or the lacerating of the burnt canvases in painting.'[22] The idea of fire as a medium derived from Miró's vast experience of producing ceramics with Artigas. At the same time, it is likely that he was aware of how Yves Klein had painted with fire (*Fire Paintings* 1961), how Millares treated his surfaces as a wound to be sutured, and how Lucio Fontana had lacerated and punctured the canvas. Millares had been included in *Miró otro* and Miró had direct access to his work and that of Fontana through the Barcelona gallery of his friend René Metras.[23] Generally less on view in Barcelona were Alberto Burri's burnt paintings, *Combustione* c.1956, although Burri was included in the important exhibition *Otro arte* (Barcelona, 1957) and a retrospective of his work was held in Paris in 1972.[24]

Jacques Michel, another reviewer of the 1974 show, emphasised that the elements of 'rupture' and 'revolution' in Miró's paintings were most evident in the burnt series: 'It is another Miró who violates his canvases as if he shouted in rage against a world with which he does not live in peace. How otherwise to explain his latest canvases, lacerated, burned, perforated, which, hanging in the middle of the last room, summon memories of some tragic event?'[25] The artist simply told Michel: 'These are anti-paintings.'[26] For the Surrealist writer José Pierre, echoing Dupin, 'they are truly paintings in which the flame has been invited to collaborate,

consequently corroding not only the canvas (blackening the stretcher more than a little), but devouring the forms and the colours set out on the support.'[27] While the fire destroyed the paint, the artist sought to reinvent the world: 'Miró has not denied painting, for forty-five years he has undertaken to assassinate it. Because one only assassinates what one loves, and what endures (because if it were not to last, why would there be a need to assassinate it?)' Pierre concluded:

the visit to the three floors of the Grand Palais takes the shape of a heroic journey where each period shows us Miró slaying the dragon, ceaselessly reappearing from its ashes, from the complaisance of one's self. And bringing painting back, by the scruff of its neck, with its furious mission of negating mediocrity, of challenging the world as it is and proposing a world to be (re)invented.[28]

One of the most interesting articles regarding the centrality of the *Burnt Canvases* for the exhibition was by Raoul-Jean Moulin in *L'Humanité*, the newspaper of the French Communist Party. For Moulin these canvases were 'the martyred body of painting, as if the violence of the fire in the hands of Miró had suddenly managed to match the work of time and the elements continuing the work of men'.[29] Miró saw fire as productive, telling Moulin: 'I love to work with fire. Fire has unforeseeable reactions. It destroys less than it transforms, it acts on what it burns with an inventive force which possesses magic. I wanted to paint with fire and by fire'.[30] He further argued for the artist's social awareness: 'The artist does not live in bliss. He is sensitive to the world, to the pulsation of his time, to the events which compel him to act.

This is bound to happen. This is not an intellectual attitude but a profound feeling, something like a cry of joy which delivers you from anguish.'[31]

In his subsequent conversations with Georges Raillard, Miró described the series as a rejection of the speculative art market. 'I have burned these canvases', he said, 'on the level of form and profession, and as another way of saying shit to all of those people who say that these canvases are worth a fortune.'[32] He revealed that his action referred back to the midsummer festival of St John (23–24 June), which features fireworks and bonfires of old furniture ('when I was young, I never missed the bonfires on the 24 June … this pleasure I found in the canvases of 1974'), and we might speculate that this reference also evokes what the philosopher Gaston Bachelard called 'the principle of purification'.[33] Miró also drew attention to the way in which he suspended the canvases in Paris: 'Both sides were living, the front and the back … and the void in the middle, through which anything could pass'.[34] His emphasis on the void in painting recalled both the transparency of painting on glass in *Miró otro* and the reversal of his own name in the poster for that same exhibition, which through a graphic device demonstrated the doubled, 'other' Miró of aggression and resistance.

Crisis and Politics

Miró's renewed 'assassination of painting' coincided with the sustained economic and political crisis of the later years of Francoism. Antoni Jutglar's analysis of the recurrent and

145
Toile brûlée I
4–31 December 1973
Burnt Canvas I
Acrylic on burnt canvas
130 × 195
Fundació Joan Miró, Barcelona

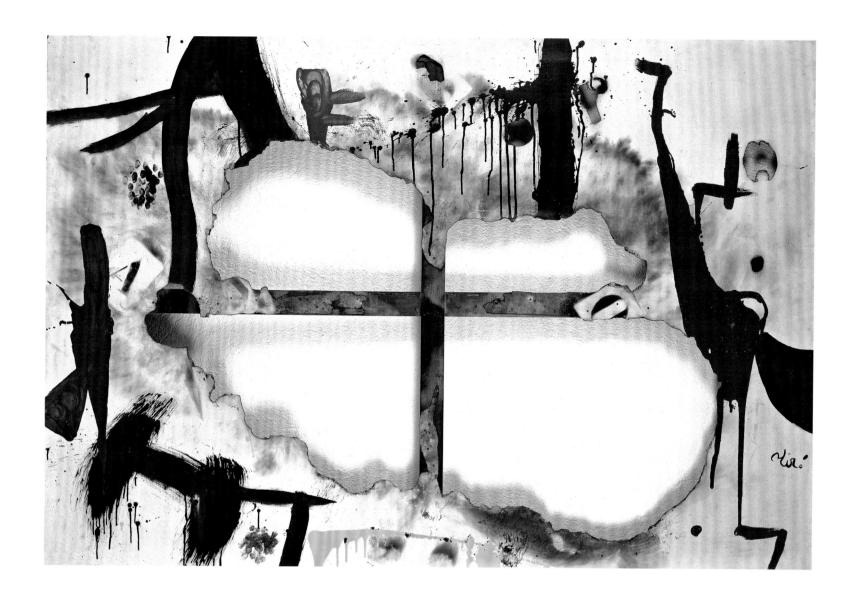

massive unemployment during these years was typical of this pessimistic climate.[35] Apart from the economic and spiritual crisis, and despite a new period of development fuelled by tourism, the 1960s in Spain were marked by political detention, torture and executions. In 1963 the regime had the Marxist militant Julian Grimau executed. In 1966, in a bid to democratise the Universitat de Barcelona (University of Barcelona), students and faculty held a clandestine meeting at the Capuchin Monastery in Sarrià at which they agreed a 'Declaration of Principles' and issued the manifesto *For a Democratic University (Por una universidad democrática)*.[36] Apart from the university students and staff, thirty intellectuals and artists were present, including Jutglar and Tàpies as well as Oriol Bohigas, Albert Ràfols Casamada, Xavier Folch, Joaquim Molas and Jordi Solé-Tura. The police locked in the delegates and only permitted them to leave after confiscating their identity cards. Many of the participants in the 'Capuchinada', including Tàpies, were later imprisoned.[37]

Miró, Dupin, Picasso and Michel Leiris were among the international artists and writers who donated works and manuscripts to raise funds to pay the fines of those arrested.[38]

On 13 December 1970, three hundred Catalan professionals, intellectuals and artists staged a meeting at the monastery of Montserrat[39] to denounce the Burgos Trials (3 December 1970), torture and the death penalty.[40] Tàpies was again present, along with Miró, Daniel Lelong, Jacques Dupin and Mario Vargas Llosa.[41]

Political violence on both the right and left marked these difficult years. On 20 December 1973 a group of ETA militants assassinated Admiral Luis Carrero Blanco in a violent bombing in the centre of Madrid as a revenge attack following the trial of ten leaders of the outlawed trade union Comisiones Obreras. The assassination was widely debated in the press and hugely disruptive for the Spanish state.[42] As we have seen, the *Burnt Canvases* were underway in December 1973 and, although they were started well before the assassination, it

seems likely that Miró was sensitive to these political events as he made his unusual series.

The political violence did not stop there. The Catalan anarchist and member of the anti-Francoist MIL (Movimiento Ibérico de Liberación), Salvador Puig Antich, had been detained three months earlier, in September 1973. Following the death of a plain-clothes policeman during his arrest, Puig Antich was condemned to death by the garrotte and executed on 2 March 1974.[43] During the preceding period of international appeals for clemency, Miró continued his intense preparations for the Paris retrospective and dedicated one of his major triptychs, *L'Espoir du condamné à mort* (*The Hope of a Condemned Man* no.159), on 9 February 1974, to Puig Antich, whom he described as 'the young Catalan anti-fascist' and as 'this poor Catalanist boy'.[44]

Through the *Burnt Canvases*, made when Puig Antich was in custody, Miró sought to achieve not only the political protest he had already made through his symbolic presence at Montserrat, but also a protest through the practice of his

art. A political gesture could be relegated to the realm of anecdote, while an attack on painting itself represented a more fundamental attack on the bourgeois reduction of art to elite culture or economic commodity. In 1970 Alexandre Cirici had argued that Miró's interest in the primitive and primordial, symbolised by the image of the foot in contact with the earth (e.g. his walking on the burnt canvases so as to leave the trace of his steps), represented a rejection of the conservative intellectual elitism long proposed by Eugeni d'Ors.[45] Miró's 'insurrection' belonged to the world of the peasant labourer and, for Cirici, 'Miró ... raises a cry of protest or, at least, offers a lucid vision, but also creates an image of the joy of one who lives in harmony with his own world'.[46] At the same time, Miró's revolt was one which positioned art firmly in the world, that is, outside the confines of conventional philosophical and institutional models. So his *Burnt Canvases* represent the end of one conception of painting and the beginning of a completely new phase of artistic production.

146
Toile brûlée II
4–31 December 1973
Burnt Canvas II
Acrylic and oil on
burnt canvas
130 × 195
Private collection

147
Toile brûlée III
4–31 December 1973
Burnt Canvas III
Acrylic on burnt canvas
195 × 130
Banco Português
de Negócios, Lisbon

1 Gianni Vattimo, *The End of Modernity: Nihilism and Hermeneutics in Postmodern Culture*, trans. Jon R. Snyder, Cambridge 1988, p. 53.

2 The title of the exhibition and its poster, *Miró otro* ('The Other Miró'), was in Spanish rather than Catalan apparently at the insistence of the censors.

3 See Arroyo's *Miró rehecho o La desgracias de la coexistencia* (Galleria Il Fante di Spade, Rome, 1967) and *Miró refait ou les malheurs de coexistence* (Galerie André Weill, Paris, 1969).

4 Jacques Michel, 'Miró chez Miró', in *Le Monde*, 6 June 1974.

5 The different sections of the exhibition were listed on the reverse of the poster.

6 'Miró otro en el colegio oficial de Arquitectos', in *Diario de Barcelona*, 10 May 1969 (Arxiu Fundació Joan Miró, Barcelona).

7 Rafael Santos Torroella, '¿otro Miró?', in *El Noticiero Universal*, 14 May 1969 (Arxiu Fundació Joan Miró, Barcelona).

8 See Pere Portabella, 'Miró l'altre' in *Miró*, Malet et al. 2006, pp.43–7, and Daniel Giralt-Miracle, 'Clausura de "Miró otro"', in *Destino*, 12 July 1969.

9 Català-Roca 1995, p. 82.

10 Raillard 1977, p.177.

11 'Miró: Polemico. ¿Los "escobazos" deben desparecer?', in *Tele-Expres*, 9 May 1969 (Archive Fundació Joan Miró, Barcelona).

12 Ibid.

13 Aragon, 'Barcelona à l'aube', in *Les Lettres françaises*, no.1287, 11–17 June 1969 (Archive Fundació Joan Miró, Barcelona).

14 Louis Aragon, *La peinture au défi: exposition de collages*, exh. cat., Galerie Goemans, Paris 1930.

15 The many nails are evident on close examination of the paintings.

16 FJM 3493.

17 FJM 3337.

18 FJM 2122. This drawing has a sample of the oil experiment affixed to it with sand added.

19 FJM 2209B. Such a cat was kept in the studio in Palma. These ideas were rejected, though Miró did hang objects on the large *Sobreteixims* also made with Royo.

20 Jacques Dupin, 'Notes sur les peintures récentes', in *Joan Miró* 1974, p.25.

21 Jeanine Warnod, 'La peinture est "en décadence depuis l'âge des cavernes"', in *Le Figaro*, 18 May 1974.

22 Miró quoted in ibid.

23 J.F. Yvars and Margaret Metras, *René Metras 1926–1984: Reconstruir los sueños*, Barcelona 2008, pp. 191–5. Miró showed with Galería Metras in the seasons of 1964–5, 1972–3 and 1977–8, Fontana in the seasons 1966–7 and 1970–1, and Millares in the seasons 1965–6 and 1973–4.

24 *Otro arte. Exposición de pintura y escultura* (Sala Gaspar, Barcelona 1957). Millares was also in this exhibition. The Musée national d'art moderne organised a retrospective of Alberto Burri (May–July 1972), and Millares frequently exhibited in New York with Pierre Matisse Gallery between 1960 and 1974.

25 Michel 1974.

26 Miró quoted in ibid.

27 José Pierre, 'Miró l'assassin', in *La Quinzaine littéraire*, 1–15 June 1974.

28 Ibid.

29 Raoul-Jean Moulin, 'Faire son chemin avec Joan Miró (ou l'apprentissage de la liberté)', in *L'Humanité* (Paris), 25 May 1974.

30 Miró quoted in ibid.

31 Miró quoted in ibid.

32 Raillard 1977, p.27.

33 Ibid., p.134. See also 'Idealized Fire. Fire and Purity', in Gaston Bachelard, *The Psychoanalysis of Fire*, trans. Alan C. M. Ross, Boston 1964, p.103.

34 Raillard 1977, p.134.

35 Antoni Jutglar, *Aspectes històrics de la crisi de l'Occident. Notes per a una història social contemporània*, Barcelona 1963, esp. pp.204–5.

36 Francisco Fernández Buey, 'Memoria personal de la Fundación del SDEUB (1965–1966)', in *Hispania Nova Revista de Historia Contemporánea*, no.6 (2006), pp.833–43. See also Borja de Riquer, *La dictadura de Franco*, *Historia de España* series, Barcelona 2010, p.566.

37 Barbara Catoir, *Conversations with Antoni Tàpies*, Munich 1991, p.113.

38 Antoni Tàpies, *Mémoire: Autobiographie*, trans. Edmond Raillard, Paris 1981, pp.434–40. See also María Luisa Lax's text in this volume.

39 De Riquer 2010, p.699.

40 'The Assembly of Montserrat Manifesto', in William B. Watson and Noam Chomsky, 'Spanish Outrage', *The New York Review of Books*, 22 July 1971.

41 Tàpies quoted in Catoir 1991, p.115. See also Raillard 1977, p.188.

42 De Riquer 2010, p.704. It was known as *Operación Ogro* and became the subject of a film of that title directed by Gillo Pontecorvo (1979).

43 De Riquer 2010, p.709.

44 Miró quoted in Moulin 1974. See also Miró quoted in Raillard 1977, p.44.

45 Pellicer 1970, p.138. See especially *Burnt Canvas II* and *Burnt Canvas V*.

46 Ibid., pp.176–7.

148
Toile brûlée IV
4–31 December 1973
Burnt Canvas IV
Acrylic on burnt canvas
130 × 195
Fundació Joan Miró,
Barcelona. Gift of
Pilar Juncosa de Miró

149
Toile brûlée V
4–31 December 1973
Burnt Canvas V
Acrylic on burnt canvas
195 × 130
Fundació Joan Miró,
Barcelona. Gift of
Pilar Juncosa de Miró

Joan Miró: The Triptychs

MARKO DANIEL

The Hope of a
Condemned Man III 1974
(detail of no.159)

In 1956, Miró moved into his new studio (no.150), designed by his old friend Josep Lluís Sert, the architect of the Spanish Republican Pavilion at the 1937 Paris Exposition Internationale.[1] At the age of sixty-three a dream he had written about almost two decades earlier became reality.[2] But after moving into his grand new studio, Miró, who had virtually stopped painting, spent another few years focusing on sculptures,[3] ceramics and other projects. It was only after he had completed two large ceramic murals for the UNESCO building in Paris in 1958, for which he received the Guggenheim International Award, and after his second trip to the USA for his retrospective at the Museum of Modern Art in New York in 1959,[4] that he resumed painting in earnest, working on a variety of media from canvas to card and burlap to wood. Miró commented how in his new studio he finally felt that he had enough space but the experience of unpacking crated-up works he had not seen since he had left Paris[5] was 'a shock, a real experience', and he went through a process of critical self-examination: 'I was merciless with myself. I destroyed many canvases, and even more drawings and gouaches.'[6] The intense reviewing of previous works from different periods of his life, he claimed, was behind this extended period of inactivity as a painter, and drove him not just to destroy many old pieces but subsequently also to resume work on some of these canvases, paint over them and otherwise respond to these reminders of the past.[7]

When his new works since 1959 were exhibited at Galerie Maeght in Paris, 1961, the latest were a stunning group of three large paintings, *Bleu I, II, III* 1961 (*Blue I, II, III*, no.153). This triptych had been finished just before the exhibition opened;

in fact, Miró retouched at least one of the canvases, *Blue II*, when it was already hanging on the gallery walls (no.154). The *Blue* triptych was Miró's first and it throws into sharp relief a set of concerns that were to occupy him over the next decade and a half during which he painted four more major triptychs.

A photograph of Miró at work on *Blue II* clearly brings home the scale of these three paintings (each measures 270 × 355 cm). The large black blobs that run horizontally along the middle of this canvas like a row of heads invite the viewer into the open space of the canvas, making the vertical slash of red paint cutting in on the left all the more towering. In *Blue I* the larger number of splashed black dots and a shorter, bleeding red stroke create a busier feel. A thin line bisecting the canvas from top to bottom recurs in the final panel of the triptych, where it loosely meanders up to one of the other two compositional elements, a short red line at the top right. Its gentle loop seemingly confines the black dot to the bottom right corner and simultaneously opens up an expanse of pure colour on the other side, where the brushed smudges map out an intense field of empty space, a humming blue void, which brings to mind earlier paintings such as the Stockholm *Tête de paysan catalan* 1925 (*Head of a Catalan Peasant*, see no.34).

Among Miró's notes from the 1960s there is a clipping from a local newspaper showing not much more than a single phrase by Victor Hugo, 'L'art c'est l'azur' (literally, 'art is blue'), highlighted by Miró.[8] While this supernal aspiration is a sentiment shared by Mallarmé and the Parnassian poets, who were greatly admired by Miró, Julia Kristeva argued that 'the perception of blue entails not identifying the object' and

that blue is 'the zone where phenomenal identity vanishes'.[9] Significantly, the receptors in the human eye responsible for the detection of short wavelengths (blue) only make up a tiny fraction (about two per cent) of the colour-sensitive photoreceptors, and are almost entirely absent from the fovea centralis, the point of sharpest visual acuity at the centre of the retina, being distributed much more towards the periphery.[10] Kristeva focused on the fact that foveal vision, that is to say centred vision concerned with the identification of detail, is developed in humans about sixteen months after birth, long after colour perception. She extrapolated from this an association of foveal vision with subject-formation (Jacques Lacan's 'mirror stage') and suggested that the 'noncentred or decentring effect' of blue lessened 'both object identification and phenomenal fixation'.[11]

The relevance of Kristeva's argument to this discussion of Miró's *Blue* triptych is perhaps most evident in relation to the isocephalic line of crisp dark blobs in *Blue II*, the central panel flanked on the left by one with floating blurred shapes and on the right by an almost void blue colour field 'filled only', as Rosalind Krauss said of the magnetic field paintings, 'with the pulsation of unimpeded colour'.[12] The varying intensity of blue paint – brushed, washed, smudged on white ground – animates the surfaces with a pictorial depth that is in constant topological exchange with the real, physical space defined by the three large canvases. Their phenomenological presence seems to articulate precisely the relationship between the subject and the world described by Kristeva:

The chromatic experience can then be interpreted as a repetition of the specular subject's emergence in the already constructed space of the understanding (speaking) subject; as a reminder of the subject's conflictual constitution, not yet alienated into the set image facing him, not yet able to distinguish the contours of others or his own other in the mirror.[13]

Kristeva's comments bring out not just the affect of the triptych on the single spectator, but crucially draw attention to the viewer being in the world with others. The relationship between individuality or singularity and the collective and social is thus reflected back on the viewer even in their quiet immersion in the pictorial space.

Physically, the monumental presence of the triptych (with a combined length of over ten metres) stands out from Miró's paintings up to this date. It can be traced back to his first visit to the USA in 1947; the exposure to the new American painting he encountered in New York, where he spent nine months working on a mural for the Cincinnati Terrace Plaza Hotel, felt to him 'like a punch to the chest'.[14] In an interview with Margit Rowell he admitted that the freedom, boldness and daring of the young American painters' works had a decisive impact on him by signalling new possibilities and directions,[15] but I suspect that on his second visit to the USA in 1959 he was just as struck by the sheer ambition of their large scale, and this led to his energetic resumption of painting after his return to Mallorca. The *Blue* triptych is the culmination of this period.

Miró considered them slow paintings – not because of the time it took to paint them but because of how long it took him to work out in his head what he wanted to achieve: 'It took an enormous effort on my part, a very great inner tension to reach the emptiness I wanted.'[16] These comments for the first time directly introduce the importance that Asian art, calligraphy and the philosophical concepts of Zen Buddhism, as he understood them, held for him:

150
Miró's studio designed by Josep Lluís Sert and completed in 1956, now part of the Fundació Pilar i Joan Miró, Mallorca

It was like preparing the celebration of a religious rite or entering a monastery. Do you know how Japanese archers prepare for competitions? They begin by getting themselves into the right state, exhaling, inhaling, exhaling. It was the same thing for me. I knew I had everything to lose. One weakness, one mistake, and everything would collapse.[17]

There is a great drama to Miró's account of how he readied himself for these paintings; a sense that he approached them with a very keen awareness of their importance at this point in his career, in relation to international developments in modern art and his place in it. The three canvases, on which he worked simultaneously, were clearly conceived as a single significant event that integrated intellectual and physical engagement.

Miró's enchantment with Japanese culture was imported to the relative isolation of Mallorca via diverse routes. The ascetic qualities of his paintings of the late 1920s had already led critics, notably Leiris and Gasch, to make comparisons

with Oriental thought.[18] More specifically, amongst the assorted notes he filed away there is a torn-out newspaper review of Eugen Herrigel's famous *Zen in the Art of Archery*.[19] Herrigel was a professor of philosophy at the University of Erlangen who had spent five years in the 1930s teaching philosophy at a university in Japan and studying archery in order to deepen his understanding of Japanese culture. His book, published in 1948, conflated the philosophical and physical aspects of Zen and archery and presented a spiritual-religious amalgam that defined the popular view of Zen (and *kyūdō*) in Europe and the USA, notably among the Abstract Expressionists and European informalists.[20]

Miró described his working process on the *Blue* triptych in a way that suggests an emulation of the practices described by Herrigel, particularly in talking of the discipline with which he embarked on the three paintings. He started very early in the morning, preparing himself by drawing in charcoal on to the canvas before taking an almost meditative approach to a more detached contemplation of what he had done so far.

153
Bleu I/III
Bleu II/III
Bleu III/III 4 March 1961
Blue I, II, III
Oil on three canvases
Each 270 × 355
Centre Pompidou, Paris.
Musée national d'art moderne /
Centre de création industrielle
I – Purchased in memory of
Dominique Bozo, with the assis-
tance of the Heritage Fund, and
the help of Sylvie and Eric
Boissonnas, Jacques Boissonnas,
Hélène and Michel David-Weill,
the Friends of the Museum,
Pierre Bergé, Yves Saint Laurent,
Yves Saint Laurent Fashion
House and the participation of
many supporters, 1993
II – Gift of the Menil Foundation
in memory of Jean de Menil 1984
III – Purchased 1988

154
Miro retouching **Blue II/III** at
Galerie Maeght, Paris, 1961
Private collection

JOAN MIRÓ: THE TRIPTYCHS

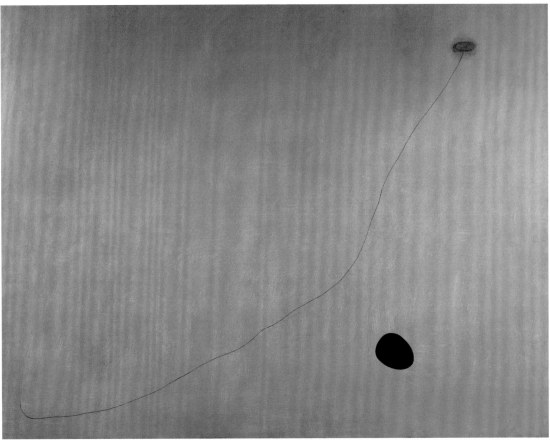

155
Peinture murale I jaune-orange
18 May 1962
Peinture murale II vert
21 May 1962
Peinture murale III rouge
22 May 1962
Mural Painting I Yellow-Orange
Mural Painting II Green
Mural Painting III Red
Oil on three canvases
Each 270 × 355
Private collection

For the rest of the day, I would prepare myself internally. And finally, I began to paint: first the background, all blue; but it was not simply a matter of applying colour like a house-painter: all the movements of the brush, the wrist, the breathing of the hand – all these played a role.[21]

The blue surface of the paintings is indeed quite alive with nuanced brushmarks that bear out the artist's claims for the depth of his physical and mental engagement with the process. A phrase like 'the breathing of the hand' perfectly conjures up a movement defined by the push and pull of action and deliberation. It is no surprise that, speaking at the time of their first exhibition, Miró said: 'This struggle exhausted me.'[22]

The small newspaper fragment with the review of *Zen in the Art of Archery* that Miró kept in his notes has a further bearing on his work on the triptychs. It is illustrated with a brush painting of a circle, triangle and square by the Japanese Zen master Sengai Gibon.[23] This also appears in another of Miró's newspaper cuttings,[24] where the caption is based on Suzuki's description in the catalogue of a touring exhibition of Sengai's works shown in Europe from 1961 to 1963:

This painting … represents the three fundamental forms of the universe. The circle represents the infinite, and the infinite is at the base of all beings. But the infinite itself is formless. The triangle is the fixed and inalterable natural law from which all forms arise. The square is the first form it creates. A square is the triangle doubled. This doubling process goes on infinitely and we have the multiplicity of things, including man.[25]

The striking simplicity of Sengai's painting, combining three symbols, basic geometric shapes, with a text running vertically along the left side,[26] had an obvious relevance to Miró, who had developed his own vocabulary of cosmological signs. For at least a decade, between 1971 and 1981, Miró continued working on sketches for a triptych based on the square, triangle and circle motif, which he associated with the title 'towards the unknown', though he never realised it.[27] Irrespective of the precise meaning of Sengai's circle, triangle and square,[28] the very openness of the universal account suggested by Suzuki no doubt itself attracted Miró. Based on a small island in the Mediterranean, on the periphery of the repressive Franco regime, he simultaneously looked

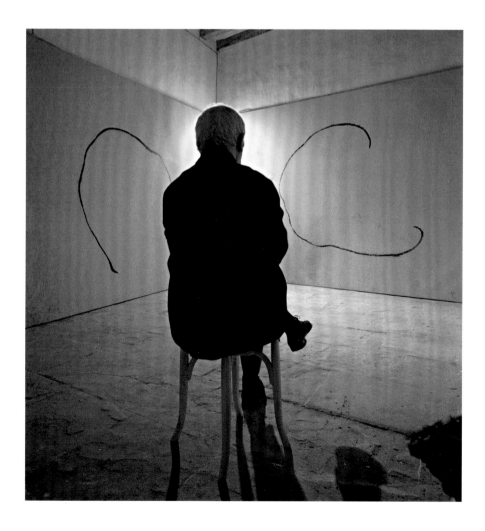

156
Francesc Català-Roca
Miró in front of **The Hope of a Condemned Man** in progress at his Son Boter studio, 1974
Photographic Archive F. Català-Roca, Col·legi d'Arquitectes de Catalunya

as far east and west as he could, drawing on his experience of recent American painting and on his more spiritual fascination with Zen and East Asian art to forge a profoundly new approach for his own art.

Miró's fascination with Asian art was of course shared with the new generation of US and European artists alike, but it is particularly in the triptychs that his idiosyncratic understanding comes into its own. His *Peinture murale I jaune-orange*, *Peinture murale II vert* and *Peinture murale III rouge* 1962 (*Mural Painting I Yellow-Orange*, *Mural Painting II Green*, *Mural Painting III Red*, no.155), made a year after the *Blue* triptych, again use large monochromatic colour fields on which an austerely restricted set of symbols (two dots and three vertical lines on the first canvas; a few calligraphic lines on the other two) is superimposed. Dupin attempted to associate specific references to Miró's vocabulary with these, identifying the first as a shooting star, the second as a landscape or reclining woman, and the third, intriguingly, as the ladder of escape.[29] Yet their power is to a considerable extent chromatic and phenomenological: a combination not just of their individual sizes but, crucially, of their encompassing effect in filling the field of vision of the spectator

standing before them. This also distinguishes them from another remarkable comparator, more than likely unknown to Miró, Aleksandr Rodchenko's much smaller monochromatic triptych, *Pure Red, Pure Yellow* and *Pure Blue* 1921, which plays with a primary boldness and sets up a dynamic relationship that is very much contained on the wall.

The relationship between economy of means and dramatic impact is even more extreme in *Peinture sur fond blanc pour la cellule d'un solitaire I, II, III* 1968 (*Painting on White Background for the Cell of a Recluse I, II, III*, no.158). These three paintings consist of no more than a single thin black line meandering vaguely diagonally across the dry, smudgy white of a canvas primed with acrylic. The lines reveal themselves to be composed of separate strokes building up shorter segments that thicken and thin as the brush is lifted off the surface and returns to it, resembling the sections of a stem of bamboo rather than a single reed. Miró's phrase of the hand breathing again comes to mind and is echoed in the viewer's physical response as one in turn approaches the surface for a closer look or steps back to experience the rhythm of the threefold repetition of the calligraphic sign.

157
Sketch for **The Hope of a Condemned Man**
14 December 1974
Fundació Joan Miró, Barcelona

158
Peinture sur fond blanc pour la cellule d'un solitaire I
20 May 1968
Peinture sur fond blanc pour la cellule d'un solitaire II
21 May 1968
Peinture sur fond blanc pour la cellule d'un solitaire III
22 May 1968
Painting on White Background for the Cell of a Recluse I, II, III
Acrylic on three canvases
268 × 352, 267 × 350, 267 × 351
Fundació Joan Miró,
Barcelona

159
**L'Espoir du condamné
à mort I, II, III**
9 February 1974
*The Hope of a
Condemned Man I, II, III*
Acrylic on three canvases
Each 267 × 351
Fundació Joan Miró,
Barcelona

When Miró worked with the architect Josep Lluís Sert on his Foundation in Barcelona, they specifically designed chapel-like spaces so that the two triptychs he was planning to donate would surround the viewer on three sides. Clearly, another dimension needs to be added to the mix. The triptych has a specific place in the European tradition of religious painting where it not only relates to the Christian concept of the Trinity, but also plays a key role in articulating specific iconographic relationships and hierarchies. With its origins in pre-modern conventions, artists using this form 'were not restricted by a necessary agreement between the temporal and the spatial realm. Their time was that of eternity; their space that of infinity'.[30] As Klaus Lankheit, the pre-eminent theorist of the triptych, emphasised, the rational pictorial conventions of a coherent, single perspectival space introduced in the Renaissance were at odds with the cultic-religious function of the triptych and led to its gradual decline. It was only towards the end of the nineteenth century that, as part of a new wave of secularisation, the triptych form experienced a revival by virtue of its ability to give abstract themes a sacralising treatment.[31] Lankheit specifically defined its effect as the pathos of a transcendent truth exceeding our empirical experience of being.[32] The fact that Miró had originally toyed with *Paintings for a Temple* as the title for the *Mural Painting* triptych and that he decided against this and inscribed the more neutral title on their backs is significant in this context, too, conforming to a well-established pattern of sublimating the obvious and direct into more elliptical, elusive and cryptic references in the process of moving from sketch to finished work.

Shorn of its purely Christian legacy, this sacralising function matches Miró's conception of the three *Paintings on White Ground* as establishing a quasi-architectonic space, the cell of the title, which suggests equally a monk's withdrawal from the material world and the space of detention and punishment of a prisoner in solitary confinement, a reading which the original French 'solitaire' permits more readily than the English 'recluse'. It appeals to the condition of 'super-imagination' that Gaston Bachelard suggested we feel 'in the presence of the simpler images through which the exterior world deposits virtual elements of highly coloured space in the heart of our being', as exemplified by the poet Pierre Jean Jouve's description of his 'secret being':

> La cellule de moi-même emplit d'étonnement
> La muraille peinte à la chaux de mon secret.
> (The cell of myself fills with wonder
> The white-washed wall of my secret.)[33]

Given that Miró was in his mid-seventies, living a life of local seclusion despite his international recognition, I cannot but read this work as implying an allusion to his own being in the world, his own condition, life and mortality.

The fourth triptych, *L'Espoir du condamné à mort I, II, III* 1974 (*The Hope of a Condemned Man I, II, III*, no.159), which Miró explicitly associated with the violent political repression of the anti-Franco opposition during this final phase of his regime, can thus perhaps also be seen as reverberating with a polysemic richness that exceeds any direct reference to the execution of Salvador Puig Antich.[34] For his archive, Miró grouped together a cluster of titled sketches, some

dating back to 1969, in which he began to explore this theme. The change of wording in his captions is as significant as the compositional developments, starting with the straight religious reference of *Homme crucifié* 1969 (*Crucified Man*) to titles that reference contemporary events more directly as in *Prisonnier crucifié* 1973 (*Crucified Prisoner*, no.151) or *Homme torturé s'évadant* 1974 (*Tortured Man Escaping*, no.152).[35] The vertical hatching of these sketches that suggested an upright human figure was sublimated and turned into faint fields of vertical splashes and, in two of the canvases, bold drips of white paint poured onto the canvas.

Whether or not the hope of the 'man condemned to death' includes a veiled self-reference on the part of Miró, something on which he never commented, there is ample evidence of the intensity of his engagement with this triptych. The physical evidence suggests speed: the main motif in each panel is executed as a black line that articulates the surface in a single large gesture; on each of the three panels it holds a different dynamic relationship to a single coloured blotch in red, blue and yellow, executed in furious brushstrokes. These contrast with the much smaller dots of dark colour that are more carefully rubbed into the canvas. Thinner drips of paint run down from the thick black lines; vertical flicks of liquid black run along the bottom and sides of the panels, and white paint that has been thrown at the canvas streams down to complete the animated dynamism of the set.

Despite this appearance of rushed intensity, Miró's sketches demonstrate not just the careful deliberation with which he thought through the composition of each individual work, but also the relationship between the three. Rather than the standard hierarchy of an emphatic central panel flanked by two subordinate ones or a simple linear arrangement of panels, these sketches show that he adopted a triadic relationship in which each of the canvases relates equally to the other two. The dozen small sketches he made in everything from notebooks to torn fragments of paper, starting in 1969,[36] establish the overall composition from the start and, overwhelmingly, do so not in single panels but across all three, arranged in a triangle (no.157).[37]

In the catalogue of Miró's retrospective at the Grand Palais in 1974, where *The Hope of a Condemned Man* triptych was first shown, Jacques Dupin called it 'possibly the most difficult to understand work of this exhibition and, without doubt, the most important'.[38] In his detailed, poetic and closely observed description he argued that its three silent panels register 'agony, anxious waiting and imaginary escape'. But above all he emphasised the character of Miró's line, 'interrogated, sustained millimetre by millimetre, a hundred times resumed, corrected, lost, found again, like the path of an exhausting initiation'.[39] These lines that define the central shapes of the three panels recur throughout Miró's late painting and in themselves embody the characteristic tension between decisive action and careful deliberation that so defined his outlook on life in general. Rare, but all the more viscerally exciting, are the moments when hope is the clear winner, as in the explosion of paint bursting across *Feux d'artifice I, II, III* 1974 (*Fireworks I, II, III*, no.160).

In a striking instance of the poetics of space being suffused with the material conditions of the real, Miró painted the two earlier coloured triptychs in the bright, open, airy,

160, overleaf
Feux d'artifice I, II, III
9 February 1974
Fireworks I, II, III
Acrylic on three canvases
Each 292 × 195
Fundació Joan Miró,
Barcelona

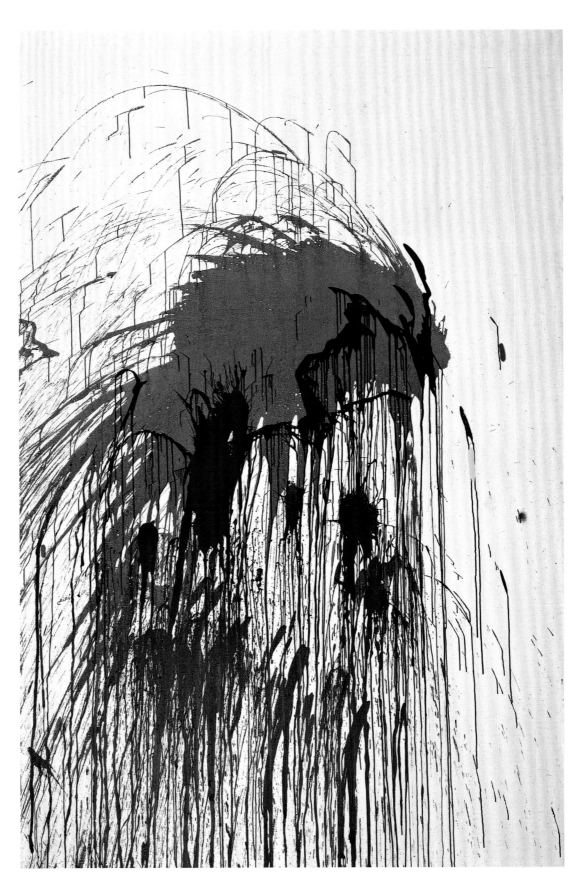

modernist space of Sert's purpose-built studio (no.150), while his three white triptychs were produced in the dark and enclosed rooms of Son Boter, the eighteenth-century house next door that he had purchased with his prize money from the Guggenheim Award in 1959. Here he was photographed by Francesc Català-Roca, meditating on the as yet unfinished *The Hope of a Condemned Man* in a pose carefully composed to evoke silent and austere enlightenment (no.156). In the room next to this there also remain traces of the paint he flung at *Fireworks* after it dripped down and gathered in pools on the floor of the old building. There is a sense in which the different spaces – Sert's studio and Son Boter, and even the different rooms within Son Boter – give birth to works with quite distinct sensibilities. *Fireworks* and *The Hope of a Condemned Man* were of course painted simultaneously in adjacent rooms in the old house.[40]

Each of the three panels of *Fireworks* is defined by black paint of different opacity, ranging in effect from thick black to a thinner, paler wash, which Miró repeatedly flung against the canvas in high upwards arcs. He also placed much smaller coloured marks – isolated short strokes in red, blue and yellow; a blurred dot in dark purple – on each painting. But the layered, large black shapes determine the overall aspect. The black drips have a dynamic composed of two vectors – the direction of throw and the pull of gravity – and it is the interplay of these two that defines them not only as the negative, black on white, trace of fireworks, but also sets up the relationships between the vertical panels. The paintmarks that continue across the central and right panels indicate that these two were positioned contiguously during the painting process: the main splash of black on the right-hand panel continues in one smooth arc onto the central canvas. While the thick black splash on the central canvas sits much lower, it also extends a few streaks back onto the adjacent panel.

Looking at the two canvases together, one notices how their respective splashes, thrown onto the support from different directions, one towards the other, are palpably confrontational and create a dense crossing of lines. By contrast, the left-hand side of the central panel is almost entirely bare, drawing all the more attention to the boundary between it and the adjacent panel, whose fireworks of radiating black lines is cut off sharply at the right-hand edge.

Given that the process of making of this work is so audaciously candid, the disjuncture between the first and second panels demands attention. What happened here? We know from the paintmarks on the floor that the triptych was painted while leaning against the studio wall. The disjuncture is due to the simple circumstance that there was a gap between the panels, one of two doorways in the wall that led to the two smaller side rooms which Miró also used as studio spaces and where he was synchronously working on the horizontal panels of *The Hope of a Condemned Man*, wrapped around the sides of the room.

The disjuncture marks the opening that allows one to pass from the space of one work into that of the other. It marks the entry, through the lofty, forceful, dynamic space of *Fireworks* into the more contemplative and emotionally complex, more interior world of *The Hope of a Condemned Man*, whose title suggests the divergent if not mutually opposing affects already discussed.

Not just coeval, the two triptychs unfold through each other and jointly describe a topological configuration of emotional and aesthetic intensity that shows Miró at his most bold and eloquent. They give evidence of defiance and celebration, but also speak of the flowering of rebelliousness against the dying regime that animated intellectual circles in Spain and shout there is life in the old dog yet.

1 Sert later also designed the Fondation Maeght in Saint-Paul de Vence (1964) and the Fundació Joan Miró in Barcelona (1975).

2 Joan Miró, 'Je rêve d'un grand atelier', *XXe siècle*, May 1938, in Rowell 1986, p.161–2.

3 See Kerryn Greenberg's text in this volume.

4 The UNESCO murals were inaugurated on 3 November 1958. Miró received the Guggenheim Award in 1958, presented by President Eisenhower in a ceremony at the White House on 18 May 1959. Miró's exhibition at MoMA ran from March to May 1959.

5 Miró stored work in progress at Lefebvre-Foinet in Paris from 1939, when he went to Varengeville, until 1956.

6 Rosamond Bernier, 'Comments by Joan Miró', in Rowell 1986, p.257.

7 This of course includes his famous overpainting of a copy of his *Self-Portrait* (see no.82), begun in 1937 and finished on 23 Feb. 1960. For a more detailed discussion of this, see Teresa Montaner's essay in this volume and Bernier in Rowell 1986, pp.257–8.

8 Fundació Joan Miró, FJM 3482.

9 Julia Kristeva, *Desire in language: A semiotic approach to literature and art*, Oxford 1980, p.225.

10 Eugene Hecht, *Optics*, second edn, Reading, Mass. 1987.

11 Kristeva 1980, p.225.

12 Rosalind Krauss, 'Magnetic Fields: The Structure', in Krauss and Rowell 1972, p.11.

13 Kristeva 1980, p.225.

14 Jean Leymarie, 'Préface', in *Joan Miró* 1974, p.17.

15 'Interview with Margit Rowell', in Rowell 1986, p.279.

16 Bernier, in ibid., pp.258–9.

17 Ibid., p.259.

18 See Christopher Green's text in this volume and Cabañas 2000, pp.12–21.

19 Fundació Joan Miró, FJM 2125: 'Zen y el tiro con arco', by Signorelli, n.d.

20 Herrigel's archery master in Japan had not in fact been an adherent of Zen and is considered 'an eccentric instructor'. It was only after reading Daisetz T. Suzuki's writings in 1938, i.e. after his return to Germany, that Herrigel redefined his training as Zen. Suzuki (1870–1966), in turn, wrote a foreword that appeared in the English and Spanish editions (both 1953). It is via this intercontinental travel of ideas that Miró, in Spain, received his insight into Japanese culture from Japan directly and via the USA, France and Germany. For a detailed analysis of Herrigel see Shoji Yamada, 'The Myth of Zen in the Art of Archery', in *Japanese Journal of Religious Studies*, vol.28, no.1, 2001, pp.1–30.

21 Bernier in Rowell 1986, p.259.

22 Ibid.

23 The work by Sengai Gibon (1750–1837) is not titled or dated. It is often referred to as *The Universe*, following Suzuki's interpretation, though more recent scholarship tends to use ○△□.

24 Fundació Joan Miró, FJM 2516.

25 Daisetz Teitaro Suzuki, *Sengai. [Exposition itinérante de Sengai en Europe, 1961–1963]*, Tokyo 1961.

26 The inscription merely states 'The first Zen monastery in Japan', which 'Sengai frequently used as a sort of title to go with his signature' (Shōkin Furuta, *Sengai: Master Zen Painter*, Tokyo 2000, p.45).

27 See for example Fundació Joan Miró FJM 2514 and FJM 2515, both 1971; FJM 2526–8, dated 11 Feb. 1974, i.e. just around the time of *The Hope of a Condemned Man*; FJM 4599–4601 or FJM 4605; and FJM 11720 from a 1981 notebook.

28 Furuta's study (see note 26) presents a comprehensive overview of different readings.

29 Dupin 1961, p.321.

30 Shirley Neilsen Blum, *Early Netherlandish Triptychs: A Study in Patronage*, California studies in the history of art 13, Berkeley 1969, p.5.

31 Klaus Lankheit, *Das Triptychon als Pathosformel*, Abhandlungen der Heidelberger Akademie der Wissenschaften, Heidelberg 1959, pp.42–3.

32 Reinhard Spieler, *Max Beckmann: Bildwelt und Weltbild in den Triptychen*, Cologne 1998, p.48.

33 Gaston Bachelard, *The Poetics of Space*, trans. Maria Jolas, Boston 1969, pp.227–8.

34 See William Jeffett's text in this volume.

35 *Crucified Man*, 16 April 1969, FJM 2071, *Crucified Prisoner*, 10 Feb. 1974, FJM 2043 and *Tortured Man Escaping*, 14 Dec. 1973, FJM 2137.

36 Clearly of the same work, the early date of the first of these sketches indicates that Miró began the project before the specifics of Puig Antich's fate occurred. The earliest sketches are untitled but from 14 Dec. 1973 (FJM 2057) some are titled *L'Espoir du prisonnier*. The final title, with its balanced evocation of hope and death, only appeared on the finished works.

37 See Fundació Joan Miró, FJM 2073 (15 Jan. 1969), FJM 2178 (9 Nov. 1972), FJM 2116 (29 Dec. 1972), FJM 2206 (30 Jan. 1972), FJM 2057 (14 Dec. 1973), FJM 2074 (23 Jan. 1974), FJM 2089 (3 Feb. 1974). By contrast, there is only one sketch, on a narrow strip of newspaper, where the three works are arranged in a line (FJM 2004, 12 May 1973), one early precursor of a single panel (FJM 2942, 21 March 1963) and one set of sketches where each panel occupies a single sheet of paper (FJM 2117–19, 10 Jan. 1973).

38 Jacques Dupin, 'Notes sur les peintures récentes', in *Joan Miró* 1974, p.25. Dupin also engaged in a strategic act of misdirection, saying 'I don't draw any conclusion' from the fact that the painting was begun 'long before the arrest, trial and condemnation to death of a young anarchist militant from Catalonia', and that it was 'finished a few days before execution of this man by the garrott.'

39 *Joan Miró* 1974, pp.26–7.

40 Both are dated by Miró on the back of the canvases with a completion date of 9 Feb. 1974

Chronology

This chronology is necessarily a synthesis of information from a variety of more detailed sources. It brings particular focus to three periods in which Miró's work appears more closely engaged with the politics of his time. For further details see especially Anne Umland's chronology in Lanchner 1993, the FJM and FPJM chronologies and the letters in Minguet, Montaner and Santanch 2009.

	1893	**1898**	**1907**	**1910**
MIRÓ	20 April: Joan Miró born in Barcelona, the eldest son of Dolores Ferrà i Oromí and Miquel Miró i Adzeries. From 1900 divides the summer between his paternal grandparents in Cornudella and his maternal grandmother in Mallorca.		Aged fourteen, begins to study at the School of Commerce and at La Llotja School of Fine Art, under Modesto Urgell.	Works for commercial chemists Dalmau i Oliveres.
ART	Founding of the catholic Cercle Artístic de Sant Lluc. The architect Antoni Gaudí is one of its members. Birth of the painter Enric Ricart.	The painters Ramón Casas, Santiago Rusiñol and the young Pablo Picasso are among those who make Els Quatre Gats café a centre of modernism in Barcelona.	Spanish edition of *Azul* (1888) by the Nicaraguan poet, Rubén Darío.	February: *Manifesto of Futurist Painters* published in Milan.
WORLD	October: anarchist Pauli Pallàs is executed for attempted assassination of Captain General of Catalonia, Arsenio Martínez Campos. In revenge, Santiago Salvador bombs the Gran Teatre del Liceu on 7 November, killing 20.	10 December: Spanish-American War ends with surrender of Cuba, Puerto Rico and the Phiilippines and Guam to USA, perceived as a final loss of Empire.		May: Halley's Comet visible in Europe.

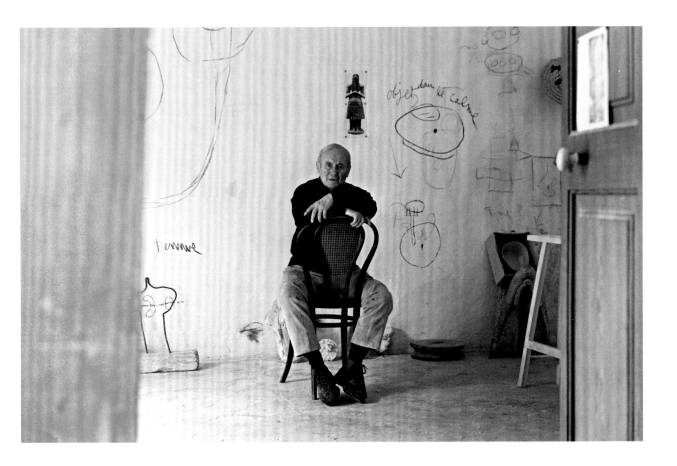

Francesc Català-Roca
Portrait of Joan Miró,
Palma de Mallorca, 1967
Photographic Archive
F. Català-Roca, Col·legi
d'Arquitectes de Catalunya

1911

Summer: convalesces from typhus at recently purchased farmhouse in Mont-roig.

1912

Studies at Francesc de Galí School of Art alongside Josep Ràfols, Enric Ricart, Joan Prats and Llorens Artigas.

1914

Shares a studio with Ricart in Carrer Arc de Jonqueres.

1915

10 June: begins military service.

1916

Spring: meets Josep Dalmau, the owner of Galeries Dalmau.

7 October: shares a studio with Ricart in Carrer Sant Pere Més Baix, Barcelona.

October: Cubist room causes controversy at Salon d'Automne in Paris.

Eugeni d'Ors publishes *La ben plantada* summarising *Noucentisme* aesthetics.

20 Apri – 10 May: *Exposició d'Art Cubista* at Galeries Dalmau, Barcelona.

14 April: in Zurich, the term 'Dada' is coined for anti-artistic activities.

In Barcelona, the Galeries Dalmau exhibitions include Robert and Sonia Delaunay, Rafael Barradas and Joaquin Torres García and Albert Gleizes.

July: Agadir Crisis in French Morocco heightens military tension between Germany and France.

July: outbreak of First World War. Germany invades France through Belgium but is halted at the Marne (September). Spain's neutrality encourages boom in Barcelona.

June: Austro-Hungarian army defeat Russia at Lemberg.

February – July: sustained German assault on Verdun, followed by the Battle of the Somme (July).

1917

August: Miró's regiment is called to suppress General Strike in Barcelona and Sabadell.

Late December: completes military service.

Ricart's first solo show at Galeries Dalmau.

Francis Picabia publishes his Dada periodical *391* in Barcelona.

April – July: *Exposition d'Art Français* at the Palau de Belles Ars in Barcelona.

June: Picasso arrives in Barcelona with Ballets Russes.

April: USA enters First World War in response to German submarine attacks.

August: The general strike is forcibly suppressed by the army and Eduardo Dato declares martial law.

October: Bolshevik Revolution in Russia brings Vladimir Lenin to power.

November: architect Josep Puig i Cadafalch is elected president of Mancomunitat, the commonwealth of Catalan assemblies.

1918

February: designs cover for Joan Salvat-Papasseit's *Arc-Voltaic* and holds first solo exhibition at Galeries Dalmau (16 February – 3 March).

28 February: co-founds Agrupació Courbet (with Ràfols, Ricart and others). They exhibit at Exposició d'Art, Palau de Belles Arts in May.

16 July – 3 December: works at Mont-roig in the second half of the year, returning to Barcelona for Christmas; this was to become his annual pattern until 1936.

11–16 June: Igor Stravinsky's *Petruschka* performed at Gran Teatre del Liceu, Barcelona.

9 November: death of the poet Guillaume Apollinaire in Paris.

March: with the Treaty of Brest-Litovsk, Lenin withdraws Russia from the war. Leon Trotsky organises Red Army in ensuing Civil War with White Russians.

11 November: the end of the First World War. In Germany, Kaiser Wilhelm II abdicates and the Weimar Republic is declared.

December: in Madrid, Catalanist members walk out of parliament.

1919

28 May – 30 June: Agrupació Courbet again exhibits at Exposició d'Art, Palau de Belles Arts, includes *House with Palm Tree* (no.2).

29 June – 22 November: in Mont-roig.

April: Walter Gropius becomes Director of the Bauhaus in Weimar.

September: Picabia's paintings cause a scandal at the Salon d'Automne in Paris.

5 – 12 January: the Communist Spartacist uprising in Germany is violently suppressed.

25 January: The Statute of Autonomy of Catalonia is approved by the Mancomunitat Assembly. Francesc Macià links the workers' demands with those of autonomy.

1920

February: first trip to Paris. Miró visits Picasso's studio on 2 March and attends *Festival Dada*, Salle Gaveau on 26 May before returning to Barcelona.

15 October – 12 November: shows *Self-Portrait* 1919 and *Mont-roig, the Church and the Village* 1919 (nos.15 and 16) in the Catalan section of the Salon d'Automne, Paris.

26 October – 15 November: exhibits in *Avant-garde French Art*, Galeries Dalmau.

17 January: poet Tristan Tzara arrives in Paris from Zurich to galvanise Dada activities that link Picabia with the poets Louis Aragon, André Breton, Paul Eluard, Benjamin Péret and Philippe Soupault.

May: Breton and Soupault publish the automatic text *Les Champs magnétiques*.

Puig i Cadafalch publishes *L'arquitectura romànica a Catalunya*.

Germany begins to see spiralling inflation.

November: General Severiano Martínez Anido is appointed Civil Governor of Barcelona; he bans unions and has their leaders deported.

1921

February – June: in Paris, sublets the studio of Catalan sculptor Pablo Gargallo at 45 rue Blomet, next to the painter André Masson who becomes a lifelong friend.

29 April – 14 May: Dalmau organises Miró's first solo exhibition in Paris at the Galerie La Licorne. He presents Picasso with Miró's *Self-Portrait* 1919.

Late June – November: begins *The Farm* (no.17) at Mont-roig.

May: Breton writes introduction to Max Ernst's exhibition of Dada collages, Galerie Au Sans Pareil, Paris.

Josep Carbonell and J.V. Foix edit the journal *Monitor, Gaseta Nacional de Política, Art i Literatura* (1921–3).

8 March: assassination of Eduardo Dato, Spanish Prime Minister.

July: in the Moroccan war, Spanish troops are defeated at Annual.

December: establishment of the Irish Free State.

1922

Early May: completes *The Farm* and consigns it to Léonce Rosenberg who, in turn, submits it to Paris Salon d'Automne (1 November – 17 December).

17 November: in his lecture at the Ateneo, Barcelona, to accompany the Francis Picabia exhibition at Galeries Dalmau, Breton speaks of Jarry, Rimbaud and Picasso.

Romanesque murals rescued by Joaquim Folch i Torres are installed in Museu d'Art i Arqueologia Barcelona.

28 October: Italian Fascists March on Rome. Benito Mussolini becomes Prime Minister.

1923

4 March: returns to Paris. With Masson, he develops friendships with rue Blomet circle of writers Antonin Artaud, Robert Desnos, Georges Limbour and Michel Leiris.

July – December: at Mont-roig he begins work on *The Tilled Field* (no.20).

13 December: birth of Antoni Tàpies.

James Joyce publishes *Ulysses*.

June: provincial elections won by the newly formed Acció Catalana and the Partit Republicà Radical.

13 September: Captain General of Catalonia, Miguel Primo de Rivera, stages a coup and, with the King's approval, sets up a military dictatorship in Madrid, suspends parliament and imposes press censorship. He issues a decree on separatism, banning the display of the Catalan flag, and restricting the Catalan language to family life.

1924

March – June: returns to 45 rue Blomet where he begins work on *Harlequin's Carnival* and *Head of a Catalan Peasant* (nos.19 and 30)

14 June: attends ballet *Mercure* with set designs by Picasso and music by Eric Satie at the Théâtre de la Cigale, Paris, just before returning to Catalonia.

Winter: Masson makes 'automatic' drawings free of conscious control.

September: rue Blomet group, including Masson, Limbour and Artaud, draw closer to Breton.

October: Breton's *Manifeste du surréalisme* and Aragon's 'Une Vague de rêves' mark the founding of Surrealism and are followed by the publication of the periodical *La Révolution surréaliste* (December).

January: the Spanish dictatorship bans most political parties.

21 January: Vladimir Lenin dies in Moscow, precipitating the Soviet power struggle.

May: leftist 'Cartel des gauches' win a majority in the French elections. They officially recognise the Soviet Union and agree to evacuate the Ruhr, the German industrial region occupied in 1923, due to non-payment of reparations.

1925

January – July: continues *Head of a Catalan Peasant* series in Paris (no.31 and 32)

February: Aragon, Eluard and Pierre Naville visit Miró's studio. Breton visits and buys *Catalan Landscape* (*The Hunter*) (no.18).

12–27 June: first solo exhibition, Galerie Pierre, Paris, with a catalogue preface by Péret.

July: involvement with Surrealism confirmed by the appearance of *Catalan Landscape* (*The Hunter*) in *La Révolution surréaliste*; *The Tilled Field* is published in October.

By 9 November: Hemingway purchases *The Farm*.

18 April: Aragon lectures on Surrealism at Residencia de Estudiantes, Madrid.

15 July: Breton publishes the first part of 'Le Surréalisme et la peinture'.

14–25 November: Galerie Pierre holds first Surrealist exhibition, for which Breton and Desnos write the preface. The opening starts at midnight. Miró shows *Harlequin's Carnival* alongside works by Arp, Giorgio de Chirico, Max Ernst, Paul Klee, Masson, Picasso and Man Ray.

Desnos publishes *La Liberté ou l'amour*.

While in exile in Paris, Macià raises money for an invasion of Catalonia.

April: Paul Painlevé becomes the Prime Minister of France.

April: Paul von Hindenburg elected president of The Weimar Republic

Adolf Hitler publishes *Mein Kampf*

1926

February: arriving from Mont-roig, Miró moves into a new studio at 22 rue Torlaque, Cité des Fusains in Montmartre. Arp and Ernst are his neighbours.

March: Miró and Ernst design the sets of *Romeo and Juliet* for Ballets Russes; it is premiered at Théâtre Sarah Bernhardt, Paris (May), though the Surrealists protest.

9 July: on his father's death, Miró returns to Barcelona to stay with his mother.

26 April: the weekly *L'Amic de les Arts* is edited in Sitges by Josep Carbonell. J.V. Foix, Sebastià Gasch and Lluis Montanyà are among the contributors and the magazine features the artistic avant-garde, including Miró and Salvador Dalí.

10 June: death of Antoni Gaudí.

In Paris, Christian Zervos launches the periodical *Cahiers d'Art*.

31 December: Dalmau opens second exhibition of Salvador Dalí's work.

Hemingway novel was published in 1926

May: General Strike in Britain.

November: Macià and Estat Català volunteers fail in their plot to invade Catalonia. The public trial attracts international publicity to the Catalan cause but the defendants are expelled from France.

1927

January – June: brings *Animated Landscapes* (no.22) to Paris from Mont-roig. He grows increasingly friendly with Breton and Eluard, and expresses his desire to 'assassinate painting'.

July – November: completes *Animated Landscapes* at Mont-roig (nos.23 and 24).

1928

May: travels to see Arp's exhibition in Brussels and on to Amsterdam.

1 July: first published interview appears in *Gaceta Literaria* in Madrid.

1929

April: Miró introduces Dalí to the Surrealist group.

July: becomes engaged to Pilar Juncosa in Palma de Mallorca. They marry in the Church of San Nicolas in October and settle at number 3 rue François-Mouthon, Paris in November.

1930

17 July: birth of Maria Dolores, only child of Joan Miró and Pilar Juncosa, in Barcelona. In August, the family move to Mont-roig.

1931

24 January: magazine *Ahora* publish an interview in which Miró asserts his independence from Surrealism and reiterates his claim to 'assassinate painting'.

July – November: works on Ingres paper and objects with found materials at Mont-roig.

18 December – 8 January: Shows painting-objects at Galerie Pierre, Paris.

1927

January: Eluard's poem, 'Joan Miró', is published in *L'Amic de les Arts*.

May: First performance of *Romeo and Juliet* at Gran Teatre del Liceu, Barcelona.

Masson's sand paintings introduce automatic techniques to his canvases.

Serge Eisenstein's *Battleship Potemkin* and Abel Gance's *Napoléon* shown in Paris cinemas.

1928

March: *Manifest Antiartístic Català*, known as the *Manifest Groc* because of its yellow paper, written by Dalí, Gasch and Montanyà, is circulated in Barcelona.

Federico García Lorca publishes *Romancero gitano* and Breton publishes *Nadja*.

1929

18 May: Exposición Internacional de Barcelona features the vernacular *Poble Espanyol* and Ludwig Mies van der Rohe's Rationalist German Pavilion.

6 June: première of Dalí and Luis Buñuel's film *Un Chien andalou* in Paris.

December: Breton's *Second manifeste du surréalisme* announces significant expulsions.

1930

22 March: Dalí, a new recruit to Surrealism, attacks family conventions in a controversial lecture 'Posició moral del surrealisme' at the Ateneo, Barcelona.

22 October: Miró attends the private première of Dalí and Buñuel's second film, *L'Age d'or*. In November, the cinema is attacked by Fascists and, following a press campaign, the film is banned for blasphemy.

1931

In *Le Surréalisme au service de la révolution*, Dalí prompts colleagues to make Surrealist objects with provocative juxtapositions.

18 September: René Crevel lectures on Surrealism in Barcelona.

1927

July: the Federació Anarquista Ibèrica (FAI) is founded at a secret anarchist conference in Valencia and the decision is taken to gain control of the Confederació Nacional del Treball (CNT).

October: signing of the treaty ending the war in Morocco.

1928

30 September – 2 October: Macià presides over an assembly of separatists in Havana, Cuba, that approves a provisional constitution for a Catalan Republic.

1929

May: General Secretary Joseph Stalin expels Leon Trotsky from the USSR and adopts a policy of collectivisation in the Soviet Union.

24 October: Wall Street Crash is followed by a worldwide depression.

1930

28 January: having lost support of the military, Primo de Rivera resigns; he is succeeded by General Dámaso Berenguer.

16 March: Primo de Rivera dies in Paris.

September: the Socialists are strongest party at the German elections, followed by Nazis.

1931

14 April: King Alfonso XIII abdicates and the Second Spanish Republic is proclaimed. Two days later Macià forms a provisional Catalan government in Barcelona, and by mid-June a new Statute of Autonomy has been drafted.

29 June: Socialists win the Spanish General Election. Niceto Alcalá-Zamora y Castillo becomes Prime Minister, and is elected President on 10 December after ratification of new constitution. This includes disestablishment of the Church, religious freedom and desecularisation of education.

21 September: Britain abandons the gold standard.

1932

Due to financial hardships, Miró makes Barcelona his base.

April: travels to Monte Carlo for the ballet *Jeux d'enfants* which he designed.

June: attends the Paris opening for *Jeux d'enfants* at the Théâtre des Champs Elysées.

July – November: in Mont-roig, where he is visited by Alexander and Louisa Calder.

1 – 25 November: first solo exhibition at the Pierre Matisse Gallery, New York.

21 January: Dessau Council close Bauhaus, which moves to Berlin.

September: in Barcelona the American sculptor Alexander Calder performs his *Cirque Calder* at GATCPAC (Grup d'Arquitectes i Tècnics Catalans per al Progrés de l'Arquitectura Contemporània).

November: ADLAN (Friends of New Art) is formed on the initiative of Joan Prats to promote the avant-garde in Barcelona. Joan Prats introduces Miró to the architect Josep Lluís Sert.

7 May: French President Paul Doumer is assassinated.

May: Hindenburg re-elected German President, with significant votes for Hitler. In July, the Nazi party wins the German election though without an overall majority.

9 September: The Statute of Autonomy of Catalonia is approved, and Catalan is recognised as an official language. Macià is elected President and forms a government (December).

8 November: Franklin Roosevelt is elected President of the USA. His 'New Deal' addresses the economic Depression.

1933

Early August – early October: in Mont-roig, works on a series of collage-drawings.

October – early November: in Paris for solo exhibition at Galerie Georges Bernheim and contributes to *Les Surindépendants*.

February: Breton, Eluard and others join editorial board of *Minotaure*.

March: in Germany, culture is placed under Joseph Goebbels's Ministry of Propaganda to enforce the Nazi's anti-modernism: the Bauhaus in Berlin is closed, modernists, such as Vasily Kandinsky and Paul Klee, sacked and, on 10 May, books are burned.

7–18 June: *Exposition Surréaliste*, Galerie Pierre Colle, Paris.

Buñuel shoots *Tierra sin pan*.

30 January: Hitler becomes Chancellor of Germany and the Nazis take power. The Reichstag Fire (27 February) is blamed on the Communists.

19 November: The Confederación Española de Derechas Autónomas (CEDA), including the Falange led by José Antonio Primo de Rivera (the former dictator's son) wins a majority in the elections. Members enter the Partit Republicà Radical government of Alejandro Lerroux.

25 December: death of Macià, Lluís Companys is elected president of the Generalitat and forms a new coalition government in Catalonia.

1934

February – March: in Paris.

May: solo exhibition at Galerie des Cahiers d'art in Paris coincides with a special number of *Cahiers d'art* dedicated to Miró. With 40 illustrations and articles by writers and friends, it is the most important publication on his work to date.

ADLAN organises an exhibition of recent works by Miró at the Galeria Syra.

October: in Mont-roig, Miró is aware of the violent events in Barcelona and Asturias. He makes fifteen pastels that he terms his 'savage paintings'.

The Generalitat carries out a reorganisation of museums, and the Museu d'Art de Catalunya is opened in the Palau Nacional.

5 February: 'Trial' of Dalí by Surrealists in Paris for 'Hitlerianism'.

August: in Moscow, Andrei Zhdanov establishes Socialist Realism.

14 January: In Catalonia, the left wins the municipal elections. The conservative Lliga Catalana abandons the sessions at the Catalan Parliament until September.

6–7 February: following riots and anti-Fascist strikes in Paris, Gaston Doumergue forms Government of National Unity.

April: legislation passed by Companys in the Catalan parliament generates conflict with the Madrid government.

17 December: In Barcelona designs cover of periodical *d'Aci d'Alla*, dedicated to contemporary art.

4–6 October: opposing CEDA ministers in the national government, the Alliança Obrera of Socialist and Communist groups, organise strikes, leading to an uprising among miners in Oviedo and a general strike in Barcelona. Companys proclaims a Catalan Republic within the Spanish Federal Republic. The army arrests Companys and the members of the Generalitat and institutes a state of emergency and press censorship.

1935

10 January – 9 February: solo exhibition, Pierre Matisse, New York.

Spring: visits Brussels and, in late June, Paris.

12 July – late October: summers at Mont-roig. With *Figures in Front of a Volcano* (9–14 October, no.48) and *Man and Woman in Front of a Pile of Excrement* (15–22 October, no.4) he begins twelve small paintings, half on copper and half on masonite, that convey profound anxieties. These works continue until May 1936.

24 February – 31 March: *Thèse, Antithèse, Synthèse*, Kunstmuseum, Lucerne, includes works by Miró.

11 May: to accompany the *Exposición Internacional del Surrealismo*, Breton lectures at the Ateneo de Santa Cruz de Tenerife. The *Gaceta de Arte* is dedicated to Surrealism.

2 January: the Catalan Statute of Autonomy is suspended, though the state of emergency is lifted and the Partit Republicà Radical, in alliance with CEDA and the Lliga, form the Generalitat.

6 June: Companys and colleagues sentenced to 30 years in prison.

15 September: the Nazis institute Racial Laws stripping Jews of German citizenship.

December: in the wake of a corruption scandal Lerroux is forced to resign, precipitating Spanish elections. The parties of the left form the Frente Popular to oppose CEDA.

1936

January – early June: in Barcelona, where he collaborates with GATCPAC on a design project by Josep Lluís Sert, Josep Torres Clave and Antoni Bonet.

Early June: travels through Paris to London for Surrealist exhibition.

August – October: following the outbreak of war, Miró is in Mont-roig working on twenty-seven paintings on masonite. He takes them to Paris (for transport to his show at Pierre Matisse in New York) and, despite fears for his family, he stays there.

December: joined by Pilar and their daughter, the family decides to stay in France.

January: ADLAN organises a Picasso exhibition at the Sala Esteva which attracts some 8,000 visitors and tours to Madrid and Bilbao. Paul Eluard, who is in Barcelona for the exhibition, gives a lecture on Communism and Surrealism.

12 February – 31 March: *L'art espagnol contemporain*, Jeu de Paume, Paris. Miró also takes part in *Abstract and Concrete: An Exhibition of Abstract Painting and Sculpture*, which tours Britain.

2 March – 19 April: *Cubism and Abstract Art*, Museum of Modern Art, New York, includes five works by Miró.

22–29 May: *Exposition surréaliste d'objets*, Galerie Charles Ratton, Paris.

June: *International Surrealist Exhibition*, New Burlington Galleries, London, organised on the initiative of Roland Penrose and David Gascoyne, by Breton, Eluard and the Belgian Surrealist E.L.T. Mesens.

July: soon after outbreak of Civil War, Picasso accepts honorary directorship of the Prado, offered in recognition of his support for the Republic.

Federico García Lorca killed near Granada.

November – December: *Fantastic Art, Dada, Surrealism*, Museum of Modern Art, New York.

February: the Frente Popular wins a majority and Manual Azaña becomes Prime Minister (3rd May). The government declares an amnesty for political prisoners and reinstates the Catalan Statute of Autonomy. The Catalan parliament reconvenes and Companys is re-elected as President of the Generalitat. Land is seized and churches attacked across Spain.

7 March: the German army re-enters the demilitarised zone of the Rhineland.

May: Italian conquest of Abyssinia, greeted with international condemnation.

17 July: the assassination of the Monarchist leader, José Calvo Sotelo (13 July), provides the pretext for a military mutiny against the Spanish Republic. The uprising is led by Nationalist forces in Morocco under General Franco, coordinated by General Emilio Mola in the north and General Manuel Goded in Mallorca. On 19–20 July, with the arrival of Goded, the Barcelona garrison mutinies but is defeated by Civil Guards and militant workers. Goded is arrested. Companys encourages anarchist leaders to set up the Central Committee of Anti-Fascist Militias.

14 August: Franco's Nationalist army captures Badajoz, linking forces in the north and south. The Republic holds Madrid, Valencia, the Basque country, Asturias and Catalonia.

9–14 September: a conference of 27 countries resolves not to intervene in the Spanish Civil War.

8 November: the Siege of Madrid begins. Republican defenders are joined by the International Brigade supporters.

18 November: Germany and Italy recognise Franco's government.

October: General Franco assumes formal leadership of the Nationalists.

1937

January: paints *Still Life with Old Shoe* in a room of the Galerie Pierre (no.73).

March: moves to 98 boulevard Auguste Blanqui, a building owned by architect Paul Nelson. He attends life classes.

April – July: designs *Aidez L'Espagne* in support the Spanish Republic and paints *The Reaper* in the Spanish Republican Pavilion at the Paris Exposition Internationale.

May – June: shows at the Galerie Pierre, Paris and Zwemmer Gallery, London.

May: Breton opens Surrealist Galerie Gradiva in Paris.

12 July: Exposition Internationale opens in Paris. Picasso's *Guernica*, Julio Gonzalez's *Montserrat* and other major works shown alongside Miró's *The Reaper* in the Spanish Republican Pavilion.

19 July: *Entartete Kunst* exhibition of 'degenerate' art in Munich.

Responses to the Spanish Civil War include Mary Low and Juan Bréa *Red Spanish Notebook*, Arthur Koestler's *Spanish Testament*, André Malraux's *L'Espoir* and Pablo Neruda's *España en el corazón*.

31st March: Spanish Nationalists launch a major offensive in the north.

26 April: German Condor Legion aircraft destroy Guernica, the ancient Basque capital.

3–8 May: Rising of Anarchists and Syndicalists in Barcelona.

15 December – 22 February: Battle for Teruel in eastern Spain.

1938

January – July: makes prints with Roger Lacourrière and S.W. Hayter.

March: completes *Self-Portrait I* (no.76).

4–28 May: solo exhibition, Mayor Gallery, London

Summer: holidays at Varengeville-sur-Mer in Normandy and Cassis in the south of France.

24 November – 7 December: solo exhibition, Galerie Pierre, Paris.

January – February: *Exposition internationale du surréalisme*, Galerie Beaux-Arts, Paris.

25 July: in Mexico, Breton and Diego Rivera sign manifesto 'Pour un Art révolutionnaire indépendant' composed with Trotsky.

Miró and Masson contribute prints to *Solidarité* portfolio.

Accounts of the Spanish Civil War include Hemingway's 'The Heat and the Cold' and George Orwell's *Homage to Catalonia*.

In Paris, Jean-Paul Sartre's *La Nausée* and Nathalie Sarraute's *Tropismes* are published.

13 March: German annexation of Austria in Anschluss.

15 April: Spanish Nationalist army reaches the Mediterranean, dividing Catalonia from the rest of the Republic.

29 September: British and French Prime Ministers, Chamberlain and Daladier, acquiesce in Hitler's annexation of the Sudetenland.

23 December: Spanish Nationalist armies begin major offensive in Catalonia.

1939

January – July: lives and works at boulevard Auguste Blanqui, Paris.

August: rents villa Clos des Sansonnets at Varengeville, eventually staying until May 1940. Georges Braque and architect Paul Nelson are neighbours; Calder and others visit.

24 March – 5 April: Miró exhibits with Klee, Tanguy and Masson in *La Rêve dans l'art et de la littérature*.

26 January: the fall of Barcelona.

27 February: the resignation of President Azaña signals the collapse of the Spanish Republic.

15 March: Germany invades Czechoslovakia.

28 March: the fall of Madrid.

29 March: the surrender of Valencia.

1 April: Franco declares victory.

September: Germany invades Poland. Great Britain and France declare war on Germany. Under the Nazi-Soviet Pact, the Red Army takes eastern Poland and attacks Finland.

1940

21 January: completes the first of the *Constellations*: *Sunrise* (no.93). *The Ladder of Escape* (no.9) follows on 31 January.

14 May: completion of *Acrobatic Dancers*, the tenth *Constellation*. Threatened by the German invasion of France, Miró and his wife decide to return to Spain (20 May). Waiting in Perpignan in early June, they cross into Spain but avoid Barcelona, settling instead with the Juncosa family in Palma de Mallorca by the end of July.

4 September: completion of *The Nightingale's Song at Midnight and Morning Rain*, the eleventh *Constellation* and first of the ten made in Palma.

January – February: *Exposición Internacional del Surrealismo*, Galeria de Arte Mexicano, Mexico, organised by Breton, Wolfgang Paalen and César Moro.

1 April: Franco announces a project to build a memorial; Valle de los Caídos, inaugurated in 1959.

In Tokyo, Shuzo Takiguchi publishes the first monograph on Miró.

9 April: Germany invades Denmark and Norway.

10 May: Germany invades France, the Netherlands and Belgium. Allied troops are evacuated from Dunkirk (26 May – 2 June). Winston Churchill becomes British Prime Minister.

10 June: Italy declares war on Britain and France.

14 June: abandoned by the government, Paris is occupied by the Germans. On 18 June General Charles de Gaulle calls for resistance, but the Franco-German Armistice is signed four days later. Within a month the Germans control Occupied France, while Field Marshal Phillipe Pétain assembles an 'independent' government at Vichy (10 July).

June: USSR annexes Baltic states.

July: Battle of Britain resists German invasion; the Blitz follows in September.

21 August: assassination of Leon Trotsky in Mexico.

1941

June – October: returns to Mont-roig for the first time since 1936. He finishes the *Constellations* there and begins the *Barcelona Series*.

18 November: first major retrospective exhibition of Miró's work opens at Museum of Modern Art, New York, organised by James Johnson Sweeney.

March – April: Breton and Masson are among Surrealists heading for exile in USA.

November: Miró's exhibition at Museum of Modern Art, New York, is paired with Dalí's first retrospective there.

April: German invasion of Yugoslavia and Greece.

June: Hitler launches surprise invasion of the Soviet Union, besieging Leningrad and advancing on Moscow by December.

7 December: surprise Japanese attack on the US naval base at Pearl Harbour, Hawaii, brings USA into the war. Japan takes Hong Kong (25 December).

1942

Late February: returns to Barcelona to visit his sick mother.

October: after summer at Mont-roig, Miró settles in Barcelona.

14 October: in New York, Breton and Marcel Duchamp organise *First Papers of Surrealism*; a week later Peggy Guggenheim opens *Art of This Century*.

Camilo José Cela publishes *La Familia de Pascual Duarte* in Madrid, though the second edition (1943) is seized by the censors.

13 September – 2 February 1943: Battle of Stalingrad.

November: British army defeats the Germans at El Alamein, leading to capitulation in North Africa in May 1943.

1943

January – June: living and working in the family apartment at 4 Passatge del Crédit, Barcelona.

25 July: Collapse of Mussolini's regime. Prime Minister Marshal Pietro Badoglio signs Armistice with (3 september) and declares war on Germany (13 October).

September: beginning of Russian counter-attack against German occupation.

1944

27 May: death of Miró's mother, Dolores.

July: ships the *Constellations* and *Barcelona Series* to New York.

5 October: Picasso announces he has joined the Communist Party.

28 November: Group Exhibition at the Salon d'Automne, Palais de Tokyo, Paris, known as the Salon de la Libération.

6 June: D-Day Landings of Allied troops in Normandy.

25 August: Paris liberated; General de Gaulle reinstates Republic.

1945

9 January – 3 February: *Constellations* shown at Pierre Matisse Gallery, New York to great acclaim.

January – July: remains in Barcelona, returning after summer in Mont-roig.

In Paris, Sartre publishes *L'Âge de raison* as the first part of the wartime trilogy *Les Chemins de la liberté (Roads to Freedom)*, and Maurice Merleau-Ponty publishes *Phénoménologie de la perception*.

Roberto Rossellini's Neorealist film *Roma città aperta* released.

7 May: Germany surrenders following Hitler's suicide (30 April). The death camps of Buchenwald and Auschwitz revealed.

15 August: Japan surrenders after USA drops atomic bombs on Hiroshima and Nagasaki (6 and 9 August).

1946

January – July: in Barcelona.

July – October: summers in Mont-roig.

8 November – 6 December: *Premier Salon d'Art Catalan*, Galerie Lucien Reyman, Paris.

December 1946: UN resolution condemns Franco's government in Spain.

1947

February – October: pays his first visit to the USA, staying in New York but visiting Cincinnati (where he is making a mural for the Terrace Plaza Hotel). He meets Jackson Pollock and others including Arshile Gorky,

January: Picasso completes *Monument for the Spaniards Who Died for France*.

July – August: *Exposition Internationale du surréalisme*, Galerie Maeght, Paris.

April: in France, De Gaulle forms anti-Communist *Rassemblement du Peuple Français*.

August: Declaration of Independence of India and Pakistan.

1948	**1949**	**1950**	**1951**	
Clement Greenberg, Peggy Guggenheim and Louise Bourgeois. Thomas Bouchard films him painting.	18 February: first trip to Paris in eight years.	26 June: trip to Paris. 22 December: a stay in Mallorca is cut short suddenly when Miró's uncle dies.	25 June: visits solo exhibition, Galerie Maeght, Paris. Commissioned by Gropius to make mural for Harvard University, Cambridge.	October – November: *Calder-Miró*, Contemporary Arts Association, Houston.
Simone Weil publishes *La Pesanteur et la grâce*.	In New York, Clement Greenberg publishes a monograph on Miró. Dalí returns to Spain after 8 years in USA.	Prats and others establish *Cobalto 49* to revive contemporary cultural activity in Barcelona.		Spanish Pavilion at Milan Triennial includes a work by Miró.
	24 June – 12 May 1949: Berlin Blockade and Airlift.	23 May: Federal Republic of Germany (West Germany) comes into being, followed in 7 October by German Democratic Republic (East Germany). October: Mao Zedong declares China a Communist state.	February: US Senator Joseph McCarthy launches anti-Communist campaign. June: North Korea invades South Korea triggering the three-year Korean War.	

161
Untitled 5 February 1972
China ink and pencil on
paper
18.9 × 964
Paper scroll
Fundació Pilar i Joan Miró,
Mallorca

1952

March: impressed by *Jackson Pollock* exhibition at Studio Paul Facchetti, Paris.

December: Picasso completes *War and Peace* murals in Vallauris.

1953

January – May: in Barcelona prior to solo show at Galerie Maeght, Paris (June).

Madrid Pact sees USA provide economic aid in return for military bases in Spain.

5 March: death of Stalin.

1954

25 February: Miró's first ceramics made in collaboration with Artigas at Gallifa are fired.

19 June: awarded Grand Prize for Engraving at the Venice Biennale.

3 November: death of Henri Matisse.

July: France accepts Communist control of North Vietnam.

December: France sends troops to put down insurrection in Algeria.

1955

Focuses on ceramics and on graphic works.

14 May: Communist countries of Eastern Europe form Warsaw Pact.

1956

January – May: Miró and Artigas work on commission for UNESCO in Paris.

September: settling into new studio at Son Abrines near Palma, designed by Sert, brings review of years of work recovered from storage.

2nd March: France grants independence to Morocco; Spanish Morocco follows (7 April).

November: Anglo-French invasion of Suez Canal Zone, in response to Egyptian nationalisation, collapses under US and UN pressure.

1957	1958	1959	1960
March: visits prehistoric cave paintings at Altamira.	April – May: completes UNESCO ceramic murals that are inaugurated at the organisation's headquarters in Paris on 3 November.	18 March – 10 May: second retrospective at Museum of Modern Art organised by James Thrall Soby. May: receives the Guggenheim International Award from President Eisenhower. Inspects his damaged mural at Harvard University.	June: US Ambassador to Spain makes Miró an honorary member of the American Academy and Institute of Arts and Letters. Works with Artigas and his son, Joan Gardy Artigas, on ceramic mural to replace Harvard University painting.
The Situationist International is founded.	March: Picasso completes *Fall of Icarus* for UNESCO headquarters in Paris.	*New American Painting* exhibition tours Europe, bringing Abstract Expressionism to wider attention. December: Surrealists' 'EROS' exhibition Galerie Daniel Cordier, Paris.	June: Nouveau Réalisme artists (Arman, Yves Klein, Raymond Hains, Niki de Saint-Phalle and Jean Tinguely) show in Paris. October: Picasso begins mural decorations for the Colegio Oficial de Arquitectos de Cataluña y Baleares, Barcelona.
November: Soviet Army crushes Hungarian uprising against Communist rule.	28 September: approval of the constitution of the Fifth French Republic.	January: Fidel Castro takes power in Cuba. July: establishment of Basque separatist organisation ETA.	1st of May 1960: US 'U2' spy plane crashes in USSR sparking diplomatic crisis. De Gaulle's offer of self-determination for Algeria sparks riots of French settlers. 8 November: John F. Kennedy wins Presidential elections.

1961

4 March: completes the monumental *Blue* triptych.

17 November: travels to New York and Harvard to see completed mural.

In Paris, Jacques Dupin publishes major monograph on Miró's life and work.

Buñuel releases *Viridiana*.

12 April: Russian cosmonaut Yuri Gagarin is first man in space

17 April: US invasion of Cuba fails at 'Bay of Pigs'.

13 August: building of Berlin Wall dividing the city between the two Germanies.

1962

8–22 May: completes *Mural Painting I Orange-Yellow, Mural Painting II Green, Mural Painting III Red,* which are shown at his retrospective at Musée national d'art moderne in Paris.

6 June: death of Yves Klein.

Censors allow Cela's *La Colmena* (*The Hive*, Buenos Aires 1951) to be published in Spain.

3 July: Declaration of Independence of Algeria.

22-28 October: Cuban Missile Crisis threatens nuclear war.

1963

February: works with Sert on the Fondation Maeght, Saint-Paul-de-Vence, devising ceramic sculptures for the gardens with Artigas.

9 March: opening of Museo Picasso, Barcelona.

31 August: death of Georges Braque.

3 June: death of Pope John XXIII and election of Paul VI (21 June).

22 November: assassination of US President John F. Kennedy.

1964

28 July: inauguration of Fondation Maeght, Saint-Paul de Vence.

12 September: travels to London for Tate retrospective (August – October) and *Graphic Art* exhibition at the ICA, both organised by Roland Penrose.

2 July: US Senate passes Civil Rights Bill.

1965

October: travels via Paris to New York (for his show at Pierre Matisse Gallery) and Chicago.

November: Cultural Revolution in China.

June: USA sends troops to Vietnam.

1966

September: makes his first trip to Japan and meets the poet Shuzo Takiguchi, the author of his first monograph (1940).

28 September: death of André Breton.

4 November: flooding ruins Renaissance artworks in Florence.

April – May: clashes between police and students at Spanish universities.

1967

October: awarded the Carnegie International Grand Prize for Painting.

20 January: students and intellectuals hold celebration of Picasso in Barcelona.

21 April: Colonels' coup in Greece.

5 - 10 June: Six-Day War between Israel and Arab neighbours.

9 October: Che Guevara killed in Bolivia.

1968

June: third trip to USA where he is named *Doctor Honoris Causa* by Harvard University.

July – September: retrospective of almost 400 works held at the Fondation Maeght, Saint-Paul de Vence.

February: Picasso gives *Las Meninas* series to Museo Picasso, Barcelona, in memory of his friend and secretary Jaime Sabartés.

18 June: police break up protests by students and some exhibitors at Venice Biennale.

In Spain, a state of emergency is declared in the Basque country after clashes result in the murder of a police officer.

4 April: assassination of US Civil Rights leader, Martin Luther King.

September – October: begins *May '68* 1968–73 (no.120) and completes triptych *Painting on White Background for the Cell of a Recluse* (no.158).

November – January 1969: retrospective moves to the

4–6 October: *Arte povera – Azioni povere* events in Amalfi include Luciano Fabro, Jannis Kounellis, Mario Merz, Marisa Merz and Michelangelo Pistoletto.

May: following the student occupation of Nanterre University in March, student protests in Paris, the 'Events of May 68', threaten the French State. On 30 May, De Gaulle calls, and wins, a General Election on 30 June.

Hospital de la Santa Creu, Barcelona, as part of 'Miró Year' celebrating his 75th birthday. It is Miró's first major exhibition in Spain.

Pere Portabella makes *Nocturno 29* based on a screenplay by Joan Brossa.

6 June: assassination of US Senator Robert Kennedy.

21 August: Soviet army crush the liberalising 'Prague Spring' in Czechoslovakia.

1969

April: paints on the windows of the Colegio Oficial de Arquitectos de Cataluña y Baleares, Barcelona, as part of the exhibition *Miró Otro*, May – June.

June: works with Artigas on murals for Barcelona Airport and for Osaka, Japan.

22 March: exhibition *When Attitudes Become Form* at the Kunsthalle Bern brings together international conceptual art practices.

Portabella makes *Miró l'altre* and *Aidez l'Espagne* films for *Miró Otro*.

November: second trip to Japan associated with the mural commission for the Gas Pavilion, Osaka Universal Expo.

24 January: Martial law imposed in Spain in response to growing opposition.

15 June: Georges Pompidou becomes President of France.

20 July: USA lands Neil Armstrong on the moon.

15 October: millions of Americans march to protest against the Vietnam conflict.

1970

15 March: opening of Osaka Universal Expo features Miró's ceramic mural.

September: inauguration of the ceramic mural for Barcelona Airport.

January: Museo Picasso in Barcelona receives works from the artist's family in the city.

April: Dalí announces creation of Teatre-Museu Dalí in Figueres.

In London, Roland Penrose publishes his monograph on Miró.

May: US National Guards kill anti-war protesters at Kent State University, Ohio.

December: Trial in Burgos of Basque separatists focuses opposition to Spanish regime.

24 October: Salvador Allende elected President of Chile.

1971

October: attends *Francis Bacon* exhibition at Grand Palais, Paris.

October – November: *Miró Sculptures,* Walker Arts Center, Minneapolis, Cleveland Museum of Art and Art Institute of Chicago.

1972

29 February: agrees to donate a work to the Salvador Allende International Resistance Museum in Santiago, Chile.

27 June: formal constitution of the Fundació Joan Miró in Barcelona.

Buñuel releases *Le charme discret de la bourgeoisie.*

30 January: British troops kill 13 civil rights marchers in Londonderry ('Bloody Sunday'); IRA bombings spread to mainland Britain.

February: US President Richard Nixon visits China.

1973

October – January 1973: important exhibition of 1920s and recent work, *Joan Miró: Magnetic Fields*, held at Solomon R. Guggenheim Museum, New York.

20 April: 80th birthday is celebrated by exhibitions at Galerie Maeght, Paris and Fondation Maeght, Saint-Paul de Vence, as well as Museum of Modern Art, New York (*Miró in the Collection of the Museum of Modern Art*, October – January 1974) and

8 April: death of Pablo Picasso.

Portabella makes two films on Miró's work: *Miró Tapís* and *Miró Forja* (on tapestry and sculpture).

Català-Roca films Miró making the burnt canvases.

College of Architects, Palma (*Miró 80 Vuitanta*, November – January 1974).

December: creates his *Burnt Canvases* (nos.145-9).

August: USA withdraws troops from Vietnam, but intensifies bombardment.

7 November: Nixon re-elected US President.

27 January: signing of ceasefire in Paris ends Vietnam conflict.

11 September: Salvador Allende is killed in military coup in Chile.

October: Oil Crisis, with serious economic implications in Europe and USA.

20 December: Admiral Carrero Blanco, appointed as Spanish Prime Minister in June, is killed by an ETA bomb in Madrid. Arias Navarro replaces him.

1974

January: installation of *Oiseau Lunaire* sculpture in Place Robert Desnos, Paris, close to his 1920s studio at rue Blomet. Awarded the *Legion d'honneur*.

9 February: signs works for his exhibition at Grand Palais in Paris, including *Fireworks*

28 September: opening of Teatre-Museu Dalí in Figueres.

triptych (no.160) and *The Hope of a Condemned Man* (no.159).

May – October: A major retrospective exhibition at the Grand Palais, Paris is complemented by the complete graphic work shown at Musée d'Art Moderne de la Ville de Paris.

12 February: Prime Minister Arias Navarro pledges reform of the Trade Union Law and Local Government Law encouraging hopes of greater political freedom.

2 March: Catalan anarchist, Salvador Puig Antich, is executed.

25 April: the Carnation Revolution ends the Salazar regime in Portugal.

8 August: US President Nixon resigns over bugging of Watergate building.

1975

10 June: unofficial opening of Fundació Joan Miró-Centre d'Estudis d'Art Contemporani, Barcelona.

1976

Official inauguration of Fundació Joan Miró, Barcelona.

Miró and Joan Gardy Artigas create a mosaic for the Pla de l'Os pavement on La Rambla in Barcelona.

1977

Miró collaborates with the theatre group La Claca on *Mori el Merma* at Sant Esteve de Palautordera (filmed by Català-Roca).

In Paris, Georges Raillard publishes *Joan Miró: Ceci est la couleur de mes rêves*.

1978

Spring – Summer: *Mori el Merma* presented in Palma, Barcelona and elsewhere, including at the unveiling of *Couple d'amoureux* sculpture at La Défense, Paris.

May – July: Retrospective at

20 November: death of Giorgio de Chirico.

Museo Español de Arte Contemporáneo, Madrid, coincides with the award of the Gran Cruz de la Orden de Isabel la Catolica.

20 November: death of General Francisco Franco. Two days later Juan Carlos becomes King of Spain and begins transition to a constitutional monarchy.

1 July: Adolfo Suárez is appointed President of the Spanish Government. Beginning of the Transition.

9 September: death of Mao Zedong.

15 June: free elections in Spain.

16 March: former Italian Prime Minister, Aldo Moro, is kidnapped and killed by Leftist Red Brigades.

6 August: death of Pope Paul VI followed by brief reign of Pope John-Paul I, and election (16 October) of Karol Wojtyla as John-Paul II.

1979

Awarded Doctor Honoris Causa, Barcelona University.

1980

October: King Juan Carlos I awards Miró the Spanish Gold Medal for Fine Arts.

15 April: death of Jean-Paul Sartre.

1981

7 March: formal constitution of Palma studios as the Fundació Pilar i Joan Miró.

1982

1983

April: 90th birthday widely celebrated in Barcelona.

25 December: death of Joan Miró. His funeral follows two days later at the Church of San Nicolás, Palma de Mallorca.

29 December: burial in family vault, Montjuïc Cemetery, Barcelona.

February: Iranian Revolution brings Ayatollah Khomeini to power.

September: outbreak of Iran-Iraq War.

6 October: assassination of President Sadat of Egypt.

Socialist government in Spain (1982–96) consolidates democracy.

Further reading

'Joan Miró'. *Cahiers d'Art*, vol. 9, no.1–4 (1934)

Miró, Joan. 'Je rêve d'un grand atelier'. *XXe siècle*, no. 2 (May – June 1938), pp. 25–28

Takiguchi, Shûzo. *Miró*. Tokyo: Atelier, 1940

Sweeney, James Johnson. *Joan Miró*. Exh. cat. New York: Museum of Modern Art, 1941

Greenberg, Clement. *Joan Miró*. New York: Quadrangle Press, 1948

Dupin, Jacques. *Miró*. Paris: Flammarion, 1961 ; *Joan Miró: Life and Work*. Trans. Norbert Gutermann. New York: Harry N. Abrams, 1962 (English edition)

Cirici Pellicer, Alexandre. *Miró en su obra*. Barcelona: Labor, 1970 ; *Miró llegit: una aproximació estructural a l'obra de Miró*. Barcelona: Edicions 62, 1971

Penrose, Roland. *Miró*. London: Thames & Hudson, 1970. (World of art)

Krauss, Rosalind ; Rowell, Margit. *Joan Miró: Magnetic Fields*. Exh. cat. New York: Solomon R. Guggenheim Museum, 1972

Joan Miró. Exh. cat. Paris: Grand Palais, 1974

Raillard, Georges. *Joan Miró: Ceci est la couleur de mes rêves: Entretiens avec Georges Raillard*. Paris: Seuil, 1977 ; *Conversaciones con Miró*. Trans. Carlos del Peral. Revised edition. Barcelona: Granica, 1978

Stich, Sidra. *Joan Miró: The Development of a Sign Language*. Exh. cat. St. Louis: Washington University Gallery of Art, 1980

Rose, Barbara. *Miró in America*. Exh. cat. Houston: Museum of Fine Arts, 1982

Borràs, Maria Lluïsa. *Joan Miró: Sèrie Barcelona*. Exh. cat. Barcelona: Casa Elizalde, 1984

Homage to Barcelona: The City and its Art, 1888–1936. Exh. cat. London: Hayward Gallery, 1985

Rowell, Margit. *Joan Miró. Selected Writings and Interviews*. Boston: G.K. Hall, 1986

Malet, Rosa Maria. *Obra de Joan Miró*. Catalogue raisonné. Barcelona: Fundació Joan Miró, 1988 (text in Catalan, Spanish, French and English)

Jeffett, William. 'Joan Miró's Vagabond Sculpture', in *Joan Miró: Sculpture*. Exh. cat. Southampton: Southampton City Art Gallery, 1989

Malet, Rosa Maria; Jeffett, William. *Joan Miró: Paintings and Drawings 1929–41*. Exh. cat. London: Whitechapel Art Gallery, 1989

Combalia, Victòria. *El descubrimiento de Miró: Miró y sus críticos 1918–1929*. Barcelona: Destino, 1990

Minguet Batllori, Joan M.; Vidal i Oliveras, Jaume. 'Cronologia Crítica (1906–1939)', in Giralt-Miracle, Daniel (ed.). *Avanguardes a Catalunya 1906–1939*. Exh. cat. Barcelona: Fundació Caixa de Catalunya, 1992

Joan Miró 1893–1993. Exh. cat. Barcelona: Fundació Joan Miró, 1993

Dupin, Jacques. *Joan Miró*. [ed. rev. 1961]. Barcelona: Polígrafa, 1993 (Catalan, Spanish and English ed.); Paris: Flammarion, 1993 (French ed.)

Lanchner, Carolyn. *Joan Miró*. Exp. cat. New York: Museum of Modern Art, 1993

Umland, Anne. 'Chronology', in Lanchner 1993

Rowell, Margit. *Joan Miró: Campo de Estrellas*. Exh. cat. Madrid: Museo Nacional Centro de Arte Reina Sofía, 1993 (text in Spanish and English)

Escudero i Anglès, Carme; Bravo, Isidre; Malet, Rosa Maria. *Miró en escena*. Exh. cat. Barcelona: Fundació Joan Miró, 1994 (text in Catalan, Spanish and English)

Català-Roca, Francesc. *Impressions d'un fotògraf: Memòries*. Barcelona: Edicions 62, 1995

Green, Christopher; Malet, Rosa Maria. *Joan Miró: Campesino catalán con guitarra, 1924*. Exh. cat. Madrid: Museo Thyssen-Bornemisza, 1997

Dupin, Jacques; Lelong-Mainaud, Ariane. *Miró: Catalogue Raisonné: Paintings, vol.1 1908–1930*. Trans. Cole Swensen y Unity Woodman. Paris, 1999

Cabañas, Pilar. *La fuerza de Oriente en la obra de Joan Miró*. Madrid: Electa, 2000

Dupin, Jacques; Lelong-Mainaud, Ariane. *Miró: Catalogue Raisonné: Paintings, vol.2 1931–1941*. Trans. Cole Swensen y Unity Woodman. Paris, 2000

Hammond, Paul. *Constellations of Miró, Breton*. San Francisco: City Lights, 2000

Lomas, David. *The Haunted Self, Surrealism, Psychoanalysis, Subjectivity*. New Haven; London: Yale University Press, 2000

Minguet Batllori, Joan M. *Joan Miró: L'artista i el seu entorn cultural (1918–1983)*. Barcelona: Publicacions Abadia de Montserrat, 2000. (Biblioteca Serra d'Or; 244)

Paris-Barcelone: de Gaudí à Miró. Exh. cat. Paris: Grand Palais, 2001

Dupin, Jacques; Lelong-Mainaud, Ariane. *Miró: Catalogue Raisonné: Paintings, vol.3 1942–1955*. Trans. Cole Swensen y Unity Woodman. Paris, 2001

Escudero, Carme; Montaner, Teresa. *Joan Miró: desfilada d'obsessions*. Exh. cat. Barcelona: Fundació Joan Miró, 2001 (text in Catalan, Spanish and English)

Dupin, Jacques; Lelong-Mainaud, Ariane. *Miró: Catalogue Raisonné: Paintings, vol.4 1959–1968*. Trans. Cole Swensen y Unity Woodman. Paris, 2002

Lubar, Robert S. 'El nacionalismo lingüístico de Miró', in *París-Barcelona, 1888–1937*. Exh. cat. Barcelona: Museu Picasso, 2002, pág. 401–415

Coyle, Laura; Jeffett, William; Punyet Miró, Joan. *The Shape of Color: Joan Miró's Painted Sculpture*. Exh. cat. Washington, D.C.: Corcoran Gallery of Art, 2003

Dupin, Jacques; Lelong-Mainaud, Ariane. *Miró: Catalogue Raisonné: Paintings, vol.5 1969–1975*. Trans. Cole Swensen y Unity Woodman. Paris, 2003

Lubar, Robert S. 'Painting and Politics: Miró's Still Life with Old Shoe and the Spanish Republic', in Spiteri, Raymond; LaCoss, Donald (eds.). *Surrealism, Politics and Culture*. Aldershot; Burlington: Ashgate, 2003

La Beaumelle, Agnès de. *Joan Miró 1917–1934: la naissance du monde*. Exh. cat. Paris: Musée national d'art moderne. Centre Pompidou, 2004

Dupin, Jacques; Lelong-Mainaud, Ariane. *Miró: Catalogue Raisonné: Paintings, vol.6 1976–1981*. Trans. Cole Swensen y Unity Woodman. Paris, 2004

Labrusse, Rémi. *Miró: Un feu dans les ruines*. Paris: Hazan, 2004

Minguet Batllori, Joan M. *El Manifest Groc: Dalí, Gasch, Montanyà i l'antiart*. Exh. cat. Barcelona: Fundació Joan Miró, 2004 (ed. in Catalan and Spanish, transl. in English)

Miró: Fundació Pilar y Joan Miró. Barcelona: Lunwerg, 2005 (t. in English and Spanish)

Fernández Miró, Emili; Malet, Rosa Maria et al. *Joan Miró 1956–1983. Sentiment, emoció, gest*. Exh. cat. Barcelona: Fundació Joan Miró, 2006 (text in Catalan, Spanish and English)

Fernández Miró, Emilio; Ortega, Pilar. *Miró: Catalogue Raisonné: Sculptures*. Paris: Daniel Lelong ; Successió Miró, 2006

Greeley, Robin Adèle. *Surrealism and the Spanish Civil War*. New Haven, 2006

Robinson, William H.; Falgàs, Jordi; Lord, Carmen Belen (eds.). *Barcelona and Modernity: Picasso, Gaudí, Miró, Dalí*. Exh. cat. Cleveland Museum of Art, 2006

Balsach, Maria-Josep. *Joan Miró: cosmogonías de un mundo originario (1918–1939)*. Trans. Ma. José Viejo. Barcelona: Galaxia Gutenberg /Cercle de Lectors, 2007

Dupin, Jacques; Lelong-Mainaud, Ariane; Punyet Miró, Joan. *Joan Miró*. Murcia, 2007

Félix Fanès. *Pintura, collage, cultura de masas, Joan Miró 1919–1934*. Madrid : Alianza, 2007. (Alianza Forma; 154)

Llorens, Tomás. *Miró: Tierra*. Exh. cat. Madrid: Museo Thyssen-Bornemisza, 2008

Palermo, Charles. *Fixed Ecstasy: Joan Miró in the 1920s*. University Park: Pennsylvania State University Press, 2008. (Refiguring modernism)

Umland, Anne. *Joan Miró: Painting and Anti-Painting, 1927–1937*. Exh. cat. New York: Museum of Modern Art, 2008

Ainaud de Lasarte, Joan (established by); Minguet Batllori, Joan M.; Montaner, Teresa; Santanach and Suñol, Joan (editors). *Epistolari Català Joan Miró 1911–1945*. Vol 1. Barcelona: Barcino, 2009

List of exhibited works

From around 1920 Miro habitually titles his work by inscribing them on the reverse in French (or, very rarely, in Catalan). This is used here for the first mention of each work, with the English to follow. Earlier paintings without inscriptions have been given their conventional English titles.

Nord-Sud 1917
Oil on canvas
62 × 70
Collection Maeght, Paris
(Tate and FJM)

Portrait of Vicens Nubiola 1917
Oil on canvas
103.5 × 113
Folkwang Museum, Essen

House with Palm Tree 1918
Oil on canvas
65 × 73
Museo Nacional Centro de Arte
Reina Sofía, Madrid
(Tate and FJM)

The Rut 1918
Oil on canvas
75 × 75
Private collection.
Courtesy Giraud Pissarro Segalot

Vegetable Garden and Donkey 1918
Oil on canvas
64 × 70
Moderna Museet, Stockholm

**Mont-roig, the Church and
the Village** 1919
Oil on canvas
73 × 61
Private collection

La Ferme 1921–2
The Farm
Oil on canvas
132 × 147
National Gallery of Art, Washington.
Gift of Mary Hemingway, 1987

La Terre labourée 1923–4
The Tilled Field
Oil on canvas
66 × 92.7
Solomon R. Guggenheim Museum,
New York
(Tate and FJM)

Paysage catalan (Le Chasseur) 1923–4
Catalan Landscape (The Hunter)
Oil on canvas
65 × 100
The Museum of Modern Art, New York.
Purchase, 1936

Tête de paysan catalan 1924
Head of a Catalan Peasant
Oil and crayon on canvas
146 × 114
National Gallery of Art, Washington.
Gift of the Collectors Committee, 1981

Paysan catalan à la guitare 1924
Catalan Peasant with Guitar
Oil on canvas
146 × 114
Museo Thyssen-Bornemisza, Madrid

Tête de paysan catalan 10 March 1925
Head of a Catalan Peasant
Oil on canvas
92 × 73.2
Tate and the Scottish National Gallery
of Modern Art. Purchased jointly with
assistance from the Art Fund, the
Friends of the Tate Gallery and the
Knapping Fund, 1999

Peinture [Le Catalan] 1925
Painting [The Catalan]
Oil and pencil on canvas
100 × 81
Centre Pompidou, Paris.
Musée national d'art moderne /
Centre de création industrielle

Tête de paysan catalan 1925
Head of a Catalan Peasant
Oil on canvas
147 × 115
Moderna Museet, Stockholm.
Bequest of Gerard Bonnier, 1989

Peinture 1925
Painting
Oil on canvas
100 × 81
Museo Nacional Centro de Arte
Reina Sofía, Madrid
(Tate and FJM)

Le Repas des fermiers 1925
The Farmers' Meal
Oil on canvas
33.5 × 46.5
Private collection
(Tate and FJM)

Chien aboyant à la lune 1926
Dog Barking at the Moon
Oil on canvas
73 × 92
Philadelphia Museum of Art.
A.E. Gallatin Collection, 1952

Paysage (Le Lièvre) 1927
Landscape (The Hare)
Oil on canvas
130 × 195
Solomon R. Guggenheim Museum,
New York

Paysage (Paysage au coq) 1927
Landscape (Landscape with Rooster)
Oil on canvas
131 × 196.5 mm
Fondation Beyeler, Riehen/Basel
(Tate)

Peinture 1927
Painting
Oil on canvas
129 × 97
Centre Pompidou, Paris
Musée national d'art moderne /
Centre de création industrielle
On long loan to Musée d'art moderne
de Lille Metropole, Villeneuve-d'Ascq.
(Tate)

Peinture 1927
Painting
Tempera and oil on canvas
97.2 × 130.2
Tate. Purchased with assistance from
the Friends of the Tate Gallery, 1971

Peinture (Tête) 1927
Painting (Head)
Oil on canvas
147.3 × 114.6
Collection Nahmad, Switzerland
(Tate)

Flama en l'espai i dona nua 1932
Flame in Space and Nude
Oil on wood
41 × 32
Fundació Joan Miró, Barcelona
(FJM)

Femme 1934
Woman
Pastel on velours paper
107.9 × 71.1
Frederick R. Weisman Art Foundation,
Los Angeles

Personnage October 1934
Figure
Pastel on velours paper, mounted
on canvas
108 × 72.8
Musée des Beaux-Arts, Lyon.
Bequest of J. Delubac
(Tate and FJM)

Personnage 1934
Figure
Pastel on velours paper
106.3 × 70.5
Centre Pompidou, Paris
Musée national d'art moderne /
Centre de création industrielle
(NGA)

Personnage 1934
Figure
Charcoal, pastel and pencil on velours
paper
107 × 72
Collection of Emilio Fernández. On loan
to the Fundació Joan Miró, Barcelona

**Homme et femme devant un tas
d'excréments** 15–22 October 1935
**Man and Woman in Front of
a Pile of Excrement**
Oil on copper
23 × 32
Fundació Joan Miró, Barcelona.
Gift of Pilar Juncosa de Miró.

Nocturne 9–16 November 1935
Oil on copper
42 × 29.2
The Cleveland Museum of Art.
Mr and Mrs William H Marlatt Fund

Deux baigneuses February 1936
Two Bathers
Gouache on paper
49 × 65
Collection El Conventet, Barcelona

Les Deux Philosophes
4–12 February 1936
The Two Philosophers
Oil on copper
35 .6 × 49.8
Art Institute of Chicago.
Gift of Mary and Leigh Block
(Tate and NGA)

L'Objet du couchant 1935 – March 1936
Object of Sunset
Painted wood (carob tree trunk),
bed spring, gas burner, chain, shackle
and string
68 × 44 × 26
Centre Pompidou, Paris
Musée national d'art moderne /
Centre de création industrielle

Personnages assis 10–21 March 1936
Seated Personages
Oil on copper
44.1 × 34.9
Private collection
(Tate)

Métamorphose 23 March – 4 April 1936
Metamorphosis
Pencil, watercolour, India ink and
collage of newspaper on paper
48 × 64
Collection of the Pierre and Tana
Matisse Foundation, New York

Métamorphose 23 March – 4 April 1936
Metamorphosis
India ink, watercolour, pencil, decal and
collage of newspaper on paper
48 × 64
Collection of Richard and Mary L. Gray
and the Gray Collection Trust

Métamorphose 23 March – 4 April 1936
Metamorphosis
Pencil, watercolour, collage, decal and
stencil on paper
64 × 48
Collection of the Pierre and Tana
Matisse Foundation, New York

Métamorphose 23 March – 4 April 1936
Metamorphosis
Pencil, India ink, collage of newspaper
and decal on paper
63.5 × 47
Private collection. Courtesy Galerie
Zlotowski, Paris

Métamorphose 23 March – 4 April 1936
Metamorphosis
Pencil, India ink, watercolour, collage of
newspaper, decal and stencil on paper
59 × 47.8
Courtesy Galerie Gmurzynska, Zurich

Personnages et montagnes
11–22 May 1936
Personages and Mountains
Tempera on masonite
30.2 × 25.1
Private collection
(Tate)

[Figures] 28 May 1936
Gouache and India ink on paper
41.3 × 32.1
Collection Nahmad, Switzerland
(Tate)

Peinture Summer 1936
Painting
Oil, casein, tar and sand on masonite
78 × 108
Collection Nahmad, Switzerland

Peinture Summer 1936
Painting
Oil, casein, tar and sand on masonite
78 × 108
Collection Nahmad, Switzerland

Peinture Summer 1936
Painting
Oil, casein, tar and sand on masonite
78 × 108
Collection Nahmad, Switzerland

Peinture Summer 1936
Painting
Oil, casein, tar and sand on masonite
78 × 108
Collection Nahmad, Switzerland

Aidez l'Espagne 1937
Stencil printed in colour
31.3 × 24

Nature morte au vieux soulier
24 January – 29 May 1937
Still Life with Old Shoe
Oil on canvas
81 × 116
The Museum of Modern Art, New York.
Gift of James Thrall Soby, 1970

Femme nue montant l'escalier
March 1937
Naked Woman going Upstairs
Charcoal on card
78 × 55.8
Fundació Joan Miró, Barcelona

Tête 2 October 1937
Head
Oil, collage and towel on celotex
121.8 × 91.4
Fundació Joan Miró
(FJM)

Untitled [Head of a Man]
11 December 1937
Gouache on black paper
65.4 × 50.5
The Museum of Modern Art, New York.
Richard S. Zeisler Bequest, 2008

Nocturne 1938
Oil on cardboard
54 × 73
Private collection
(FJM)

Femme en révolte
26 February 1938
Woman in Revolt
Watercolour and pencil on paper
57.4 × 74.3
Centre Pompidou, Paris
Musée national d'art moderne /
Centre de création industrielle
(FJM)

Untitled 3 March 1938
Watercolour and pencil on paper
53.5 × 43
Private collection

Une Étoile caresse le sein d'une
négresse (peinture-poème) April 1938
**A Star Caresses the Breast of a
Negress (Painting Poem)**
Oil on canvas
129.5 × 194.3
Tate. Purchased 1983

Portrait IV June 1938
Oil on canvas
129.8 × 95.8
Collection of Samuel and Ronnie
Heyman, New York
(NGA)

La caresse des étoiles 22 July 1938
The Caress of the Stars
Oil on canvas
60.2 × 69.3
Private collection
(Tate)

Autoportrait 31 December 1938
Self-portrait
Graphite pencil on paper
16.9 × 21.9
Fundació Joan Miró, Barcelona

Jeune fille moitié brune moitié
rousse glissant sur le sang des
jacinthes gelées d'un camp de
football en flammes 14 March 1939
**Young Girl with Half Brown, Half Red
Hair Slipping on the Blood of Frozen
Hyacinths of a Burning Football Field**
Oil on canvas
130 × 195
Collection of Batsheva and Ronald
Ostrow

Femme fuyant l'incendie 5 April 1939
Woman Fleeing from a Fire
Gouache, India ink, pencil and pastel
on paper
33 × 41
Santa Barbara Museum of Art.
Gift of Wright S. Ludington
(Tate and NGA)

Femme poignardée par le soleil
récitant de poèmes fusées en formes
géométriques du vol musical chauve-
souris crachat de la mer 12 April 1939
**Woman Stabbed by the Sun Reciting
Rocket Poems in the Geometrical
Shapes of the Musical Bat Spittle
Flight of the Sea**
Gouache and oil wash on paper
40.7 × 33
Private collection
(NGA)

Le Vol de l'oiseau sur la plaine II
July 1939
Flight of a Bird over the Plain II
Oil on canvas
81 × 100
Collection Nahmad, Switzerland

Le Vol de l'oiseau sur la plaine III
July 1939
Flight of a Bird over the Plain III
Oil on canvas
89 × 116
Solomon R. Guggenheim Museum,
New York. Gift of Evelyn Sharp, 1977

Une goutte de rosée tombant de l'aile
d'un oiseau réveille Rosalie endormie
à l'ombre d'une toile d'araignée
December 1939
**A Drop of Dew Falling from the Wing
of a Bird Awakens Rosalie Asleep in
the Shade of a Cobweb**
Oil on burlap
65.4 × 91.8
University of Iowa Museum of Art.
Purchase, Mark Ranney Memorial Fund

Le Lever du soleil 21 January 1940
Sunrise
Gouache and oil wash on paper
37.8 × 45.6
The Toledo Museum of Art.
Gift of Thomas T. Solley
(Tate and FJM)

L'Échelle de l'évasion 31 January 1940
The Escape Ladder
Gouache, watercolour and ink on paper
40 × 47.6
The Museum of Modern Art, New York.
Helen Acheson Bequest, 1978

Personnages dans la nuit guidés par
les traces phosphorescentes des
escargots 12 February 1940
**Figures at Night Guided by the
Phosphorescent Tracks of Snails**
Ink, gouache, oil wash and coloured
chalk on paper
37.9 × 45.7
Philadelphia Museum of Art.
The Louis E. Stern Collection, 1963
(NGA)

Femme à la blonde aisselle coiffant
sa chevelure à la lueur des étoiles
5 March 1940
**Woman with Blonde Armpit Combing
her Hair by the Light of the Stars**
Watercolour and gouache over graphite
37.9 × 45.8
Contemporary Collection of
The Cleveland Museum of Art
(Tate)

L'Étoile matinale 16 March 1940
Morning Star
Gouache and oil wash on paper
38 × 46
Fundació Joan Miró, Barcelona.
Gift of Pilar Juncosa de Miró

Femme et oiseaux 13 April 1940
Woman and Birds
Gouache and oil wash on paper
38.1 × 45.7
Colección Patricia Phelps de Cisneros

Le Réveil au petit jour 27 January 1941
Awakening in the Early Morning
Gouache and oil wash on paper
46 × 38
Kimbell Art Museum, Fort Worth, Texas.
Acquired with the generous assistance of
a grant from Mr. and Mrs. Perry R. Bass
(Tate)

Vers l'arc-en-ciel 11 March 1941
Toward the Rainbow
Gouache and oil wash on paper
46 × 38
The Metropolitan Museum of Art.
Jacques and Natasha Gelman Collection,
1998

Femmes encerclées par le vol
d'un oiseau 26 April 1941
**Women Encircled by the Flight
of a Bird**
Gouache and oil wash on paper
46 × 38
Private collection. Courtesy Galerie
1900-2000, Paris

Femmes au bord du lac à la surface
irisée par le passage d'un cygne
14 May 1941
**Women at the Edge of the Lake made
Iridescent by the Passage of a Swan**
Gouache and oil wash on paper
46 × 38
Private collection
(NGA)

L'Oiseau-migrateur 26 May 1941
The Migratory Bird
Gouache and oil wash on paper
46 × 38
Private collection
(NGA)

Le Passage de l'oiseau divin
12 September 1941
The Passage of the Divine Bird
Gouache and oil wash on paper
45.7 × 37.8
The Toledo Museum of Art. Purchased
with funds from the Libbey Endowment,
Gift of Edward Drummond Libbey
(Tate and FJM)

Autoportrait 14 March 1942
Self-portrait
Graphite pencil on newspaper
26.5 × 25
Fundació Joan Miró, Barcelona

Personnages dans la nuit
23 November 1942
Figures in the Night
Charcoal, colour chalk and strawberry
jam on paper
50 × 65
Private collection
(NGA)

Barcelona Series (III) 1944
Lithographic pencil on transfer paper
63.5 × 46.3
Fundació Joan Miró, Barcelona

Barcelona Series (VII) 1944
Lithographic pencil and Indian ink
on transfer paper
63.5 × 47.5
Fundació Joan Miró, Barcelona

Barcelona Series (XVI) 1944
Lithographic pencil on transfer paper
60.2 × 44
Fundació Joan Miró, Barcelona

Barcelona Series (XXII) 1944
Lithographic pencil on transfer paper
62.8 × 45.8
Fundació Joan Miró, Barcelona

Barcelona Series 1944
50 black and white lithographs
41 objects, 70 × 53
2 objects, 47 × 60
6 objects, 35 × 47
1 object, 47 × 35
Fundació Joan Miró, Barcelona

Femme rêvant de l'evasion
19 February 1945
Woman Dreaming of Escape
Oil on canvas
130 × 162
Fundació Joan Miró, Barcelona
(FJM)

Femme entendant de la musique
11 May 1945
Woman Hearing Music
Oil on canvas
130 × 162
Private collection
(NGA)

Femme 1946
Woman
Oil on sandstone, bone, stone and iron
54 × 23 × 19
Fundació Joan Miró, Barcelona
(FJM)

Femme et fillette devant le soleil
30 November – 19 December 1946
**Woman and Little Girl in
Front of the Sun**
Oil on canvas
145.8 × 114.1
Hirshhorn Museum and Sculpture
Garden, Smithsonian Institution,
Washington DC. Gift of the Joseph
H. Hirshhorn Foundation, 1972
(NGA)

Le soleil rouge ronge l'araignée 1948
The Red Sun Gnaws at the Spider
Oil on canvas
76 × 96
Collection Nahmad, Switzerland
(Tate)

Painting [Figures and Constellations]
1949
Oil on canvas
73 × 92
Collection Nahmad, Switzerland
(Tate)

Femmes, oiseau au clair de lune
October 1949
Women and Bird in the Moonlight
Oil on canvas
81.3 × 66
Tate. Purchased 1951

Projet pour un monument 1951
Project for a Monument
Iron, leather, oil, gouache and pencil
on cement
41 × 20 × 16
Fundació Joan Miró, Barcelona
(FJM)

Projet pour un monument 1951
Project for a Monument
Iron, porcelain hook, gouache and
oil on stone and gouache on bone
45 × 20 × 14
Fundació Joan Miró, Barcelona
(FJM)

Projet pour un monument 1951
Project for a Monument
Cement, bronze and copper
55 × 13 × 13
Fundació Joan Miró, Barcelona
(FJM)

Projet pour un monument 1951
Project for a Monument
Bell, iron, porcelain hook, gouache and
wax pencil on cement
53.5 × 13.5 × 17
Fundació Joan Miró, Barcelona
(FJM)

Autoportrait 1937–8 – 23 February 1960
Self-Portrait
Oil and pencil on canvas
146.5 × 97
Collection of Emilio Fernández. On loan
to the Fundació Joan Miró, Barcelona

Le Réveil de Madame Bou-Bou à l'aube
1939 – 29 April 1960
**The Awakening of Madame Bou-Bou
at Dawn**
Oil and pencil on canvas
130 × 162
Ceil Pulitzer

Bleu I/III, Blue II/III, Bleu III/III
4 March 1961
Blue I/III, Blue II/III, Blue III/III
Oil on three canvases
Each 270 × 355
Centre Pompidou, Paris
Musée national d'art moderne /
Centre de création industrielle
I – Purchased in memory of Dominique
Bozo, with the assistance of the Heritage
Fund, and the help of Sylvie and Eric
Boissonnas, Jacques Boissonnas, Hélène
and Michel David-Weill, the Friends of
the Museum, Pierre Bergé, Yves Saint
Laurent, Yves Saint Laurent Fashion
House and the participation of many
supporters, 1993
II – Gift of the Menil Foundation in
memory of Jean de Menil 1984
III – Purchased 1988
(Tate and FJM)

Peinture murale I jaune-orange
18 May 1962
Peinture murale II vert 21 May 1962
Peinture murale III rouge 22 May 1962
**Mural Painting I Yellow-Orange
Mural Painting II Green
Mural Painting III Red**
Oil on three canvases
Each 270 × 355
Private collection
(Tate and NGA)

Message d'ami 12 April 1964
Message from a Friend
Oil on canvas
262 × 275.5
Tate. Purchased with assistance
from funds bequeathed by
Miss H.M. Arbuthnot through the
Friends of the Tate Gallery, 1983

Personnage et oiseau 1966
Figure and Bird
Bronze
47.5 × 26 × 20
Fundació Joan Miró, Barcelona

Femme 1966
Woman
Bronze
41.5 × 18 × 3.5
Fundació Joan Miró, Barcelona

Tête 1968
Head
Bronze
43.5 × 24.5 × 9
Fundació Joan Miró, Barcelona

Tête 1968
Head
Bronze
42.5 × 26 × 16
Fundació Joan Miró, Barcelona

Cheveu poursuivi par 2 planètes
18 March 1968
Hair Pursued by 2 Planets
Acrylic on canvas
195 × 130
Collection Gallery K.A.G. On loan to
the Fundació Joan Miró, Barcelona
(FJM)

Goutte d'eau sur la neige rose
18 March 1968
**Drop of Water on the
Rose-Coloured Snow**
Oil on canvas
195.5 × 130.5
Private collection

**Peinture sur fond blanc pour la
cellule d'un solitaire I** 20 May 1968
**Peinture sur fond blanc pour la
cellule d'un solitaire II** 21 May 1968
**Peinture sur fond blanc pour la
cellule d'un solitaire III** 22 May 1968
**Painting on White Background for
the Cell of a Recluse I
Painting on White Background for
the Cell of a Recluse II
Painting on White Background for
the Cell of a Recluse III**
Acrylic on three canvases
268 × 352, 267 × 350, 267 × 351
Fundació Joan Miró, Barcelona

**Sketch for the mural executed on
the windows of the Colegio Oficial de
Arquitectos de Cataluña y Baleares
for *Miró Otro* exhibition** 1969
Ink and wax
15.5 × 176
STUDIO PER, arquitectos

Bas-relief 1970
Bronze
86.5 × 31.5 × 13
Fundació Joan Miró, Barcelona

Constellation silencieuse 1970
Silent Constellation
Bronze
68.5 × 34 × 15
Fundació Joan Miró, Barcelona

L'Équilibriste 1970
The Tightrope Walker
Bronze and steel
53 × 28 × 13
Tate. Purchased 1982 /
Fundació Joan Miró, Barcelona

L'escala de l'ull que s'evadeix 1971
The Ladder of the Escaping Eye
Bronze
80.8 × 29.5 × 18.3
Fundació Joan Miró, Barcelona

Untitled 5 February 1972
China ink and pencil on paper
Paper Scroll
18.9 × 964
Fundació Pilar i Joan Miró, Mallorca

Mai 68 May 1968 – December 1973
May 68
Acrylic and oil on canvas
200 × 200
Fundació Joan Miró, Barcelona

Toile brûlée I 4–31 December 1973
Burnt Canvas I
Acrylic on burnt canvas
130 × 195
Fundació Joan Miró, Barcelona

Toile brûlée II 4–31 December 1973
Burnt Canvas II
Acrylic and oil on burnt canvas
130 × 195
Private collection

Toile brûlée IV 4–31 December 1973
Burnt Canvas IV
Acrylic on burnt canvas
130 × 195
Fundació Joan Miró, Barcelona.
Gift of Pilar Juncosa de Miró

Toile brûlée V 4–31 December 1973
Burnt Canvas V
Acrylic on burnt canvas
195 × 130
Fundació Joan Miró, Barcelona.
Gift of Pilar Juncosa de Miró

Homme torturé s'évadant
14 December 1973
Tortured Man Escaping
Coloured crayons and pen on paper
19.8 × 15.5
Fundació Joan Miró, Barcelona

Tête 1940 – 1 March 1974
Head
Acrylic on canvas
65 × 50
Fundació Joan Miró, Barcelona

Tête 1940 – 1 March 1974
Head
Acrylic on canvas
61 × 38.5
Fundació Joan Miró, Barcelona
(FJM)

Sa majesté le roi 1974
His Majesty the King
Acrylic on wood and bronze
254 × 22.5 × 43
Fundació Joan Miró, Barcelona
(Tate and FJM)

Sa majesté la reine 1974
Her Majesty the Queen
Acrylic on wood and nails
210 × 9.3 × 12.5
Fundació Joan Miró, Barcelona
(Tate and FJM)

Son altesse le prince 1974
His Highness the Prince
Acrylic on wood and horn
203 × 19 × 56
Fundació Joan Miró, Barcelona
(Tate and FJM)

Feux d'artifice I, II, III 9 February 1974
Fireworks I, II, III
Acrylic on three canvases
Each 292 × 195
Fundació Joan Miró, Barcelona

L'Espoir du condamné à mort I, II, III
9 February 1974
The Hope of a Condemned Man I, II, III
Acrylic on three canvases
Each 267 × 351
Fundació Joan Miró, Barcelona

Prisonnier crucifié 10 February 1974
Crucified Prisoner
Coloured crayons and pen on paper
21 × 14
Fundació Joan Miró, Barcelona

Index

Copyright

Picture credits